Greenwich Village 1963

Sally Banes

GREENWICH

Avant-Garde Performance and the Effervescent Body

VILLAGE 1963

DUKE UNIVERSITY PRESS *Durham and London 1993*

To my parents, Helen and Daniel Banes

© 1993 Duke University Press

All rights reserved

Printed in the United States of America on acid-free paper ∞

Typeset in Galliard by Tseng Information Systems

Library of Congress Cataloging-in-Publication Data and

permissions appear on the last printed page of this book.

Contents

Acknowledgments

I am grateful to many people who helped me with the research and writing of this book: Roger Abrahams, Nancy Armstrong, David Bordwell, Maria Capp, Arlene Carmen, Tony Carruthers, Marty Cooper, Robert Cornfield, Stephanie Davis, Leslie Dennis, Susan Foster, Patty Gallagher, Al Giese, Glennis Gold, Robert Haller, Jon Hendricks, Marjorie Keller, Michael Kirby, Billy Klüver, Bruce Levitt, Brooks McNamara, Julie Martin, Fred McDarrah, Jonas Mekas, Howard Moody, Barbara Moore, Peter Moore, John O'Neal, Wendy Perron, Carole Pipolo, Richard Schechner, P. Adams Sitney, Robert Stearns, John Szwed, Amy Taubin, Leonard Tennenhouse, Liz Thompson, David Vaughan, Melinda Ward, and Ross Wetzsteon. The Cultural Studies group at Wesleyan University—Hazel Carby, Noël Carroll, honorary member Michael Denning, Dick Ohmann, Richard Stamel-

man, Dick Vann, and especially Khach Tölölyan and Betsy Traube—deserve special appreciation for helping to shape my approach to cultural history.

Thanks go to all the artists whose work created the culture I have written about here, and in particular those who have taken the time to discuss 1963 with me extensively: Remy Charlip, Philip Corner, David Gordon, Deborah Hay, Dick Higgins, Lawrence Kornfeld, Jackson Mac Low, Yvonne Rainer, Steve Paxton, and Robert Whitman. I salute, in memoriam, Peter Saul and Burt Supree, who generously shared with me their recollections of the Sixties.

Fellowships from the John Simon Guggenheim Memorial Foundation and the Andrew W. Mellon Foundation, grants from the American Council of Learned Societies and Wesleyan University, as well as a sabbatical leave from Cornell University, allowed me time to write and to do research. I am obliged to the staffs of the Anthology Film Archives, the Billy Rose Theater Collection and the Dance Research Collection of the New York Public Library for the Performing Arts, the Judson Memorial Church Archives, and the LaMama E.T.C. Archives, for their kind assistance.

Parts of this book were given as talks at the Wexner Center and the Art Department at Ohio State University, the Dance Department at University of California-Riverside, the Theater and Drama Department at University of Wisconsin-Madison, and the Judson Memorial Church under the auspices of the New York University Humanities Institute. I am indebted to those institutions for inviting me to share my work-in-progress and to the individuals who offered me valuable feedback at those sessions. I am also most grateful to the Cornell students in my undergraduate and graduate seminars on the Sixties and on postmodern dance, who helped me develop these ideas.

At Duke University Press I would like to thank Joanne Ferguson, Larry Malley, Mary Mendell, Bob Mirandon, Pam Morrison, and Rachel Toor for their faith in (and work on) this project.

This book could not have been completed without the support of four people. Joan Acocella and Lynn Garafola carefully read through several versions of the manuscript; I profited enormously from their questions and suggestions. My thoughts about dance and performance have constantly been stimulated and sharpened by many late-night conversations with Joan in the past decade or so. Mary Evans was a valued sounding board who kept me on track during the ups and downs of this project over the years. My husband, Noël Carroll, read through *all* the versions, edited mercilessly, criticized, praised, gave unsparingly of his wit and wisdom, and cooked

many meals to sustain me, all the while carrying on with his own work. Although we do not always agree, his philosophical inquiries into both performance art and mass culture have always provided me with food for thought. His emotional support and intellectual generosity, tempered with a healthy dose of skepticism, have continuously energized me in this and all my projects.

I dedicate this book to my wonderful parents, who spent the 1963–64 season, among other things, driving me to teenage dance parties, tutoring me in the arts, and taking me on my first trip to Greenwich Village.

Introduction

In 1963 what we now call the Sixties began. For political historians that
year is memorable for the nuclear test ban treaty, the historic civil rights
March on Washington, U.S. help in overthrowing the Diem government in
Vietnam and the increase of American advisers there twentyfold, President
John F. Kennedy's visit to the Berlin Wall, the deepening Sino-Soviet split,
and the assassination in Dallas, among other events.[1] But in 1963 another
kind of history and another kind of politics were being made, in Green-
wich Village, New York City. This was a political history that had nothing
to do with states, governments, or armies, or with public resistance. It had,
instead, to do with art and its role in American life. For it was not only
the policymakers in Washington who were shaping American postwar cul-
ture, but also, importantly, groups of individuals setting forth models of

daily life for a generation—gently loosening the social and cultural fabric by merging private and public life, work and play, art and ordinary experience. That loosened fabric fell apart by the late Sixties, but it is the early part of the decade, specifically the year 1963, whose story I want to tell in these pages.

Here, in Greenwich Village in 1963, numerous small, overlapping, sometimes rival networks of artists were forming the multifaceted base of an alternative culture that would flower in the counterculture of the late 1960s, seed the art movements of the 1970s, and shape the debates about postmodernism in the 1980s and beyond. Inspired by—and fully conscious of—half a century of avant-garde activity, and sparked by visionary voices of the Fifties, these artists were forging new notions of art in their lives and in their works, and—through their art—new notions of community, of democracy, of work and play, of the body, of women's roles, of nature and technology, of the outsider, and of the absolute. Some of these artists eventually disappeared from view, left the world of art, or worked on the margins; and some died young. But many of them emerged by the Seventies and Eighties as acknowledged masters of their disciplines (some even as cultural icons)—including Andy Warhol, Yoko Ono, Lanford Wilson, Sam Shepard, Brian De Palma, Harvey Keitel, Kate Millett, Nam June Paik, Yvonne Rainer, Claes Oldenburg, Ed Sanders, Bernadette Peters, Tom O'Horgan, and Marshall Mason.

The rising generation of young avant-garde artists in Greenwich Village in the early 1960s in various media—from Off-Off-Broadway theater to Happenings, dance, film, and visual art—occupied a novel position in both the art world and American culture in general. Exactly by virtue of their youth and their Americanness, although they were avant-gardists, they suddenly occupied an unexpectedly central position in the arts. The economy was expanding and with it the arts and commitments to arts patronage by the state. In the United States a claim to dominance in the international art world was soaring, thanks to Abstract Expressionism, and a youth market suddenly boomed. Also the rapidly proliferating mass media easily and speedily broadcast American culture—both in the sense that the mass media spread their own images from coast to coast (and worldwide) and in that these images reproduced a spectrum of "high" and "low" culture.

This book does not aim to document comprehensively the extraordinarily rich activity in New York City in the early 1960s.[2] Instead, I want to focus on one year. The choice of 1963 (which, for my purposes, includes the 1963–64 season) is not arbitrary. This was the most productive year of the

period 1958–64, the transition between the Fifties and Sixties. Of course, 1963's activities have roots reaching back to the late Fifties and earlier, to the European avant-garde of the Teens and Twenties, and to the *poètes maudits* of the nineteenth century. But 1963 is the year when those activities peaked. I also will focus on one place—Greenwich Village in lower Manhattan. For it was primarily here, in a place already historically and culturally mythologized as avant-garde terrain, that the emerging generation of vanguard artists lived, worked, socialized, and remade the history of the avant-garde. And I will focus on only a few overlapping arenas of artistic activity. The performing arts are my special concern, for the performing body is central to all the interconnecting arts of this period.

1963

In 1963 the American Dream of freedom, equality, and abundance seemed as if it could come true. Not that it had—but that it was just about to. Expectations were rising after the economically and culturally stagnant decade of the Fifties. And now the arts seemed to hold a privileged place in that democratic vision, not merely as a reflection of a vibrant, rejuvenated American society, but as an active register of contemporary consciousness—as its product, and also as its catalyst. The Kennedy-era White House sponsored ballet performances and enjoyed European couture and cuisine, but the youthful, glamorous First Family also played touch football and danced the Twist. The very spirit—and economy—that could generously support elite culture paved the way for a distinctly twentieth-century, postwar, postindustrial American avant-garde art: democratic yet sophisticated, vigorous and physical, playful yet down-to-earth, freely mixing high and low, academic and vernacular traditions, genres and media. There was a feeling—so unlike the early 1990s—that all things were possible . . . and permitted.

Although the country had its problems at home and abroad, the official mood was optimistic. The civil rights movement persisted in its course of nonviolence, despite brutal attacks. In the summer of 1963 Martin Luther King, Jr., spoke to more than 250,000 marchers in Washington, D.C. And the movement's fight for specifically legal rights expressed a sanguine belief among many that equal rights in the eyes of the law would guarantee blacks their fair share of the system: the jobs, goods, and leisure a surging postwar economy had created. Genuine freedom seemed around the corner for African Americans. The president underwrote their cause by having a civil rights bill introduced in Congress. It is in the context of that hopeful

passion and sense of imminent liberation that blacks and with them, white liberals, intellectuals, and artists felt an entire culture buoyed in ways both direct and indirect.

The increasing postwar affluence of the Fifties seemed by the early Sixties to be spiraling boundlessly (if at times somewhat unevenly), and in 1963 the economy was boosted by a new spurt, with even further gains promised by Kennedy's proposed tax cut (finally passed in 1964). The cold war began to thaw, first with the resolution of the Cuban missile crisis in 1962 and then with the signing of the nuclear test ban treaty, which passed the Senate in September 1963. Even our increasing military involvement in Vietnam still seemed, in the liberal view, to be part of a Pax Americana. By 1963–64 there were, to be sure, a vocal antinuclear movement and nascent anti-Vietnam war and student movements, but these, like the civil rights movement, operated in an arena of hope that was leavened by an increasing sense of entitlement. Political resistance to mainstream culture was fragmented. The Old Left was decimated by the ravages of Stalinism and McCarthyism; the New Left was yet to coalesce in response to the crises of the mid- and later Sixties. Officially, it was a time of consensus. And the consensus was that life in the United States was good—and getting better. Kennedy's assassination threw the nation into shock, but it did not stop the momentum. The results of those shock waves, and the succeeding ones that would eventually erode the liberal ideal of Pax Americana, would not be felt fully until the second half of the decade.

The official mood was paralleled (although not exactly mirrored) above all in New York City, the international center of the visual art world since the end of World War II. Clearly, the United States was in the welcome throes of a "culture explosion," and New York, not Washington, was the national cultural capital. Nineteen sixty-three was an important year for all the arts in New York City. Perhaps as part of U.S. cold war competition with the Soviet Union that also led to intensified science education programs, in 1963 the Ford Foundation launched a nearly $8 million project to Americanize ballet, and the foundation had just finished structuring a similar $6 million project for theater in 1962.[3] For the first time, academic theatrical dancing was institutionalized in every corner of the United States. New York (specifically, the Russian émigré George Balanchine's School of American Ballet) served as the central training ground for teachers and students—some of whom came from distant towns and hamlets to end up becoming stars in the New York City Ballet; some of whom went back home to bring professional training from New York to their own regions. Ballet, in other words, was Americanized on the Russian model. A New

York musical institution also took a step toward being "nationalized" when President Kennedy announced plans to form a national touring company of the Metropolitan Opera, which planned to foster young singers and put on operas, in English, for college and community audiences. In the visual arts, museum-building thrived, as the Museum of Modern Art made plans to expand into the building occupied by the Whitney Museum, which was soon to move to its new site designed by Marcel Breuer, and the Museum of American Folk Arts opened. In film, the first New York Film Festival was staged at Lincoln Center's first building, Philharmonic Hall. In 1963 work was progressing on the five other buildings at Lincoln Center for the Performing Arts, a gigantic arts complex. Its second building, the New York State Theater, opened in 1964.

In 1963 questions of state arts patronage emerged as a central political concern. With Kennedy's establishment of a national arts commission in June 1963, a first step was taken toward the eventual creation of a direct federal subsidy program for the arts that would result in the National Endowment for the Arts. Arguing in the Senate for a national arts foundation, Senator Jacob Javits of New York noted that by not recognizing the arts, the United States was lagging behind other great nations and putting "the grandeur and dignity of our nation . . . at stake."[4] August Heckscher, Kennedy's special consultant on the arts, declared that the artistic life of the country could influence the course of the cold war and have an impact on the nation's international reputation. "It may be worth remembering that during the tensest hours of the recent Cuban crisis, Mr. Khrushchev was reported as spending four hours at the opera."[5] These intimations of an art gap between the superpowers, one that the United States was anxious to diminish, is reminiscent of Kennedy's warnings of the "missile gap" during his presidential campaign. Now the cold war was being recast as a cultural competition rather than a military one. The National Endowment for the Arts was not authorized until 1965, as part of President Lyndon B. Johnson's Great Society program, but in 1963–64 national debates raged in the media about such an agency's role in arts subsidies and about the share of the funds that New York City would receive.

Rising expectations in the art world, then, were visible in New York and, above all, in Greenwich Village, the historic mecca for bohemians. The prospects for those expectations were lifted along with those of mainstream arts institutions, for a thriving mainstream spawned a vigorous avant-garde. There was an ebullient spirit in the avant-garde arena—a spirit of engagement, of confidence, of pleasure, and also of transgression. It was in the 1963–64 season that Pop Art exploded; that the Judson Dance

Theater was at its most prolific; that the Living Theater was at its most productive; that the Judson Poets' Theater won five Obie awards (the *Village Voice*'s honor for Off-Broadway theater). It was in that season that Andy Warhol introduced the Pop Movie and that Kenneth Anger's film *Scorpio Rising* and Jack Smith's film *Flaming Creatures* were made—and banned; that the performance group Fluxus arrived in New York; that Charlotte Moorman organized the First Festival of the Avant Garde. In the early Sixties, rising expectations—and the contradictions that such prospects seem automatically to incur—began to fuel the social and cultural changes that, by the end of the decade, became a conflagration. The Greenwich Village arts scene—and live performance in particular—is a paradigm for that early transformation.

The Democratization of the Avant-Garde

The notions that these early Sixties artists introduced into art—urban landscape, communitas, ordinary life, freedom from rules and canons, playfulness, and physicality—were not unprecedented. They were built on the ideas and practices that these artists inherited from the Fifties and earlier, yet still found wanting. Attempting to create *new* communities, *new* traditions, *new* ways of making and viewing art, the Sixties avant-garde found itself beset by contradictions. For to make a clean break from even a despised past is impossible. In criticizing the middle-class values of modern culture, even in choosing to live and work in Greenwich Village (that is, in joining the "traditional" bohemia), these artists—many of whom were from the middle class—found that they could not help simultaneously rejecting *and* reproducing middle-class culture. They used icons of popular culture to comment on bourgeois life, but almost overnight found themselves written up in *Life*. They broke with their families in New England, the South, the Midwest, and the West to move to Greenwich Village, but they gravitated to alternative "families" in Manhattan. Unlike their slightly older contemporaries, the Beats, who had protested the stultified mainstream culture of the Fifties by alienating themselves from it, the early Sixties artists rubbed shoulders with outsiders but at the same time reached out to popular, mass audiences. Caught in a self-contradictory marriage between vanguard and popular culture, never fully able to escape bourgeois culture, yet transforming it radically along the way, the Sixties avant-garde set the stage for both political and artistic cataclysms in the later Sixties. This was the first generation of postmodern artists. They shaped the debates, forms, and institutions that would animate art and culture for the rest of the century.

Like the Soviet avant-garde of the 1920s, the early Sixties artists were both interested in and historically capable of truly acknowledging the sophisticated mass culture they were part of—and the fact that they were part of it. They used computers and television, collaborated with engineers, and brought mass media techniques into the art gallery.

But this generation of artists was unique in collapsing certain cherished bohemian values into mass post-World War II American culture. It posited an old avant-garde tension between elite and popular art and an old art world tension between Europe and America, but in ways that seemed drastically new. This generation popularized formerly elite arts— Dick Higgins's mock Russian opera *Hrusalk'* took place at the Cafe au Go Go (admission free)—and it popularized formerly elite social formations, including the notion of the avant-garde itself. But it also did the reverse, appropriating the popular as material for high art: vaudeville performances, Hollywood iconography, rock and roll, jazz, and American popular song.

Russell Jacoby argues in *The Last Intellectuals* that it was the Beat Generation that popularized high culture for Americans and thus formed the counterculture.[6] I disagree. In retrospect, it seems clear that another step beyond the Beats had to be taken to make "outsider" culture comfortable for massive youth participation: avant-garde art had to be made accessible, and avant-garde artists had to participate in, not withdraw from, all of popular culture. Because of its commitment to the democratic ethos, the art of the early Sixties avant-garde circulated transgressive ideas in what would ultimately become acceptable packages. This contradiction heralded the end of the modernist avant-garde and the beginning of postmodernism.[7]

Stanley Aronowitz has suggested that in the early Sixties there were two separate radical cultures—the political activists who became the New Left and the "alternative culture workers" (the artists)—that merged to form the counterculture of the later Sixties.[8] Despite the apparently apolitical stance of many of their works, I want to claim that models for both political and artistic radicalism *were* created simultaneously in the ferment being traced here. That these artistic acts were political, I hope will become clear, although at the time they could not, perhaps, always have been perceived as such. The Seventies' feminist refrain, for instance, that "the personal is political" and that therefore to change one's own life is a political act had already emerged as practice in the early Sixties avant-garde art world.

Influenced by older artists and intellectuals such as John Cage, Merce Cunningham, Charles Olson, Maya Deren, Norman O. Brown, and Paul Goodman—whose work and thought, though embracing the experiences

of everyday life, still, it was felt, left art accessible only to the initiated—these younger Sixties artists amalgamated the cutting edge of "high art" culture (that formerly elitist terrain) with American postwar popular culture. Their project was fueled by their peculiarly historical, almost Puritan sense of mission. These younger artists knew their art history, yet they felt themselves cut off from tradition—by choice as well as by time and geography. A juncture of two heritages—the American and the avant-garde—produced a double imperative to make things new. That is, they had a sense of history, but it was future-oriented. Yet, ironically, their particular avant-garde project was, in part, to reinvent tradition, community, and mythology. Like the next generation of postmodernists in the Eighties and Nineties, they understood themselves only fragmentarily as products of history. By 1963 their own history as innovators included an official history of the avant-garde, to which there were still many living links (after all, Marcel Duchamp was still a Villager in the Sixties; Cage taught Dada techniques in his music composition course at the New School for Social Research; the notorious 1913 Armory Show, which brought modern art to the United States, was re-created in April 1963; and the centenary of the Salon des Refusés, the birthplace of modern art in Europe, was celebrated.[9] These Sixties artists took from history what they could use, but—unlike their successor postmodernists—they entertained a utopian dream of freeing themselves from the past.

In struggling to respond to (and, inevitably, in helping to make) a new world—a postindustrial, bureaucratized, suburbanized, technologically sophisticated, expanding, and rapidly changing, yet ahistoricized, mass American culture—these early Sixties artists found themselves in a postmodern dilemma, a world of logical paradoxes. If the United States was expanding, then the world, it was proclaimed, was shrinking. If national life was increasingly sophisticated and bureaucratized, the world was increasingly primitivized as a global village. If suburbia was a wasteland, then urban rather than rural space was utopia. Machines, Marshall McLuhan asserted, were in fact part of nature: extensions of the human body.

The art of the early Sixties laid the groundwork—in content, style, and technique—for the two distinct branches of vanguard art that would directly follow it: the medium-oriented formalism of the Seventies and the deeply ambivalent, ironic, reflexive art of the Eighties and Nineties (that is, second-generation postmodernism). The early Sixties linked an exuberant, carnivalesque, boundary-blurring style of art with a cool, ironic attitude toward culture. Dormant during the formalist period of art and criticism in the Seventies, this mix returned with a vengeance in the Eighties. But

it also returned with a difference—this time in an atmosphere of national cynicism, not hope, and defined by a sense of shrinking, rather than expanding, resources. Yet at the same time it is clear that the deep scrutiny of every medium that was part of the interdisciplinary flux of the Sixties led first, in the Seventies, to a rigorous and sober asceticism, a principle of minimalism and separation oddly appropriate in the wake of Sixties excess.

Guided by a vitalizing, often critical vision of American society, these Sixties avant-garde artists attempted to build a community through art. Theirs was an alternative community that looked to folk, popular, and transgressive subcultural styles, as well as to religious ritual, for means to reject the values of both the previous generation of artists and the sociopolitical establishment. They initiated modes of production—cooperative, unalienated labor—that were rare in the 1950s.[10]

The Sixties artists' search defined an era. It became part of the massive political and cultural upheavals of the late 1960s when the scene of action moved out not only from the galleries and theaters, but from the ghettoes, universities, workplaces, and kitchens, and into the streets. When these artists' transgressions erupted beyond the boundaries of art, the Sixties as we know them begin.

I am not claiming here that members of Students for a Democratic Society (SDS), for instance, knew anything in detail about Yvonne Rainer's dances or Kenneth Anger's films, or even Andy Warhol's famous paintings of soup cans. Nor do I mean that violent events such as racist killings in the South, the Kennedys' and King's assassinations, the escalating war in Vietnam, and government repression at home were not key factors in the various political and cultural cataclysms of the later Sixties. The effects of rock music and psychedelic drugs on the counterculture are well-documented.[11] But I am arguing that these alternative modes of cultural production were crucial elements of social change. They were not just "reflections" of society; they helped shape the very form and style of political and cultural protest in the later Sixties. For one thing, however garbled its meaning, the concept of "the Happening," as spread through the mass media, was a ubiquitous figure for the expression of freedom, spontaneity, and an appreciation of art in life. Further, groups like Bread and Puppet Theater participated visibly in political rallies and demonstrations (as did individual artists in every medium). When the Living Theater returned from its self-imposed European exile to the United States in 1968, it toured college campuses, sparking debates about the effectiveness of theater as a political tool, teaching its own anarchist version of "the Rite of Guerrilla Theater" and inspiring the formation of numerous young guerrilla theater

groups nationwide.[12] Political filmmakers such as members of the national Newsreel collective borrowed images and techniques from the early Sixties underground.[13] And political posters were influenced by Pop Art, and sometimes even made by Pop artists.

In the early Sixties the arts became an important arena in which aesthetic, personal, and polemical energies were galvanized by people who were convinced, with evangelical fervor, that they had entered into a new covenant with history through the rediscovery of their chosen medium. The self-conscious political significance of the socialist realist artists in the Thirties and Forties was rejected, but so was the political disengagement of the generation of the Fifties. Though the Sixties artists did not put it this way, neither option was acceptable; a different way to make political statements had to be found. A generation of abstractionists had intervened since the last wave of political art, and a modernist preoccupation with materials now dovetailed with a pragmatic, antiexpressionist worldview. Nevertheless, abstraction was not enough, for now the arts suddenly seemed freshly empowered in ways that were light-years removed from the old socialist realism of earlier engaged artists to provide a means for—indeed, to *embody*—democracy. The early Sixties avant-garde artists did not aim passively to reflect the society they lived in; they tried to change it by producing a new culture.

Outline

This book is meant to be thematic, not documentary or archival in approach. The themes of Sixties culture will be explored through models and examples rather than by a narrative chronicle of artists or institutions. Moreover, my method is iconographic, contextual, and interpretive. Others have discussed the formal breakthroughs these art works present; I plan to examine the images they display and the methods they employ, analyzing their meanings in cultural and political context. Therefore, although illustrative examples have been selected, many more could be discussed.[14]

The first chapter lays out the physical and cultural terrain of Greenwich Village, the richly symbolic space claimed by the avant-garde. In the second chapter intersecting art worlds are sketched in terms of the concept and rhetoric of community. Chapter 3 discusses the intellectual and artistic crisis facing postwar America that gives this avant-garde its specific character: now that the United States had become the center of the international art world, which culture—high or low—would it embrace? Chapters 4 and 5 examine the two key themes of American democracy in the Sixties: equality and freedom. Chapter 6 is concerned with analyzing images of the

body. This is the unifying factor among the arts and the locus for the inter-disciplinary work that characterized the early Sixties. It was the site where the avant-garde staged its cultural struggle. And chapter 7 takes up the paradox of spiritual commitment in a predominantly atheist community, addressing, among other issues, why a church was the venue for so much radical art.

I have tried to read these works and the rhetoric that surrounds them in their own cultural context. Given the cultural distance we have traveled from the Sixties, that has often meant acknowledging political and cultural views I disagree with, for instance, essentialism in regard to "race" and gender. While I admire many of these artists and art works, I do not necessarily agree with them, or rather with what they said then. I trust that my own distance from the rhetoric I analyze will be clear.

1

Another Space

In his essay "Of Other Spaces," Michel Foucault invents a new term: heterotopia. Heterotopias, he explains, "are something like counter-sites, a kind of effectively enacted utopia in which . . . all the other real sites that can be found within the culture, are simultaneously represented, contested, and inverted."[1] Utopias may serve as analogies or inversions of a culture, but utopias are fictional, not real spaces. Heterotopias, on the other hand, are real spaces that simultaneously reflect and contest society. Often, they are sites of deviance, like prisons and mental hospitals. The same counter-site may serve different functions at different times in a society's history. Heterotopias are capable, as in theaters and gardens, of symbolically juxtaposing several spaces in a single space. And often they are rendered both penetrable and isolated by systems of entrances and exits.

In our modern culture, Foucault argues, there are heterotopias both of illusion and compensation—the latter type serving as a model more perfect and more ordered (as in certain colonies) than its original. I want to propose Greenwich Village as a heterotopia of the nation in the early Sixties, but one that offers an inverse compensation. That is, Greenwich Village is a heterotopia more free, more disordered, less "perfect" than the other real spaces of American society, a society, it was felt by some, that was becoming increasingly bureaucratized and technocratic. This chapter will be concerned with Greenwich Village as that mythic space of dissent: its history, its geography, and its genealogy.

Greenwich Village: A History

The [Washington Square] arch in the winter of 1916 was the scene of a quaint and unusual revolution. John Sloan and Marcel Duchamp with several of their Bohemian artist friends climbed the narrow staircase through the steel door on the west side. On reaching the top they spread out hot water bags to sit on, opened food and wine, lit Japanese lanterns and blew up red balloons. They read poems, fired cap pistols and with a grand shout, John Sloan declared Greenwich Village "a Free Republic, Independent of Uptown."[2]

This anecdote, taken from *Greenwich Village,* Fred McDarrah's 1963 guidebook, provides a suggestive figure for the history and myth of "the Village," in terms of both the performance itself and the way it is described. "Quaint," "unusual," "revolutionary": the Village as packaged in the early Sixties spiced tradition with eccentricity but tempered rebellion with frivolity. There is even a hint of ethnographic distance in the use of the word "quaint," as if the artists whom McDarrah chronicles were not only removed chronologically but constituted an exotic, alien tribe whose daily lives and rituals were so inexplicable that they were reduced to senseless pranks.

The very use of this particular anecdote signals a Sixties' ambivalence toward the "tradition" of the avant-garde. For despite McDarrah's presentation of the Sloan/Duchamp performance as remote and inscrutable, its meaning is clear and fits neatly with his own interpretation of Greenwich Village in 1963 as the site of a cultural renaissance—a revivified heterotopia. In fact, McDarrah's choice of this particular performance underscores the continuity of the avant-garde, for in 1963, nearly fifty years later, Duchamp was still living in Greenwich Village and attending some of the performances analyzed in this book.

Duchamp's "occupation" of the venerable monument remakes political revolution into cultural rebellion with an event that is festive (with its wine and food), artistic (with its poetry readings), exotic (with its Japanese lanterns), playful (with its cap pistols and balloons), and leftist (the balloons, after all, are red). It is also a strident statement of bohemian libertarian community ("a Free Republic") and a call for an alternative culture, autonomous from bourgeois ("Uptown") life, but at a barricade made comfortable with hot water bags. Moreover, this declaration of independence is a performance/demonstration—an enacted, not a written, manifesto. It is a parodic gesture, but its antic, concrete form affirms a radical cultural-political project. Duchamp's performance ratified Washington Square as a monument of the avant-garde.

In the early Sixties, when New York City was undergoing massive demolitions, reforms, and building construction, Greenwich Village was acutely conscious of its historical character in a number of respects: as an elegant landmark district, as a bohemia, and as an ethnic neighborhood. Indeed, it was self-consciously a steadfast village, with several interwoven histories, that its residents thought managed (partly through long-standing geographic isolation) to preserve the warmth of face-to-face, "authentic" experience in the midst of escalating metropolitan anonymity. City commissioners might target various buildings and blocks for urban renewal, make plans to reroute traffic, and close down coffeehouses; New York University might buy more and more land ringing Washington Square. But various Village people and organizations would instantaneously respond to such projects, submitting their own plans and designs, meeting with officials to find compromise solutions, or taking the city to court. This is how Villagers represented their neighborhood, both to themselves and to outsiders, in publications ranging from the *Village Voice* weekly newspaper to McDarrah's guidebook.[3]

In this section I want to examine McDarrah's *Greenwich Village* as one of the texts of the Village's self-conception, showing how he rehearses the history of this heterotopia. McDarrah's Greenwich Village was an imaginatively constructed setting, not only for the specific performances I will be analyzing here, but for a larger, metaphoric performance in which Villagers fashioned themselves and their place. While McDarrah certainly romanticizes aspects of the Village, and in many ways interprets it quite differently than I will, I do not intend the words "imaginative" and "performance" to be taken here as derogatory. For my purposes, what is interesting is not the accuracy of his assessments, but what those comments tell us about the values and preoccupations of the era—what kind of consciousness they ex-

press. In other words, McDarrah's book itself is a barometer of the time. McDarrah's potted history of Greenwich Village is, secondarily, useful for contextualizing the artists and performances I will discuss. But it must always be understood as a document produced and constrained by its cultural moment, rather than as a bundle of objective or neutral "facts."

In his introduction to McDarrah's book, David Boroff writes that the Village "is no single entity. It is, in fact, a congeries of communities . . . whose citizenry ranges from unimpeachably middle-class types to real Bohemians."[4] Both types, when interviewed, told Boroff that the Village was important to them for its "human dimension," its neighborhood atmosphere that somehow made both intimacy and autonomy simultaneously possible (but neither type mentioned the Italian or African American ethnic populations). Greenwich Village was, Boroff thought, a close community, with an unusually high degree of tolerance and diversity, traits that turned it into a "laboratory in democratic living."

"Is it possible within a city to have the equivalent of a small town with its democratic rule and its fierce concern with local issues?" Boroff asked, and he answered: "Greenwich Village, with its formidably vocal organizations, has demonstrated that such local concern is possible."[5] It was one of the few places in the United States, he also pointed out, where interracial couples could feel comfortable—although he did not perceive the contradiction that this liberal racial tolerance was, in 1963, a violation of most small-town values. For Boroff and McDarrah, the eclectic array of architectural styles and the neighborhood's very streets—which slanted and wound about the map, refusing to fit into the metropolitan grid—symbolized the Village's nonconformism.

But while the authors praised the small-town character of the Village, they were equally enthusiastic about its more commercial features (though Boroff noted with some surprise that "oddly enough, the cultural ferment which attracted people to the Village in the first place may prove to be its undoing"). The very publishers, bookstores, theaters, jazz clubs, and coffeehouses that served as outlets for the artists who lived there made Greenwich Village an entertainment center for outsiders, from New York itself and beyond, and a gold mine for real estate developers, whose projects had already begun to raise Village rents and displace the artists eastward.

The publication of McDarrah's guidebook (by Corinth, the publishing wing of E. Wilentz's Eighth Street Bookstore) was, of course, itself an index of that tourist market. It purveyed the "exotic" present but offered a standardized history of the Village—a history that ritually praised the nonconformism and communitas of the neighborhood but ritually bemoaned

its threatened demise. It packaged Greenwich Village as an alternative historical Williamsburg, Virginia—a living museum of American bohemia.

McDarrah is torn between celebrating the Village as bizarre and as staid, as eternal and as changing, as separate from New York City and as central to it, as seriously authentic and as entertainment. Each extreme is balanced by its opposite. And somehow all these contradictions are resolved as inexplicably characteristic of the Village, as creating a dialectical, kaleidoscopic vitality. This resolution is motivated by the suggestion that, in the end, the Village can be all things to all people, a spiritual cornucopia or melting pot—offering the best features of both urban and village living. Yet more deeply rooted (indeed, barely noticeable on the surface of the text) is an ambivalence toward these qualities, perhaps even a lament that the Village is already a paradise lost. Before I show that this is a familiar, perennial lament, let me briefly present McDarrah's version of Village history.

In McDarrah's account the history of Greenwich Village's settlement begins with its annexation from the Sapokanikan by the Dutch in the seventeenth century. The area from Minetta Brook to the Hudson River, called Bossen Bouwerie, became the Dutch governor's personal estate. Under British colonial rule a small town grew up in the area, a northern suburb of New York City proper (which at that time occupied only the tip of Manhattan). A single road—now Greenwich Street—connected the Village with the city. (For McDarrah, this theme of separateness is key to the neighborhood's identity. But the contradictory notion of the Village as the center of New York City is always coupled with this theme of its isolation.) By the end of the eighteenth century Greenwich Village still provided a semirural highland spot to escape the smallpox, yellow fever, and cholera epidemics raging through the town, but a thriving neighborhood soon developed when the rest of the city was quarantined. "During the epidemics . . . Greenwich Village became the center of the metropolis."[6]

In 1811, when the hills of New York City were leveled and the gridiron street plan imposed, according to McDarrah the Villagers protested, and while the hills did disappear, the winding streets and irregular blocks remained, "helping to create the atmosphere that makes the Village a community distinct from the rest of the city." McDarrah describes this battle as "the first of a yet-to-cease onslaught to make the Village conform to the physical pattern of New York."[7] He constantly states this theme throughout the book. The energy abounding in the Village in the Sixties, it is implied, stemmed partly from its self-avowedly embattled position in staking out its traditional claims—which McDarrah sees as harking back to this time—to uphold and balance the conflicting values of community and

individuality, separateness and centrality, creativity and freedom. The discreteness and nonconformity of the Village's geography neatly serves as a figure for its cultural uniqueness.

McDarrah briefly traces the myriad elements of the Greenwich Village melting pot. In the mid-nineteenth century first the Irish, then southern blacks, and then Italians settled into tenement houses south of Washington Square. Wealthier families moved uptown (making former stables, studios, and apartments available at low rents), and so by 1910 Greenwich Village began to attract artists and writers. McDarrah sums up the fluctuations of the various bohemias since the turn of the century with the myth already immortalized in the popular imagination: "They espoused Free Love, Free Speech, Radicalism, Marxism, Socialism and bizarre forms of eccentricity, read the *Masses* and wrote books."[8]

There are hidden histories of Greenwich Village that do not appear in McDarrah's book. In the context of tracing the history of jazz in Greenwich Village, Imamu Amiri Baraka (LeRoi Jones) has pointed out that it was the families of eleven African American men, formerly indentured servants, who originally settled the Village in 1644, eighteen years after they arrived in New Amsterdam. One of the conditions of their manumission was that they move to the settlement's outskirts, the "tangled swamp" that would become Greenwich Village. An African American theater company operated the Grove Theater at the corner of Bleecker and Mercer Streets in the 1820s, and there were black musicians playing in theaters stretching along Houston Street. Until poor working-class whites set fire to the black housing in 1863, killing or injuring more than a thousand people, there was a thriving African American community in the Village. After the Civil War, waves of southern blacks arrived to form a new community there, although the Village was no longer the center of African American life in New York.[9] Baraka's interest in rediscovering the history of the Village and reappropriating it as a symbolic space—but for traditional African American culture, rather than a middle-class white avant-garde—underscores the identity of the Village as an imaginary terrain that needs to be claimed.

McDarrah's history leaps from the 1910s to the present. "Since the second World War the traditional Bohemian Village has experienced a dramatic change with the rise of luxury buildings, soaring rents, the loss of some fine old landmarks, the acquisitions of New York University in the Washington Square area, urban renewal and high priced entertainment." But this is nothing new, he points out. Someone has always turned a profit from the bohemian atmosphere of the neighborhood. This, too, is part of Village life, he seems to admit, despite the protests against urban renewal

and development that thread through the rest of the book. McDarrah concludes:

> As time passed, the Existentialists came, The Silent Generation, The Beat Generation, The Conservative Generation all to compose the ever-changing, curious make-up of the Village community . . . an island still very much set off from the rest of the city by the freedom of style of its citizens as well as its physical make-up, inhabited by a variety of people so diverse that their only point of agreement is the necessity for maintaining their community . . . Greenwich Village. (ellipses in original) [10]

For McDarrah, despite his regretful mention of such ugly realities as New York University's destruction of landmark buildings and the presence of the Women's House of Detention in the Village Square, Greenwich Village is above all a "day-to-day festival," epitomized by the scene in its central gathering place, Washington Square Park (the site of the 1916 Sloan/Duchamp secession):

> On foot, on bicycles, on motor scooters and taxis, in baby carriages or sight seeing buses, whatever conveyance carries them, everyone gathers here, cats and babies, artists and intellectuals, bankers and beatniks, zen buddhists and swamis, shoe clerks and writers. . . . The fountain *is* the heart of the Village for it is here on a summer Sunday that Villagers gather to pick at banjos, shoot photographs, sunbathe, spin yo-yos, twirl lassos, protest non-violently, write poetry, shoot off-beat movies, meet friends or just plain talk. All that is missing is a community bulletin board.[11]

This celebration of a fertile, carnivalesque diversity within unity gives McDarrah the model for his book. His conceptual map of the Village promiscuously mixes venerable old landmarks (like the First Presbyterian Church on Fifth Avenue, which furnished George Washington's inauguration Bible, and the Grove Street house of Tom Paine) with monuments of old bohemia (such as Mabel Dodge's salon at 23 Fifth Avenue and the Liberal Club and Provincetown Playhouse, both on Macdougal Street) and with new avant-garde landmarks: the Living Theater, the offices of the *Village Voice,* the Cedar Tavern, the Folklore Center, and coffeehouses like the Fat Black Pussycat, Cafe Bizarre, The Hip Bagel.

And nowhere does McDarrah's delight in the figure of the paradoxical Village emerge more strongly than in his description of Judson Church, a dignified religious institution in which all sorts of traditions are smashed:

not only do the parishioners call Howard Moody, the minister, by his first name, but the church helps jailed poets, protects the rights of folksingers, houses a rehabilitation program for drug addicts, and sponsors Happenings, an avant-garde Poets Theater (the nascent Dance Theater is not mentioned), an art gallery, and a politically radical, town-meeting-style Hall of Issues.

Greenwich Village: A Map

If in 1963 you stood in front of the Judson Church, on West Fourth Street at Thompson Street, facing Washington Square Park, on your right you would see New York University stretching along West Fourth Street and northward up Washington Square East. At 15 West Fourth Street, the Square East Theater might be showing Roberts Blossom's film-theater-dance piece, *Blossoms,* and improvisational comedy by the Second City troupe. The ANTA Theater, also on Washington Square, was being built as the temporary home of the Lincoln Center Repertory Theater and scheduled to open in January 1964. Directly ahead of you, across the park, would be the shops, movie theaters, and restaurants that drew Villagers and tourists alike to stroll along Eighth Street, from Sixth Avenue past University Place, at all hours. If you walked down Eighth Street and turned left on University Place, you would reach the Cedar Tavern, a gathering place for artists and writers since the Abstract Expressionists frequented it in the Fifties. But if you kept walking along Eighth Street until you got to Third Avenue—where Eighth Street changes its name to St. Mark's Place—you would reach the new "East Village," a multiethnic, primarily Jewish, Eastern European, and Latino neighborhood, where artists and poets were beginning to find cheaper apartments and studios than in the West Village, and new bars and coffeehouses were springing up.[12]

Go north two blocks on Third Avenue, and you would find the East Tenth Street Galleries, the stronghold of the second generation of Abstract Expressionists. On the next block, at the corner of Second Avenue and Tenth Street, stood St. Marks Church, which sponsored arts festivals, poetry readings, and plays. Walk south down Second Avenue and you would pass a number of cafés—venues for poetry readings, jazz, and other performances—such as Le Metro Cafe and Central Plaza on Second Avenue, the Five Spot and Cafe Avital on St. Marks Place, and Les Deux Megots coffeehouse on East Seventh Street. Also on St. Marks Place, James Waring, Aileen Passloff, and Yvonne Rainer shared a studio where informal dance performances and lectures took place. Here was a variegated theater culture in a strip of movie theaters and Off-Broadway houses:

the New Bowery Theater on St. Marks (where underground films and poets' plays were shown); Loew's Commodore, the Anderson Theater, the Gate Theater, Casino East, the Cricket Theater, the Orpheum Theater, and St. Marks Playhouse (where Genet's *The Blacks* was celebrating its thousandth performance), all on Second Avenue; and the Writers Stage, the Rodale Theater, and the East End Theater, along East Fourth Street. A little farther east, near Tompkins Square, on East Eleventh Street and Avenue B, was the Charles Theater, the venue for early underground film screenings.

If, on the other hand, you turned left coming out of Judson Church and walked past the NYU Law School, three blocks ahead of you on West Fourth Street would be Gerdes' Folk City, the favorite stage for folksingers. One block closer were the coffeehouses and café theaters of Macdougal Street—Cafe Basement, Cafe Wha?, Why Not?, the Gaslight Poetry Cafe, the Rienzi, the Playhouse Cafe, Cafe Reggio, the Caricature—where poets, actors, musicians gathered to talk, write, and perform. There were the Players Theater, Provincetown Playhouse, and the Gene Frankel Repertory Theater, Izzy Young's Folklore Center, and a bevy of Italian restaurants. Walking down Macdougal to Bleecker Street, you would pass West Third Street and Minetta Lane—the Cinderella Club, Cafe Bizarre, Cafe Manzini, Elysee Expresso. The old striptease joints along West Third Street were disappearing as more coffeehouses and Twist discotheques cropped up, but all of these establishments were equally anathema to older Village residents. Along Bleecker Street there were even more cafés, cabarets, and theaters, a mix of venues for folksingers, poets, jazz musicians, filmmakers, and Off- and Off-Off-Broadway theater—Cafe Figaro, Cafe Flamenco, Cafe Rafio, the Dragon's Den, Take Three Cafe, The Bitter End, Cafe Borgia, The Premise, Speakeasy Jazz, the Bleecker Street Cinema (where *Film Culture* magazine sponsored underground film showings), Circle in the Square, and Washington Square Theater. This strip marked the end of what Dick Higgins remembers as the "Elephant Walk"—the poetry-reading circuit from the corner of Sixth Avenue and Eighth Street (where many prostitutes hung out), down Eighth to Macdougal (where the original Eighth Street Bookshop, the best place to find small press books, poetry, and new literature, marked the corner), down Macdougal past the park to the core of the coffeehouse district.[13] In the spring and summer of 1963, just before the primary elections, the Macdougal Street scene was "heating up," as some Village residents complained, referring to the noise, the motorcyclists, "sexual deviates," and interracial couples, and tourists objected to overpriced espresso and unreasonable cover charges; under pressure from

the neighborhood, several coffeehouse owners formed an organization that promised to set standards for cover fees and food prices as well as to control noise levels.[14]

In *Down and In,* the novelist Ronald Sukenick traces the bar and coffee-house literary scene in Greenwich Village from 1948 to 1986. In Sukenick's 1963 Village the San Remo was the favorite hangout of some Beat poets and Abstract Expressionist painters, and Sukenick claims that among them were Catholic social activist Dorothy Day and jazz musician Miles Davis, along with John Cage, Merce Cunningham, Paul Goodman, Julian Beck, and Judith Malina. Instead of the San Remo and the Bleecker Street coffee-houses, many Sixties writers went to Stanley's, a bar in the East Village. For East Village poets and novelists, like Diane Wakoski, Paul Blackburn, Diane DiPrima, Ted Berrigan, Jerome Rothenberg, Rochelle Owens, and Carol Bergé—slightly younger contemporaries of the Beats, they were already reacting to the Beats' notoriety by trying to create a "scene" of their own—the bars and cafés had already been opened up as places in which to socialize and exchange ideas, but also to perform.[15] It was this fluid café scene—a regular circuit of informal meeting places—that afforded a basis for community among artists in all media.

On the uptown border of the Village, on the corner of the Avenue of the Americas (Sixth Avenue, as Villagers continue to call it) and Four-teenth Street, the Living Theater occupied two floors of a building that also housed the Merce Cunningham Dance Company studio. There was a bookstore in the theater lobby, and the Living Theater sponsored poetry readings, film showings, and other performances, as well as its own theater repertory. People often came to the theater just for the intermission, to see which friends and strangers might be there.

West of Sixth Avenue the landmarks included the *Village Voice* office on Sheridan Square, at the six-street intersection of Seventh Avenue, Grove Street, Christopher Street, Washington Place, Waverly Place, and West Fourth Street; Max Gordon's jazz club, the Village Vanguard; the Cafe Feenjon, on Seventh Avenue South, which a *Voice* writer in 1963 likened to a neighborhood pub in her column on nightspots;[16] Chumley's Restaurant, another writers' gathering place, on Bedford Street; and the Caffe Cino on Cornelia Street, off Bleecker between Seventh and Sixth. The Cherry Lane Theater on Commerce Street, an experimental theater since the Twen-ties, in the Fifties notable for the Living Theater's early productions and for Beckett's *Endgame* and *Waiting for Godot,* was by the early Sixties an Off-Broadway house presenting plays by Ionesco and Albee, among other works. Farther west, the White Horse Tavern, on Hudson and Eleventh,

and the Lion's Head, then at the corner of Hudson and Charles, were two favorite writers' bars.

The neighborhood near these bars on Hudson Street, considered a slum by the city, had been slated for urban renewal. McDarrah reports in *Greenwich Village* that the neighborhood's residents, led by urban analyst Jane Jacobs, "marched down to City Hall in full battle dress and in a showdown forced the city to withdraw its plans," and he adds, "Sculptor Len Lye, political leader Martin Berger, Father James Flye, architect Robert Jacobs, painter Michael Goldberg, socialist writer Michael Harrington, dancer Erick Hawkins, and film-maker Ricky Leacock are among the better known personalities who live in this unique area [the most diverse in the Village]."[17] The West Village was also the place where luxury apartment buildings were rising quickly, pushing artists to move east and south to find lower rents.[18]

And on the frontier between the South Village—a solidly Italian enclave—and Chinatown, in what is now called Soho, short for South of Houston Street, artists such as Dick Higgins, Alison Knowles, and George Maciunas were already moving into raw lofts in the area of Broadway and Canal Street among the light industries and electronics parts shops bordering the Holland Tunnel access streets, quietly setting the stage for the emergence of the next (albeit short-lived) bohemia.

Greenwich Village: A Genealogy

If, as Leo Steinberg wrote, it takes only seven years for each new generation of artistic enfants terribles to be domesticated,[19] it is easy to see why the early Sixties artists coexisted with several generations of their aesthetic forebears. But it is also not hard to disentangle them. Artists who had "arrived" in the Fifties—the Abstract Expressionists, avant-garde dancers, new musicians and jazz musicians, playwrights of the Absurd, visionary filmmakers, Beat poets and Black Mountain poets—were still working at the height of their powers in the early Sixties. However, this book is not about *their* work, but about the work of their artistic offspring—those who built on and departed from their artistic practices.

Julian Beck and Judith Malina are exceptions here. Working since the late 1940s to form their Living Theater in various incarnations, they were artists who had arrived at new aesthetics several times in several decades. They belong to both the Fifties and the Sixties—not because they bridged the transition, but because their work changed. In a sense, they are their own offspring. But much of the Off-Off-Broadway movement, from the Judson Poets' Theater to the Open Theater, traces its lineage to the example and,

often, even the personnel of the Living Theater. Influenced by the ideas of Antonin Artaud and his Theater of Cruelty (M. C. Richards's translation of Artaud's *The Theater and Its Double* had been published by Grove Press in 1958), by the epic theater techniques of Erwin Piscator (with whom Malina studied in New York), as well as by the more historically removed example of the early Soviet avant-garde director Vsevolod Meyerhold, they created their own synthesis of a political theater.

The Living Theater had, in the early Fifties, been part of a growing Off-Broadway movement that included the Circle in the Square, the Phoenix Theater, the New York Shakespeare Festival, and the Artists' Theater, all of which were committed to producing serious theater in small-scale houses without expectations of commercial success. By the early Sixties, however, the Off-Broadway movement had become, for the most part, merely an unimaginative stepping-stone to Broadway, and a younger group of actors, directors, and playwrights were looking for a way to jolt theater anew. Another direct forebear of the Sixties' Off-Off-Broadway movement was the playwright Edward Albee, not only as the key American exponent of the Theater of the Absurd, and not only because his own works were first produced in Off-Broadway Village theaters such as the Cherry Lane and Provincetown Playhouse, but also because he helped produce younger playwrights. In 1963 Albee (with Richard Barr and Clinton Wilder, his producers for *Who's Afraid of Virginia Woolf?* on Broadway in 1962) organized the Playwrights Unit, dedicated to producing the work of younger playwrights in workshop productions at the Village South Theater on Van Dam Street. The same group, as Theater 1964, produced plays at the Cherry Lane (including LeRoi Jones's *Dutchman* and plays by Arrabal, Beckett, Pinter, and Albee) and the East End Theater (including Adrienne Kennedy's *Funnyhouse of a Negro*).[20]

In film, Maya Deren was an important influence, both artistically and practically, on a younger generation. Her films of the Forties and Fifties investigated ritual, myth, dream, and autobiography, in a form that P. Adam Sitney calls the trance film. While she later attacked both Surrealism and psychoanalysis, Deren's attempts to project mental processes cinematically are clearly rooted there. Sixties filmmakers would depart drastically from Deren's elegant metaphysics. But they would continue to explore, albeit in different modes, the paths she cleared to the personal and the oneiric. Deren was an inspiration for her films, for her writings on film theory, and for her indefatigable work to support and encourage independent, "creative" filmmaking. Another important figure in film was Joseph Cornell, the collagist and maker of boxes. According to Sitney, Cornell's occasional

found-footage films, with their Hollywood imagery and themes of child-hood, directly inspired Stan Brakhage, Ken Jacobs, and Jack Smith.[21]

The transition that jazz made in the late Fifties and early Sixties was from the revolutionary bebop innovations of Charlie Parker, Dizzy Gil-lespie, and their colleagues through the hard bop style of Horace Silver, Art Blakey, and others in the mid- to late Fifties, to such avant-garde pre-cursors as Miles Davis, Charles Mingus, Sonny Rollins, and John Coltrane. These last figures and their contemporaries extended jazz improvisation anew in terms of harmony, rhythm, and melody; they emphasized the music's blues and gospel roots; and they instilled sometimes overt political meaning (Mingus's "Fables of Faubus," for example) in their performances and compositions. They played at such Village clubs as the Cafe Bohe-mia, the Village Vanguard, the Half Note on Hudson Street, and at the Open Door's near-legendary Sunday night sessions. Overlapping them, and often playing in the same groups and on the same sessions, came a generally slightly younger group—Ornette Coleman, Don Cherry, Eric Dolphy, Cecil Taylor, Archie Shepp, and Bill Dixon, among them—who dramatically redefined the Village jazz scene as they shifted their perfor-mances to other clubs, lofts, and occasionally coffeehouses. The Five Spot, both before and after its move to St. Marks Place in 1963, was central to the new music.

Le Roi Jones likens the transition from hard bop to the avant-garde to the change from the civil rights movement to the black liberation move-ment.[22] There are kinship lines between this predominantly black avant-garde music world and the white avant-garde performance scene—in the person of Jones himself, who was a poet and playwright as well as a music critic, and also in Archie Shepp and the other musicians who played jazz in the Living Theater's production of *The Connection;* in Cecil Taylor and Bill Dixon, both of whom collaborated with members of the Judson Dance Theater; in some shared audience members; and in analogous aspirations toward art as a metaphor for freedom.

Similarly, the Black Mountain, Beat, and New York School poets are important as influences on performance. In his essay "Projective Verse," Charles Olson, the leader of the Black Mountain group, restored "the *kinetics* of the thing" to the performed poem, calling for a concept of open form that bases the poem in the body directly through the poet's breath.[23] A number of New York artists had studied or taught at Black Mountain when Olson was the school's rector, including John Cage, Merce Cunningham, Joel Oppenheimer, Nick Cernovich, Viola Farber, Robert Rauschenberg, and Ray Johnson. The Beats opened up the poetry-reading circuit in bars

and coffeehouses, moving poetry off the page and into informal performance, and they forged links between jazz and ordinary-language poetry as related forms of American vernacular. The more European-oriented New York School poets, including Kenneth Koch and Frank O'Hara, celebrated the city in pop imagery and were drawn to participate in more formal poets' theater events, where they collaborated with visual artists. Jackson Mac Low, like the Living Theater, was both an influence on and a practitioner of the Sixties ethos. Mac Low was politically committed to anarchist pacifism. Artistically he was influenced not only by the writings of Gertrude Stein and the collages of Kurt Schwitters, but by his readings of the *I Ching,* research on the Kabbalah and Zen Buddhism. He was moved, too, by the work of his contemporaries: John Cage's chance compositions, the music of Morton Feldman, Earle Brown, and Christian Wolff, and the choreography of Merce Cunningham. In the early Fifties Mac Low began composing poems by chance, using found texts as source material. At that time he began emphasizing the performative aspects of poetry, using the text as a score for vocalization.[24] All of these Fifties movements in poetry—with their emphasis on the body, on performance and theater, and on everyday experience—were influences on younger poets. Two of them, Diane DiPrima and LeRoi Jones, edited a mimeographed newsletter during the Sixties. *The Floating Bear* documents an expanded network that includes poets, playwrights, dancers, musicians, and painters. DiPrima studied dance and "Zen creativity" with James Waring; with her husband, Alan Marlowe, she founded the New York Poets Theater, producing plays by Jones, DiPrima, Waring, Michael McClure, John Wieners, Robert Duncan, and others. The New York Poets Theater also sponsored exhibitions of collages by Ray Johnson and photographs by Jack Smith, and in 1962 it organized a Poets Festival uptown with concerts of new dance and new music, Happenings, and film screenings. On Sundays, various members of that network gathered at DiPrima's apartment on East Fourth Street to help put out *The Bear,* which published poetry by New York and West Coast poets and performance reviews, notices of publications, concerts, and exhibitions, and community gossip.[25] The poet was an engaged citizen of the arts community—writing plays and criticism of all the arts as well as poems, publishing work by colleagues, and sitting in the audience as often as on the stage.

Black Mountain College looms large as a generating force for the Sixties avant-garde. The ongoing collaboration on the dance stage between three men who worked together at Black Mountain in the Fifties—choreographer Merce Cunningham, painter Robert Rauschenberg, and composer

John Cage—was influential in more realms than dance. Each man had an impact—more or less direct—on younger artists in his separate discipline, yet as a team they created a model for further interdisciplinary invention, from Happenings to expanded cinema.

Cunningham raised a new generation of dancers, both company members (like Steve Paxton and Judith Dunn) and others who came to study dance at his studio (like Yvonne Rainer and Lucinda Childs). These dancers used their bodies differently from other modern dancers, since Cunningham merged a Grahamesque flexibility of the spine with the brilliant footwork and vertical carriage of ballet. Cunningham's wide-ranging deployment of energy reflected a modern sensibility, and his use of chance short-circuited the logic of traditional phrasing and the beauty of traditional line. James Waring, a choreographer and painter, was also a parental figure for this generation of dancers. He taught them ballet and composition by collage and chance, arranged concerts of their work, used them as dancers in his own "pick-up" company, and introduced them to contemporary poetry, painting, and theater.

Rauschenberg and Jasper Johns, straddling the Fifties and Sixties, set the stage for Pop artists (Andy Warhol, Roy Lichtenstein, Tom Wesselmann, James Rosenquist, and Claes Oldenburg) by appropriating images and objects from everyday life and by using impersonal techniques.[26] These Pop artists, other painters and sculptors, and the Happenings-makers such as Allan Kaprow and Robert Whitman, who were trained in visual arts, were the rebellious children of the first-generation Abstract Expressionists, whose canon was established and, it was felt (at least, by younger artists), exhausted by the late Fifties. Interviewed by Irving Sandler for *Art News* in 1959, the painter George Sugarman asked, "Must we remain the obedient children of our ancient fathers? Isn't it about time we went for a stroll on our own in 1959?"[27]

Kaprow had suggested, in "The Legacy of Jackson Pollock," published in *Art News* in 1958, that action painting could extend beyond the limits of the canvas. While Kaprow wanted to remain within the visual art arena (rather than move into the theater) and continued in the late Fifties and early Sixties to exhibit his environments and Happenings in galleries, his call for a painting that becomes an aggressively sensuous environment surrounding the spectator is reminiscent of Artaud's manifestos on the Theater of Cruelty: "Not satisfied with the *suggestion* through paint of our other senses, we shall utilize the specific substances of sight, sound, movements, people, odors, touch. Objects of every sort are materials for the new art: paint, chairs, food, electric and neon lights, smoke, water, old socks,

a dog, movies, a thousand other things which will be discovered by the present generation of artists."[28] Indeed, Kaprow may have read Artaud's manifestos in the class he took with John Cage. Cage had been introduced to Artaud's essays in Paris by Pierre Boulez and had in turn brought them to David Tudor and Mary Caroline Richards at Black Mountain College, where Richards began to translate them into English.[29] The urge toward performance in the separate arts, while originating in different sources— among them, the various dissatisfactions with the respective reigning aesthetics—brought artists in disparate fields toward similar actions.[30] And it may be that, in Artaud, some of these theater, antitheater, and art performances could be traced back to a common inspiration.

Of the earlier Abstract Expressionists, Hans Hoffman was an important teacher. In 1952 a number of second-generation Abstract Expressionists founded the Hansa Gallery, named in honor of Hoffman. Kaprow, Whitman, and George Segal were the younger members of the Hansa, and after it closed in 1959, they, as well as Lucas Samaras, George Brecht, Claes Oldenburg, Red Grooms, Jim Dine, and Rosalyn Drexler joined the Reuben Gallery, which specialized in Happenings and was the site of Kaprow's first public work in that genre, the eponymous *18 Happenings in Six Parts,* in 1959. On the one hand, the assemblage, junk, and Happenings artists were reacting against Abstract Expressionism by incorporating the grittiest aspects of city life in their artworks. On the other hand, notes art critic Lucy Lippard, as the hard-edged, cool Pop style emerged, it seemed another path toward abstraction that nevertheless could distinguish itself from the metaphoric, painterly, heated style of the Abstract Expressionists.

In every discipline, John Cage was the most influential father figure to this generation of artists. The roster of students and visitors in his experimental music composition classes at the New School for Social Research is a large cross section of those who would soon become Happenings-makers, Fluxus performers, and new music composers, as well as painters, filmmakers, and poets. In the summer of 1958, members of the class included Al Hansen, Allan Kaprow, Dick Higgins, George Brecht, Florence Tarlow, and Scott Hyde, and the visitors included Jackson Mac Low, Harvey Gross, George Segal, Jim Dine, and Larry Poons. "To a great extent," Hansen remarks, "and probably to John Cage's disgust, the class became a little version of Black Mountain College."[31]

Cage encouraged his students to use unconventional instruments (or combinations of the conventional and unconventional). Both Hansen and Kaprow mention noisemaking toys,[32] and Higgins recalls guitars and paper clips. Higgins also remembers that Cage taught his students about nota-

tion, about sound properties and how to change them, about controlling durations with numbers series. When the students demonstrated their own solutions to problems that Cage had given them, the philosophy of the piece, rather than its technique, would be discussed. "Cage also showed how he had solved some problems himself, but told the class he would be quite angry if they copied any of these. Then, to reassure people, he said not to worry, he wasn't very frightening when he was angry." Mac Low was invited to read his chance poems.

For Higgins, the most important thing the class learned—which was what led, he thought, to the development of Happenings—was that " 'anything goes,' at least potentially." [33] Cage also read to the class from Robert Motherwell's anthology *The Dada Painters and Poets*. He provided historical models for a nontheatrical performance style by informing his students about the Futurist and Dada movements. He had himself created a proto-Happening in his untitled event at Black Mountain College in 1952. [34] In 1960 Cage invited one of his students, the composer and accompanist Robert Dunn, to teach a dance composition class at the Cunningham Studio. Out of this course, adapted from Cage's permissive teaching methods, came the Judson Dance Theater. [35] Cage's influence on the various arts—in the use of chance methods, a Zen attentiveness to everyday life, an interest in the nondramatic theatricality of all the arts, and a distinctly dada-esque humor—is ubiquitous. One can trace a line of descent from Cage through Kaprow, Hansen, and Dine to the Happenings; through Higgins and Brecht to Fluxus; through Rauschenberg, Johns, Segal, Poons, and others to sculpture and painting; through the Cunningham company and Robert Dunn to new dance; through Mac Low to poetry; through the Living Theater to Off-Off-Broadway theater; through Stan Brakhage to film; and, of course, through David Tudor, Earle Brown, Richard Maxfield, Robert Dunn, and many other musicians to new music.

The Urban Village

As the intellectual historian Russell Jacoby points out, one of the recurring myths about Greenwich Village is that it always seems to the current generation that the heyday of the Village as bohemia has just ended. [36] So it felt in the Twenties to Malcolm Cowley; so it felt in the late Forties to Milton Klonsky; so it felt in the early Sixties to Michael Harrington and to Stanley Aronowitz. [37] Insofar as the Village art scene is generational, this lament becomes a constantly repeating refrain. For once a generation of artists and intellectuals has established itself (call this point t_1 [time 1]), any new group that succeeds it immediately heralds change. And when the

new group, which came of age at t2, sees yet another group of enfants terribles arriving at t3, it begins the lament in its turn—just as the generation arriving at t1 had lamented the middle group's arrival and rise to prominence at t2.

In Aronowitz's view, reform Democrats had replaced artists as central figures in Village community life by the Sixties. The reform politics of the early Sixties was itself a new style of postwar mass political organizing. In traditionally Democratic New York City, the battles within the party were more urgent than competition with the Republicans. As middle-class Italians and Irish moved to the suburbs, the Democratic machine found its traditional urban electoral base decimated. In Greenwich Village, where postwar building and urban renewal had drastically shifted the demographic mix of the neighborhood, the Italian-dominated political machine was now challenged by the representatives of the upper-middle-class professionals newly settled in the West Village—including political leaders such as the young Ed Koch.[38]

Despite Aronowitz's plaint, it seems that the Village was not shifting, but growing—spreading eastward and southward. The artists (who were moving east and south partly because these middle-class professionals were moving in) still shared more political values with liberal West Villagers than with the Eastern European, Jewish, and Puerto Rican families of the East Village or the Italian enclave in the South Village.[39] For one thing, they resisted the growing American exodus to the suburbs and the spiraling enthusiasm for the standardized suburban life, the postwar version of the American Dream.

In 1963 the problem of how to make an urban neighborhood a true community seemed pressing for Village intellectuals and artists. Cities, it was felt, needed an injection of community spirit to cure their ills. And the solution often seemed to call for a specific type of urban planning that allowed for local autonomy coupled with an antisuburban mix of residential and commercial use. Paul Goodman, the anarchist, novelist, poet, playwright, and social critic, had suggested in *Communitas* (coauthored with his brother, Percival, and published in a second edition in 1960), that it was possible to plan human-scale communities in cities. In their ideal community the social functions of production and consumption are reunited; physical and architectural reintegration are "an essential part of political, cultural, and moral reintegration."[40] The Goodmans devote two appendixes to showing how New York in particular can "become a city of neighborhoods wonderful to live in, as leisurely and comfortable as it is busy and exciting."[41] The early Sixties artists were involved in self-

consciously founding communities; and further, their sense of communitas was integral to the decade's revitalization of city life. Paul Goodman was an exemplary modern renaissance man of the new city. In addition to being a political activist and social theorist (the influential *Growing Up Absurd* was also published in 1960, and by the early Sixties "free universities" based on his educational ideas were already beginning to form), he was a lay psychoanalyst. He was also an artist—a playwright, poet, and novelist. He published widely in the intellectual journals, and the Living Theater produced a number of his plays.

In 1964 Goodman edited *Seeds of Liberation,* an anthology of articles and poetry by pacifists and civil rights activists, collected from the first ten years of *Liberation* magazine. In the anthology's introduction he characterized *Liberation*—the publication of the nascent Movement—in specifically communitarian terms. "It is the annals of people who, like the editors [Dave Dellinger, A. J. Muste, and Bayard Rustin], put their bodies on the line for justice as they see it and try to live in community in a society that has given up on community."[42] Goodman noted that besides penetrating analyses—on the order of a national news magazine—of political and cultural situations both in the United States and abroad, *Liberation* was equally distinguished by "sentimental accounts of the joy of solidarity, confessional breast-beating, small details of interpersonal conflict and reconciliation—the kind of thing that fills a parish newsletter."[43] Political and artistic community, however, had replaced religious community for this avant-garde.

Goodman was friendly with other anarchist-pacifists living or working in the Village in the Fifties and Sixties, including Cage, Beck, Malina, and Mac Low. These intellectuals and artists devoted their energies to living the "modest utopia" they advocated. And while other artists did not stake out their political commitments as explicitly, their works, their institutions, and their rhetoric bespeak a utopian American faith in communitas (as will be seen in chapter 2).

Jane Jacobs, another urban analyst, had written in 1961 her critique of modernist urban renewal, *The Death and Life of American Cities.* In it, she argued that top-down urban planning was actually strangling cities by turning them into supersuburbs. Often citing examples from her own block on Hudson Street in Greenwich Village, Jacobs insisted that a truly vital urban life could thrive only where communities (urban districts built out of neighborhoods) took constructive control of their own spaces— spaces "zoned for diversity," where men, women, and children, as well as workplaces and residences, intermingled.[44]

In an era of much-touted suburban explosion and urban decay, a group of intellectuals and artists in the heterotopia of Greenwich Village blissfully lived as if the city were already recuperated. As they formed cooperatives and collectives to produce and distribute their work, they also lived as if the growing specter of American bureaucracy had been exorcised. The culture—including the arts—they made was intended for a small-scale community: integrated with daily life, incorporating both work and play, blurring distinctions between participant and observer. But since they had staked out their neighborhood in the Greenwich Village bohemia, with themselves as avant-gardists dedicated to overturning traditions, in making their communal art they had to reinvent community.

2

The Reinvention of Community

The Breakdown of the Family

In Rosalyn Drexler's play *Home Movies* the father is missing and presumed dead, and the family receives its condolence callers.[1] Mother and daughter cheerfully sing of their hatred for one another; the imperious yet ribald mother, the beautiful black maid, and the homely virgin daughter all compete for the sexual favors of the male visitors, from the father's homosexual lover to an oversexed delivery man. A nun and a priest sit in the kitchen— flirting, catching cockroaches, and praising the domesticity that they do not seem to understand simply does not operate here. In the end, after the father returns, "normal" life resumes: everyone sends out for candy, and the mother and father go to bed—to wrestle. The priest's name is Father Shenanagan; the family's name is Verdun. In this absurdist burlesque, first

performed at the Judson Memorial Church in Greenwich Village, not only is the church a laughingstock; the family is a violent battlefield.

In David Starkweather's play *You May Go Home Again,* "a domestic Noh in one act," the family is a group of dazed automatons, mouthing greeting card platitudes.[2] The daughter dreams about her forthcoming marriage; the mother runs around on all fours like a dog and recounts how she once had another daughter who got married but was eaten alive by her children; the son's baby, who looks like Ben Franklin, pukes and squirms. "David," the prodigal gay son, returns in the guise of an executioner to kill his family, but he discovers that he loves them.

In Lanford Wilson's *Home Free!,* the family consists of an incestuous brother and sister who can neither grow up nor marry to legitimize their baby. They fear their landlady and their fishmonger; in crisis, they cannot even ask their neighbors for help.[3] And in Kenneth Brown's *The Brig,* sadistic marine officers create a twisted parody of home life, calling prisoners their "children" and the prison their "home."[4]

There is an epidemic rampant in the plays of Off-Off-Broadway and in the other avant-garde performances of the early 1960s. The family is breaking down, and with it, church and community. This breakdown of the family was historical fact, for despite the official ideology of "Momism" in the 1950s, increasing numbers of older women and young people were leaving the household to live independently, and the divorce rate was rising. This was an era when more white middle-class American women were married, for more of their lives, than ever before or since, and yet the suburbanization and automation of the middle-class household, which had promised domestic bliss, seemed to backfire by turning women into isolated, unpaid, full-time domestic workers.[5] Sensing the disruption of domesticity brought on by changing gender roles during World War II, in the late Forties mainstream postwar America had blamed various symptoms—sexual "deviance," feminist politics, and even demands for child care—on a communist plot to undermine the American family.[6] But by 1963 it was clear that the breakdown of the family was a sociopolitical shift internal to American postwar economics and demographics. Betty Friedan's book *The Feminine Mystique,* published in 1963, unmistakably documented the increasing dissatisfaction that middle-class white women felt with their supposedly privileged role as housewives, a trend that had been quietly observed in the popular media for several years.[7]

There was a conflicting message in popular culture about the state of the family. While television purveyed wholesome images of the All-American suburban family in *The Donna Reed Show, Leave It to Beaver,* and other

prime-time favorites, other works of popular culture, like John Franken-heimer's 1962 film *The Manchurian Candidate* and Edward Albee's Broad-way hit *Who's Afraid of Virginia Woolf?* leaked the news, among other American ills, of the dismal failure of "Mom-ism."

The avant-garde, however, not only documented the breakdown of the nuclear family in its critique of private life. Sometimes, as in *You May Go Home Again,* it accepted alienation from the family with bittersweet melan-choly. Sometimes, as in Claes Oldenburg's *Nekropolis II,* it offered mock compensation for the modern splintering of family life. Al Hansen, him-self a Happenings-maker, wrote about this Oldenburg Happening, where people ate in slow motion while a Victrola in the bathroom played Hawai-ian music: "All was very still and quiet and the music was playing and this large group was sitting around the table like a family. In these modern times such a scene is sadly nostalgic because large families don't sit around tables any more. Each is in his own car driving all over the country."[8] There is a tongue-in-cheek tone in Hansen's statement that undercuts the lugu-brious interpretation. "In these modern times" has an ironic, deprecating ring. And "driving all over the country" has a positive, upbeat tone that actually makes it sound far preferable to being part of the lamented large family sitting around a table.

Importantly, the avant-garde also supplied images of alternative commu-nities that changed power relations, creating intimacy outside the family and valuing equality among members. In Yvonne Rainer's dance *We Shall Run,* a group of twelve adults—dancers and nondancers, in work clothes ranging from suits to sweatpants—runs steadily in shifting patterns that cause them to group and regroup for seven minutes to music by Berlioz.[9] There are no permanent leaders; every time someone seems to head the group for a time, the changing floor plan guarantees that a new facing will produce a new leader—from the back of the flock this time. And the tem-porary leaders are sometimes men, sometimes women; the large group is not factionalized, but harmoniously and with a purposeful mien constantly divides in random groups and then reunites. The image is one of a serious, even heroic, egalitarian collective.

Fluxus made collective work part of its definition. To join Fluxus was to be engaged constantly in group activities, from the concert by Fluxorches-tra at Carnegie Hall to the Fluxus "boxes" containing objects made by different artists to the cooperatively produced newsletter *cc V TRE.* Indeed, when Fluxus members published the scores generating their "borderline art" performances, they created a community in which anyone could be a member.

A very different alternative is the eroticized antifamily in works as disparate as Ron Rice's films *Chumlum* and *The Queen of Sheba Meets the Atom Man,* Jack Smith's film *Flaming Creatures,* and Carolee Schneemann's dance/performance *Meat Joy,* all of which feature, more or less literally, group sex. This not only flagrantly transgresses the sexual codes of the bourgeois family, but it suggests one way to open and extend the family— that most private of all social spheres—beyond the nuclear model of family-as-couple-cum-kids.

The rhetoric of community—the desire for community—is everywhere evident in the artworks and institutions of the Sixties avant-garde. This potentially nostalgic desire marks the group's affiliation with the modernist project of recuperating the loss of wholeness. But their resolutions were often subversive, proposing new social roles and institutions.

In common parlance, a community is usually understood as built out of families. But while community, and even a brand of domesticity, was often a desired value in the Sixties avant-garde, this notion was radically different from that of the bourgeois community, for here—foreshadowing the countercultural utopian communes of the later Sixties—"togetherness" was sought *outside of family life,* in groups coalescing around common work or common play. At times, even home life became collective—Ellen Stewart of La Mama, for instance, lived "with an assortment of people at any given time. . . . When visiting playwrights or acting troupes were in town, they also stayed at Stewart's apartment on East Fifth Street."[10] No matter how much Stewart—La Mama herself—mothered her playwrights and other theatrical colleagues, her communal domicile was not at all stamped in the pattern of middle-class American family life. This alternative communalism linked the assertion of community to the politics of egalitarianism and liberation.

Perhaps the epitome of the alternative communal site was Andy Warhol's Factory, a loft he began renting in November 1963 to use as a studio for painting and shooting films. The Factory became a place where some Village people actually lived (Billy Linich, Gerard Malanga) but where many more went simply to hang out—to do drugs, listen to music, have sex, talk, and meet people. By the late Sixties it was famous as a fashionable scene. The Factory was both site and symbol of the alternative culture's disdain for the bourgeois ethic, from work to sex to control of consciousness—a sanctified space where leisure and pleasure reigned.

Where there were spouses and children in this world of the alternative family, they often were brought directly into the artwork, defying modern

mainstream gender and age divisions of labor—restoring in a new key pre-industrial, rural patterns of family work. In Steve Paxton's outdoor dance *Afternoon,* Barbara Lloyd's baby was one of the dancers; Elaine Summers used her two-year-old son's drawing as a score for a dance. Simone (Forti) Whitman and Pat Oldenburg were both featured performers in their husbands' Happenings. This community was not yet the tribal commune of the late Sixties, although it is clearly a precursor to those social changes, and, along with the Beat opposition to family life, it helped instigate them.

The "Breakdown" of Community

The myth of the Puritan model of community—small-scale, egalitarian, and tightly bound by common threads of religion, work, and family—is crucial to the American sense of self, despite the fact that most Americans' roots lie elsewhere. In fact, that same village model can serve the prelapsarian nostalgia of almost every group of American immigrants. The historian Thomas Bender has argued that cyclically mourning the loss of communitas has shaped the rhetoric of American thought almost since the Mayflower arrived. But just how many times, he asks, can community have really withered away? Bender prefers to reconceptualize community, suggesting that it is not a static social form that is disappearing, but rather that new, dynamic, overlapping forms of small-scale networks have arisen; that people's lives have increasingly become mosaics combining both communal and more impersonal associations (gemeinschaft and gesellschaft, in standard social science terms).[11]

Yet the image of a lost paradisiacal traditional community, only recently demised, has persisted in the popular imagination and in the work of historians and social scientists as well. In thinking about ideals of community in the early Sixties, it is striking that, while the artists in Greenwich Village were celebrating their own vital sense of alternative commonwealth, a new wave of social scientists once again ritually lamented the disintegration of American community among the general population in the face of escalating urbanization (and suburbanization), industrialization, and bureaucratization. That is, communitas lost and regained had become a national obsession that permeated every stratum of the culture. But while social scientists mourned and analyzed its alleged passing, the avant-garde set about constructing its renascence.

One of those Sixties sociologists, Maurice Stein, unites these two arenas of culture when he calls twentieth-century Greenwich Village an oasis of gemeinschaft in the city. Despite questions about Stein's methods, his

The Eclipse of Community is illuminating because, especially in the chapter on bohemia, it encapsulates a view of both mainstream and subcultural America in the early Sixties that many artists and intellectuals, whether they read him or not, seem to have shared.[12] He concentrates on Greenwich Village in an earlier heyday, in the Twenties (as described by Caroline Ware in *Greenwich Village, 1920–1930*),[13] but for Stein, bohemia still promises relief from the standardization of middle-class, middlebrow America. The hipster, especially, intrigues him, for here "on the borderland between the worlds of adolescence, jazz, homosexuality, and the slum" lies a potential source for protesting mainstream complacency.[14]

The internal workings of community—or what was perceived, proclaimed, imagined, and enjoyed as community—within the Village can be seen in the way that artists produced their works, that is, the lively, often informal and unstable production and distribution networks that yielded so much of early Sixties art. This chapter will concentrate on exploring the communitarian basis and rhetoric of those networks.

The Community Reimagined

Were these artists and other Villagers struggling to form a community— and the artworks appropriate to it—as a compensation for the impending loss of small-town America, as the rhetoric (including much art) of the period often seems to suggest? Or did they gravitate to New York City's famous bohemia (as their predecessors in the Twenties had) in order to *escape* their hometowns—in flight from the stultifying atmosphere of the conservative communities of mid-America and in pursuit of cosmopolitan modernity—thereby hastening the breakdown of traditional ties? In other words, were they trying to transplant gemeinschaft to the city (à la the Fifties musical *Wonderful Town*), or did they willingly forsake the intimate pleasures of hometown gemeinschaft for the anonymity, freedom, and diversity of urban gesellschaft?

I want to argue that there is a third possibility: that they came to live and work in Greenwich Village exactly because it was possible to found an *alternative* community there. That is why, for all their appropriation of communitarian rhetoric, the artists' commonwealth was no ordinary community nostalgically reconstituted. For they were prompted to leave home (often a home in an actual small southern or midwestern town) not because the small towns were fading, but because small towns offered an unsatisfying brand of community—because there was, in fact, regardless of sociologists, no gemeinschaft at home. Or rather, because that hometown gemeinschaft was not all that it was cracked up to be—as Lanford Wil-

son's plays set in the Midwest (for example, *This Is the Rill Speaking*) attest. Unlike the utopian back-to-the-land communitarians of the later Sixties, and equally unlike the generation of Abstract Expressionists of the Fifties (who had moved out to the country to escape the city), their visions for the most part were not pastoral, but urban. These artists reinvented the village, but squarely in the city. For them, to find a utopian feeling of communitas was perhaps only possible in the city, in the forest of gesellschaft—with its system of relationships built on choice—that in fact creates gemeinschaft by defining it as its own opposite. Thus, it is not surprising that the conservative aspects of family and small-town gemeinschaft dropped out of the progressive vision of the community of Greenwich Village life. Here are the roots of postmodernism: in the revaluation and reworking of tradition, and in the aspiration to make "new" traditions—not in Harold Rosenberg's sense that modernism is a series or "tradition" of constant innovation, but in the opposite sense that shared customs should form art, even if it means inventing the customs.

The Alternative Community: Cooperatives and Cafés—
The Public Domain of Art

One of the most important aspects of the constructed community for Villagers was the intense level of engagement in public life, from politics to the arts. Perhaps it was this value placed on active participation that pushed an expanded notion of performance in general and theater in particular to the forefront of Village cultural life. To create community seemed to demand the presence of a body politic, not only in the metaphoric meaning of a consensual community, but literally in the sense of a political body—a person rendered political by physically taking part in the life of the collective enterprise.

The construction of participatory democracy took several forms in Village artistic life. One was the style of the works, which gave spectators a powerful sense of direct involvement. Another was the more or less explicit political content in the art itself. A third was the festival, anthology, or other collective structure for presentation and distribution. A fourth was the series of cooperative, alternative institutions that turned artmaking itself into a community-building process with shared responsibility and the promise of local autonomy. And yet a fifth emerged in the informal friendship networks that percolated through and across the more formal associations, creating both social and artistic bonds, leading to collaborations and interdisciplinary genres, and building audiences.

THEATER

The most visible cooperative artistic venture of the early Sixties was the Off-Off-Broadway movement. In the Fifties, Off-Broadway had sprung up as an alternative to commercial theater (tracing its inspiration back to the Washington Square Players and Provincetown Playhouse in Greenwich Village in the Twenties), but eventually it was beset with financial and artistic problems similar to those of mainstream theater. By the late Fifties it was clear that most of the theaters were simply producing yet more bourgeois traditional drama—plays by Europeans and by a previous generation of American writers—O'Neill, Williams, Miller. This was not, in other words, an outlet for young new American playwrights, except perhaps Edward Albee. It also was no longer an outlet for new methods of staging. And by 1960 Off-Broadway finances were almost as prohibitive to experimentalists as Broadway itself; the cost of mounting a nonmusical production was $12,000 to $15,000.[15] Still Off-Broadway ventures, many of them located in Greenwich Village, had created a precedent not only for serious theater, but for a communal attitude, often a deliberately amateur attitude toward theater production, that by the early Sixties, it seemed, needed to be revived.

The Living Theater, which had a season at the Cherry Lane Theater in 1951–52 and then held performances at The Loft, uptown at 100th Street and Broadway, was one Off-Broadway theater group that struggled to maintain its artistic standards, always in the face of financial hardship and confrontation with municipal authorities.[16] A season planned in a basement on Wooster Street in 1948 never opened, since the police charged that the theater was a front for a brothel. The Cherry Lane Theater was closed for violating fire regulations. Then The Loft was closed by the buildings department for overcrowding. When the Living Theater, with its stated threefold commitment to poet's theater, actor's theater, and community theater, finally moved into its last "permanent" quarters on Fourteenth Street and Sixth Avenue in 1959 (this building too would be closed, by the IRS, late in 1963), it served as an inspiration and a mother lode for the new Off-Off-Broadway movement—an alternative to the alternative now grown stale.

Julian Beck, a painter, and Judith Malina, an actress, both grew up in New York City; they met as teenagers in 1943. Married in 1948, Beck and Malina put on the first program by the Living Theater in their apartment on West End Avenue in August 1951. Initially, they saw as their mission the forming of a theater for a community of artists—providing a stage for

poets, artists, and actors to join in making collaborative works of non-naturalistic theater. Jean Cocteau, the French artist who worked in a variety of media, was an early inspiration to them in the late Forties when they began to plan; they corresponded with him and produced his *Orpheus* at The Loft in 1954.

But by the end of the decade their concern with community had shifted from forming a community of artists to organizing, through art, in the larger community—rousing both actors and audience to political consciousness and action, in particular against the Bomb (as nuclear and atomic bombs were known) and for world peace. Throughout the Sixties the Living Theater would be a model for political theater groups internationally. Even within the Movement they were controversial for their anarchism. But their political dramaturgy was as much in the vanguard in the Sixties as their earlier work in the poets' theater had been in the Fifties.

In his introduction to *The Brig,* the last play produced by the Living Theater at their Fourteenth Street home, Beck describes their goals in 1959 when they chose the first repertory program for the new theater—which included Luigi Pirandello's *Tonight We Improvise,* William Carlos Williams's *Many Loves,* and Jack Gelber's *The Connection.* "These play-within-a-play devices arose out of a crying need on the part of the authors, and of us, to reach the audience, to awaken them from their passive slumber, to provoke them into attention, shock them if necessary, and, this is also important, to involve the actors with what was happening in the audience." Beck goes on very pointedly to invoke his notion of the ancient Greek model in which the polis reached its genuine, fullest expression through the theater. This, for him, is the ideal model of what a truly political, democratic, communal theater can be. "To aid the audience to become once more what it was destined to be when the first dramas formed themselves on the threshing floor: a congregation led by priests, a choral ecstasy of reading and response. . . . By bringing the play into the theater and mixing together spectator and performer, the intention was to equalize, unify, and bring everyone closer to life. Joining as opposed to separation." [17]

The Becks were pacifist anarchists, allied both artistically and politically to other anarchists like Paul Goodman, John Cage, and Jackson Mac Low. Their political views as well as their increasingly open attitude about theater practice led them to adopt unconventionally antihierarchical methods of working with their actors. Most acting studios, and even the ensembles of Off-Broadway, subscribed to the cult of authority assumed by the director since his rise in the art theaters of the late nineteenth century. Beck

describes Malina's unusually "free style of staging," begun in 1959 with Jack Gelber's play *The Connection*.[18] This was, for Beck, a political choice, a step toward democratizing the rehearsal and production process.

> She began to let the actors design their movements, creating a remarkable rehearsal atmosphere in which the company became more and more free to bring in its own ideas. Less and less puppetry, more and more the creative actor. The careful directing books we had used at the beginning were by now quite gone. She began to suggest rather than tell, and the company began to find a style that was not superimposed but rose out of their own sensitivities. The director was resigning from his authoritarian position. No more dictation.[19]

The Living Theater's productions, from Brecht to Goodman to Brown's *The Brig*, constituted a politically oriented attempt to change the world rather than merely to entertain it—"to involve or touch or engage the audience, not just show them something," as Beck put it. *The Connection* shoved the junkie's condition down the spectator's throat and suggested that the audience might willy-nilly be more involved than they admitted to themselves in the problems of other people's addictions. Beck boasted that "Almost fifty men fainted during the run of *The Connection*. . . . Always around the same point. The overdose." In *The Brig* the point was to make the audience come to feel the violence that was actually taking place on stage: "Let them hear the noise, let it cause them pain, let them feel the blows to the stomach . . . until there are no prisons anywhere," Beck wrote.[20] Thus, the Living Theater challenged its spectators to meditate on their moral obligations as social beings.

The plays themselves raised questions of the body politic. But also the Living Theater was politically oriented to community in that it hosted all sorts of other events. These ranged from poetry readings to dance concerts to film screenings to political meetings, especially for peace organizations—of which one, the New York Strike for Peace, was run by the Becks themselves. The Living Theater served as a town hall, not just for the community of artists, but for the larger community of Villagers. And the Living Theater's influence in the theater community reached much further than their own plays, since two of the most influential Off-Off-Broadway groups, the Open Theater and the Judson Poets' Theater, had former Living Theater members at their helms. In addition to these two direct progeny, many more groups followed the examples that the Living Theater set for experimenting with both artistic and social forms.

The Open Theater extended even more radically the cooperative nature

of ensemble theater-making that the Becks had initiated. Its director, Joseph Chaikin, described an epiphany that several Off-Off-Broadway theater people echo in various accounts of political awakening in the Sixties when Chaikin recounted how, cast as Gayly Gay in Brecht's *Man Is Man*, after three years with the Living Theater he realized that this acting, in these political plays, no longer felt like just a stepping-stone to bigger and better roles on Broadway. Rather, it was something profoundly fulfilling on its own terms—not just a job or a skill or a chance to succeed, but a spiritual and socially conscious engagement that, in fact, made him question his previous ambitions and ideas about success.[21]

In early 1963 Chaikin, at that time still a member of the Living Theater, was asked by a group of Nola Chilton's acting students to work with them. The first meeting of the Open Theater in February 1963 included seventeen actors and four writers.[22] The group, which at times included other playwrights, directors, musicians, and even critics, slowly worked its way through internal political battles and various, at first desultory, experiments with improvisation and other non-naturalistic acting techniques. In December 1963 it presented its first public performance—more a demonstration of exercises and skits than a play—at the Sheridan Square Playhouse.

From the start, the dilemma for the group was two-pronged: how to find a new theatrical method, on the one hand, and how to function as a democratic ensemble in realizing that method, on the other. At first, some members went so far as to draft a constitution for the group to ensure that no single member become a dictatorial leader. Although Chaikin quickly emerged as an (at first) unofficial leader, his approach to acting and to performing preserved the sense of the collective and, further, of the collective-within-the-community. This is clear from the group "sound and movement" exercises that effectively bonded the ensemble through physical interaction and collective creation.

By the mid-twentieth century, ensemble acting was nothing new; it had been the core of Stanislavsky's enterprise at the Moscow Art Theater at the turn of the century. And in the Fifties it had been the watchword of the early Off-Broadway movement. But for Chaikin the utopian ideal of the ensemble forming the life of the group both in and out of the performance was still crucial—and still unrealized in the theater as he knew it in the early Sixties. "I believe," Chaikin wrote, "that we are on our own in trying to expand and develop ourselves, but it is all in vain unless we collaborate together and pool for an ensemble."[23]

Geraldine Lust, who had been a coproducer of Jean Genet's *The Blacks*

at St. Marks Playhouse, was another director who joined the early Open Theater group. She was concerned even more specifically with the social function of the theater as a possible place to stake out a vanguard political position and wanted theater people to serve as leaders who actually propose, rather than merely reflect, community values:

> Among the themes we explored [was] the conviction that theater should be functioning at a point beyond that which the community has reached, although this is a reversal of the traditional relationship in which theater reflects the events around it; it seemed to us that our times were moving so swiftly that we could not afford to let the most effective voice be the tardy one. This led to an examination of what is community in the 1960s and what is leadership for it, and we wondered how it might be possible to create, through theater, ideas for a community.[24]

And the critic and playwright Arthur Sainer remembers that the sense of community overflowed the acting workshops into more general talk sessions. "We met, for instance, one Sunday afternoon after John Kennedy's assassination because we wanted in some way to share our feelings about the murder that had just taken place."[25]

The desire to work collectively is also clear (at least, as the history of the Open Theater has been written) in the way that writers, actors, musicians, and directors were integrated into the making of a piece, all contributing texts, images, and research without respect to the boundaries of their official capacities. Further, the sense of community was expressed in the informality of the initial demonstrations—at the group's loft, open free of charge to any spectator who happened to learn about them through the grapevine.[26]

The public showing began with a group warmup, "A Ritual Hello." This was a sound-and-movement exercise in which the communion of the group is set in place. The "game" was to pass from one to another an abstract action composed of sound and movement. As in a game of "Telephone," the sound and movement would be transformed with each communication. Importantly, each giving-and-receiving pair shared for a moment a single action, which is considered a common, nonverbal language. The "ritual" consolidated the group as an ensemble.[27] The program also included a short play by Jean Claude van Itallie, *Variations on a Clifford Odets Theme*, in which a naturalistic scene of a banal family was transformed when the actors began, through sound and movement, to act out the characters' feelings and fantasies.[28] That is, actors dismantled the stan-

dard neurotic theater family of the realistic theater. Another of van Itallie's plays on the program was *The Murdered Woman,* inspired by the story of Kitty Genovese, the New York woman who recently had been assaulted and killed while people in surrounding apartments ignored her cries for help.[29] From the start of its public performances, then, the Open Theater made the issue of community—of family and neighborhood—a crucial topic.

In October 1963 the Living Theater was closed by the IRS, and early in 1964 the Becks left New York with some members of the troupe for a European tour (which became a four-year, self-imposed exile). But Chaikin (and Peter Feldman, Lee Worley, and several other Open Theater workshop members who had simultaneously remained part of the Living Theater) stayed in New York to concentrate on bringing the Open Theater into public life. They saw as their role now the continuation and expansion of the political and social engagement into which the Becks had initiated them. But theirs was an engagement articulated specifically in the theater (rather than, for instance, in the peace movement)—by experimenting with the theater-making process and creating performance through the nonhierarchical, collaborative work of the "community" of the new ensemble: writer, actor, and director.

The other Off-Off-Broadway theater with a direct filial link to the Living Theater was the Judson Poets' Theater, an outgrowth of the Judson Memorial Church's arts program. Al Carmines was hired as assistant minister in 1961, and quickly he organized the Judson Poets' Theater with the help of Robert Nichols, a poet, playwright, and architect who had already produced some plays at the church. The first play that Nichols chose was *The Great American Desert* by the poet Joel Oppenheimer (a student of Charles Olson's and a younger member of the Black Mountain group). It was a contemporary satiric Western, peopled with the ghosts of American mythical heroes. The play immediately posed problems regarding obscenity. But the church decided from the first on a policy of noninterference and freedom from censorship. Oppenheimer asked Lawrence Kornfeld, who had been assistant director and general manager of the Living Theater from 1957 to 1961, to direct his play. Despite his initial reservations about working in a church setting because he thought it would be too Establishment-oriented, Kornfeld agreed. He remained to become the theater's resident director. *The Great American Desert* opened on November 18, 1961, on a double bill with Guillaume Apollinaire's Surrealist play *The Breasts of Tiresias;* the program's total budget was $37.50.[30]

The repertory that developed at the Judson Poets' Theater ranged from experiments by young poets to medieval mystery plays. In 1962, when Al

Carmines began to compose original music based on popular forms for some of the plays, JPT inaugurated the Off-Off-Broadway musical, which flowered fully in the 1963–64 season with *Home Movies* and *What Happened*.

If the Open Theater was a group of professional theater people engaged in community building by making an alternative professional (though non-commercial) theater together, the Judson Poets' Theater was a community theater in the sense that it was an outlet for local writers, it sought a neigh-borhood audience, it charged no admission fees, and its casts were a mix of professionals and local amateurs. The actors for *The Great American Desert* were poets, journalists, and blue-collar workers recruited, according to Kornfeld, from the Cedar Tavern, where Oppenheimer had first pro-posed that the director get involved in the project. The result was "a very nice, warm, sweet-tough tone," a direct, unpolished folk quality, stemming partly from the actors' lack of training but also from Kornfeld's precise di-rection that appealed to both audiences and critics. Jerry Tallmer noted: "The nice thing . . . is that it is not slickly professional. It has all the loose edges of high vitality and low budget." Carmines went so far as to define the communal nature of the Judson Poets' Theater for participants—both actors and spectators—as a new kind of religious communion, a modern ritual celebration.[31]

Yet despite its increasingly conscious role as an avant-garde "folk" the-ater, the community that the Judson Poets' Theater expressed was, ad-mittedly, a self-contained and esoteric one. When Rosalyn Drexler's *Home Movies,* one of the triumphs of the JPT's 1963–64 season and the win-ner of two Obie awards,[32] moved to the Provincetown Playhouse (that is, from Off-Off-Broadway to Off-Broadway), the mainstream critics and audiences were completely bewildered.[33] Michael Smith, reviewing the transferred production, attributed its failure directly to its leaving the com-munal arena: "The performances are more evenly professional now, and some of them have become surer and better, but 'Home Movies' has lost its direct contact with the audience and has become less fun. One no longer feels a complicity in its swipes at conventional values. The open di-rectness of the production faded when it stepped into the show-business arena; audience and actors are friendly peers in the hominess of Jud-son Church, but in the 'professional' theatre they are employers and em-ployees."[34] The goal for Off-Broadway actors and productions had been to move up to Broadway. But for Off-Off-Broadway, graduating to Off-Broadway—leaving the alternative home and the alternative community—was a fate to be avoided, for it altered the relations of production, turning artists into alienated labor.

Joseph Cino opened Caffe Cino on Cornelia Street, off Bleecker west of Sixth Avenue, in December 1958 with the intention of running it simply as a coffeehouse, that is, a "social place" for poetry readings, art exhibitions, folksinging, and "general geniality."[35] As some of readings outgrew themselves, becoming more extended and dramatic in form, a theater sprouted in the tiny café, with its eight-by-eight-foot stage (at first just a cleared-out space, and later a platform) and its walls encrusted with memorabilia. Soon it was a gathering place where aspiring actors and playwrights could try out new material in what they describe as an extraordinarily permissive atmosphere, presided over by the ever-supportive Cino. Joe Cino's personal history is shrouded in mystery. Perhaps a former actor or dancer, he made the Caffe Cino his life until he committed suicide in 1967. A center for the gay underground, Caffe Cino sowed the ground for the blossoming of the gay theater movement of the Seventies, Eighties, and Nineties.

The performances at the Caffe Cino ranged from readings to scenes to full-scale (if small-scale) productions. There was no admission charge. A basket was passed around for contributions, which the actors shared. By 1963 there were two shows a night, at 9 and 11 P.M.,and an additional 1 A.M. show on weekends. Although Cino made no bones about his leadership role ("I decide on everything that comes into the room," he wrote. "I talk to playwrights, I talk to directors. I work with people"),[36] he is remembered as a generous host, solicitous to his friends and guests. That the space was called a "room," rather than a theater, underscores the aura of domesticity that Cino created.

Caffe Cino has been mythologized more as a family than as a collective. As Albert Poland and Bruce Mailman describe it, this first Off-Off-Broadway theater was a haven of offbeat domesticity, compensation for—actually, an improvement on—home for deracinated downtown theater people (here, after all, unlike at home, one's "family" was always supportive and loving). "Caffe Cino was a wonderful place to work; it was warm, friendly, and personal. . . . Someone said [Joe Cino] was like Santa Claus—always a little pick-me-up—a hug for everyone. . . . He did not believe in the isolation of the artist."[37] The playwright Robert Heide, referring to Joe Cino as "a big Papa," recalls that he took struggling playwrights "under his wing" and regularly fed starving actors. "[Cino] felt that playwrights were bad children, easily spoiled by money, fame or too much attention. . . . Joe's dream for his playwrights was to buy a hotel (if he ever got the money, which he did not) and give each one a room with a typewriter and paper. He said he would personally lock them in their prospective cubicles for so many hours a day so that they could just write."[38]

Doric Wilson remembers that the actors used the kitchen as a dressing room and shared Cino's butcher block, "they, to make up; he to make sandwiches. There was the night Joanna Vischer . . . applied a slice of pepperoni to her cheek at the very moment Scotty delivered to a customer a rouge pad on a roll."[39] Robert Patrick, like Julian Beck, invokes the great age of communal theater in ancient Greece when he remembers Caffe Cino as "tribal" and extravagantly claims that Caffe Cino "produced the most extensive and influential surge of theatrical experimentation since Euripides."[40]

The liberating privacy that its participants identified as feeling at home— even though this was a home whose peace was constantly threatened by police busts, since the theater was unlicensed, and even though domesticity in real life never guarantees privacy—was key to the creative ferment at Caffe Cino. People could try things out informally for a supportive audience that was practically at the actors' fingertips, and, most important (unlike at home), anything was allowed. This was a liberated home, a party with parents perennially out of town and a generous uncle, rather than a father, at the helm. (It was also a family where homosexuality, rather than heterosexuality, was the norm.) Even the fact that "the room," as Cino referred to it, was not a true theater, but a space handmade anew for each production, without any budget, added to the feeling of imaginative freedom and cooperative, domestic warmth. Larry Loonin remembers the room festooned one night with crepe paper and looking like a high school gym after a dance.[41] According to Heide: "Joe regarded 'the room' as a magical place just like the 'special' bedroom shared by the incestuous brother and sister of Jean Cocteau's *Les Enfants Terribles*. Things in 'the room,' as well as plays done there, were somehow designated as 'sacred.'"[42]

The budgets at Caffe Cino were small or nonexistent, and often aesthetic choices were motivated by the need to make the actors stand out from the audience. Generally, an open ladder served as scenery—actors would climb it to add emphasis to their lines—or else the cast would go out to scavenge in the Village and bring back a set. Johnny Dodd, who often did the lights, tapped into the subway lines for electrical power.[43] The actors wore wild and elaborate costumes, Loonin recalls, "in order to distinguish themselves from the audience (which itself was dressed up)," and both the lighting and the delivery were intense. "There were two styles of speaking: hysterical and very hysterical." The cramped space and minimal budgets led, as Patrick points out, to an emphasis on language over physical movement or production values. Loonin also remembers sitting in the café scribbling the last few lines of his play as someone else's play was just about to end. If

the cast did not show up, as sometimes happened, people sat and read and talked as usual.

Remembered now as an early center for both gay plays and a "campy" gay theatrical style (although the crowd was not exclusively gay), the Caffe Cino early on began to produce plays by Oscar Wilde and Tennessee Williams. But it also produced a new generation of gay playwrights. Lanford Wilson's seminal *The Madness of Lady Bright* ran an unprecedented 168 performances. Robert Patrick had to play the lead role in his *Haunted Host* because the character, a playwright who lived on Christopher Street, was so outrageously "out." There also were early efforts by other gay playwrights, including Doric Wilson and William M. Hoffman. The Caffe Cino was a private world where, as Hoffman remembers, "most of us . . . were only barely aware that writing about gays was unusual. We lived in a fairly enclosed world, perhaps a theatrical Garden of Eden, and thought little about the outside."[44] But not only can the birth of American gay theater be traced to the Caffe Cino; despite Joe Cino's abhorrence of "The Bitch Goddess" success, the careers of many now-famous playwrights, directors, and actors, both straight and gay, gained important early impetus there— including Sam Shepard, John Guare, Lanford Wilson, Tom Eyen, Marshall Mason, Tom O'Horgan, Jean Claude van Itallie, Harvey Keitel, Neil Flanagan, and Bernadette Peters.

Ellen Stewart, the founder, guiding spirit, and eponymous "Mother Earth" of Cafe La Mama, was an African American from Louisiana. (Her history is somewhat difficult to sort out—indeed, it tends to take on a legendary quality—since on different occasions she gives different versions of the same stories.) Family members had been in vaudeville and burlesque, and her brother, who went to Yale Drama School, was an aspiring playwright. Stewart says she "fled" to the East Village from her fifth marriage, in the Long Island suburbs, and was a fledgling fashion designer when she met two theater people, Jim Moore and Paul Foster. "Ellen wanted a boutique; Paul wanted to do plays."[45] In the summer of 1962 they opened a theater-boutique in a basement on East Ninth Street that seated twenty-five people. Although they never sold any clothes there, a commission the following year for a fashion design job gave Stewart the money to open a new space, named Cafe La Mama, at 82 Second Avenue. The first productions in the old basement theater were plays by Tennessee Williams, Eugene O'Neill, and Harold Pinter, as well as some new American playwrights; but the new Cafe La Mama on Second Avenue was dedicated almost entirely to the work of young writers, some of whom were also Caffe Cino

regulars: Paul Foster, Lanford Wilson, Sam Shepard, Tom Eyen, David Starkweather, Ross Alexander, Tom O'Horgan, and others. If the emphasis of the Open Theater was on the acting ensemble, at La Mama it was definitely on the playwright. Although every participant in the theater process was important to Stewart, "the playwright is the inspiration, the beginning, the germ. All things must serve him in their particular way," she insisted.[46]

There were overlaps and connections between Cafe La Mama, Caffe Cino, and the Open Theater. Eventually, some of the Open Theater workshops showed pieces at the second Cafe La Mama, which opened in November 1964 at 122 Second Avenue. (La Mama E.T.C.—Experimental Theater Club—opened in its present location at 74 East Fourth Street in 1969. Of all the theaters discussed in this section, La Mama is the only one that has survived continuously in New York.)

Like Joe Cino, Ellen Stewart provided not only a space to work in, but a spiritual home that took care to nourish the body as well. Again, the rhetoric of alternative domesticity crops up in the different histories of Cafe La Mama. "Ellen Stewart cooked soup to feed her actors and playwrights. Her salary went into the communal kitty. She understood the importance of her playwrights. She rang a cowbell at the beginning of each performance and welcomed the audience to the theater with her now famous, 'Welcome to La Mama; dedicated to the playwrights and all aspects of the theater.' They were her life and she was their mother."[47]

Plays ran for one week. The point was not to make a polished production, but for the playwright to be able "to write, see, and learn." Stewart felt that long runs would corrupt her theater's values, "getting [La Mama] involved in the success-failure hang-up." After she chose a play and helped the playwright find a director, Stewart stayed away from the production process, which was entirely in the playwright's hands. Depending on who directed and who was cast, the styles of the productions varied.

Stewart described her theater as a pushcart of her own.[48] It was an offbeat version of a family business, run by an antifamily. In this Mom-and-Pop theater store without a Pop, the exotic Mom, dressed in a bandana, fringes, scarves, and colorful paisleys, introduced every performance, then sat on the steps during the play to prevent interruptions. There she held informal "office hours," answering correspondence and receiving actors and playwrights.[49] If new playwrights were the neglected children of the American theater, La Mama gave them a home.

Michael Smith, who wrote drama criticism for the *Village Voice* and also wrote and helped produce plays at Caffe Cino and with the Open Theater,

meditated in his introduction to *Eight Plays from Off-Off Broadway* about the nature of this community. Here, he thought (joining Beck and Patrick in an edenic nostalgia for an organic, holy theater), the mythic original nature and purpose of theater—"to join performers and spectators in a mutual experience"—was once again felt. It was a theater of paradoxes: "It is amateur theater done largely by professionals. It is theater with no resources but the most sophisticated audience in America. It is both casual community theater and dedicated experimental theater. It is proposing an alternative to an established theater which hardly knows it exists." Smith admitted: "Off-Off Broadway is decidedly clubby. To some extent it has a coterie audience; to some extent it is snobbish and self-glorifying; to some extent it is a playground. Sometimes it is despicable."

"But," he concluded, "all these weaknesses are inseparable from its strength, which is its human scale. . . . Off-Off Broadway there is neither pay nor negotiable publicity, and thus no way to evade the personal commitment of every choice."[50] Even Smith's rhetoric invokes the "other" family, for, he writes, "I was on hand for its birth and have seen its growing pains; I feel like a fond uncle. . . . It's a place to see my friends."[51]

The scale, the intimacy, and the lack of funds—sometimes even the common experience of harassment by city authorities—drew the actors and spectators of Off-Off-Broadway into what they saw as a collective leap of faith. Its playfulness invested the theater with energy. Its small scale and informality, as well as the passionate commitment of its volunteer participants, made them perceive it as community regained. Professionalism was seen as an alienating evil, amateurism as an incorporative good. For in their view, part of the problem with professionalism was that people came to specialize and work in separate, alienated, and bureaucratized spheres. But in the Off-Off-Broadway theater, it was felt, people achieved a state of social cohesion that allowed them to make a total, unified contribution. Joe Cino put it simply: "The best things happen when the entire company works together with concern for the entire production[,] . . . when the entire company is completely involved with the production, onstage and off."[52] In what was thought of as the community expression that Off-Off-Broadway allowed, art was meant to be made not for profit but for people, and community was felt to be remodeled and regained.

HAPPENINGS AND POP ART

Besides Off-Off-Broadway, a separate, parallel theater community—one made up of nontheater people—was firmly entrenched in the Village by 1963. This was the group of Happenings-makers whose new art form

had been christened in 1959 with Allan Kaprow's event *18 Happenings in 6 Parts*. Michael Kirby's 1965 book *Happenings* documents the work of five key Happenings-makers, all originally trained as painters: Kaprow, Red Grooms, Robert Whitman, Jim Dine, and Claes Oldenburg.[53] Others involved in making or performing in Happenings—whether they were given the new genre's often disputed label or called Events, Situations, Sound Theater, or even New Music—included Al Hansen, Simone Forti, George Brecht, Dick Higgins, Alison Knowles, Lucas Samaras, Jackson Mac Low, La Monte Young, Toshi Ichiyanagi, Ray Johnson, and Yoko Ono. By 1963 Higgins, Brecht, and others had joined the group known as Fluxus. In a sense it is difficult to separate the two (or more) groups, since there were concerts and festivals that included people from each, as well as dancers and musicians. And, too, the Fluxus population constantly mutated. Still, it is worth looking at them separately where possible.

Both Happenings and Fluxus developed out of ideas from John Cage's class in "Composition of Experimental Music," which he taught at the New School for Social Research from 1956 to 1960 (see chapter 1). Various members of this class, in which students made performances and discussed them, attributed the beginnings of Happenings to their experiences there. Influenced by the Italian Futurists, Dadaists, Zen Buddhism, and the theater theories of Antonin Artaud, Cage's notion of music had expanded to become a nondramatic or (to use Michael Kirby's term) nonmatrixed form of theater.[54] By the Seventies this kind of theater would be branded performance art. Cage himself had organized a precursor to Happenings at Black Mountain College in 1952, but, for the most part, his own performances remained classified as music.[55]

Although visual art per se is not a primary area of analysis here, it is important to trace the gallery and interpersonal connections of the art world, especially the Pop Art world, since it was in these galleries and through these networks that so many performances were given. And most importantly, the very people who were making visual art were drawn to make live performances as an extension of, even an alternative to, that art. Therefore, the Pop Art and Happenings groups will be discussed together.

Kaprow grew up in Arizona. He trained in philosophy at New York University and art history at Columbia, as well as in studio art. He studied painting with Hans Hoffman and for several years attended Cage's new music class at the New School. In 1963 Kaprow had been teaching painting and art history at Rutgers University for ten years.[56] Along with Robert Watts and Roy Lichtenstein (his colleagues in the art department), Lucas Samaras and Robert Whitman (his former students), George Segal (who

lived on a farm near Rutgers), and George Brecht (who worked in the area), Kaprow was known as a member of the "Rutgers group." In 1958, when Kaprow made his first Happening at Rutgers and had begun extending his visual art from painting into environment, the gallery that represented him—the artists' cooperative Hansa Gallery—was also showing Whitman and Segal. The Hansa Gallery had been founded in 1952 by students of Hans Hoffmann who departed from their teacher's Abstract Expressionism. Located at first in Greenwich Village, in 1954 it moved uptown to Central Park West, where Richard Bellamy was its director and Ivan Karp was for a time his assistant.[57]

Meanwhile, inspired by the Hansa Gallery, Red Grooms had opened the City Gallery in his own studio with Jay Milder, another painter. Born in Nashville, Tennessee, Grooms studied at the School of the Art Institute in Chicago and the Hans Hoffman School of Fine Arts in Provincetown; he moved to New York in 1957. In 1958–59 Grooms and Milder showed their own work and that of other figurative artists such as Bob Thompson, Lester Johnson, and Mimi Gross. Grooms gave Oldenburg and Dine their first New York exhibitions. In 1959–60 he opened the Delancey Street Museum on the Lower East Side, where he sponsored paintings, environments, and Happenings.

The Hansa Gallery closed in 1959. That fall, Anita Reuben opened her Reuben Gallery specifically to carry on the Hansa's figurative, anti-Abstract Expressionist movement. The Reuben, located first at 61 Fourth Avenue and then at 44 East 3rd Street, was for three years a lively center for downtown art, especially as a crucible for Happenings. Kaprow's *18 Happenings in 6 Parts,* which lent the nascent genre a name, took place there in October 1959. Subsequent seasons saw events by Grooms, Kaprow, Whitman, Dine, the electronic composer Richard Maxfield, George Brecht, dancer Simone (Forti) Morris, and Oldenburg. During the first season, exhibitions included work by Brecht, Samaras, Whitman, and, in a group show entitled "Below Zero," Brecht, Dine, Martha Edelheit, Grooms, Hansen, Ray Johnson, Kaprow, Oldenburg, Rauschenberg, Segal, James Waring, and Whitman.[58]

At the same time, many of these artists were showing at the Judson Gallery, which had opened in the basement of Judson Memorial Church in late 1958 and ran from 1959–60 under Kaprow's (unofficial) directorship. In 1959–60 Dine, Oldenburg, and Wesselmann showed work there several times, including Oldenburg's environment *The Street.* Kaprow showed his environment *The Apple Shrine* at the Judson Gallery in 1960. "Ray Gun Spex," a series of Happenings early in 1960, included works by Oldenburg,

Dine, Dick Higgins, Hansen, Kaprow, and Whitman. By 1961 the Judson group had merged with the Reuben group and also were being shown at the Martha Jackson Gallery.

In 1960 Richard Bellamy, the former director of the Hansa, opened the Green Gallery uptown, which soon came to specialize in Pop Art. Its roster included Segal, Samaras, and, by 1963, James Rosenquist, Claes Oldenburg, and Tom Wesselmann. The dealer Ivan Karp moved to the Leo Castelli gallery, where Jasper Johns and Robert Rauschenberg were featured artists.

Claes Oldenburg was born in Stockholm in 1929. His early childhood was spent in New York and Oslo. He moved to Chicago with his family in 1937 and was naturalized as an American citizen in 1953. Oldenburg graduated from Yale University with degrees in literature and art. While attending the School of the Art Institute in Chicago, 1952–54, he worked as an apprentice reporter at the Chicago City News Bureau and then as an illustrator for *Chicago Magazine*. In 1956 he settled in New York, working part-time at the Cooper Union Museum School Library.

Oldenburg describes the gallery/social network alignments of the late Fifties and his own feeling that he was an outsider at first:

> I didn't live in New Jersey, and I wasn't part of the New Jersey school, of which Kaprow was the leader. I didn't study with Cage. I discovered this whole area when I was looking for a gallery in 1958 and came across Red Grooms, who had started the City Gallery, which was the prototype of the Judson and many other informal artist-run places which also housed performances. . . .
>
> At the same time, I found Jim Dine, who had also found Red. The City Gallery was a splinter from the Hansa Gallery, and we formed the younger generation. After having my first one-man show at the Judson, I went away for the summer; and when I came back I saw Kaprow open the Reuben Gallery with his *18 Happenings in 6 Parts*. It wasn't until then that I gradually came to realize the existence of this New Jersey group. . . . Also through Kaprow, I met George Segal and Roy Lichtenstein. That year, of course, I had started the Judson Gallery with Jim Dine, Dick Tyler, and Phyllis Yampolsky. Although I had seen Kaprow at a Hansa picnic at George Segal's farm in 1958, the Reuben performance was my first meaningful contact with him.[59]

By 1963, the year that Grooms founded Ruckus Productions as a multimedia performance company and Andy Warhol began making films, the interdisciplinary nature of the visual art world had become clear. Warhol,

born near Pittsburgh, earned a B.F.A. from the Carnegie Institute of Technology and moved to New York in 1949, where he first worked as an illustrator for *Glamour* magazine and then as a free-lance commercial artist from 1950 to 1957, when he began to support himself as an independent artist. In 1952 he began to exhibit his drawings in fine arts galleries, but it was the 1962 exhibitions of his Campbell Soup cans in Los Angeles and New York that catapulted him to fame.

Warhol describes a slightly later set of completely different alignments from that of the Judson/Reuben group. Partly through artists' agent and filmmaker Emile de Antonio ("De"), this network put him in touch at first with the art world and by 1963 with the poetry, dance, and film worlds. The fashion industry had been open to him since his early days as a commercial artist. Warhol's was a world—or a series of overlapping worlds—in which art, work, and play intermingled, and professional and social networks were broadly woven: "I'd met the surrealist poet Charles Henri Ford at a party that his sister, Ruth Ford, the actress, who was married to Zachary Scott, gave at her apartment in the Dakota on Central Park West and 72nd Street, and Charles Henri and I began going around together to some of the underground movie screenings. He took me to a party that Marie Menken and her husband Willard Maas, underground filmmakers and poets, gave at their place in Brooklyn Heights. . . ."

Through Ford and the Maases, Warhol met Gerard Malanga, a young poet, whom he hired as an assistant.

> Sometimes when people came by to see my work, [Malanga would] give a reading to them. . . . Gerard kept up with every arty event and movement in the city—all the things that sent out fliers or advertised in the *Voice*. He took me to a lot of dank, musty basements where plays were put on, movies screened, poetry read. . . .
>
> We went out to Coney Island a few times that summer (my first time on a roller coaster), groups of whoever was around—people like Gerard; Jack Smith, the underground filmmaker-actor; Taylor Mead, the underground actor; Wynn Chamberlain, the Magic Realist painter; and Nicky Haslam, a new art director at *Vogue*. . . .
>
> The people who entertained were the ones who really made the sixties, and Wynn Chamberlain entertained a lot. . . . Everybody used to go to Wynn's parties [on the Bowery]—all the artists and dancers and underground filmmakers and poets.

When Chamberlain rented a house from Eleanor Ward (Warhol's dealer at the Stable Gallery) in Old Lyme, Connecticut, in the summer of 1963,

Warhol spent weekends there, along with up to forty other people. He watched Jack Smith filming *Normal Love* there and, watching poet John Giorno sleeping, decided to buy a camera and make his first film, *Sleep*.

> In the fall of '63 I started going around more and more to poetry readings with Gerard. I would go absolutely anywhere I heard there was something creative happening. We went down to the Monday night poetry readings organized by Paul Blackburn at the Cafe Le Metro on Second Avenue between 9th and 10th streets where each poet would read for five or ten minutes. On Wednesday nights there was a solo reading. Poets would just get up and read about their lives from stacks of papers that they had in front of them.

Warhol also started going with Ford and Malanga to dance concerts at the Judson Church. There he renewed his acquaintance with Stanley Amos, an art critic for an Italian newspaper. Amos lived around the corner from the Judson Church, on the same floor as Tom O'Horgan. Warhol describes the apartment as an extension of backstage for the Judson. "At Stanley's there were always playwrights scribbling in a corner and Judson dancers rehearsing and people sewing their costumes up."[60]

By 1964, when the young English artist Mark Lancaster came to see him at the factory, Warhol and friends had routinized their art-nightlife. "We usually worked till around midnight, and then we'd go down to the Village, to places like the Cafe Figaro, the Hip Bagel, the Kettle of Fish, the Gaslight, the Cafe Bizarre, or the Cino. I'd get home around four in the morning, make a few phone calls, usually talk to Henry Geldzahler[61] for an hour or so, and then when it started to get light I'd take a Seconal, sleep for a couple of hours, and be back at the factory by early afternoon." Warhol introduced Lancaster to the entire New York art circuit.

> I sent him to dinner at Henry Geldzahler's, and though Henry he met Jasper Johns and [Frank] Stella and [Roy] Lichtenstein and Ellsworth Kelly, and then once I sent him as a get-well present to Ray Johnson who was in Bellevue Hospital with hepatitis. We went down together to that art gallery near Washington Square that Ruth Kligman, who'd been Jackson Pollock's girl friend and was right in the car with him when he was killed, was running with her new husband, Mr. Sansegundo. They screened movies every night and Jonas [Mekas] would be there with underground filmmakers like Harry Smith and Gregory Markopoulos.[62]

Thus, Warhol was initiated into the film world that would shortly become his oyster. I have quoted Warhol at length here because his own gossipy, anecdotal style conveys so clearly the way the professional art world, for him, was a community, a social world.

In regard to issues of community, Happenings as a genre had erupted precisely as a way to make visual art more participatory for the spectator. In tracing his movement from making Environments to making the more audience-active form of the Happening, Kaprow stated his dissatisfaction with both the spectator's passivity and the limitations of the gallery space, which seemed to separate art from life too harshly.

> There was a sense of mystery [in the Environments] until your eye reached a wall. Then there was a dead end. . . . I thought how much better it would be if you could just go out of doors and float an Environment into the rest of life so that such a caesura would not be there. I tried camouflaging the walls one way or another. I tried destroying the sense of bounded space with more sound than ever, played continuously. . . . But this was no solution, it only increased the growing discord between my work and the art gallery's space and connotations. I immediately saw that every visitor to the Environment was part of it. I had not really thought of it before. And so I gave him occupations like moving something, turning switches on—just a few things. Increasingly during 1957 and 1958, this suggested a more "scored" responsibility for that visitor. I offered him more and more to do, until there developed the Happening.[63]

Community-building also had to do with the relation of the author-director to the participants. For Kaprow, total engagement involved the author's participation, for both moral and experiential reasons. "I find it practically necessary to appear in my own works because my presence amongst the other participants is extremely important as an example. If I stayed apart and watched, especially now [1965] when I insist on there being no spectators, they would say, 'What kind of a man is this?' Furthermore, I need to be part of it to find out what it is like myself. Imagining a Happening and being in one are two different things."[64]

Spectators were expected to change the direction of their seats and move from room to room, or to arrive at unusual locales and figure out how best to witness the events in the Happening. In such works as Kaprow's *A Spring Happening* and Robert Whitman's *The American Moon,* gallery spaces were transformed and the audience was asked to move through tun-

nels, and not all were willing to comply. In Oldenburg's *Autobodys,* the spectators sat in their cars in a parking lot, illuminating the action with their headlights. For Oldenburg, like Kaprow, the audience's activity was always understood as part of the total experience of the Happening. "The audience is considered an object and its behavior as events, along with the rest. The audience is taken to differ from the players in that its possibilities are not explored as far as that of the players (whose possibilities are not explored as far as my own). The place of the audience in the structure is determined by seating and by certain simple provocations."[65]

Even where the audience was not given instructions for specific tasks that would involve them in the performers' action, the cramped spaces of the Happenings' venues, just as in the café theaters of Off-Off-Broadway, often created a feeling of participation. There was no stage to separate actor and audience. Indeed, the spectators often were deliberately surrounded by the action. And the action was happening practically on top of them— in Whitman's *Water* and *The American Moon,* literally so. They might be bombarded with strong smells—the spray paint in Whitman's *Flower* and the paint and squeezed oranges of Kaprow's *18 Happenings in 6 Parts*—or loud noises—the crashes, clattering, buzzing, and screeching of innumerable Happenings—or objects—the lima beans and the final "curtain" of muslin, which fell to cover the audience, of Oldenburg's *Gayety.*

By 1963, both Happenings and Pop Art had become institutionalized. The cooperative movements that had given impetus to the City Gallery and the Judson Gallery, and that had joined Happenings-makers as diverse as Kaprow and Oldenburg in centers like the Reuben Gallery, had dispersed. On the one hand, competition and tensions had arisen among various participants (even within the subgroups that had merged, for instance, at the Reuben), and, on the other hand, increased visibility led to group and individual shows at larger galleries and museums in New York and farther afield, as well as commissions outside the alternative galleries for Happenings and other events. A wealthy New York couple, Robert and Ethel Scull, financed the Green Gallery and made collecting Pop Art a success symbol in the New York social world, drastically upgrading the economic status of the artists they favored. In the fall of 1962 the Sidney Janis Gallery uptown showed Dine, Lichtenstein, Oldenburg, Rosenquist, Segal, Warhol, and Wesselmann in a group show entitled "The New Realists," and in 1963 the Guggenheim Museum's show "Six Painters and the Object" featured Dine, Johns, Lichtenstein, Rauschenberg, Rosenquist, and Warhol. The two exhibitions consolidated Pop Art's success. Meanwhile, Happenings-makers such as Oldenburg and Whitman produced their own works sepa-

rately in nongallery spaces. Oldenburg opened his Ray Gun Mfg. Co. on East Second Street in 1962, where he put on a series of Happenings from February through May; and Whitman showed his 1963 theater events at 9 Great Jones Street.

Still, although the careers of the assemblagists, Pop artists, and Happenings-makers (and those who did both visual and performance work) were crystallizing in diverse, more individualized directions, some continued to participate in communal group events that were populated by artists from various networks: dancers, musicians, poets, and those working in less easily defined disciplines. At the month-long Yam Festival in 1963 (organized by George Brecht and Robert Watts and sponsored by the Smolin Gallery at various locations around the city and at George Segal's farm), for instance, the participants included Brecht, Trisha Brown, Lucinda Childs, Philip Corner, Red Grooms, Al Hansen, Dick Higgins, Ray Johnson, Allan Kaprow, Michael Kirby, Alison Knowles, George Maciunas, Jackson Mac Low, Robert Morris, Ben Patterson, Yvonne Rainer, Robert Watts, and La Monte Young.

The community that had been formed by the Happenings-makers, by junk, assemblage, and environment artists, and by Pop artists was partly a product of gallery programming. It was a temporary community built of overlapping social networks, but it also was rent by various personal conflicts, often cast in terms of aesthetic disagreements. Still, the community was seen by both participants and onlookers as a homey and informal network. Gallery openings were eagerly anticipated social events. Performances and other gatherings at George Segal's farm in New Jersey, notably in 1958 when Kaprow's first Happening was performed there, and in 1963 when the Smolin Gallery Yam Day events took place there, were likened to community picnics. The *Village Voice* critic Leonard Horowitz concluded his account of Yam Day: "It was a lovely day, Mrs. McDarrah made delicious pot roast sandwiches, there were lots of pretty girls, and as you can guess, it was just a picnic."[66] And Bud Wirtschafter's film of the event, *What's Happening*, has the feel of a home movie documenting a family picnic.[67]

But as some of the Pop artists and some of the Happenings-makers became individual "commodities," sought after by galleries and museums, given commissions for performances by universities, and commanding enormous fees and unprecedented publicity, the sense of community, always less important for the visual artists with their ready-made gallery networks, began to disintegrate. And Fluxus emerged out of some of the alternative festivals and groupings. With what was for some members an ex-

plicitly political understanding, Fluxus in their publications, performances, and objects reinstated the values of community.

FLUXUS

George Maciunas, a graphic designer, met composer La Monte Young in Richard Maxfield's class in electronic music, which superseded Cage's class at the New School. Young had studied music at the University of California, Berkeley, and he had become friendly with sculptor Robert Morris and dancer Simone Forti (who was then married to Morris), two other West Coast artists who settled in New York. Maciunas, a Lithuanian émigré who ran AG Gallery with a compatriot, met the Morrises and a number of other artists through Young. In March–July 1961 Maciunas and Young put on at AG gallery a series of interdisciplinary "Literary Evenings and Musica Antiqua et Nova" concerts (cosponsored with *Bread & * magazine). The group included dancers Trisha Brown, Simone (Forti) Morris, and Yvonne Rainer, composers Henry Flynt, Joseph Byrd, and Toshi Ichiyanagi (at the time, Yoko Ono's husband), poet Jackson Mac Low, and visual artists Walter De Maria, Dick Higgins, Ray Johnson, and Robert Morris. A number of the same artists—many of whom were connected through the John Cage and Richard Maxfield classes—participated in the series of performances that La Monte Young organized at Yoko Ono's loft on Chambers Street in January–June of that year.

In 1960 Young had been invited to guest-edit an issue on performance and poetry for *Beatitude East*. He invited Mac Low to coedit the volume. The journal cancelled the project, but Maciunas offered to design and produce the issue and helped put together what was finally published in 1963 as *An Anthology*, a collection of music and performance scores, poems, stories, and essays.[68] In September 1962, while still working on *An Anthology*, Maciunas went to Europe with a group of performers, partly, he says, to publicize the collection and future collective publications. Maciunas was already planning the next publication, which he intended to call *Fluxus*, so the fourteen concerts he organized were given that name.

As Jon Hendricks traces the beginnings of Fluxus, by the end of 1962 the prolific Maciunas had:

> written the 1st of several Fluxus Manifestos, conceived of a form of publishing inexpensive editions of an artist's work that could be added to when more work was written, made plans for a series of yearboxes of new work from many countries, designated a short lived collective leadership of the group, and started to confront audiences and

artists with their own rotten eggs. By late 1963 Maciunas started to produce cheap open editions of artist's events, score, games and concepts. These . . . Fluxus Editions were entirely designed, assembled, edited and published by Maciunas and quite often were also his own free interpretations of an artist's idea.[69]

From the start, Maciunas was interested in a notion of mass production and circulation that was partly inspired by Soviet constructivist, functionalist experimentation in art and graphic design of the Twenties. But in his desire to make art accessible, he was partly inspired by Cage and his Zen-influenced use of everyday experiences in art. Maciunas's program was specifically framed as anti-art, in the sense that he railed against the professionalization of art and called instead for amateurization. He believed that art should be able to be made by everybody and should be accessible to everybody through the mass distribution of low-cost multiples. Of course, Maciunas was not producing his multiples in numbers great enough for a truly mass distribution. And further, he found, after he opened a store on Canal Street in 1964, that most people were not interested in buying the Fluxus works.[70] But the idea of accessibility to both the art experience and the products of art put his Fluxus activities in a very different arena from the increasingly expensive collector's items that Pop Art was turning out to be.

There is a satiric edge to the rhetoric Maciunas employed in his early Fluxus manifestos. For instance, in one that is a visual collage, alternating hand-printed slogans, with items photographed in reverse black and white from a dictionary definition of "flux," Maciunas states the goals of his art movement. On the medical meanings of flux ("a fluid discharge from the bowels or other part; the matter thus discharged; to cause a discharge from, as in purging"), Maciunas commented: "*Purge* the world of bourgeois sickness, 'intellectual,' professional & commercialized culture, PURGE the world of dead art, imitation, artificial art, abstract art, illusionistic art, mathematical art,—PURGE THE WORLD OF 'EUROPANISM' [*sic*]!" To the meanings having to do with flowing, including the tide setting in toward the shore and the state of being liquid through heat, Maciunas appended the biblical-sounding slogan: "PROMOTE A REVOLUTION-ARY FLOOD AND TIDE IN ART, Promote living art, anti-art, promote *NON ART REALITY* to be fully [fully is crossed out in the original] grasped by all peoples, not only critics, dilettantes and professionals." And prompted by the chemical and metallurgical meaning "any substance used to promote fusion, esp. the fusion of metals or minerals," he wrote: "*FUSE*

the cadres of cultural, social & political revolutionaries into united front & action."[71]

This rhetoric was not entirely tongue-in-cheek, for some Fluxus members have noted that Maciunas's truly pro-Soviet politics were unattractive to other members of the group. A rebellious son of anti-Soviet Lithuanian émigrés, Maciunas was defiantly, militantly pro-Soviet. And not only the rhetoric, but the message certainly fit with Maciunas's beliefs. He told Larry Miller in 1978 that Fluxus was definitely intended to be "low art." "There's a lot, too much high art . . .; that's why we're doing Fluxus," Maciunas explained. Miller then asked him to compare Fluxus and high art. He replied: "First of all, high art is very marketable. . . . Second, the names are big names, they're marketable names. . . . Now high art is something you find in museums. Fluxus you don't find in museums."[72]

There was a purposely communal structure built into the very choice of Fluxus events and venues—the festival, the shop, the anthology. Dick Higgins provides another sense of community in Fluxus—a hometown, rather than a Leninist collective, sense—in "A Child's History of Fluxus." In a third-person, mock-naive tone, he sketches a world full of like-minded people—George Brecht, Dick Higgins, La Monte Young, Jackson Mac Low, "and plenty of others" in the United States; Wolf Vostell, the Americans Ben Patterson and Emmett Williams, the Korean Nam June Paik, all in Germany—were doing like-minded things, although not yet part of a single group. Also they shared a desire for democratic leveling that was expressed through performing quotidian actions. "They did 'concerts' of everyday living; and they gave exhibitions of what they found, where they shared the things that they liked best with whoever would come. Everything was itself, it wasn't part of something bigger and fancier. And the fancy people didn't like this, because it was all cheap and simple, and nobody could make much money out of it."[73]

At this point, Maciunas, the catalyst who would bring all these people together, arrives in Higgins's narrative, working with Young and Mac Low on *An Anthology* and putting on concerts at his gallery. Explaining that Maciunas gave up the AG Gallery when he spent all his money on publishing *An Anthology* and went to Germany, Higgins recounts:

> With him he took some big boxes all chockablock full of leftover things that La Monte and the others had collected, but which didn't fit into the "Anthology."
>
> George Maciunas's idea was to get together with people in Germany who were doing the same kind of thing, and to do something

like a book and something like a magazine—it would be printed every so often, and it would always change, always be different, always be really itself. It needed a name. So George Maciunas chose a very funny word for "change"—fluxus. . . . To let people know about this kind of book, he decided to give some fluxus concerts there, so the newspapers would write about them and people would find out about his books.

So in September 1962 the first of the fluxus concerts happened in a little city where George Maciunas was living, in Wiesbaden . . . Dick [Higgins] went there from New York, with Alison (Alison Knowles) his artist wife, and they took with them lots of pieces by other American people who had been finding and sharing fluxus kinds of things.

The concerts certainly did get written about! They were on television too. Poor George Maciunas's mother! She was an old-fashioned lady, and when the television showed all the crazy things that her son George was doing at the fluxus concerts, she was so embarrassed that she wouldn't go out of her house for two weeks because she was so ashamed of what the neighbors might say. . . . Actually, some of the neighbors really liked the fluxus concerts. The janitor at the museum where the fluxus concerts were happening liked them so well that he came to every performance with his wife and children.[74]

Despite Maciunas's aversion to museums, Fluxus was soon in demand all over Europe and, as Higgins somberly puts it, "Fluxus got famous. And then fluxus began to get copied." Then, in Higgins's account, the problem of what had heretofore been a very loose concept of membership in the group reached a crisis.

Once fame began to happen George Maciunas and the other fluxus people had to figure out what to do next to keep fluxus fun and working for everybody. George liked to be the boss; but he was smart enough to know that he couldn't be boss and tell the fluxus artist[s] what to do, because they'd quit and they were mostly better artists than he was. So he became the chairman instead. That meant that he couldn't tell people what they *had* to do, or what they must *not* do if they wanted to stay part of fluxus; instead he could tell the world what fluxus *was,* and anyone who wanted to do that kind of thing was Fluxus. That was smart because it meant the fluxus people didn't break up into gangs that disagreed, the way lots of artists' groups did before that. They stuck together to do fluxus kinds of things, even when they were also doing other kinds of things at the same time.[75]

In fact, Maciunas constantly purged old Fluxus members and anointed new ones. It almost seems that Maciunas's constant redefinition of the membership was part of Fluxus's identity and definition, its fluidity. Ken Friedman muses:

According to some people, to be part of Fluxus you had to be one of seven people who went on a specific group of concerts in Europe in 1962. George didn't believe that some of these people remained ideologically pure, so he welcome[d] some people into Fluxus and kicked some out. Among the people he kicked out were Dick Higgins, Emmett Williams, Alison Knowles and Nam June Paik.

Now George never formally called Dick or Alison back in, but everyone knows they are in. George felt they were in, too. Who knows why?[76]

In fact, Friedman points out, the various membership lists and histories drawn up between 1962 and Maciunas's death in 1978 were so variable that they should not be taken as definitive. Even the Fluxus Manifesto of 1962 was not definitive, since "nobody would sign it, not even George," although he had written it himself.[77]

According to Friedman, the rules for membership in Fluxus, as Maciunas defined them, were only three, and they were simple:

1. Fluxus is a co-operative.
2. Each member works for all members.
3. Whatever you present or publish, you must include over 50% Fluxus members, and you must call it Fluxus.[78]

There was, indeed, a Leninist flavor in this notion of collectivity, and early Soviet experiments in collective living and in artists' participation in co-operative ventures inspired Maciunas to organize Fluxus further. Beyond an art movement, it was moving toward a utopian model of cooperative work and life. Already by 1963 Maciunas and other Fluxus members were early settlers in the Soho district of New York City. By 1966 Maciunas was instrumental in buying and organizing artists' cooperatives—which he called Fluxhouses—in loft buildings. These buildings not only affirmed a sensitivity to everyday life, but they rejected the bourgeois separation of both life and art and work and art (the loft buildings were former small-industry work spaces). The plans at first included cinematheques or theaters on the ground floor, basements with various workshops and dark-rooms, and individual artists' residences on upper floors. Later plans also included the possibility of food co-ops, discotheques, farms outside the city, and a collective settlement on Ginger Island, in the British Virgin

Islands. In 1967 Maciunas specifically referred to the Fluxhouse co-ops as Kolhoz (the Russian/Soviet word for collective farm). Several of these cooperative buildings were eventually acquired, and Maciunas himself designed the Cinematheque on the ground floor of the 80 Wooster Street building, which opened in 1968, was the first home of Richard Foreman's Ontological-Hysteric Theater and, from 1974–1982, housed the Anthology Film Archives.[79]

But despite Maciunas's interest in Soviet planning, architecture, and design, there was in the Fluxus rhetoric an American utopian strain, transplanted to the urban landscape. Friedman remarks: "When Fluxus was promulgated in the United States by ethical zealots and marvelous charlatans, it was as American as William Ellery Channing, Harriet Beecher Stowe and Mark Twain. When Fluxus went creeping from state to state with festivals and philosophy, some 45 of these United States, year after year, it wasn't American because it went *through* America, it was American because it embraced American largesse, pioneer neighborliness and frivolity." It was, that is, not a foreign, Soviet collective, but a new expression of traditional American community art. And he notes: "It is no coincidence that many play-party games and folk amusements resemble *events*. . . . Americans such as David Antin and Tom Garver didn't see Dick Higgins or Der Fluxus-Mozart as musicians. Such folk called us "The Paul Bunyan of Intermedia" and "The Johnny Appleseed of Contemporary Art.'"[80]

Despite the occasionally Stalinist tone of Maciunas's pronouncements, and despite its limited appeal in practical terms, Fluxus proclaimed a radically democratic appropriation of artmaking and art products to all. Maciunas called the early works "forms that everybody could do," and he sketched a vision of a world where, with a grass-roots experience of art permeating everyday life, the professional artist would be eliminated.[81] Friedman urges: "Fluxus invites each human, every human to come forward, to work or to play. The ritual is interactive, the audience can address, transform, change. Whoever picks up a box of cards by George Brecht, by Takehisa Kosugi, by Robert Watts, can make the art. Whoever wants to look at some shoes by Alison Knowles or Aktual clothing by Milan Knizak can also make, sign and have."[82]

DANCE

Both the downtown dance world and the underground film movement were directly inspired by the enterprising spirit of the Off- and Off-Off-Broadway movement (as well as by Happenings) to found alternative institutions—or anti-institutions—for presenting their work. Mod-

ern dancers never had the equivalent of Broadway theater seasons. From the 1930s, concert runs generally lasted a weekend or two, and budgets were modest compared to those of commercial dramatic productions. But if ballet was the dance world equivalent to Broadway, the hardening of the arteries that had set into modern dance by the early Sixties made it the dance world's Off-Broadway—unadventurous, overinflated, and overpriced. There were some maverick modern dance avant-gardists in the 1950s—among them, Merce Cunningham, who was the most famous, and James Waring, Katherine Litz, Paul Taylor, Aileen Passloff, and Beverly Blossom—who struggled to present their work independently. Some of them even formed small cooperative production groups. But with the birth of the Judson Dance Theater in the early Sixties, a vital and highly visible collective made its impact, not only on the dance world, but on the Village arts scene in general.

A loosely organized collective of choreographers—including not only people trained as dancers, but, unusually, visual artists, musicians, poets, and filmmakers—the Judson Dance Theater grew out of a dance composition class that the musician Robert Dunn, who had studied with John Cage, taught at the Merce Cunningham dance studio. The Judson group gave its first concert at the church as an "end of the class recital" on July 6, 1962. That autumn, group members began meeting in a weekly workshop to show one another their dances. From 1962–64, the Judson Dance Theater cooperatively produced nearly two hundred dances in twenty public concerts—sixteen group programs and four one-person evenings.

In looking for a place to show their work, the future members of the Judson Dance Theater had some familiar theater venues to consider. Several of the dancers who were taking Robert Dunn's choreography class at the Cunningham studio in 1961–62 had danced in James Waring's concerts at the Living Theater. David Gordon, trained as a visual artist at Brooklyn College and a dancer in Waring's company, had shown his first dance there, on a program of work by Waring's students in 1960. Two other Waring dancers, Yvonne Rainer and Fred Herko, had made their debuts as choreographers there at a group dance concert that Waring organized in July 1961. Rainer, who had come to New York from San Francisco in 1956 initially to study acting, trained in dance with Ann Halprin on the West Coast and, in New York, with Merce Cunningham and at the Graham studio. Herko had grown up in a New York City suburb and trained as a ballet dancer. When Dunn's students decided in the spring of 1962 to put on a public concert of works from the composition class, they felt that the 162-seat Living Theater was too small. Yvonne Rainer had seen the first

production of the Judson Poets' Theater in the choir loft of Judson Church, and she suggested that the group look into the feasibility of holding a concert there.[83]

Dunn was a composer, not a choreographer. He worked as an accompanist at the Cunningham studio and other modern dance studios and was married to the Cunningham dancer Judith Dunn. He had taken Cage's experimental music composition course at the New School and was invited by Cage to teach choreography at Cunningham's studio. Dunn was the leader at the collective sessions to organize his students' concert, which turned out to be a four-hour marathon in the church sanctuary. The fourteen choreographers divided up the work, from doing the publicity to working the lights. Admission was free, and nearly three hundred people attended. Concert of Dance #1 was innovative in both its cooperative production and its choreographic methods. The press release for the program emphasized that it included dances made by chance techniques, indeterminacy, rule-games, tasks, improvisation, spontaneous determination, and other methods (like scores and cut-ups), all of which deliberately undercut the standard modern-dance narrative or emotional meanings. The program began with an overture, which was the projection of a film collage, and continued with twenty-two dances, some of which were performed in silence, some to music by Erik Satie or John Cage, one to rock music, and one of which was a collaboration between the dancer Fred Herko and the jazz pianist Cecil Taylor. Movement style ran the gamut from everyday gestures to Cunninghamesque movement to quotations of ballet.

Jill Johnston, the dance critic for the *Village Voice,* titled her review of the first concert "Democracy," and prophesied—correctly—that this group would galvanize a renaissance in modern dance for the first time in twenty years. Indeed, this group would dominate postmodern dance for twenty years to come.

Although the concert had been planned as a one-shot deal, its success, both critical and popular, caused some of the choreographers to think about future possibilities. Rainer later wrote: "We were all wildly enthusiastic afterwards, and with good reason. Aside from the enthusiasm of the audience, the church seemed a positive alternative to the once-a-year hire-a-hall mode of operating that had plagued the struggling modern dancer before. Here we could present things more frequently, more informally, and more cheaply, and—most important of all—more cooperatively."[84]

From the start, as Rainer makes clear, the dancers and other artists involved in the Dunn class aspired quite consciously to work as a community. They also soon found themselves leaderless. Dunn remained a friend to the

group but no longer offered his course the following autumn. The class had graduated. A challenge was now posed as to how this community would shape itself. The Judson Dance Theater, as the cooperative began to call itself in April 1963, met weekly—first at the studio Rainer shared with Waring and Passloff, then in the basement gym at the Judson Church. In January 1963 the group gave two more concerts in the gym, and in April it sponsored Rainer's evening-length *Terrain* in the church sanctuary, where more group concerts followed. By the following April, when the weekly workshop sponsored its sixteenth and last group concert, it had presented nearly two hundred dances, either at the church or under the name Judson Dance Theater in other locations—the Gramercy Arts Theater, a skating rink in Washington, D.C., and a New Jersey forest. All of these concerts, including those presenting only one person's work, were collectively produced.

Even more than the Off-Off-Broadway groups, the Judson Dance Theater was explicitly dedicated to working collectively. And an important part of its work was discovering together how to reach collective decisions. The weekly workshop was never an exclusive group—one of the earliest principles was that the sessions were open to anyone who wanted to attend. The participants adopted a methodology of consensus and set up a rotating chair system at the first meeting. Some of these ideas came from Ruth Emerson, a dancer who grew up in Urbana, Illinois, had a degree in mathematics from Radcliffe, and studied with Anna Halprin, Martha Graham, and Merce Cunningham. Emerson was also working on antinuclear organizing with the American Friends Service Committee and the General Strike for Peace. She learned the method of consensus from Quaker practice. Emerson recalled that the use of consensus

> was partly a political feeling, because we all felt that establishment dance and choreography had discriminated against us in an authoritarian way. I was working as a volunteer at the American Friends Service Committee, and that made me want to work in my daily life and work situations in the way that people were trained to struggle with problems at AFSC. . . . I had a conviction that a consensus was better than a democratic vote. [Otherwise,] the majority would always end up with some minority.[85]

Thus, like the Living Theater, these artists turned to political groups, in particular the peace movement, to find models for group and institutional decision-making. Although not every JDT member attended workshop sessions regularly, a core group did make the meetings a regular commitment.

One of the core, Elaine Summers, who had studied dance since childhood in Massachusetts but also trained as a visual artist, remembers: "We met every single week for over two years. During the second year Christmas and New Year's fell on the workshop night; the one social thing we ever did was that we had a New Year's party after the class was over. The meetings usually started at eight o'clock and would end between eleven and midnight. . . . We set up a rotating chairmanship. The chairman got to say what kind of criticism we were to indulge in that evening."[86] According to Alex Hay, a painter who joined the group to make dances, the commitment to meet weekly was not difficult: "The energy was incredible. All I would think about each week, for about a year, was the Judson workshop."[87] Judith Dunn, a dancer with Cunningham's company who had majored in anthropology at Brooklyn College and had a master's degree in dance from Sarah Lawrence, wrote about the workshop's method:

> At the beginning there was no central authority or hierarchical structure operating. The group concerts and the workshop were cooperative and voluntary with a nondiscriminatory policy regarding works performed and workshop members. (James Waring once said in a fit of pique, "Judson Dance Theater is the world!") No important [decisions] were made until everyone concerned and present agreed. On occasion this method was time-consuming but in my opinion not at all wasteful.[88]

The extraordinary level of attention and energy devoted to the process of group dynamics crystallized one aspect of community in the Judson Dance Theater—its unity. But another aspect was its variety—the invigorating multiplicity of perspectives and methods, flowing from tolerance as well as the participation of artists trained in different media, that seemed to serve as a metaphor for pluralism. Of course, the collaborative work by Cunningham, Cage, and Robert Rauschenberg served as an important model for the mixing together of the arts, but this earlier, yet overlapping generation's collaborative method specifically called for separation, not union. The diversity that marked this particular community's democratic participation was especially clear in the format of the group programs. Most concerts included eight or more dances—by as many choreographers. After Concerts #3 and #4, the first to be held in the church sanctuary, Jill Johnston wrote in the *Voice:*

> One of the good things about the Judson concerts is the indiscriminate attitude of including just about as many dancers or nondancers

(in as many kinds of actions and movement) as seem willing to participate. The programs may tighten up later on, but for the moment a certain amount of indiscrimination makes the most encouraging situation for everybody concerned. If that sounds provisional, I would add that I think it's great to be as inclusive as possible, because it's more like life that way. On a large, unwieldy program many experiences are available, and you can love it or hate it or fall asleep and not be too concerned about getting your trouble's worth every foot of the time.

Be that as it may, there have been enough dancers on these programs to make the boat rock with dangerous excitement. The possibilities of form and movement have become unlimited. There is no kind of movement that can't be included in these dances; there is no kind of sound that is not proper for accompaniment. Only the integrity of the performer is at stake, the integrity to do the business at hand, to be inside that business, so that the action and the performer become one. The sluggish run of a non-dancer can be as moving and important as the beautifully extended leap of a dancer.[89]

Nondancers were used in the Judson dances for practical reasons (given their availability) as well as for moral and political ones (given the policy of nondiscrimination). But as with the amateur actors of Off-Off-Broadway and the nonactors in Happenings (some of whom, in turn, were Judson dancers), this practice was meant to strip the polish from dance style and restore to dance what was felt to be an antitheatrical authenticity of presence. By the same ethos, quotidian actions performed in a matter-of-fact style were incorporated into the choreography—for instance, the pantomimed cooking or washing actions in Steve Paxton's *English;* the actual eating, drinking, and walking in his *Proxy;* the woman ironing the dress she was wearing in Judith Dunn's *Acapulco;* or the yawning, coughing, laughing, scratching, and ass-slapping of Ruth Emerson's *Cerebris and* 2. Thus, it was no longer even necessary always to have trained dancers perform in the works, since the dance-technical requirements were often minimal. For this generation, the display of ordinary bodies and daily actions ("Make a dance about nothing special" was one of Robert Dunn's assignments) signaled a synthesis of art and daily life—spheres that industrial culture had separated.

As in any community of young people, another strong bond formed in the Judson Dance Theater stemmed from the personal relationships in the group. Friends brought in other friends, lovers, spouses. Yvonne Rainer brought in the composer Philip Corner, and he introduced Malcolm Gold-

stein, another musician, and Goldstein's wife, the dancer Arlene Rothlein. Later, Rainer and Robert Morris became a couple. Alex Hay, a painter as well as a JDT choreographer, was married to dancer Deborah Hay. The dancer Fred Herko lived with Billy Linich, who often did the lights (and who was shortly to move to Warhol's Factory). More JDT couples included William Davis and Albert Reid; Trisha Brown and Joseph Schlichter; Steve Paxton and Robert Rauschenberg; James Tenney and Carolee Schnee-mann; David Gordon and Valda Setterfield; and Robert and Judith Dunn. Alex Hay was Robert Rauschenberg's studio assistant, and Tony Holder, who was friendly with the Hays, also worked for Rauschenberg. Judith Dunn, Steve Paxton, Carolyn Brown, Valda Setterfield, Bill Davis, Barbara Lloyd, and later Albert Reid and Deborah Hay all danced in Merce Cun-ningham's company, and Robert Rauschenberg was still (until 1964) the company designer and stage manager. In addition to the Dunn composi-tion class, many of the dancers not in the company also knew one another from taking technique class at the Cunningham studio. Rainer, Herko, Gordon, Rothlein, Deborah Hay, and Lucinda Childs danced with James Waring, Billy Linich did Waring's lights, and John Herbert McDowell was Waring's chief composer. Elaine Summers met McDowell and others through Waring. Lucinda Childs studied with Judith Dunn at Sarah Law-rence College, as did Carla Blank, who danced in Merle Marsicano's com-pany with Sally Gross, Laura de Freitas, and June Ekman. So did Meredith Monk, one of the second-generation Judson choreographers who began showing work, with Kenneth King and Phoebe Neville, in 1964. And Sally Gross had danced with Judith Dunn when both were in college; Gross was the person who brought Jill Johnston, the *Voice* dance critic, to see the first Judson concert. Johnston's reminiscence of her friendship with Gross and her husband vividly conjures up the early Sixties Village social scene:

> I was enchanted by her lifestyle. Or I should say, I was amazed. It was so different from my proper, Protestant life. There were kids' draw-ings all over the walls, the ceilings and walls were peeling, the floors sloped, and everybody seemed to be having a good time. There were drums around, and they did strange things. They seemed to be living a vital existence. They knew exciting people—black jazz artists and stuff. I was suddenly caught up in a swirling social life. We'd go to the Dom, a discotheque of the early 60s, and the Cedar Bar. We'd make the rounds of the bars and go to big parties and do the Twist and all the other latest dances and any other thing, finally, that you felt like doing, and go to hear the jazz musicians. She was my introduction to

that entire world. Those people that she knew all connected up with the Judson somehow.[90]

As Rauschenberg remembers the art world social network: "It was a big family," for which the "Judson Group" was a focal center.[91] Philip Corner recalls: "Everybody who was doing anything that wasn't obviously moribund or academic" was involved, going to one another's performances and collaborating on events, no matter how disparate their forms, methods, and goals.[92]

Two aspects of the Judson Dance Theater community are striking. One was that in it, women not only had status equivalent to men; they were a dominant majority. In the Beat era of the late 50s, the image of the dancer-girlfriend in black tights—the original of Feiffer's cartoon—was that of an appendage to the male intellectual or artist. In the worlds of Happenings and Pop Art, the working population was equally male-dominated, although social events included wives and girlfriends–again, often dancers. But in the community built around the Judson Dance Theater, women emerged from their ranks as merely artists' girlfriends to create a space (admittedly, a space traditionally considered women's territory) where they could be leaders and creative artists—not in a protofeminist separatist mode, but in concert with their male peers. And they transformed that space from a marginal, lower-status art form to a central arena—where all the arts met—for avant-garde expression of the early Sixties.

This was an important transformation, for in taking on the role of serious women artists, these dancers authorized women as artists in other media for the next two decades. Rainer moved from this arena to become an important director in the independent film world. Schneemann, who had found that as a painter she was condescended to and as a Happenings-maker excluded from what she perceived as an all-male club, went from the Judson Dance Theater back into painting and into filmmaking. By the Seventies the second wave of feminism had produced a generation of women artists who moved into performance art, painting, and filmmaking, as well as dance and theater, some directly inspired by the specific examples of these Judson dancers, and some unwittingly benefiting from the breakthroughs these women had made in the Sixties art world.

The second striking aspect of the Judson Dance Theater, related to the first, is that the JDT seemed to supply a work life indissolubly woven together with a social life, as the above genealogy suggests. The dancers were connected socially to visual artists especially, and also to musicians, filmmakers, and writers. Those artists also were drawn into the Judson

activity, not only as collaborators on dance productions, but as chore-ographers in their own right. The Judson dance workshops were rich in community feeling, deeply linking work and play. This utopian feeling of unalienated, socially rooted labor attracted artists from various other disciplines, who may have belonged to galleries or enjoyed socializing with their peers, but whose work process ultimately was solitary. That is, Judson Dance Theater became a metacommunity of sorts where the different communities revolving around single arts disciplines coalesced and where interdisciplinary imagination flourished.

UNDERGROUND FILM

Like the illegal theater productions in the coffeehouses, the folksingers' gatherings in Washington Square Park, and the café readings of the Beat poets before them, avant-garde film showings became the target of con-stant harassment by city authorities. So nascent film organizations found themselves perpetually on the move. Irritating as this persecution was, it solidified the bonds of the avant-garde film community as the embattled filmmakers mobilized on the defensive.

The film critic Jonas Mekas, a Lithuanian émigré (and a family friend of George Maciunas) who was a poet and filmmaker, was the leader and the spokesman from the barricades—the midwife and self-described "self-appointed minister of defense and propaganda of the New Cinema"—who unceasingly found yet another theater to let him arrange and curate screenings. He publicized—in his magazine, *Film Culture,* and in his *Village Voice* "Movie Journal" columns—not only the films, their makers, and their showings, but also the critical and political battles that constantly beset them.[93] Mekas spoke for a sensibility that animated the entire Village artists' community as he outlined in his columns a quintessentially Ameri-can modern romanticism that championed youth, spontaneity, honesty, humor, and innocence, and also the vitalizing excesses of Baudelairean evil. His vision of the personal cinema, which celebrates the truth and freedom of the individual imagination in ways that are poetic, often obscure, and yet can and must be shared (outside of the tainting bureaucracy of commerce), crystallizes a view of art shared by this generation. In Mekas's ethos, human communion and the sensuousness of ordinary experience form a bedrock for the unique genius that spins images of perversity as well as wonder.

In the Fifties the major presenter and distributor of independent films—not only the avant-garde, but scientific, political, and art documentaries, rare cinema classics, and even commercial films that seemed "too strong" to be viable with general audiences—was Amos Vogel's Cinema 16 sub-

scription film society in New York, which operated from 1947 to 1963. According to Scott MacDonald, Vogel's programs were self-consciously arranged along dialectical lines of juxtaposition, inspired by the montage technique favored by the Soviet filmmaker Sergei Eisenstein. The limitations imposed by censorship regulations stipulated that Cinema 16 run as a private membership organization. There was a political, pedagogical aim in Vogel's catholic programming that challenged the complacency (and sometimes the morals, the aesthetics, or both) of McCarthyite America.[94]

Vogel was the first avant-garde film distributor in the United States, and his monthly Cinema 16 evenings (as well as other events, such as field trips for members to the Eastman House film archives in Rochester, New York, and the film courses he helped design at New York University and the New School) educated a generation of experimental filmmakers and film viewers. Both the Robert J. Flaherty Awards for documentary filmmaking and Maya Deren's Creative Film Foundation Awards for avant-garde films were given under Cinema 16's auspices.

But as instrumental as Cinema 16 was in distributing and exhibiting avant-garde films, Vogel operated much like any other commercial distributor in that he offered only exclusive contracts, and the filmmakers themselves had little control over their work. So by the late Fifties and early Sixties various efforts were made by avant-garde and independent filmmakers to exhibit and distribute their work cooperatively; they also wished (contrary to Vogel's programming practice) to include entire programs devoted to the works of individual filmmakers. Despite his liberal political leanings in terms of film content, once the New American Cinema Group and the Film-Makers' Cooperative got under way, Vogel criticized them for their democratic inclusiveness, which he felt diluted audience interest. But the competition by these filmmakers' organizations, as well as various other factors less directly associated with the avant-garde per se—the sheer financial difficulty of running the organization, and the rising competition from television, art houses, college film societies, and even pornography theaters—led to Cinema 16's demise in 1963.[95] A vacuum was formed, and the Film-Makers' Cooperative moved in to fill it.

In 1960 Mekas was instrumental in organizing, with Lewis Allen, the New American Cinema Group, a collective of independent filmmakers. (Allen was the producer of Shirley Clarke's *The Connection,* the cinematic adaptation of the Living Theater's notorious 1959 production about heroin addicts waiting for a fix.) Twenty-three filmmakers attended the group's first meeting and signed a manifesto that outlined their goals and cited as a model the Off-Off-Broadway theater's success in negotiating the financial

demands of the unions. The manifesto reserved control of every aspect of filmmaking—from financing to production, distribution, and exhibition—to the filmmaker. It demanded freedom from censorship. It criticized the Hollywood big "Budget Myth" that made for bloated productions. And it provided for a cooperative fund, financed by the filmmakers' profits, to aid the work of the organization's members who included Mekas, Clarke, Allen, Emile de Antonio, Robert Frank, John Cassavetes, Lionel Rogosin, and Gregory Markopoulos.[96]

On behalf of this group, de Antonio began to distribute independent feature films for theatrical release, while Mekas became the programmer for midnight screenings of avant-garde films at the Charles Theater. These included one-man shows of both the historical avant-garde and new film-makers and open-house screenings for works in progress. Never unified by aesthetic interests, the New American Cinema Group dispersed by 1962, but its principle of independent distribution continued when that year Mekas took over the group's distribution project and formed the Film-Makers' Cooperative. At first it was geared specifically to handle the avant-garde films that he advocated, but eventually any film that an independent film artist wished to submit was accepted. Cosponsored now by the Film-Makers' Cooperative and *Film Culture,* Mekas's midnight screenings moved in 1963 to the Bleecker Street Cinema. After the Bleecker canceled the series, it continued in June 1963, under the name Film-Makers' Show-case, at the Gramercy Arts Theater. There, in the summer and fall of 1963 and in the winter of 1964, one could see new films by Stan Brakhage, Gregory Markopoulos, Ron Rice, Kenneth Anger, Jack Smith, the Kuchar Brothers, Andy Warhol, and George Landow. Thus, the Showcase and the Cooperative became crucial institutions for spreading the work of the underground filmmakers, and, further, the Showcase was a gathering place where the artists and spectators could meet. This community, whose seeds were planted in 1960, extended to become a national network when, in 1962, Bruce Baillie started the Canyon Cinema screenings as a West Coast version of the Film-Makers' Showcase and in 1963 the Canyon Cinema Cooperative.[97]

But in March 1964 the New York City License Department closed the Gramercy Arts Theater, and a month of difficulties began. Mekas moved his screenings to the New Bowery Theater, where he was arrested on ob-scenity charges for showing Jack Smith's *Flaming Creatures,* and the theater was closed. The Gate and Pocket Theaters also were closed, and Mekas was again arrested, when he showed *Un Chant d'Amour,* a film by Jean Genet that included homoeroticism. The freedom of speech issue already

had been raised for independent films in 1960 when Clarke's *The Connection,* censored for obscenity, became a test case that dragged through the courts until 1962.[98] In an end-of-the-year "Movie Journal" column, Mekas chronicled how, after the films were seized and the theaters closed in early 1964, the film community went underground, with sporadic private screenings, as production dauntlessly continued:

> APRIL: A dark period in the New York film underground begins. No screenings for seven months. With no place to meet, film-makers' spirits go low. Clandestine screenings continue at the Co-op late into the summer, until the Co-op is raided and cops are placed nightly across the street.
> MAY: Dick Higgins shows *Invocation* at a downtown loft; . . . Stanton Kaye's *Georg* and Bruce Baillie's *Mass* introduced via Co-op screening. . . .
> JUNE: . . . Washington Square Galleries begin their film screenings and then are closed by the License Department. . . .[99]

Finally, in November the New Yorker Theater became a home for a new series of public screenings, now christened the Film-makers' Cinematheque. Despite the fact that avant-garde filmmakers had for years watched films at the New Yorker and discussed them afterward in the New Yorker bookshop, Mekas now saw in the move uptown a potential threat to the integrity of the avant-garde film; the media notoriety sparked by the spring arrests and the new uptown audiences signaled to him a dangerous mainstream encroachment. "The underground," Mekas wrote, had to "reorganize its forces and its tactics."[100] It defined itself, that is, as a guerrilla force.

Mekas occupied a unique position in the film underground as both central organizer and public voice, providing instant feedback after skirmishes with the authorities through an information service whose tone was "direct from the front." For this reason, of all the arts, the film world seems—at least to one looking back at the Sixties from the present—the one with the most urgent sense of itself as a subculture fully at war with the establishment. The Living Theater also battled various authorities. This led to the closing of their theater in October 1963 and the Becks' imprisonment. As pacifist anarchists and the organizers of the General Strike for Peace, the Becks had been arrested before for activities that had nothing to do with their theater. They were political people who went into a self-imposed exile in protest against the American system, which they had criticized directly in *The Brig.* But it was Mekas who crossed police lines, along with the cast

and the audience, to make a documentary film of *The Brig* at its fateful last performance when the Living Theater had been closed down and sealed shut by the IRS; it was Mekas who realized the weight that a permanent record—especially of *that* night's performance—could have; it was Mekas whose *Voice* column gave him the power to turn the harassment of the theater people and the censorship of the filmmakers into a weapon of agitation and mobilization. Reversing the socialist realist slogan "Art is a weapon," Mekas proclaimed art the end, not the means, of social struggle. No doubt in part because he had grown up in Eastern Europe, was involved in anti-Nazi resistance, and spent time in several displaced persons camps, Mekas simultaneously adopted authoritarian and military rhetoric—he made reference to tactics and strategy, to "the front lines of cinema" and "the ranks of the underground." He returned to the artistic vanguard the military ethos of its etymological origins, but his experience with totalitarianism forever marked him as a freedom fighter. Mekas's battle against censorship will be discussed further in chapter 4; but here I want to show how the issue of censorship figured in his understanding of community.

As a steadfast partisan of the New American Cinema, Mekas warmly—and by now almost singlehandedly, since Maya Deren had died in 1961, and Amos Vogel closed Cinema 16 in 1963—supported a growing community of filmmakers that took shape in the early 1960s and that suffered its moment of crisis in spring 1964 even as it peaked. He suspected, in fact, that it was the attainment of that critical mass of activity that led to the confrontations with the police. Like Joe Cino and Ellen Stewart, Mekas made a haven for a "family" of artists in programming his screenings and in giving the filmmakers a voice in his column—often literally, in extended quotations from interviews. Yet, perhaps because he was a transplanted European whose romanticism did not include the edenic notion of a specifically American organic community, or perhaps remembering all too clearly Nazi invocations of the *volk*, he had no delusions that he and his fellow underground filmmakers were making community film, nor did he cherish any illusions about the sanctity of community; he rarely invoked the rhetoric of communitas.

Rather, for Mekas the "community" was a complacent, dull, bourgeois entity to which the artist, as a romantic poet of the imagination, must perennially stand in opposition. Community meant lawmakers, police, and philistines. After *Flaming Creatures* and *Scorpio Rising* were declared obscene in the courts, Mekas wrote in a column entitled "On the Misery of Community Standards":

Artists of all times, as well as artists of today, have been and are engaged in fighting the "community standards," in uplifting man's soul, in pulling man upwards—even if it has to be done by pulling him up by his ears.

The community standards of today, like those of yesterday, are low and vulgar. The community sits flat on its ass, like a sick duck. . . .

To measure art by "community standards" means to measure art by the standards of those forty people in Brooklyn who stood and watched their own neighbor being killed: This is the community standard.[101]

The community that Mekas and the underground filmmakers formed was a band of outsiders, a vanguard cadre running its alternative institutions and events under threat of censorship and arrest and challenging mainstream values by symbolically violating them at their very core.

The Paradox of the Alternative Community

The artists, consciously forming their communities through their work, were circulating ideas about social bonds that articulated the values of one part of the Greenwich Village population. There was a vivid sense of community in the Village, yet the underlying and largely unacknowledged paradox of this activist civic spirit was that two different groups lived in the Village—"Villagers" and locals (i.e., artists and intellectuals vs. members of the ethnic community)—and that these two groups often had conflicting interests. That is, the very sense of strong local autonomy and traditional life that attracted new artist residents was rooted in an actual ethnic community whose values they only partly shared and which they were, in fact, displacing. The deracinated young Villagers, for instance, could delight in the festive marketplaces of Bleecker Street and the low rents of the South and East Village, but they despised machine politics and the racist behavior of their Italian neighbors, and they had middle-class expectations about their children's education—if they had any children. For, of course, many of the artists rejected the conservative family values the ethnic subcommunities cherished, opting for common-law couplehood, single or gay life. Unlike their ethnic neighbors, they saw in the Village not a haven *for* family life but freedom *from* it. Certainly the two groups' ideas about community art were utterly disparate. Neither the folksingers in Washington Square Park nor the East Village poets were the bards of local ethnic culture.

So the artists and intellectuals, who had left their families and geographi-

cal roots to come to New York, imagined their own community, but theirs was a very different kind of network from that of the Italian and Irish locals. The artists and intellectuals formed a constructed network, based on work, school, and other interests; it contrasted with the networks of the local community—based on kinship, ethnic, and religious ties—with which the artists' networks coexisted, often uneasily.

Of course, this paradox threads through the history of Greenwich Village, perhaps even defines it. Over and over again, the artists, seeking communitas along with low rents, moved into the neighborhood, with its already entrenched conservative communities. One way that the artists identified themselves was in opposition to those community values. As the artists brought media attention and tourist trade, increasing real estate values, the ethnic communities as well as the younger artists were forced out. Carolyn Ware described this phenomenon in her study of the Village in the Twenties; in the Seventies the label became gentrification and the realization developed that in New York as in other cities there was a pattern of settlement in which artists move into "slums," only to find themselves displaced by tourists and then wealthy professionals. The literature on Greenwich Village since the Twenties constantly reiterates this pattern.[102]

But in the early Sixties, when the cycle was reoccurring in the Village, this was not a perceived contradiction. The artists thought of themselves as a grass-roots community, sending out pioneer settlers on the frontiers beyond the historical district of the Village: the East Village and the neighborhood south of Houston Street known now as Soho.

A view toward the future and a rootedness in the present distinguished this generation of bohemians from the modernists of the Twenties and from the Victorian-era intellectuals who had repudiated modernism by retreating into arts and crafts revivals.[103] In their search for community, authenticity, and vitality, these artists inherited a modernist attitude. But their ideas about community were anything but nostalgic, for they were based on youth, not generational successions, and they were concerned with collectivity, not hierarchical authority. Moreover, unlike the modernists, these artists embraced older, often scorned artistic traditions and also tried to construct new ones. They connected their search for community with the politics of egalitarianism and liberation. The result was an art that mixed high and low styles, that often savored and saluted the past, but with a sophisticated sense of dislocating contemporaneity that framed and recombined old things in new, postmodern ways. Andy Warhol, for instance, meditating on the silver-painted look that Billy Name (aka Linich) created

in the Factory—which came to be globally identified with the Warhol pop style—claims for it a double symbolism of past and future: "It was the perfect time to think silver. Silver was the future, it was spacy—the astronauts wore silver suits—Shepard, Grissom, and Glenn had already been up in them, and their equipment was silver, too. And silver was also the past—the Silver Screen—Hollywood actresses photographed in silver sets."

The artists formed a community, but not an isolated, inward-looking one that relied on local traditions. Rather, their community—like their art—was plugged into what Marshall McLuhan termed the "global village" being created by the electronic mass media.[104] This was a powerful community, even if it imagined itself humble. Andy Warhol, again, in writing later about the scene in 1963, characterizes this contradictory situation of a local community at the center of an international art world and international politics. In a thoroughly postmodern way, he invokes a cozy domesticity that his own cool, distant art belied:

> It's always surprising to me to think how small the downtown New York City avant-garde scene was in relation to how much influence it eventually had. A generous estimate would be five hundred people, and that would include friends of friends of friends—the audience as well as the performers. . . .
>
> South of 14th Street things were always informal. The *Village Voice* was a community newspaper, then, with a distinct community to cover—a certain number of square blocks in Greenwich Village plus the entire liberal-thinking world, from flower boxes on MacDougal Street to pornography in Denmark. The combination of extremely local news with international news worked well for the *Voice* because the Village intellectuals were as interested in what was happening in the world as in what was going on around the corner, and the liberals all over the world were interested in the Village as if it were a second home.[105]

If the modernist slogan was "You can't go home again," this first generation of postmodernists claimed that you can. But home, for them, was entirely reconceived as an insurgent community.

3

Which Culture?

"New" Traditions: Whither American Art?

The generation of artists and intellectuals who came of age in the Sixties faced choices that determined not only their own styles of art and thought, but also that of a nation. America's post-World War II search for identity encompassed every aspect of the culture and, as we saw in chapter 1, often took the form of competition with the Soviet Union, where both science and art seemed to play a much more significant everyday role than in the United States. Before the war the United States had a history of looking to Western Europe as a guide for high art. Part of this history included the feeling that European art *was* high art and, vice versa, that indigenous American art—the art, that is, of Native Americans, African Americans, waves of European immigrants, and the popular arts that trans-

formed these various folk traditions to entertain larger audiences—was inferior culture. And yet, after the war, the United States had become a superpower both politically and culturally. But in what directions its new capacities would take it was open to question.

The European émigré artists who settled primarily in New York during and after World War II lent their creative forces to American culture. But at the same time the American situation—its rise to political and economic power—dictated that every aspect of indigenous American culture be reassessed, not only in terms of patriotic pride, but in terms of criticism and resistance. The cultural politics of Popular Front leftists before and during the war had glorified local folk and popular traditions. This was partly based on Soviet models (in terms of form), but the traditions they had unearthed were distinctively American (in terms of content). During the Fifties, however, anxiety about popular (or mass) culture mounted among a generation of cultural critics, especially as the leftist intellectuals of the Thirties moved toward the liberal center or further right on the political spectrum. For many, like Clement Greenberg and Dwight Macdonald, mass culture and the invocation of the folk were directly connected to, if not the causes of, the totalitarian regimes of Hitler's Germany and Stalin's Russia.

So by the Sixties the dilemma of how American culture was to be formed and conceptualized was fed by several strands of thought. An older generation of art critics and intellectuals, revering European high art, found popular culture anathema to political freedom and deemed folk culture extinct. But younger artists and critics were energized by the compelling vitality of an expanding mass culture industry. In retrospect, it seems clear that there were a number of interlocking reasons why popular and folk arts were embraced by this generation. One way to distinguish American art from European art was to install it in those traditions that seemed uniquely American, yet to do so in an original way that would be forward-looking rather than nostalgic. In borrowing folk and popular art they were using a standard modernist avant-garde primitivist strategy that had begun with the Romantic movement of the nineteenth century. Moreover, the Sixties project of community-building invested "low" art with moral and political value, for popular and folk traditions were associated with egalitarian values and the integration of art and daily life. On another front, the role of the downtown artists as a new wave of a critical avant-garde invested any art despised by the previous generation with an added aura of attraction. Finally, these directions were joined in the imperative, shared by both

the avant-garde and mainstream American culture, to "make it new." To discover how to create "new" traditions—to invoke an American artistic heritage without, however, making traditional art—was the task facing this avant-garde.

A Community Makes Folk Art

If the generation of avant-garde artists that came of age in the early Sixties consciously erected a community, then the purpose and nature of their artmaking project faced certain questions. We call the art of traditional communities folk art—a term that implies not only function and form, but issues of training, subject matter, resources, and distribution. Folk art is embedded in the social process—it is art *by* the community *for* the community. Furthermore, it is made outside the sphere of professionalism: it need not compete in the contemporary market, and its makers are not trained toward that end. Whether this art is an object or a performance, it often appears unpolished and lively, since it is handmade and unique. Using training methods rooted in oral traditions—often pre-Renaissance or non-Western, and hence radically divergent from mainstream art—folk artists recycle the world around them, recasting both themes and materials of daily life in terms that are simultaneously personal and communal. For the individual person, in the folk group, is already ensconced in the commonwealth—is herself produced by the traditions she has learned to practice.[1]

But what about the art of self-imagined communities?[2] What about the "tradition" forming the Sixties artists—the avant-garde, which values innovation over custom (the very opposite of folk art practice)? Is it possible to take folklore forms and folklore context out of their social milieu to consciously create a new American folklore from above, rather than from below? It might be argued that the avant-garde—like the folk—constitutes a subculture rather than fitting into the mainstream of American art and life. Still, it is a subculture that historically has been privileged in its cultural mobility, borrowing forms and content from "high" as well as "low" culture, from exotic as well as local practice. Hence, it is important here to consider which traditions, in particular, this avant-garde was attracted to. Further, we might ask about the nature of this paradoxical impulse to merge the vanguard with the vernacular (i.e., with what in the previous generation had been considered the rearguard of art). Why did such a crossover arise during precisely this historical moment? It is in this crossover impulse that the origins of postmodernism are located.

The Paradox of Avant-Garde Folklore
In July 1963 *Art in America* published its fiftieth anniversary issue. The theme, befitting both the magazine's name and the Independence Day publication date, was "What Is American"; the format was an anthology of articles previously published in the magazine—which had been founded the year of the notorious 1913 Armory Show—with an emphasis on American art. In the preface to this issue, the editors explain that the focus of the magazine has traditionally been on American art and artists; hence, the theme of the anniversary issue. And then the editors make an abrupt but quite provocative leap, occasioned by the collection of articles they are introducing, from American art in general to American folk art. It seems indigenous art, here, is almost automatically equivalent to vernacular art. That is, art made in this country, no matter what its context, is ineluctably annexed to local traditions.

> While the title of this magazine has been interpreted in the broadest sense by the editors as art not only produced *by* American artists but that of all nationalities to be seen *in* America, the emphasis has been on native art and artists—on what is American—so this became the theme of the anthology.
>
> Folk art was first published in the magazine as an important branch of native American art (in the thirties, when it was still generally relegated to the antiques category) and several special issues were devoted to it.[3]

The leap may be abrupt, but in terms of Sixties rhetoric it is also logical; it signals an early Sixties urge to identify the essence of American art with the vernacular. For although, quantitatively speaking, the range of articles in this anniversary issue deals with more "high" art than folk art, the implicit message is that even high art in America is stamped with our national character and therefore somehow counts as vernacular art.

Behind a cover with a reproduction of a naive painting from 1845— *Fourth of July Picnic at Weymouth Landing, Mass.*, by Susan Merrett[4]—the issue includes a survey of American themes and styles, from limner portraits to Jackson Pollock, by Lloyd Goodrich; an article on Shaker design by Edward Demin Andrews; an article on Abstract Expressionism by Sam Hunter; an article on the machine in American art by John I. H. Baur; a portfolio of jazz photographs by Lee Friedlander; various articles on and by individual artists, including Winslow Homer, Ben Shahn, and Leonard Baskin; and a preview of sixteen color plates of "primitive watercolors"

to be exhibited at the Abby Aldrich Rockefeller Folk Art Collection in Williamsburg, Virginia.

The issue also includes two articles that particularly concern us here. One is an essay on Pop Art by Dorothy Gees Seckler, "Folklore of the Banal." The second, by Alice Winchester, editor of *Antiques* magazine, is entitled "Antiques for the Avant-Garde." The second article shows a number of photographs of eighteenth- and nineteenth-century American crafts items, grouping them under such labels as "The Lembruck-Modigliani look," "The childlike approach," "Experiments with the linear," "Streamlined design." The article's headline notes: "Some of our Victorian ancestors were as way out as today's 'pop' artists." The thrust of the article is to show that Pop Art is nothing new; like folk art, it comes out of a venerable tradition—in fact, the writer seems to say, Pop Art's tradition *is* American folk art. Meanwhile, the article also hitches to Pop Art's wagon a renewed interest in other arts formerly deemed too humble for art-critical notice, that is, crafts and the decorative arts.[5]

Seckler's article, "Folklore of the Banal," originally published in a 1962 issue of *Art in America,* is more concerned with discussing works of Pop Art and the intentions of the artists than in a theoretical discussion of why it should be classified as folk art. She mentions the subject matter (commonplace objects and a sense of locale) and technique (hard-edged, concrete), but for the most part she assumes that her readers know what folk art is and why she uses that term for Pop Art.

In fact, the definition of folk art in the popular imagination was rather vague at the time; even art historians used a different meaning of the term than did folklorists, folk music aficionados, or the remnants of the Old Left that in the 1940s had searched for an indigenous American tradition along nationalistic, folk-revival, Popular Front lines. But part of what is going on in this entire issue of *Art in America*—by placing the Pop artists among all these references to folk art as the next step in an inevitable historical progression—is the appropriation of Pop Art as the newest stage of American folk art. This was an attempt to champion two separate art enterprises considered questionable by most reigning art institutions (including the rival art journals) by yoking them together in a patriotic invocation.

The visual art world was not alone in invoking folk art to describe the avant-garde of the early Sixties. Albert Poland and Bruce Mailman, chroniclers of Off-Off-Broadway, also borrow folklore terminology to characterize early Sixties avant-garde theater, but for different reasons. They see both commonplace images and audience involvement as part of the folk art

experience. And they contrast modernist art's arcane symbol system with the shared accessibility of folk art and the new avant-garde.

> Not since the great age of the American music hall and the melodrama has there been such real audience devotion and interaction. The audience participates; they boo, they cheer, but most of all they *enjoy* the plays and they attend the theatre because the new symbols are as familiar to them as they are to the playwrights. One need only be familiar with general American sociology to understand the new syntax: the movies on Saturday nights, popcorn, Cokes, the radio, TV, comic strips, drugs, etc.
>
> Unlike earlier artists of this century who broke new ground, these writers do not have to invent or revitalize myths to mine their symbols. . . . The work of [Yeats, Eliot, and] Ezra Pound is almost incomprehensible to the uninitiated. . . .
>
> [But] the playwrights of Off-Off-Broadway have their mythology at hand—American folk art. If folk art is a product or form produced by artisans (rather than artists) of the general population and representative of that population, then the fashion illustrators, industrial designers, sign makers, photographers, etc. are the craftsmen of that art. . . .
>
> More people in the United States today would understand and relate to the statement "X is like a Bette Davis movie" than to the statement "X is like the story of Ruth."[6]

Poland and Mailman's definition of folklore may be fuzzy, for they conflate folk performance with popular entertainments and the mass media. They also confound folk art objects with commercial art, and they equate folk legend with mythology. But what is significant here is that the very notion of folklore, however jumbled its definition, is championed as the basis for both style and content. Moreover, the invocation of folklore packs an antielitist political punch.

The Happenings-makers, too, often attribute their inspiration to vernacular performance, although once again the distinctions tend to blur between folk performance (such community events as children's basement theatricals, civic pageants, church plays, parades, festivals, play party games, and so on) and popular performance (vaudeville, burlesque, circus, minstrel shows, medicine shows, and other professional commercial ventures). Nevertheless, deliberate reference was made to specific aspects of various types of vernacular performance through their chosen forms and methods.

For both artistic and political reasons, the use of nonprofessionals was an important feature of the Happening. Theoretically, actors and non-actors were equals in this enterprise; in fact, nonactors were even preferred. Partly for practical reasons the performers were usually friends and family of the artist. But there was also a desire to avoid the polish of professional theatricality. Kaprow explains:

In first doing Happenings, I looked for friends to perform, anybody who would help me out, and they tended to be artists, poets, musicians that I knew. Since I knew very few actors, I did not go to them except when Julian Beck recommended a few, who immediately turned out to be useless to me because they wanted to act. They wanted to have stellar roles. They wanted to *speak* for the most part, and I utilized little verbiage in my work. And all the things which I suggested were quite contrary to their background. Even with the best of intentions, they were very self-conscious and awkward. But my other friends, who were unaccustomed to acting, were quite capable because they sensed the origins of what they were doing in painting. . . . They did not have to worry about their "projectability," their verbal ability, their "onstageness," and so forth.[7]

The result was a performance that to many seemed refreshingly free of professional mannerisms, that in its very unprofessionalism appeared somehow less clumsy and more relaxed—more, that is, "at home." This domestication of art was seen as analogous to the workings of folk performance.

Red Grooms was entranced as a child with the circus and with the traveling amusement shows and state fairs in his hometown in Tennessee. Like many children, he also put on plays in his backyard. *"The Burning Building* [Grooms's first New York Happening] on Delancey Street," he explains, "was an extension of my [childhood] backyard theatre. I wanted to have some of the dusty danger of a big traveling show. And the chicken-coop creakiness of a backyard extravaganza. And the mysteries of the operations behind the proscenium."[8] Here, Grooms indicates that he was consciously mixing three "levels" of art in his Happenings: popular entertainment ("a big traveling show"), folk theater ("a backyard extravaganza"), and high art ("the mysteries . . . behind the proscenium").

Oldenburg named the first program of Happenings he organized at Judson Church in 1960 Ray Gun Spex, making reference to the abbreviation for the Swedish word for burlesque.[9] And, as Barbara Rose has pointed out, Oldenburg's sources for Happenings included "newsreels, silent movies,

horror films, slapstick comedy, school pageants, vaudeville, burlesque, and other popular performing traditions. . . . His characters . . . include the Chaplinesque tramp, the Tobacco Road drifters, and the W. C. Fields buffoon."[10] Some of the activities in Oldenburg's *Injun* were reminiscent of a Coney Island fun house. Further, "in [the 1963 Happening] Gayety," Oldenburg wrote, "I want to create a civic report on the city of Chicago. . . . This is like the civic projects one did in sixth grade."[11] And indeed, in *Scarface and Aphrodite,* Vernon Zimmerman's film adaptation of *Gayety,* one sees many of the elements of children's homemade theater. The participants are clearly not trained actors. A school trash can with a pointed top is crudely painted to resemble a skyscraper. Ladders draped with cloth serve as scenery, and hand-lettered signs indicate different geographical locations. Even the blackboard and sink in the room are pressed into service as scenographic elements. A lumpy, floppy airplane made of stuffed cloth periodically sweeps the room. And the fluorescent lights in the room are flashed on and off to represent a storm. The style is deliberately homespun, even awkward and messy. Yet those very qualities make the performance playful and pleasurable.

The relationship to popular and folk performance may be found in the structure of the Happenings as well as in their style and content. What Michael Kirby terms the "compartmented structure" of many Happenings is more like a variety show, vaudeville, or circus than like a well-made play.[12] Like Red Grooms, Al Hansen recalls as a major folk art precedent his childhood backyard theater, in which, with his brothers and their friends, he recycled and domesticated mass media images. He remembers that they "would put on sort of rodeo-circus-western-thriller-product-of-American-movies-play collages." And he suggests that this type of folk source—the illogic of children's play—is responsible for what might appear to be the surrealistic quality of juxtaposed compartments and of stylistic collage in Happenings.[13]

> The different leadership types in the groups of girls and boys doing this would each argue for the kind of thing they had been affected by most recently in the movie houses, so if it was decided to put on a western drama with rodeo overtones, there would mysteriously appear a child who stubbornly insisted on being Charlie Chan with a short chopping axe in the sleeve of his coat, or the phantom of the opera, or Flash Gordon. Whenever anarchy is demonstrated[,] people in the audience who are free souls join in. The whole quality and tone of these theater pieces were much like a happening.[14]

In film, too, the model of folk art practice was alluring, for it allowed wide distribution as well as broad participation. Underground film often cast itself as a folk version of the medium Hollywood had made a mass art. Jonas Mekas titled part of a 1963 column in the *Village Voice* "8 mm. Cinema as Folk Art," and he wrote:

> You know what? It is the 8 mm. movie that will save us. It is coming. You may think I am crazy. But I know people, very talented people, shooting their movies on 8 mm. The day is close when the 8 mm. home-movie footage will be collected and appreciated as folk art, like songs and the lyric poetry that was created by the people. Blind as we are, it will take us a few more years to see it, but some people see it already. They see the beauty of the sunsets taken by a Bronx woman when she passed through the Arizona desert; travelogue footage, awk-ward footage that will suddenly sing with an unexpected rapture; the Brooklyn Bridge footage; the spring cherry blossoms footage; the Coney Island footage; the Orchard Street footage—time is laying a veil of poetry over them.[15]

Even filmmakers working in 16 mm. deliberately adopted the look of home movies; in the works of Ken Jacobs, Jack Smith, Barbara Rubin, Andy Warhol, and others, the film stock was often grainy, unedited, and unevenly lit. Their camera movements were jerky and unpredictable. Takes seemed to be too long or too short. And rather than acting out a narrative, performers cavorted about, often performing for the camera—instead of accepting the Hollywood convention that the lens is an invisible voyeur.

Often these films, like amateur home movies, were silent. Where there were soundtracks, they were laid on separately. And usually these sound-tracks consisted of collages of narration and snatches of popular music that sounded impromptu and homemade. In Ken Jacobs's *Blonde Cobra*, Jack Smith accompanies his previously filmed actions with childlike fan-tasy stories, sings lullabies, and plays his favorite records. And even the audience—instructed in two places to turn on a radio—participates in the making of the soundtrack. In Jacobs's *Little Stabs at Happiness*, there are old songs and silences, and at one point the filmmaker's voice appears on the soundtrack to comment on the action and to reminisce about the people who appear in it. This film, only eighteen minutes long, includes footage with perforations marking the beginnings and ends of film rolls, and each roll records a different activity in a different place. Some of its actions are unusual or bizarre (Jack Smith, for instance, has blue makeup on his nose and sits in a bathtub nibbling on a doll's crotch in between puffs on a ciga-

rette, and later, as The Spirit of Listlessness, he cavorts in a clown suit on a rooftop, playing with a phallic balloon and a mirror). But overall there is a sense of everyday life and a rhythm of aimless, intermittent recording—of a bare light bulb; of a pair of women's feet as she sits rocking; of shadows on the side of a building; of a couple in an alley smoking, drinking tea, and conversing noiselessly; of children playing games on the street. Intensified by the use of an uncontrolled, swinging camera, these desultory moments and awkward shots liken *Little Stabs* to amateur home movies. Bereft of both narrative continuity and the full panoply of production support, and full of uncontextualized private moments, the film seems more like a scrapbook, a photo album, or a diary than the kind of movie usually screened in public.

The activities depicted in these underground films have a home-movie bent even when the "actors" in them are artists rather than ordinary people. For we seem to see these people in their domestic, rather than professional, situations. Stan Brakhage's portraits of his friends, family, and pets were influential here—from *Cat's Cradle* (1959; with Stan and Jane Brakhage, Carolee Schneemann, and James Tenney) to the birth films of his children *Window Water Baby Moving* (1959) and *Thigh Line Lyre Triangular* (1961) to the explicitly titled *Films by Stan Brakhage: An Avant-Garde Home Movie*. In the underground films of the early Sixties, people hang out, dance, eat, drink, smoke, wander around the city, or spend a day in the country.

Warhol, who bought his first movie camera in 1963, filmed a haircut (*Haircut*), a tourist sight (*Empire State*), a friend sleeping (*Sleep*), a friend eating (*Eat*). Not only were these leisure-time activities of the type favored by amateur home-movie aficionados, but the festive holiday ambience of the film screenings resembled home-movie showings at family gatherings. During the long films (*Sleep* and *Empire*) especially, people came and went at their pleasure, napped, chatted, and brought food to share.

Other films also put home-movie style and activities on the agenda. For instance, Gene Friedman's cinedances, collectively entitled *Three Dances 1964*, include members of the Judson Dance Theater workshop doing social dances at an impromptu party in the church gymnasium (*Party*), Judith Dunn improvising in her studio (*Private*), and museumgoers in the sculpture garden at the Museum of Modern Art (*Public*). And although Robert Breer's film *Pat's Birthday*, featuring Claes and Pat Oldenburg and the Ray Gun Players, is a "fiction film"—a scripted performance, with carefully edited takes—it deliberately has the feel of a homespun documentary. To an uninformed viewer, it might appear not even to be a record film of a Happening, but a recording of a real-life series of antics during a trip to the

country, seemingly on the occasion of Pat Oldenburg's birthday, caught on film by one of the participants.

These "artless" art films document the (real or fictional) lives of the artists in their community. The everyday details of their private or social leisure time are put on record. In early Sixties American culture, more leisure time was available to more people than ever before. That the avant-garde celebrated this new fact of life may be seen in the endless stream of images (not only on film, but in performance and visual art) of festivals, holidays, home life, idle hours, and plain goofing off. The sheer quantity and the utterly aimless quality of these images pushes the avant-garde representation of leisure beyond a mere reflection of mainstream culture's new mores. Rather, these images seem to insist on replacing the work ethic with an ethos of pleasurable idleness. Their refusal to participate in the mainstream culture of corporate production and consumption—with its well-defined, separate spheres for work and play, production and reproduction, public and private life, onstage and backstage—set the stage for the dropout culture of the late Sixties.

The values of folk art emerged in the dance world as well. The downtown choreographers did not quote folk dancing per se, as had socialist realist modern dancers (for instance Sophie Maslow in *Folksay*) or the "Americana ballet" choreographers (for instance, Agnes de Mille in *Rodeo* and Jerome Robbins in *Fancy Free*). These choreographers, working in the 1940s, had tapped into a long history of stylizing folk dancing for theatrical use. Rather, the early Sixties choreographers looked for methods and images outside of what had long been a danceworld cliché in order to signal community and artisanal values. For instance, Steve Paxton advocated the direct use of unstylized pedestrian actions as a way to criticize the elitism of both ballet and modern dance and to encourage audiences to find worthwhile their own ways of moving. Walking, in particular, was key for Paxton; for everyone walks, and anyone's way of walking is valid for that person, he has noted.[16] Other methods included the use of games, tasks, and sports—from the rule games and ball games of Rainer's *Terrain,* to the crouches, bumps, and jostling recalling football players in Trisha Brown's *Lightfall.* They also included the use of perfectly ordinary "found" movements from everyday life; the use of social dancing, as in the Twist section of Elaine Summers's *Suite;*[17] and demystifications of the ballet or modern dance mystique—bringing high-art dance back home, so to speak— as in Rauschenberg's *Pelican* (which featured Carolyn Brown on pointe, but dressed in a gray sweatsuit, partnered by two men on roller skates), Fred Herko's underground story ballet *The Palace of the Dragon Prince,*

and David Gordon's "Prefabricated Dance" in *Random Breakfast* (in which the choreographer gave ironic instructions for how to make a successful modern dance).[18]

The values of folk art were especially evident in Fluxus, whose works made use of homemade, humble materials and quoted American folk pastimes and material culture, like play-party games and boxed collections of objects. George Brecht's board games, bead puzzles, rubber stamps, and decks of playing cards, like the boxed and canned works by various other Fluxus artists, were multiples, but of a strange sort. These items were neither the expensive limited editions of high art nor the mechanically produced, identical items of the mass market. Rather, the wooden boxes, tin cans, and brown corrugated papers that contained the various Fluxus works, the idiosyncratic collection of objects in them that made "no two boxes alike," and the objects themselves—mismatched beads and odd buttons, stray Scrabble tiles and mah-jongg pieces, old toys, cards, labels, string, stones, and other ephemera—made these works resemble folk crafts. Fluxus newspapers were more like a cross between a parish newsletter, an advertising circular for a general store, and a neighborhood bulletin board than a mass-circulation tabloid. The newspapers were the medium through which graphic images, photographs, announcements, ads for Fluxus editions and performances, recipes, jokes, and scores for performances were swapped. The found images and wide variety of typefaces in the newspapers mixed old-fashioned Victoriana with ultramodern style.

Fluxus performances often seemed like gently skewed versions of old-fashioned parlor entertainments, sidewalk games, and magic tricks. For instance, Jackson Mac Low's *Piano Suite for David Tudor & John Cage* is a musical composition in four movements.

> (any number of persons may participate in one or more of the movements)
> 1. Carefully disassemble a piano. Do not break any parts or separate parts joined by gluing or welding (unless welding apparatus & an experienced welder are available for the 2nd movement). All parts cast or forged as one piece must remain one piece.
> 2. Carefully reassemble the piano.
> 3. Tune the piano.
> 4. Play something.

Emmett Williams's *Ten Arrangements for Five Performers* reads: "conductor rings bell, performers move about freely. conductor rings bell again, performers freeze and say a single word. this procedure is repeated nine

more times." And George Brecht's *Recipe* gives the following ingredients and instructions:

cloth
paper
match
string
knife
glass
egg
Level cloth.
Place paper on cloth.
Light match.
Extinguish.
Mark paper with burnt match.
Tie at least one knot in string.
Cut string with knife, arranging pieces on cloth.
Place glass, open upward, on cloth.
Place egg in glass.[19]

I will discuss how these works differed from folk art. But first I want to ask why these works—Pop Art, Off-Off-Broadway theater, Happenings, underground films, new dance, and Fluxus—made in the context of a high-art avant-garde art world, were so often likened to folk art. For one thing, often the style of the works—low-budget, deliberately crude, homemade, nonrealistic, small-scale, often humorous or playful, improvisatory, and personal in presentation—invited comparison with the rough-hewn vitality of naive painting, home movies, small-town civic pageantry, and festival occasions. For another, the content of these avant-garde works often recalled that of folk art—life's daily activities and objects, no matter how seemingly humdrum; the body in all its simultaneous grace and grotesqueness; the social life of the community. Finally, even the means of production and the functions of the avant-garde films, artworks, and performances of all kinds seemed folklike: the participants were family and friends; the materials were usually whatever was at hand; often the venues were not official stages or museums, but churches, clubs, lofts, storefronts, even homes; the audiences were local, sometimes learning about the performances through word of mouth; the times were often after-hours; the scale was intimate; and the unpolished amateur style itself invited potential participation by anyone in the community.

Also in these performances and artworks, as in the folk arts rooted in

the communal leisure time of a neighborhood or village, there seemed to be less of a division between private and public life. The filmmaker Jack Smith, for instance, claimed:

> Movies aren't just something like I came to; they are my life. After *Flaming Creatures* I realized that that wasn't something I had photo-graphed: Everything really happened. It really happened. I—that those were things I wanted to happen in my life and it wasn't some-thing that we did, we really lived through it; you know what I mean? And it was really real. It just was. It just was almost incidental that there was a camera around. In other words, if it had happened before the camera was invented, it would have gone on much the same way it did.[20]

In folk performances and home movies, one sees one's family, friends, and neighbors on stage and on screen, but those stages and screens are the spaces of daily life. Similarly, props and costumes are made of familiar ob-jects and materials. The social distance that prevails between performers and spectators in professional theater is diminished, and that seems to make "real life" and "art" intertwine. Framing their work as art made by a com-munity, about the community, for consumption by the community, the avant-garde tried to re-create the powerful social glue of folk expression.

Popular Culture as Urban Folk Art

Perhaps the practice of Pop Art shows why the distinction between folk and popular culture was not sharply made in the Sixties avant-garde. If folk art's material is daily life, then the everyday objects of the urban village were said to constitute a new landscape—made of the objects of commer-cial consumer culture—to recycle. Pop Art assailed the elitist hermeticism of the Abstract Expressionist aesthetic by "letting the world in again." But the world had changed since art last imitated it. And the world was no longer the rural landscape that produced traditional folk art. It was the topography of postindustrial popular culture: fast food, durable consumer goods, sports events, and mass-produced items and images—including not only signs and comic strips, but even fine art reproductions. Popular cul-ture—or the uses people made of it—was sometimes thought to be a new, urban folk culture.

The hallmark of the Pop Art style was the application of commercial art techniques—which Rosenquist, Lichtenstein, and Warhol, at least, had learned from their jobs in the advertising and fashion industries. Commer-cial art was considered by some the first truly democratic, widely accessible

American art. So to use its techniques was thought to be a way to tap into a contemporary and distinctively American urban folk art. Red Grooms's comment is telling: "There's a proletarian feeling about my work. That type of energy and subject matter excites me a lot. And I've always felt a kinship to commercial people."[21]

Andy Warhol, above all, brashly asserted the commercial connection as something to exploit, not as something to apologize for. For example, he criticized Rauschenberg and Johns for using pseudonyms when they worked as window dressers at Tiffany's in the early Fifties. Warhol attributes the seeds of Pop Art to Emile de Antonio, who as an artists' agent found commercial work for painters so that they could earn a living. "De was the first person I know of to see commercial art as real art and real art as commercial art, and he made the whole New York art world see it that way, too."[22] De Antonio, in turn, was friendly with John Cage, his neighbor in Stony Point, New York, and perhaps was influenced by Cage's acceptance of all of life as part of art.

Even Warhol's work methods flattened high art and low art into a single pop action. "I had this routine of painting with rock and roll blasting the same song, a 45 rpm, over and over all day long. . . . The music blasting cleared my head out. . . . In fact, it wasn't only rock and roll that I used that way—I'd also have the radio blasting opera, and the TV picture on (but not the sound)—and if all that didn't clear enough out of my mind, I'd open a magazine, put it beside me, and half read an article while I painted."[23] Although Warhol does not mention the Surrealists, his methods recall not only their urge to create automatically, but their fascination with earlier popular culture.

Folk Art Makes a Community

As we have seen, the groups that constituted the Greenwich Village avant-garde constructed themselves as a community. Since folk art may be defined as the art that a community makes for itself, perhaps it seemed to them that to make art that somehow resembled folk art could work backward, as an index of potent, productive communal bonds. That is, if community implies folk art, then to have what looks and feels like folk art must, in part, constitute community. In the paradox of avant-garde folklore, folk art was thought to create communal bonds, rather than vice versa.

Oddly enough, while the folk music scene in Greenwich Village was exactly contemporaneous with the avant-garde community, the two worlds did not overlap. The avant-garde attraction to folk art did not include straightforward celebrations of traditional folk culture. Rather, it bor-

rowed styles of folk expression for its own community-building purposes.

Although the rhetoric extolling folk art is unmistakable in both the art and criticism of the period, folk art is used in the artworks themselves in diverse ways. Peter Schumann's Bread and Puppet Theater, for instance, performing Christmas and Easter plays and a *Totentanz* at Judson Church, borrowed techniques directly from German folk theater traditions that date back to the Middle Ages. Schumann restored old traditions, but, transplanting them to a new context, he changed their meaning. They became subversive, stressing the power of the common man over absolute divine power.

In Ron Rice's film *The Queen of Sheba Meets the Atom Man,* on the other hand, Taylor Mead and Jack Smith quote folk art traditions ironically when they cavort in folkish little dances that are in no way meant to be authentic, but that nevertheless *are* meant to signal their characters' spontaneity and "naturalness"—i.e., their supposed folk qualities.

The entirely new genres of Happenings and Fluxus performances are a third aspect of the urge toward folklore. They are "new traditions," inventions that borrow from a mix of older sources, including circus, silent films, play-party games, and other folk and popular entertainments; yet they appear not as continuations or adaptations of those particular traditions, but as new manifestations of art with familiar elements.

The recycling of folklore styles and genres fit with the democratic ethos of postwar liberalism, but at the same time it undercut the values of mainstream art as well as those of folklore collectors. The avant-garde's "folkishness" was strident, rather than quaint. Their works were based on urban culture rather than rural culture. And they were awkward, messy, body-oriented, very much of the present, not neat and antiquated.

By 1963 Pop Art paintings in uptown Manhattan galleries and museums were selling for thousands of dollars. It is difficult to see how, as Seckler claims, they could by any means be considered folk art—even if one grants that the commercial art techniques used by the artists are derived from a modern version of "industrial folklore" and hence lie outside the fine art tradition. Perhaps the unofficial film screenings, unlicensed theater clubs, street events, and various occasions at George Segal's farm are better candidates as folk performances. Still, even these events constituted a different kind of folk art than small-town Fourth-of-July parades or actual naive painters. For often they were performances and objects made by artists who "knew better" but, for one reason or another, deliberately chose humble means and methods.

This avant-garde "folklore" was quite different than that of the Old Left

and Popular Front artists of the Thirties and Forties, who nostalgically lionized American vernacular culture for the purposes of working-class solidarity, but who translated folk material into their own familiar forms of "high art"—realist drama, visual art, and modern dance—and tried to bring this high art, in turn, to the masses. The Sixties avant-garde did not mean to proselytize for high art, but in a neoromantic spirit to plunge directly into what appeared to be a route to unfettered vigor.

For the artists' prizing of the "natural," the "authentic," and the child-like, as well as their criticism of the state and its institutions, has deep roots stretching back to Jean-Jacques Rousseau's *Confessions*. Their celebra-tion of innocence and their use of "primitive" forms recalls the visions of William Blake. Like William Wordsworth, they tried to incorporate "the real language of men" in their art. And they, like the early Romantic art-ists, were considered bizarre by their contemporaries for seeing beauty in the commonplace. But the Sixties artists, living in a postindustrial, high-technology universe, had an entirely different relationship to nature than the early Romantics. Both nature and culture had utterly transformed since the eighteenth century.

The Sixties avant-garde version of folklore was a reappropriation of the notion of traditional community expression for a new, invented commu-nity. In this context, "tradition" no longer referred to a continuous, shared tradition. Further, the art that a community makes for itself takes on a dif-ferent meaning when that community is a self-selected fellowship of artists who originally come from a variety of local traditions. In terms of artis-tic practice, those artists were more interested in the disruption than the persistence of their own shared tradition—the high-art heritage. In this respect, they were carrying on the Romantic tradition. If they turned to folk and popular traditions, it was not for their conservative values, i.e., for their authority, derived from longevity and social convention. Rather, it was because, for these first-generation postmodernists, these were semi-otically potent alternative sources to be plumbed. For folk and popular art as genres had a specific meaning that was appropriate to Sixties avant-garde art. They were antihierarchical, antiprofessional, and egalitarian. In the context of post-World War II America and its arts institutions, these genres were transgressive means to exalt the ordinary.

In the name of democracy and community these artists deliberately bucked the tide of professionalization in their chosen fields of art. They used professional techniques from the *wrong* traditions, as in James Rosen-quist's billboard formats, Yvonne Rainer's use of strippers' bump-and-grind routines, or Kenneth Anger's found-footage of religious films. Or

they re-amateurized professional techniques—as when Fred Herko appropriated ballet in his underground dances; when Robert Dunn made fake electronic music with live human voices in his accompaniment to Judith Dunn's dance *Index;* when Andy Warhol meticulously hand-painted Brillo cartons; when various filmmakers underexposed or overexposed their film and blurred their images; or when Fluxus appeared at Carnegie Hall in tuxedos, carrying French horns, but "played" them by leaning over to drop hundreds of ping-pong balls onto the stage, recalling Dada's earlier attacks on bourgeois expectations. Ironically, one way to disrupt the tradition of the genteel elite arts was to try to reinstate another tradition—raucous, literally profane, folk art. Hence, Pop Artists could feel triumphant, not insulted, when Max Kozloff complained that Pop Art—together with its audience—was vulgar. "The truth is," Kozloff wrote, "the art galleries are being invaded by the pin-headed and contemptible style of gum-chewers, bobby soxers, and, worse, delinquents."[24] To be delinquent was exactly what the new generation of avant-garde artists desired.

The work of an artists' community need not be categorized as folk art. In the early 1950s the Living Theater, for instance, was a nucleus for a group of young avant-garde artists in various fields—music, painting, poetry, and dance, as well as theater. The members and friends of the Living Theater sometimes slept in the theater or in the directors' apartment, congregated at the San Remo bar, and sewed costumes at the last minute; and the Becks held postperformance parties for the audience at their home. Yet the aspirations of the Living Theater at that time remained literary and poetic, in the realm of high culture. Judith Malina, acknowledging her circle as a community, still called the opening program at the Cherry Lane Theater "An Evening of Bohemian Theater"—not at all invoking folk performance, but rather, an elite circle. When the Becks did several performances in their living room on West End Avenue, the atmosphere was that of a modernist intellectual chamber theater, not a kids' recreation room (as it would be in the Caffe Cino). The group *was* a community of sorts, as were the Abstract Expressionists, but its art was highbrow and esoteric.[25]

By the Sixties, things had changed, even for the Living Theater. To be highbrow now was to be old-fashioned, pedantic, and rarefied. It recalled the Eisenhower Fifties, a generation grown old before its time—corporate, anxious, and slickly professional. In the Sixties, to make a new version of folk art seemed, given the democratic ethos of both mainstream and avant-garde, first of all, possible (in ways that, in the 1990s, we would find impossibly transhistorical and transcultural). It also seemed a refreshingly simple and "authentic" alternative to the previous generation's art.

In using both the impersonal techniques of commercial art and the anony-mous quality of traditional folklore,[26] the Sixties avant-garde sought an art rinsed clean of the previous generation's excesses of personality.

Like the students-turned-farmers of the Kennedy administration's Peace Corps and the grass-roots political organizers in the civil rights and peace movements, increasing numbers of young artists joined the avant-garde art world—empowered by the egalitarianism of the volunteer ethic. They may not have served the appropriate, traditional apprenticeships or followed all the rules of the profession. But they soon discovered that they could make their own rules, and that the terrain of artmaking was there, wide open, for the taking. The country's brash confidence was mirrored in a generation of young artists who felt it was their right and their privilege to enter and participate in that formerly patrician terrain, the world of art. They did not need to be authorized or patronized when they could, as Ellen Stewart put it, "have a pushcart of their own." Rising expectations, created by—and surpassing—the skyrocketing of economic and cultural conditions, gave birth to art that flatly asserted the democratic yet disturbing principle of leveling. If folk art is the art of the community, it is also the art of the ordinary, proclaiming the democratic principle of equal rights. Thus, to embrace folk art in the early Sixties should have been an exemplary artistic gesture, given the pluralist liberal ethos of the Kennedy era. But in fact, to embrace "low" art was also to *épater le bourgeois,* despite high art's history of absorbing previous such shocks into the mainstream. To see why the use of folk and popular culture was still so shocking to the Establishment and yet was deemed so politically appropriate by the avant-garde, we need to unravel, briefly, some of the debates surrounding folk, popular, mass, and high culture in the Fifties.

The Shock of Schlock
In the years following World War II, various American intellectuals—faced with the stunning increase of postwar leisure time for middle and work-ing classes and the parallel expansion of technology, mass media, and the American entertainment industry—addressed what they saw as the "prob-lem" of a rapidly mushrooming American mass culture. Like the theorists of the Frankfurt School in Weimar Germany, American intellectuals under-stood that mass culture was the new culture of the modern era, and they saw its analysis as an important—perhaps *the* most important—social-political task for cultural theorists. Many of the American critics saw popu-lar culture in the same harsh terms as the Frankfurt School: as an opiate that dulled working people's senses, making them susceptible to the kinds

of demagoguery that had led to fascist and communist regimes in Europe. So at the same time that avant-garde artists were discovering the affective power of popular culture, they came into conflict with a generation of critics who found it loathsome.

The group known as the New York intellectuals, in particular, worried about the role of mass culture in a democratic society and, conversely, about the possibility of democracy in a mass society whose tastes and beliefs are formed by the mass media. In the pages of journals like *Partisan Review, Commentary,* and the *New Republic,* and in anthologies like *Mass Culture: The Popular Arts in America,* the definition as well as the flaws and possibilities of popular culture were urgently debated. While these debates were at their peak in the late Fifties, they remained lively issues in the early Sixties.[27] In fact, *Mass Culture* was issued in paperback in 1964, as was Norman Jacobs's anthology *Culture for the Millions?* and Stuart Hall and Paddy Whannel's *The Popular Arts: A Critical Guide to the Mass Media.*[28]

It is important for an understanding of Sixties art to examine some of the theoretical debates surrounding popular or mass culture. For although the artists considered here did not take part in them directly, the debates set the context for the emergence of Pop Art and its parallel movements in the other arts. By adopting techniques, styles, and materials from the mass media, popular entertainments, and folk arts, the artists validated forms that critics like Clement Greenberg scorned. In turn, Greenberg, Max Kozloff, and others disdained Pop Art and its equivalents in theater, dance, and film. Thus, the turn to pop culture on the part of the artists must be understood as a complex gesture. It was not only a gesture of celebration, a zesty populist encomium to a newly reborn United States, independent of European high culture, rediscovering its own history of indigenous arts. Nor was it simply a gesture of democracy, an egalitarian urge to level cultural strata. It also was one of resistance and dissent, a historically conscious and deliberate slap in the face to the custodians of high culture, an act of setting the stage for a new avant-garde generation's values in opposition to the old. The artists changed the terms of the debates about high and low culture by mixing these previously starkly opposed categories.

For the most part, the historians, sociologists, art and literary critics, philosophers, writers, and other theorists of American culture—people like Hannah Arendt, Leo Lowenthal, Edward Shils, James Baldwin, Clement Greenberg, and Dwight Macdonald—writing in *Mass Culture* and *Culture for the Millions?* hold both mass art and mass audiences in contempt. They find popular or mass culture morally as well as aesthetically bankrupt,

a product of advanced capitalist consumerism foisted on an unthinking, passive populace—nothing but "spurious gratification."[29] They fear mass culture as a potential course of international relapse into fascism. Their rhetoric is one of pathology; mass culture is a disease of the social body.[30] And they find mass audiences too vulgar to know better than to consume such unsatisfactory goods—unable to appreciate Art (Culture with a capital C). Some—like Randall Jarrell, Arthur Berger, and James Johnson Sweeney–speak of the "plight" of the creative artist in the face of mass society—for who can resist the blandishments of broader audiences and higher pay, even at the cost of diluting one's art? Where they are optimistic about the mass media, many, like Stanley Edgar Hyman, locate their hope in the possibility that mass audiences will be intellectually uplifted by the wider distribution of the products of high culture through the broadcast media of radio, television, and magazines.

Despise mass culture as they might, these cultural critics could not ignore it. In the Fifties, to take some kind of stance on the "problem" of mass culture was, they considered, an absolutely pressing intellectual task; as Hannah Arendt put it, "mass culture is the culture of a mass society. And mass society, whether we like it or not, is going to stay with us into the foreseeable future."[31] The new postmodern art movements of the early Sixties—and their successor postmodernists in the Eighties—ensured that mass culture would be on the agenda for any discussion of art over the next three decades.

But mass culture and high culture were not the only two terms possible in analyzing the stratification of culture. In the debates of the Fifties and Sixties, there are at least three models for conceptualizing culture, dividing it into two, three, or four strata. While some critics treat the oppositions between the "high" and the "low," others propose a multitiered spectrum or hierarchy of cultures. I want to look at some of these models to show how the term "popular" in regard to art or culture shifts meaning. This, may shed some light on the problematic issues raised by the term Pop Art itself, as well as by the rhetoric of popular and folk art that the avant-garde consistently used.

In "Comments on Mass and Popular Culture" historian Oscar Handlin makes distinctions between two types of "low" culture: what he sees as artificial, soulless mass culture and authentic, vital popular culture (the latter he also calls folk culture or unofficial culture). He argues that when the bureaucratized mass media swallowed up "popular" (that is, folk) art (and high art along with it), the connection between audience and artist was destroyed, along with the artist's responsibility and the audience's

freedom of choice. Unlike the high art of official culture, popular art, for Handlin, was above all characterized by two aspects. The first was its functionalism. "Popular songs were to be danced to, vaudeville to be laughed at, and embroidery to be worn or cover a table." This functionalism made popular culture authentic, where high culture was artificial. The second was its intense connection between artist and audience (which the coming of mass culture destroyed).

> Popular culture, although unstructured and chaotic, dealt directly with the concrete world intensely familiar to its audience. There was no self-conscious realism in this preoccupation with the incidents and objects of the everyday world. Rather, this was the most accessible means of communication. . . . The very character of the popular theater, for instance, in which the spontaneous and the "ad lib" were tolerated, encouraged a continuous and highly intimate response across the footlights. So too, the journalism of American ethnic sub-groups maintained an immediate awareness of the needs and problems of their readers. . . . The writers and actors sprang from the identical milieu as their audience did, and maintained a firm sense of identification with it.

The resonance with the avant-garde rhetoric extolling Greenwich Village community life is unmistakable.

Perhaps unaware that a new avant-garde was turning once again to folk and popular elements, Handlin notes the appeal that popular culture had to the early twentieth-century avant-garde, which had seen that "millions of people found in [popular] culture a means of communication among themselves and the answers to certain significant questions that they were asking about the world around them." The historical avant-garde, "repelled by the inert pretensions of official culture, often found refreshing elements of authenticity in the popular culture of their times. Bohemia, too, was a kind of ghetto in which the artist, equally with the Italian or Negro laborer, was alien, cut off from respectable society."

In Handlin's account, high culture—with its canons, durable objects, and official histories—endured where popular nineteenth-century culture perished, because high culture could resist the distortions of the mass media more easily than unofficial, popular culture, which "was all but obliterated." What disturbs Handlin about mass culture is not the content or origin of the art communicated by the mass media, for it can consume art from either high or low origins. After all, "Euripides and Shakespeare can

perfectly well follow the Western or quiz show on TV, and the slick maga-
zine can easily sandwich in cathedrals and madonnas among the pictures
of athletes and movie queens."[32] Rather, it is the *way* in which the mass
media communicate—purveying irrelevant material to a passive audience
that has no rapport with the creators of it—that corrupts everything the
media touch. Hence, mass culture is not a continuation of popular or folk
culture, but a degradation of it.[33]

The Sixties avant-garde seized on this tendency of mass consumer cul-
ture to purvey *everything* in a promiscuous mélange, but they saw it as
liberating, not deadening. The artists translated the omnivorousness of
mass media into collage techniques that, like Surrealist juxtapositions,
were meant to release the imagination. James Rosenquist's paintings—
with their hard-edged, air-brushed imagery and their layers on layers of
dissimilar media representations—are billboardlike but also resemble the
chaotic welter of television images. Robert Whitman has said that his in-
spiration for the compartmented structure of his Happenings came from
watching television variety shows as a child.[34] Some artists even seized
on television itself as part of the artwork—like Nam June Paik and Wolf
Vostell, with their disruptions of the television signal, and Tom Wessel-
mann, who lodged a live TV in the canvas of his *Still Life #28*. Television
provided material as well as method for art.

If Handlin wants primarily to distinguish stultifying mass culture from
what he sees as earlier, vital forms of folk or popular culture, Clement
Greenberg in his classic essay "Avant-Garde and Kitsch" takes a much dif-
ferent approach in separating mass culture from high art. For Greenberg,
mass culture is simply kitsch (the German word for trash). Kitsch is the
"rear-guard," the underbelly of culture that accompanies the modern phe-
nomenon of the avant-garde. The avant-garde, which began in the late
nineteenth century as a quasirevolutionary social formation, soon found
that it was dependent on bourgeois patronage to survive. Separated from
the public domains of both mainstream culture and revolutionary politics,
it turned inward, "in search of the absolute," becoming more and more ab-
stract and making "art for art's sake." For Greenberg, the historical shift to
and function of the avant-garde is that—unlike realistic art, which imitates
the world—it serves as an "imitation of imitat*ing*," a formalist critique of
the disciplines and processes of art itself. Hence, the avant-garde is inevi-
tably part of elite culture, inaccessible to the masses (who have neither the
time nor the training to understand it), and therefore reliant for support
and appreciation on "the rich and the cultivated." But, unlike past histori-

cal art formations, the twentieth-century avant-garde is no static instance of Alexandrianism; the avant-garde is necessary, on Greenberg's account, for only it keeps "culture *moving*."

On the other side, Greenberg argues, along with the modern industrial age and the avant-garde came universal literacy and kitsch. Kitsch (which includes popular, commercial, and mass art) is not true culture, but "ersatz culture" that (like a vampire) has sucked the lifeblood of genuine high culture, wiped out folk art, and (more like a virus) has infected the entire globe. Kitsch arose in response to the needs of an urbanized industrial proletariat, which, having gained a modicum of literacy without the leisure necessary for elite cultural training, repudiated the oral traditions of rural folk culture but, "discovering a new capacity for boredom. . . . [were] hungry nevertheless for the diversion that only culture of some sort can provide." Kitsch is the culture of consumption, easily digestible since it is already predigested; it is formulaic and parasitic on the techniques and discoveries of high culture. Its raw material is "the debased and academicized simulacra of genuine culture. . . . vicarious experience and faked sensations. . . . Kitsch is the epitome of all that is spurious in the life of our times." Furthermore, unlike the avant-garde, which challenges sterile academicism in art, kitsch is actually the "front" for academicism in art, masquerading as high culture and seducing avant-garde artists with its profits. Further, kitsch poses as folk art, but it is not, for kitsch can only arise when "the methods of industrialism displace the handicrafts."

Into which category would Greenberg have placed a work like Kenneth Anger's *Scorpio Rising*? If Greenberg's analysis of avant-garde and kitsch is applied to the film, the result is neither fish nor fowl. The film, more or less about the preparations for and denouement of a motorcycle drag race, is a narrative. But it is fragmented rather than linear, structured in thirteen episodes accompanied by as many rock songs. As P. Adam Sitney has pointed out, the editing technique is that of rapid montage, and the form of the film, with its autonomous "numbers" (presaging MTV in the 1980s), owes more to early film serials than to the unified narratives of Hollywood.[35] Still, the film quotes standard Hollywood genres, in particular the motorcycle movie. It uses footage taken from a religious film about the life of Christ. And the scene in Scorpio's room, in particular, is rich with references to popular culture of all kinds, from television to comics. But out of all these ingredients from popular culture a difficult, ambiguous work is fashioned, with multilayered meanings partly arising out of its juxtapositions and split-second editing. At times, the camera seems to caress the motorcycles lovingly; at times, the image contrasts with the lovelorn lyrics

of the songs in a derisively comic mode. Does Anger celebrate motorcycle culture, comparing Scorpio to a mythic, charismatic, Puckish figure? Or does he criticize the demonic leader who waves the motorcyclists on to their death and consumes a generation of youth in a puff of smoke? Scorpio is a fusion of Christ and Hitler. It is a sign of *Scorpio Rising*'s postmodernist ambivalence that it refuses a single interpretation and a unified moral stance, mixing avant-garde and kitsch cultural modes.

For Greenberg, only two levels of culture exist in mass society: the living but difficult culture of the avant-garde, which is available only to the educated, cultivated, and "sensitive" spectator; and kitsch—"short-cut," imitation art. What is wrong with kitsch is that it traffics in realism. For if art is meant to be separate from daily life, realism dispenses with the artistic conventions that serve as borders between the two domains. Its fondness for narrative and its heightened sense of drama make the meanings of realist art overly transparent. If avant-garde art is difficult because it requires reflection, kitsch already includes within itself the results of such reflection; it is synthetic, predigested art, full of effects, rather than causes. Finally, Greenberg concludes, kitsch is the result of rising egalitarianism, which can all too easily go sour and lead to fascism, for kitsch is precisely the arena where the masses can express their social malaise by attacking elite culture.[36]

Greenberg's essay is often cited for its strongly negative position on mass culture. But it also contains the roots of his formulation of artistic modernism in two crucially intertwined components, for the repudiation of all contemporary popular culture leads Greenberg to place a high premium on formalism, above all, in high art. Popular culture stands for sensual pleasure, consumption, passivity, ease of interpretation, realism, and narrativity. The avant-garde equates formalism with intellectual pleasure, interaction, activity, difficulty of interpretation, and abstraction.

Given his views on modernism, abstraction, and the optimal distance between the artwork and humdrum daily life, it is not surprising that Greenberg and his cohort reviled Pop Art as the latter-day embodiment of kitsch. Greenberg wrote, for instance, that it was "diverting" but "superficial," and he concluded that "it amounts to a new episode in the history of taste, but not to an authentically new episode in the evolution of contemporary art."[37] Peter Selz wrote in *Partisan Review* that Pop Art merely celebrated the status quo and, furthermore, "cater[ed] to infantile personalities capable only of ingesting, not of digesting or interpreting." In fact, these critics describe Pop Art itself in the exact terms they use for mass culture, as if the two were identical. Selz concludes that Pop Art "is as

easy to consume as it is to produce and, better yet, is easy to market, because it is loud, it is clean, and you can be fashionable and at the same time know what you're looking at." With Pop Art, he charged, the art market had descended to the level of mass consumer capitalism by "[introducing] the great American device of obsolescence into the art world."[38] But, of course, Pop Art was not at all the same as popular culture. It was actually yet another manifestation of the avant-garde's historical fascination with "low" art, and it quoted popular culture to comment on it—although not always negatively.

Sociologist Edward Shils disagrees with cultural theorists like Greenberg and Macdonald who claim that mass culture has destroyed "superior" culture. Rather, he sees in "superior" culture's decline—or rather, its failure to flourish in the United States—the imprint of American "puritanism, provincialism, and specialization." Another cause is the lack of a true community of intellectuals, coupled with the philistinism of the rest of the American elite. Finally, he concludes, the prospects of mass society itself need not be threatening if intellectuals pursue their responsibilities in continuing to produce "superior" culture and in bringing it to the masses. This is the "process of civilization" that he recommends, "the expansion of the culture of the center into the peripheries of society and . . . the diffusion of superior culture into the areas of society normally consuming mediocre and brutal culture." Thus, for Shils the artist and intellectual are like missionaries at home, civilizing the masses with their art.[39]

But this was a role that the avant-garde artists of the early Sixties rejected. For they saw in popular culture an enviable energy that was lacking in the correct, difficult, (old) avant-garde art that Greenberg championed. Instead of going down from Olympia to enlighten the masses, they wanted to bring the insights, skills, techniques, and pleasures of popular culture back home to high art.

Collapsing the Cultures

What is interesting in thinking about the early Sixties avant-garde is not whether Pop Art, Happenings, Fluxus, underground film, café theater, or new dance would be better categorized, strictly speaking, as folk art, as popular art, as mass art, as kitsch—or as high art. What matters is that those categories, which Fifties intellectuals were at such pains to elaborate, were deliberately collapsed by the Sixties avant-garde. The desire to dissolve those distinctions is in itself striking, for it signals once again the avant-garde refusal to accept the bourgeois version—even, in this case, the liberal, progressive bourgeois version—of good taste, as well as of cultural

history. The palimpsest of folk culture was self-consciously reinstated, but this time it included layers of recent popular, mass, and high culture.

For instance, in *The Queen of Sheba Meets the Atom Man,* Taylor Mead and friends read fanzines and pulp novels, sell poetry on the street, and put on a living-room folk version of *Hamlet* copped from Laurence Olivier's movie version of Shakespeare. Robert Rauschenberg mixes fine art reproductions with duplications of mass media imagery in a number of works. Roy Lichtenstein reworks Picasso, comic-book style, in *Woman with a Flowered Hat.* And in Tom Wesselmann's still lifes and nudes, not only are the genres and themes of the Great Masters quoted, but prints of their works often hang on the walls in the thoroughly pop interiors that the artist pictures.

Yet striking, too, is the desire by artists and critics to certify this particular avant-garde—exactly by means of collapsing these distinctions— simultaneously as traditional, as democratic, and yet as despised and marginal. They seemed to say, contra the Fifties "bread and circuses" analysis of popular art as a symbol of social decay,[40] that the two traditions in American art were not high and low, but the artificial and the genuine, the Establishment (whether that of the museum or the television network) and the anti-Establishment.

With their Romantic aspiration to the "authentic," they felt free to mobilize every means from every "level" of culture—avant-garde to kitsch, "superior" to "mediocre" to "brutal." They reclaimed for their own purposes not only the techniques and media, but also the spaces of *both* the unofficial and the official, the despised and the authorized traditions—lofts and Carnegie Hall, storefronts and art museums, roller skating rinks and universities. Their instinct was to create an egalitarian meeting place of culture where high and low met on a two-way street. This stood in opposition to a liberal, upwardly mobile cultural "melting pot" that would patronizingly raise all audiences up to appreciate high culture.[41] Their project challenged the Greenbergian formalist idea that art should remain separate from everyday life. In fact, they embraced the quotidian as the most appropriate material and form for art.

4

Equality

For a number of reasons the incorporation of folk and popular arts was a vital strategy for democratizing the avant-garde in the early Sixties. Folk arts—intended for humble purposes and humble audiences, and made by community members for communities—invoked the traditional American value of equality, expressed through community-building, that preoccupied avant-garde culture during this period. On the other hand, the broad dissemination and intellectual accessibility of popular arts—mass forms made by professionals to cater to a variety of local communities' tastes and values—served the Sixties avant-garde as another route to equality. Both of these cultural strata challenged the values of elite culture. So by promiscuously embracing and transforming both folk arts and popular entertainments, the avant-garde seemed to believe that it would perforce

make art familiar and accessible to all, both in the doing and receiving. In this way it could advance political ideals, showing the hypocrisy of a society where equality had not, in fact, been achieved, while breaking with mainstream art conventions. That the raising of traditional political values seemed transgressive pointed up that in reality they were not being upheld.

Equality of opportunity to show one's art was one of the purposes for founding the alternative institutions described in chapter 2. In venues like the Film-Makers' Showcase, Judson Dance Theater, Caffe Cino, and Flux-hall, at least in theory the chance to appear on a program was open to all. The frequency of programs in these venues meant that there was adequate demand for a steady supply of artworks. Thus, equality was effected in part by reducing competition and selection. Part of the point of community-building was to create opportunities to show works and, in a democratic spirit, to spread them to the widest number of participants. Whenever that sense of equal sharing and presenting—without juries, without hierarchies, and without stars—was threatened, tensions and conflicts arose.[1]

But the desire for equality was not only an institutional matter of equal rights and opportunities for artists. The artworks themselves expressed a more generalized urge to extend and apply in every arena demands for equality, paralleling the demands that the civil rights movement had placed high on the national political agenda. Through the elements of style—their chosen media, genres, subjects, forms, structures, and materials—artists gave the drive toward equality a variety of shapes. In doing so, in fact, they were not so much celebrating an American value or reflecting the reality of American society; rather, they sought to change that reality by construct-ing models for the equality that they found was actually lacking in the culture at large. In other words, to invoke the traditional value of equality was, ironically, to challenge the status quo.

In chapter 3 I discussed the leveling of high and low cultures in these early postmodern works and institutions. This was a symbolic action that was thought to be one way of actually producing a new, democratic culture, accessible to all—bourgeois, bohemian, and underprivileged alike—both economically and intellectually. In this chapter I want to analyze various other tactics for democratic parity, focusing on three stylistic expressions of the insistence on equal rights—leveling differences, the authorization of the ordinary as content for art, and radical juxtaposition as a preferred structure.

First, however, it is necessary to note one aspect of the early Sixties avant-garde that is painfully apparent in retrospect: despite the rhetoric—both verbal and artistic—of equal rights and equal opportunity, very few

African Americans or other people of color systematically played a part in most of its arenas (the Living Theater and Fluxus were two notable exceptions). In chapter 5 I will return to this issue in discussing the theme of freedom.

However, I should note here that in examining the theme of equality, it is crucial to realize that for this predominantly white avant-garde of the early Sixties, the notion of equality was a generalized one and did not particularly focus on racial equality (although as we will see, that theme was sometimes present). Racial equality, that is, was not a paramount theme, although concerns about it permeated the political life of Greenwich Village and influenced the direction of the avant-garde in indirect ways. Rather, where the theme of racial equality appeared, it was seen as part and parcel of a class-focused issue of democratic access for all and a leveling of political hierarchies for all. Also, although equal rights were the demand, the civil rights movement often cast itself symbolically as a freedom movement.

The white avant-garde's preoccupation with egalitarianism reflected many of these artists' own experience of entering the hitherto upper-class world of high art en masse. To be sure, at times they perceived an affinity between their own situations and that of African Americans, and many of them were sympathetic to black social movements and to black artists, as well as, in some cases, to African American forms of art. They danced black social dances and listened to black popular music, and this had an impact on their aesthetic values. Sometimes these white artists even incorporated explicit civil rights claims in their own work, or the work they organized. Some were politically active in civil rights organizations. But on the whole, their own forms of symbolic leveling were first and foremost expressions of their own situation—that is, their aim was the democratization of the avant-garde in terms of class, and sometimes gender, but not race or ethnicity.

Equality Levels Differences

In dance, Merce Cunningham's practice had already metaphorically leveled hierarchies in terms of the body, the stage space, and phrasing. Chance techniques dictated that no longer could one part of the body or area of the stage claim privilege over another, and no particular moment had an automatic "right" to be framed as a climax. The dancers who came after Cunningham were even more drastic in their desire for egalitarianism, however. Some felt that in Cunningham's work a sense of social hierarchy still persisted. Cunningham himself and Carolyn Brown, for instance, were

usually the featured performers. A number of younger choreographers were concerned with establishing in their dances images of community, specifically of a community of equals onstage. Yet they wanted to do so without recourse to the kinds of symbolic images used by earlier modern dance choreographers—for instance, Doris Humphrey in her well-known utopian works, such as *New Dance* and *The Shakers*. In Rainer's *Terrain* the cult of personality was undermined when certain dancers were singled out—but only temporarily—by the addition of white T-shirts or blouses to their black leotards and tights.[2] The use of an undifferentiated ensemble and shifting leadership was key to many Judson dances. Rainer's *We Shall Run* has been discussed in chapter 2; in Elaine Summers's *Dance for Lots of People,* a mass dance for fifteen people that looked like a silent communal ritual, the dancers formed human clumps out of which soloists emerged to gesture momentarily, only to be drawn back into the group.[3] Although the look of the performers in a Judson Dance Theater performance might deliberately range from highly trained to untrained, there was no hierarchy based on technical ability. In other words, in theory at least, there were no stars. There may have been differences, but there was equal opportunity for all.[4]

In the visual arts Andy Warhol developed a double-edged attack on the "star" mystique. His homegrown crop of underground "superstars," created through his screen tests and "home movies" at the Factory, were one side of this critique; his silk-screen multiples of real stars like the Marilyn, Liz, Elvis, and Marlon series (1962–64) were the other side. Both were ways to mass-produce notions of glamour, stardom, and fame—with deadpan satire. The Factory films and superstars constituted a folk aspect of stardom, in which an alternative, grass-roots, underground Hollywood was constituted at a fraction of Hollywood's economy and scale of operation. Anyone stumbling into the Factory scene was incorporated into the mystique. Stardom was mass-produced here in the sense that it was available (although in an alternative arena) to almost anyone. Yet the multiples of actual Hollywood and popular music stars constituted a popular culture aspect of stardom in which people become icons and seem only to exist in multiple, mass-produced images.[5]

The ultimate in the democratization and mass production of stardom was Warhol's notorious assertion that "In the future everybody will be world famous for fifteen minutes."[6] For Warhol, the unprecedented equalizing impulse of the Sixties was a definite political statement, a desire to level class differences. His group lived the fantasy that they had entered a

utopia where these gaps were, in fact, erased. "In the 60s everybody got interested in everybody else," Warhol wrote. "Everybody was equal suddenly—debutantes and chauffeurs, waitresses and governors." This was a totally reimagined culture. It was an atmosphere in which a working-class girl from New Jersey (who later ended up as a sewing machine operator) could temporarily reinvent herself, under Warhol's auspices, as "Ingrid Superstar," actually living out the American myth (fostered by Hollywood and the fanzines) of a magically effortless rise from rags to fame and fortune.[7]

Fluxus also criticized the reigning art world hierarchy. As George Maciunas charted it, Fluxus Art-Amusement had a democratizing effect that would counter the deadlines of high art.[8] Fluxus, that is, wished to remove

ART	FLUXUS ART-AMUSEMENT
To justify artist's professional, parasitic and elite status in society, he must demonstrate artist's indispensability and exclusiveness, he must demonstrate the dependability of audience upon him, he must demonstrate that no one but the artist can do art.	To establish artist's nonprofessional status in society, he must demonstrate artist's dispensability and inclusiveness, he must demonstrate the selfsufficiency of the audience, he must demonstrate that anything can be art and anyone can do it.
Therefore, art must appear to be complex, pretentious, profound, serious, intellectual, inspired, skillfull, significant, theatrical, it must appear to be valuable as commodity so as to provide the artist with an income. To raise its value (artist's income and patrons profit), art is made to appear rare, limited in quantity and therefore obtainable and accessible only to the social elite and institutions.	Therefore, art-amusement must be simple, amusing, unpretentious, concerned with insignificances, require no skill or countless rehearsals, have no commodity or institutional value. The value of art-amusement must be lowered by making it unlimited, massproduced, obtainable by all and eventually produced by all. Fluxus art-amusement is the rear-guard without any pretention or urge to participate in the competition of "one-upmanship" with the avant-garde. It strives for the monostructural and nontheatrical qualities of simple natural event, a game or a gag. It is the fusion of Spikes Jones, Vaudeville, gag, children's games and Duchamp.

itself from the historical avant-garde's repeated pattern of entry into mainstream art, which many saw as another version of consumer culture whose competitions and hierarchies turn artworks into expensive commodities. But ironically, only an avant-garde movement in this historically charged moment could have chosen to present itself as rearguard. For "real" kitsch on the Greenberg model would never acknowledge itself as such, let alone celebrate its will to "insignificance," lack of skill, and worthlessness.

If one way to attempt to achieve equality by leveling differences was to obliterate the star system, another was to celebrate amateurism. The antihierarchical desire to erase differences between professionals and amateurs manifested itself in a number of ways. Artists not only delighted in making work outside their area of training; they also raised deep questions about the merits of the accepted techniques of their chosen fields. John Herbert McDowell and Philip Corner were composers who choreographed; Carolee Schneemann, Robert Morris, and Robert Rauschenberg

were visual artists who choreographed. Steve Paxton and other dancers made music (in Paxton's *Music for Word Words,* a sound-producing action— the deflation with a vacuum cleaner of a plastic room with arms and legs into a costume—was presented as the musical accompaniment to a dance performed the previous evening). Andy Warhol, a graphic artist, and Elaine Summers, a choreographer, turned filmmakers. And various dancers, actors, and designers in Happenings, dances, plays, films, and other performances were often nonprofessionals, or professionals in other disciplines. This was not simply a matter of artists using available resources, although practical considerations partly dictated this principle. But the very choice to consider using nontrained performers was rooted in the egalitarian impulse that claimed value in each person's natural abilities and that refused to give higher status to either side of the footlights or to any one art form. As Taylor Mead put it in regard to theater, "acting went in many directions. . . including out the window."[9] Jonas Mekas advised young filmmakers to "invent cinema from the beginning, as if nobody had done it before you."[10]

Fluxus music undercut technique by using unconventional instruments —for example, Dick Higgins's *Concert Number Ten* (March 1963): "calls for hooks, cowbells, cymbals, drums, incense, whistles, smoke bombs, toys, dogs, tractors, flowers, bees, sunlight, hay, logs, drums, motors, saws and hundred-year-old hand tools."[11]

Even when conventional instruments were used, the Fluxus performer did not necessarily have to know the traditional techniques for playing them. Two 1963 compositions by Robert Watts, for instance, featured brass instruments, but they were not played according to any known musical technique. In *Duet for Tuba,* "Tuba is prepared to dispense coffee from one spit valve and cream from another," while in *F/H Trace:* "French horn is filled in advance with small objects or fluid (rice, bearing balls, ping pong balls, mud, water, small animals, etc.). Performer then enters stage, and bows to audience tipping the bell so the objects cascade out toward audience."[12] Indeed, in these pieces the performer thumbs his or her nose at technique, transgressively misusing the musical instrument. Despite the gentle humor in Watts's subversions, their challenge to the sacrosanct handling of musical instruments was almost as shocking as Nam June Paik's *Solo for Violin* (1962), in which the artist slowly smashed a violin to bits. In this way, dispensing with technique seemed revolutionary.

These antitechnical works, as well as the emergence of the genre of Happenings, conceived as nonprofessional—even antiprofessional—theater, constituted an attack on what was felt to be an increasingly bureaucratized,

professionalized society. This tendency foreshadowed the late Sixties move simply to drop out of professionalism and technique altogether.[13]

A third expression of the desire to erase hierarchical differences was the challenge to the gap between artist and audience. Antitechnique itself was seen as a way to close that gap. The dancer Steve Paxton, for instance, used nontechnical, nondance movements—like walking—to find a common ground between performer and spectator.[14]

At the Caffe Cino and Cafe La Mama, the stages were so small that the play literally spilled into the audience. At the Judson Church, dance and theater audiences in the sanctuary, choir loft, and gym sat only a few feet from the action, which often took up more of the space than the spectators did. These performance situations, like the Happenings in which spectators were led from one place to another or surrounded by the action, echoed Artaud's call in his Theater of Cruelty manifesto for a deeper, more meaningful spectacle that leaves the proscenium stage and its neatly framed, distant imitation of reality in order to envelop the spectator with the immediacy and sensory engagement of sight and sound. "We abolish the stage and the auditorium and replace them by a single site, without partition or barrier of any kind, which will become the theater of the action. *A direct communication will be re-established between the spectator and the spectacle, between the actor and the spectator, from the fact that the spectator, placed in the middle of the action, is engulfed and physically affected by it*" (emphasis added).[15]

Above all, the physical gap between performer and spectator was drastically diminished in Happenings. This was especially the case in those by Allan Kaprow, which grew out of his desire to incorporate the art gallery spectator more directly into his Environments—as initiators, not just witnesses, of artwork/actions. At first, Kaprow recalled, "I gave [the spectator] occupations like moving something, turning switches on—just a few things. . . . I offered him more and more to do, until there developed the Happening."[16] For Kaprow, that is, the very identity of the genre Happenings has to do with the activation of the formerly passive spectator and his or her physical incorporation into the space of the work. Once Kaprow began using performers (that is, people he rehearsed and instructed before the event), the gap was reopened somewhat, but the physical closeness and mobility of the spectators, as well as the fact that Kaprow shied away from using trained actors, helped to vitiate the differences between those taking part in the work and those watching it. Eventually, Kaprow, for both practical and theoretical reasons, moved from involving the audience to doing away with audiences altogether. Participants became both performers and spectators, for instance, in his *Household* (see chapters 2 and 6). When added

to the simplicity of the structures, the elimination of the spectator as a separate role in the performance process further democratized Kaprow's Happenings by making them open to anyone.

At Fluxus performances the audience often was invited to participate. Performances of Alison Knowles's *Shoes of Your Choice,* for example, were completely realized by the audience: "A member of the audience is invited to come forward to a microphone if one is available and describe a pair of shoes, the ones he is wearing or another pair. He is encouraged to tell where he got them, the size, color, why he likes them, etc."[17] Or the piece might be written for anyone to do, whether or not there was an audience. For example, Yoko Ono's score for *Collecting Piece III* shows that an audience is superfluous:

> Break your mirror and scatter the pieces over different countries.
> Travel and collect the pieces and glue them together again.
> You may use a letter or a diary instead of a mirror.
> You may break a doll or an airplane a thousand feet high in the
> sky over a desert.[18]

The same was true of Robert Watts's more manageable *Casual Event:*

> Drive car to filling station
> Inflate right front tire
> Continue to inflate until tire blows out
> Change tire*
> Drive home
> *if car is a newer model drive home on blown out tire.[19]

Precursors to Conceptual Art, these scores projected performances that not only anyone could do, but that totally fused the roles of performer and spectator.

A fourth aspect of leveling distinctions was the urge to blur boundaries between art forms. It almost seemed as if no one field had the moral right to claim precedence or importance over another (as had been the case in academic high art implicitly since Aristotle, and explicitly since Renaissance neoclassical aesthetic theories). One way to avoid gradations was to switch from one's own art form and practice a form not one's own, as described above. But another was to fuse several art forms. Was George Brecht's *Water Yam*—a wooden or cardboard box in which one could find between sixty-nine and eighty Event cards giving instructions for actions—sculpture, poetry, or theater? When the members of the Bread and Puppet The-

ater performed in Peter Schumann's Christmas and Easter pageants, were they musicians, dancers, actors, the bearers of moving sculpture, or religious celebrants? Was Philip Corner's multimedia piece *Flares,* presented at Judson Dance Theater's Concert #8, a dance, a piece of music, a light show, or a painting? Was Elaine Summers's *Fantastic Gardens* film or dance? Was Robert Morris's *Site* dance or painting? Were Robert Whitman's Happenings visual art, film, or theater?

This was by no means the first cultural moment in the West when artists chose to break down boundaries between art forms and when interdisciplinary performance genres emerged. Indeed, many folk and popular entertainment forms mix means. But unlike other instances of the syncretism of genres—during the Renaissance, for instance, when performance was instrumental in producing and affirming hierarchical political structures— here the political context made the fusion of the arts a potent symbol for equality. Other twentieth-century avant-garde movements had broken down boundaries between art forms—notably Futurism and Dada, both important influences on the Sixties artists. But now an interarts union came, for one thing, on the heels of the essentialist modernism of the 1950s (in terms of art history). Thus, it challenged that theory's hierarchical ordering of and separation between media. It also came at the moment in American history when to invoke equality was read as a gesture of inclusionary democracy (in terms of political history). Moreover, the syncretism of art genres had always been part of the African-rooted black aesthetic. The refusal to acknowledge categories and borders between hitherto separate art forms, genres, and media became an assertive stance against the perceived elitism of Euro-American specialist modernism on behalf of a populist, egalitarian integration of all forms.

As we have seen, many of the artists aimed to level differences between artist and spectator, between amateur and professional, and among art forms. Following Artaud, the Living Theater went even further in its desire totally to erase differences between theater and life. This exploration of the gap between art and life also was something that Robert Rauschenberg had called for. The Living Theater's production of Jack Gelber's *The Connection* was Pirandellian in its confusion of frames.[20] Presented as a documentary, which begins with the (fictional) film producer Jim Dunn introducing first the (fictional) author, Jaybird, and then the (fictional) junkies and (real) jazz musicians, and the (fictional) cinematographers who film them, the play intentionally confuses the audience as to the levels of reality it presents.

What is "inside" and what is "outside" the "real" play? When does the play actually begin? What is improvised and what is scripted? Are the

drugs, is the overdose, actual or staged? Jaybird, the putative author, keeps telling the audience that the play is improvised, and he keeps interrupting the production to complain that the action is getting out of control. His seemingly spontaneous interventions, of course, are strictly scripted, as anyone watching the play twice would realize.

According to Julian Beck, "Not once, but often, people requested their money back at the box office because they had not come to see a bunch of people rehearsing; they wanted to see a show, the finished product," and "Night after night, several hundred times in fact, the audience applauded whenever the actor playing the producer . . . said, 'And this is Jaybird, the author of *The Connection*.'"[21]

If realism was the watchword of modernism in the theater, the Living Theater surpassed the realism of illusion by calling for—indeed, by constructing—a postmodern super-realism of concrete fact and anti-illusionism. Beck implies that by embracing life and seemingly putting it on the stage unaltered—not only through the device of a play (or rehearsal for a play) within a play, but also through the use of silences, of real-life timing, of profanity, and, most importantly, of taboo subjects like the drug addicts of *The Connection* and the brutality of the American military in *The Brig*—a new form of realism could emerge. This, he proposed, would be a truer form of realism that showed the reigning American theatrical style of Stanislavsky-derived Method naturalism to be hypocritically full of fabrication. For Beck, this had to do not only with aesthetic values, but with morality and the politics of equality.

> What had been passing for realism was not real. There had to be pauses. Directors had to learn to let actors sit still for a long time in one place as in life, and actors had to learn to adapt to this new idea. There had to be an end to sets with angled walls, the whole false perspective bit. There had to be real dirt, not simulations. There had to be slovenly speech. If there was to be jazz, then it had to be real jazz and not show-tune jazz. If there was to be real speech, then there had to be real profanity; the word "shit" would have to be said, not once but again and again and again until audience ears got used to it. . . . We had to risk embarrassment; we had to risk boring the audience, but it had to be done. . . . It was important to show that [addicts] who . . . were considered the lowest of the low . . . were human.[22]

Equality Celebrates the Ordinary

The recuperation of the ordinary was crucial to the Sixties ethos. The way had been prepared in the Fifties and earlier by the incorporation of mundane sounds, sights, objects, words, and actions by artists like John Cage in music, Robert Rauschenberg and Jasper Johns in visual art, Jack Kerouac and Allen Ginsberg in literature, Merce Cunningham and Paul Taylor in dance, Samuel Beckett in theater, and Joseph Cornell in film and visual art. These artists, in turn, had been inspired by earlier artists like Erik Satie, Marcel Duchamp, Gertrude Stein, and Kurt Schwitters. By the Sixties, however, attention to the everyday had been democratized. It had become a symbol of egalitarianism, and it was the standard stuff of avant-garde artworks and performances.

John Cage's precepts in this regard were seminal for the Sixties generation of artists. As early as 1940 with *Living Room Music,* Cage had used as instrumentation "objects to be found in a living room," and, in other works, flowerpots, beer bottles, tin cans, and his well-known pianos prepared with bolts, screws, and rubber bands. *Imaginary Landscape #4* (1951) called for twelve radios. With *4'33"* (1952), his legendary piece written for the pianist David Tudor, in which "no sounds are intentionally produced," Cage opened the way for a music made entirely of ambient sound. For Cage, this piece stated a moral-political position: all sounds should have equal opportunity to be heard and appreciated. Moreover, Cage's embrace, in the Fifties, of Zen Buddhism, led to a nonhierarchical, nonjudgmental appreciation of dailiness and the commonplace.

In "Lecture on Nothing," Cage accounts for his adoption of inclusiveness and ordinariness in specifically political terms. "I found that I liked noises even more than I liked intervals. I liked noises just as much as I had liked single sounds. Noises, too had been discriminated against; and being American, having been trained to be sentimental, I fought for noises."[23] In extending the concept of human rights to nonhuman elements, Cage set the stage for a quintessentially Sixties attitude toward what might or might not be represented in art, that is, that political justice should be served in representing what had hitherto been excluded—in this case, the ordinary.

Two artists who influenced Cage in the direction of ordinariness also influenced the Sixties avant-garde. These were Erik Satie and Marcel Duchamp. For Cage, Satie's work accorded with the Zen tenets of renunciation and the acceptance of the world-as-it-is. Cage admired Satie's statement that L'Esprit Nouveau "teaches us to tend towards an absence (*simplicité*) of emotion and an inactivity (*fermeté*) . . . , conceived in a spirit of humility and renunciation."[24] Cage felt that Satie's music, like the

works of Duchamp and Robert Rauschenberg, was salutary in introducing emptiness, the banal, and the found object into artistic structure.

As Calvin Tomkins points out, Robert Lebel's 1959 volume on Duchamp, published simultaneously in French and English, introduced a younger generation of artists and scholars to the artist's work and thought. As a result, a veritable Duchamp boom broke out in the art world, culminating in 1963 when the first major retrospective of his work was organized by Walter Hopps at the Pasadena Art Museum. Tomkins credits the Duchamp boom with stimulating the use of banal subject matter by Pop artists.[25]

Samuel Beckett's influence on the European Theater of the Absurd and its American offshoots Off-Broadway, like Edward Albee's plays, may be obvious. But perhaps Beckett is also a source for the staging of the banal in this group of artists as well, not only in dramatic theater (the Living Theater's production of Gelber's *The Connection* clearly echoes *Waiting for Godot*), but in the nonliterary theater of Happenings and Fluxus. Beckett completed the step begun by the realists in the nineteenth century. That is, everyday life had long before been introduced on the stage by writers like Zola, Ibsen, and Hauptmann. But that everyday life was still written as noble tragedy. As Susan Sontag recently pointed out, Beckett's radical gesture was to portray the "microstructure," the triviality of the way we in fact experience everyday life from moment to moment—bereft of any playwright's grand designs and momentous themes:

> Beckett has actually discovered a new dramatic subject. Normally people on the stage reflect on the macrostructure of action. What am I going to do this year? Tomorrow? Tonight? They ask: Am I going mad? Will I ever get to Moscow? Should I leave my husband? Do I have to murder my uncle? My mother? These are the sorts of large projects which have traditionally concerned a play's leading characters. Beckett is the first writer to dramatize the microstructure of the action. What am I going to do one minute from now? In the next second? Weep? Take out my comb? Stand up? Sigh? Sit? Be silent? Tell a joke? Understand something?[26]

For the Sixties artists who came after Beckett, to concern themselves with microstructure now seemed a project quite large enough. For microstructure is the form that organizes the commonplace; microstructure, hitherto considered inconsequential, in the Sixties took on political meaning and seemed synonymous with the *demos*. That is, if the elite are concerned with macrostructure, then microstructure is the biography of the world's rank and file whose lives are usually unsung.

The use of the ordinary in Joseph Cornell's Surrealist boxes and collages and his montage films was different from Beckett's or Cage's practice. Such use assumed a lyrical, symbolic bent. Rather than employing the familiar as a Cageian window through which to see more of life-as-it-is, Cornell's framing and juxtaposition of mundane objects and actions released a sense of mystery, of imagination, of transcendent beauty—a Surrealist technique that was influential on several members of the Sixties generation.

Jonas Mekas, writing about Cornell in 1963, calls him "the real poet of dailiness, of the unpretentious, of the anti-art film." "He makes these insignificant little movies. Most people do not even think they are movies: They are so artless. And ah, how much love there is in Cornell's movies! Love for people, for flowers, for the summer girls, for the little tree leaning in the dark corner without sun, for the birds in the sad park trees. St. Francis would have been a friend of Joseph Cornell." [27]

Another influence was the Beat film *Pull My Daisy* (1959), about a day in the domestic life of a group of poets.[28] An encomium to dailiness and spontaneity, in its time *Pull My Daisy* was celebrated by the avant-garde (and criticized by the mainstream) as an improvised documentary on Beat life.[29] The ease, wit, informality, and aimlessness of *Pull My Daisy* was a revelation to many. Mekas wrote of it in an early column: "I don't see how I can review any film after *Pull My Daisy* without using it as a signpost. . . . [It] clearly point[s] toward new directions, new ways out of the frozen officialdom and midcentury senility of our arts, toward new themes, a new sensibility. . . . *Pull My Daisy* reminds us again of that sense of reality and immediacy that is cinema's first property. . . . I consider *Pull My Daisy*, in all its inconsequentiality, the most alive and the most truthful of films." [30]

These, then, were some of the "poets of dailiness" of the previous generations of the avant-garde. It was partly because of their teachings and examples that the appreciation of the ordinary reached a new level in the Sixties. But there were other reasons that the artworks of the Sixties abounded in prosaic actions and objects, that the quotidian as style and subject matter threaded through every art form, as well as through intermedia genres. In the political context of the rhetoric of equal rights, what had been an aspect of avant-garde style took on centrality and significance.

The embrace of the ordinary was not a monolithic project. It encompassed various styles, programs, and projects—from an almost biblical, mystical injunction humbly to love the world around one to an irreverent, transgressive embrace of schlock culture; from a lyrical appreciation of the small, simple, and ephemeral things in life to a deliberate strategy of boredom; from a desire to expand perception to a refusal of Aristote-

lian catharsis. Additionally, the mundane itself might be defined differently according to each artist—from the untrained voice, the unpolished pace, and the sounds and sights of unsullied nature to the images and goods disseminated by radios, television, movies, advertising, and other media of mass consumer culture. So to accept the ordinary might require a monkish, ascetic attitude, or it might mean being fully engaged in the brash, material here and now. But for all of these diverse ways of arriving at it, this simplicity of source and outlook—which in the Fifties had often still been contained within the high art frame—now fused with the political exuberance of the Kennedy era, burst through the gallery walls and the theater proscenium, and demanded equal rights.

The ordinary stood for many things, but, given the political tenor of the period, it stood, above all, for the populist aims of accessibility and equality—for both artists and audiences. The activity of artmaking had been opened wide by the artists' assertion that anyone could make art. They were living proof. They were ordinary people, some of whom had gone to college for free on the GI Bill, some of whom had not gone to college at all. Many were from working-class families, and some were the children of immigrant parents. Their own experiences, as well as their attitudes toward art, were clearly different from those whose families could afford both the training and the posttraining support typical of artists in previous generations. For the first time, the postwar economy supported American artists without independent means, and postwar art history taught them that European bohemias had supported people like them in the past.

These artists were ordinary people, and, in turn, they made art that putatively anyone could understand. To watch people walk, run, work, eat, sleep, make love, tell stories, and smile, and to see objects that closely resembled food, clothing, furniture, games, bathroom fixtures, and other familiar items—or that actually *were* food, clothing, furniture, games, and so on—now seemed the most worthwhile thing an artist could help a spectator to do.[31]

One no longer made plays or dances or films about people falling hopelessly in love or falling from power, or even people unable to fall in love. Instead, people in Happenings, Fluxus, new dances, Off-Off-Broadway theater, Pop Art, and underground films ironed clothing, combed or shampooed their hair, and shaved their legs. They smiled, slept, smoked cigarettes, went to the movies, sent their audiences to the movies, played cards, read newspapers, got haircuts, played hopscotch, played ball, and rollerskated. They made love and they made lunch. In their very banality, these activities became charged with meaning. For in examining them—activi-

ties which everyone engages in, but does differently—the simultaneous variety and unity of human life seemed evident. And this in itself seemed a form of equal representation.

Judith Dunn's dance *Acapulco* was a collage of commonplace activities in which a woman ironed a dress she was wearing, two women played cards, and a woman combed the hair of another woman, who said "ouch." The use of slow motion in parts of the piece transformed these banal events into dance movement.[32]

In his soft sculptures, Claes Oldenburg took a decidedly comic/erotic turn by changing these things' scales as well as their textures. He had used mundane objects in The Store, but unlike those earlier lumpy, painted plaster flags, clothing, and food items, these large, sometimes unnaturally shiny objects bulged and sagged and were often soft and stiff at the same time. They seemed to make not only themselves, but the human body they so uncannily resembled grotesquely alien—very much in the manner of Swift's story of Gulliver's encounter with the Brobdingnagians and their queen whom Gulliver, while buried in her cleavage, has an opportunity to examine in microscopic detail.[33]

Andy Warhol's Brillo boxes were perhaps the most famous example of appropriating the banal.[34] The boxes do not so much awaken us to the unappreciated colors, textures, or shapes in ordinary objects (although they are satisfyingly bright and succinct); instead, like Roy Lichtenstein's comic-book images, they force us to think about artistic conventions, which historically segregated the ordinary from the extraordinary. Arthur Danto argues that the point of these perplexing artworks, like the point of Duchamp's *Fountain,* was not to engage the spectator's aesthetic sense— to call attention to the sensuous values of the carton (or the urinal)—but to propose a theory about art.

Danto suggests that thinking about the Brillo boxes' right of entry into the gallery is equivalent to thinking about everyone, rich or poor, drinking Coke. Seen from another perspective, this is not so much a story about leveling downward (bums on the corner may drink Coke, but they could not afford a Warhol soup can), but about the cherished American myth of success—the possibility of meteoric success in a land of social mobility and equal opportunity. The Brillo boxes' triumph was no more or less of an American Cinderella story than that of Warhol himself, born near Pittsburgh, the son of Czech immigrants.

Jonas Mekas, writing about Warhol's 1963 film *Eat,* which was forty-five minutes long and showed Robert Indiana eating a mushroom, advances another motivation for authorizing the banal—to attack what was seen as

pretentiousness in the grand themes and the grand forms of the previous generation's art.

> A man is eating a mushroom (or a piece of orange or an apple perhaps; it doesn't matter). He does nothing else, and why should he? He just eats. There are thoughts and reveries appearing on his face, and disappearing again, as he continues eating. No hurry, nowhere to hurry. He likes what he is eating, and his eating could last one million years. His unpretentiousness amazes us. Why doesn't he think of something else to do; why doesn't he want anything else? Doesn't he seek anything important? . . . We are not—or are no longer—familiar with such humility of existence. . . .
>
> What pompous asses we are![35]

Warhol himself implies that Pop Art trained one to return to everyday life with a new appreciation for the familiar, and it made that experience available to all. Describing his trip to California with Gerard Malanga, Wynn Chamberlain, and Taylor Mead in the fall of 1963 for an opening of Warhol's Liz and Elvis paintings at the Ferus Gallery in Los Angeles, Warhol remembers:

> The farther West we drove, the more Pop everything looked on the highways. Suddenly *we all felt like insiders* because even though Pop was everywhere—that was the thing about it, most people still took it for granted, whereas we were dazzled by it—to us, it was the new Art. Once you "got" Pop, you could never see a sign the same way again. And once you thought Pop, you could never see America the same way again. The moment you label something, you take a step—I mean, you can never go back again to seeing it unlabeled. . . . The mystery was gone, but the amazement was just starting. [emphasis added][36]

It was on this trip that Warhol saw the Duchamp retrospective in Pasadena. So perhaps it is not surprising that in his fantasy that Pop Art has appropriated all of life, Warhol seems to echo Cage's observation about Duchamp: "Therefore, everything seen—every object, that is, plus the process of looking at it—is a Duchamp. Turn it over and it is."[37]

Material for many Fluxus performances could be found in any household. In Alison Knowles's *Nivea Cream Piece—for Oscar Williams,* performed at several Fluxus concerts, a parade of performers enters one by one to massage their hands with a common brand of hand cream, then the group leaves in the reverse order.[38] At times, *Nivea Cream Piece* was performed on the same program as Dick Higgins's *Gångsång,* for which

the instructions read: "One foot forward. Transfer weight to this foot. Bring other foot forward. Transfer weight to this foot. Repeat as often as desired."[39]

Fluxus artist Robert Watts's objects from this period include compartmented boxes with rocks marked with their weights, *Yam Ride* (a Goodyear tire with the words "Yam Ride" stenciled on the side in silver), and *Yam-flung/5 Post 5*, a sheet of one hundred stamps featuring faces of celebrities, ordinary people, pinup girls, statues, and figures from old-fashioned illustrations.[40] The rocks and the tire were claimed for art, after the manner of Duchamp and Warhol. But in the stamp series, those ordinary people who appeared among movie stars and other idealized images of all sorts were lifted from the realm of the everyday to the realm of art. These works were so close to being indistinguishable from real life that they returned the viewer to the daily realm with altered vision. As in Andy Warhol's discovery about the American pop landscape, or Cage's report on daily objects as Duchamp creations, they proposed that all the world could be appropriated as Fluxus.

In his homespun puppet show spectacles, Peter Schumann of the Bread and Puppet Theater wanted to show theater itself as something simple and direct, where a sense of the holy inheres in life's smallest, most commonplace things. In his *Christmas Story,* for instance, the story of the Nativity was shown with puppets of different sizes, from six-inch puppets for the people of Bethlehem to masked human actors to a fifteen-foot-high angel held aloft on a pole. King Herod smoked a cigar; one actor, wearing a three-faced mask, played the three magi, led by a boy holding a star at the end of a stick. Shepherds danced over milk crates, and various musical interludes featured a Jew's harp, drums, a recorder, toy horn, tin-drum, and hand-clapping. Schumann doubled as musician and narrator, turning a paper scroll "cranky" with pictures of Joseph and Mary's journey as he told the well-known story "simply and in his own plain words."[41] Like the string, paper cartons, and pots and pans of the Paper Bag Players—a children's theater group whose personnel overlapped with the Judson Dance Theater and Poets' Theater—Bread and Puppet used cheap, humble, and utterly familiar means to construct a realm of the spiritual and the fantastic. Indeed, the paltriness of Bread and Puppet's means was intrinsic to its early Christian doctrine that it is the meek, not the rich, to whom the world rightfully belongs.

For Schumann, the simple act of eating bread is fundamentally a sacrament, as theater also should be. "We would like you to take your shoes off when you come to our puppet show or we would like to bless you with the

fiddle bow. We want you to understand that theatre is not yet an established form, not the place of commerce that you think it is, where you pay and get something. . . . It is more like bread, more like a necessity. Theater is a form of religion. It is fun."[42]

Thus, interest in the prosaic took on a range of forms. There also were an array of spiritual and political reasons for what Jean Cocteau had earlier called "the rehabilitation of the commonplace." For some Fluxus members, like Philip Corner, the ordinary could serve as a mantra of sorts. That is, the word, object, or action itself might be nothing special, but when repeated or concentrated on, it could be the catalyst for a mystical experience.

> What's behind the ordinary is the ordinary as extraordinary. After all, to be concerned with the ordinary had a lot to do with interest in Zen and the Zen idea of meditation on the ordinary—seeing through the ordinariness of things to a mystic revelation. When you're interested in a mystic experience, then the ordinary is maybe just one way to it, but that's linked to other things. Repetition inducing a transcendental state is, you might say, 180 degrees from the ordinary.

For Corner, like Mekas, the appreciation of the mundane also had to do with criticizing pedantry in art.

> Embracing the ordinary was an attack on pretentiousness; pretentiousness is itself an attack on the relationship between life and art. To become pretentious means that you use art not to vivify and reinforce and exalt life, but for some kind of egotistical agenda of your own, which has to do with self-aggrandizement. The same thing that makes art portentous is pretentious in its self-conscious will to raise itself above what's considered merely ordinary.

Part of the point for many Sixties artists was that "you were trying to establish a more organic, living-ful relationship between your work and your life."[43]

Some of the Fluxus members, then, saw art-in-life as a route to the mystical. But as Dick Higgins made the distinction at the time, some preferred the Schweikian over the Faustian mode of artmaking—that is, a down-to-earth, concrete approach instead of a neo-Romantic vision. In his polemical 1964 essay *Postface*, describing many of the works of the early Sixties, Higgins wrote:

> Faust . . . makes a gnostic religion or way of life or even mystery out of art. . . . On the other hand, as the social situation has deteriorated in

this country over the past few years, many of us have more and more come to insist on values that belong more to the Schweikian mode. We like quite ordinary, workaday, non-productive things and activities. In context, they take on great something-or-other. While Rome burns, I work with butter and eggs for a while, George Brecht calls for:
> *at least one egg

and Alison Knowles makes an egg salad and La Monte Young plays B-F sharp on a fiddle hour after hour.[44]

As Higgins suggests, many of the Fluxus people and related artists had political motives for their attraction to the quotidian. Like John Cage, the poet Jackson Mac Low was a pacifist and a self-acknowledged "anarchist-populist," influenced as well by the compatible tenets of Taoism and Buddhism. Mac Low's political beliefs in the dignity of the individual and his spiritual attraction to random methods (which not only release the artist from personal choice, but seem to frame individual words and sounds in a noncoercive) way join to form a metaphor for the ideal society. Mac Low attributes to the influence of Kurt Schwitters his own interest in seeing the possibilities released by using the ordinary in art.[45] His political beliefs led him, as well, to bring poetry into the performance arena. Remembering Mac Low's readings in the early Sixties, the poet Jerome Rothenberg credits him as inspiring many other poets to begin performing their works (rather than simply publishing them). Rothenberg remembers Mac Low's egalitarianism:

> For myself—as for other poets & artists in the vicinity—the invitation to perform with Mac Low became the occasion for hearing the work from within it. If this made us part of "a free society of equals," then it was as well a society in which one figure exercised a curious & quirky leadership, to bring us towards our own experience & understanding; for, along with the anarchist commitment, was a desire that the others act as real "co-initiators," in an atmosphere of mutual attention.[46]

In August 1963 Mac Low devised a system for writing poems based on what he called "a DAILY LIFE list." In a later essay he gave instructions for using this system to write poetry. Twenty-six sentences culled from the most ordinary household conversation (for example, "I'm going to the store," "Is the baby sleeping?" "I'd better take the dog out") were numbered from one to twenty-six, lettered from A to Z, and assigned to playing cards by number and color (but not suit). Mac Low's instructions include how to choose a motivating set of letters, numbers (or a combination of

both), or playing cards; how to allow for the number of lines in a strophe and the number of strophes in the poem; and how to use alternate lists of sentences along with or instead of the original list. Here was a literary practice made of the stuff of dailiness and ordinary in the sense of being available for anyone's use.[47]

George Maciunas's interest in the ordinary, like Mac Low's, was politically motivated, but from a different standpoint. Maciunas and the composer Henry Flynt subscribed to an early Soviet-inspired belief, in tune with both the short-lived Proletcult organization and with some notions of Constructivism (as exemplified by the Lef and Novyi Lef groups). In their view, art as a specialized activity and the role of the artist as a separate profession were bourgeois notions. They claimed that in a proletarian, socialist society art is (or should be) an everyday practice in that all people can make art and in that it is not separate from daily life. As Mac Low described it, Maciunas's view was that "in a realistic economy, you should have a realistic art, and for him that meant especially [work by] George Brecht and La Monte Young's 1960 pieces, and secondarily the rest of the [Fluxus] people. For Maciunas, Fluxus embodied the idea that 'You can look at anything with an art attitude,' as a specifically political notion."[48] To be sure, Maciunas's concept of realism was radical. The simplicity, concreteness, and deliberate insignificance of Brecht's and Young's works would have been utterly incomprehensible, if not condemned as formalist and decadent, in the Soviet Union at the time.

The ordinary was used in the Sixties, for a variety of individual reasons, to form a general project: to weave together life and art. Previously, art had seemed to stand outside of everyday life—at least in the post-Renaissance world of fine art. As we have seen, the techniques as well as the motivations for installing the ordinary in art were diverse. But most of the avant-garde agreed on this point: that incorporating the commonplace in art was a way to achieve the populist aims of accessibility and equality.

Moreover, the inclusion of the ordinary, among other subjects, seemed to lift from art its ultimate limitations, granting artists the artistic analogue of a right to free speech. Why not include the ordinary? And why not express the forbidden—drugs, sex, nudity? Both categories—the banal and the taboo—seemed equally transgressive. And the egalitarian ethos said that both deserved equal opportunity and equal representation in art.

Certainly what "the ordinary" meant in 1963 was felt to be tangibly different from what it had meant in other eras. Now the ordinary included not only the folk culture of private and community life, but the public, technological mass culture that, in a booming consumer culture, had become

inextricably interwoven with the private sphere. In the late nineteenth century, realist painters, novelists, and theater directors turned their attention to the "ordinary," but they maintained firm boundaries between their art and the real life it depicted. They installed in their art the subject matter of daily life, in many cases to challenge the hierarchies of aesthetic genres. But in nineteenth-century realism, even where styles changed to more appropriately express a modern, at times modest, subject matter, the artistic conventions were still preserved. There remained a "fourth wall," and there remained a canvas, safely ensconced in a frame.

But even those who might have defended the advances of nineteenth-century realism and various twentieth-century modernisms were offended by one wing of the avant-garde: Pop Art, and its manifestations in the other arts. For Pop Art embraced a world where, in the view of the mainstream, "real life" seemed to have canceled out art; where the very radios, television sets, billboards, and even art prints of that real life were seen as impoverished, degraded, emptied replicas of genuine life; and where collectors and connoisseurs seemed to consist only of philistine nouveaux riches and teenagers—Kozloff's "vulgarians." Thus, for the artists and defenders of the avant-garde, to embrace the ordinary was not only a gesture of egalitarianism, but a way, once again, to *épater le bourgeois*—including the successful avant-garde and art critics of an earlier generation.

Equality Creates Model Structures

The Sixties urge toward equality shaped the very structures that artists employed to generate their work—structures that were meant to model behavior and catalyze political change. Multimedia itself enacted an equal union of the arts. But even more striking as a token of equality was the use of collage or radical juxtaposition, the structure of choice for Happenings, Fluxus concerts, paintings, dances, plays, and underground films. In the odd, pop intermarriage between commercial art, the fashion world, and the avant-garde world of New York in the early Sixties, even Diana Vreeland, the editor of *Vogue*, borrowed the collage format for her composite photographic layouts. Her pages were assemblages of cropped, blown-up images of various body parts from different models, resembling a photographic version of a Surrealist "exquisite corpse."

Look, for instance, at James Rosenquist's paintings such as *Nomad* or *The Promenade of Merce Cunningham*. In the first, among the images juxtaposed within the frame are the lower halves of two ballerinas' bodies, a picnic table with a bench, a light bulb, a microphone, spaghetti with tomato sauce, meatballs, and green olives, a package of "NEW Oxydol," a road-

side sign in a grassy field, and a billfold. In the second, somewhat simpler composition, we see a pair of shod feet against a background of spaghetti, in turn against a fragment of a woman's face, which itself is overlaid on more spaghetti. On the one hand, Rosenquist's own particular technique of juxtaposition—with some images upside-down or at an angle, some fragmented, some in color, some in black-and-white, some looking like monochrome halftones, and all in different scales—resembles the billboards he once painted to earn a living. That is, although one might not see some of these images in ads, the jumble of images is analogous to the archaeology of a billboard's successive advertisements. These are not actually ordinary images culled from everyday life; rather, they are everyday objects represented in the chaotic form, as well as the photorealist technology, of that particular branch of consumer culture's image production.

On the other hand, the assortment of seemingly unconnected information, arranged in this way—without clear foreground or background differentiation or the logic of scale—and added to the fact that many of the subjects of these images are not at all consumer products, turns the paintings into something more suggestive than merely a billboard's palimpsest. The format evokes a mental landscape, a grab bag of unconscious memories and experiences that seem of equal importance. Or, perhaps less personally, it evokes an American landscape drawn according to an all-seeing eye that refuses to order its motley perceptions according to the rules of perspective—a terrain dotted with many kinds of equally regarded things: high culture and mass media; nature and technology; country, city, and suburbia; food, money, detergent; a dancer's feet in everyday life, a beautiful woman à la fashion ads, today's lunch. Everything seems equal to everything else, not in the cynical sense that nothing matters, but in an all-encompassing, egalitarian embrace.

Yvonne Rainer remembers that an important influence on her own use of radical juxtaposition as a choreographic structure was working with Simone Forti on an early dance, *See-Saw*. Rainer was impressed by the disjunct, episodic structure of the piece. "She made no effort to connect the events thematically in any way. . . . And one thing followed another. Whenever I am in doubt I think of that. One thing follows another."[49] Merce Cunningham's use of chance techniques for choreography had earlier removed thematic links and developmental phrasing from the dance; both his and John Cage's use of aleatory devices were influential on the Sixties dancers, although Cunningham's movement vocabulary on the whole was much more abstract. James Waring, a collagist in the visual arts as well as choreography, was also an influence. But importantly, Forti and the

other members of the Sixties generation used disjunct structures to organize much more ordinary movements. Framed in this way, these previously overlooked movements seemed newly invested with dignity and regard. They seemed, so to speak, to "have the floor" for the first time.

In some cases Rainer juxtaposed unrelated styles or phrases of movement, from ordinary "found" movements to the awkward, ugly, or socially impermissible. These were combined either simultaneously (as in the "Duet" section of *Terrain,* in which Trisha Brown performed romantic ballet postures with the upper part of her body—head, arms, and shoulders—and burlesque movements with the lower part of her body) or in sequence (as in the "Bach" section of the same dance, in which each performer had an individual score of movements chosen from a gamut that included sixty-seven separate phrases culled from earlier sections). Rainer also juxtaposed movement phrases to seemingly ill-suited music. Most shockingly, Rainer juxtaposed her movements to the spoken word, in such works as *Ordinary Dance* and the "Spencer Holst Solos" in *Terrain.* In different ways, all these hitherto inappropriate mixtures spoke to egalitarian values. The dance styles of high and low culture were given equal worth in Brown's part in "Duet"; while in the "Bach" section of *Terrain,* when dancers were arbitrarily assigned other dancers' movements, dance phrases themselves were weighted alike, and every dancer was not only a soloist, but had the chance to perform and share one another's movements. In "Bach," that is, the social roles of the dance company were rewritten, for the community and equality of the traditional corps de ballet were annexed to the individual uniqueness and worth of the soloist. Similarly, in her use of music and of verbal material, Rainer seemed to say that no aspect of human activity should be excluded from consideration for representation in the dance.

Before World War I the Italian Futurists embraced the variety format of Marinetti's beloved London music hall entertainments as the ideal avant-garde performance form.[50] In the 1920s the Soviet avant-garde theater and film director Sergei Eisenstein recommended a circuslike "montage of attractions" as a structural model. Similarly, from plays (like Robert Nichols's *The Wax Engine* or the Diane di Prima–James Waring collaboration *Poets' Vaudeville* at the Judson Poets' Theater) to Fluxus festivals, the episodic variety show format dominated the Sixties avant-garde.

Compartmented structure was the label that Michael Kirby gave to the collage form of Happenings. Rather than making use of the information structures of traditional theater—in which action develops through exposition and characterization—compartmented structure presents events that are autonomous. Kirby writes: "*Compartmented structure* is based on

the arrangement and contiguity of theatrical units that are completely self-contained and hermetic. No information is passed from one discrete theatrical unit—or 'compartment'—to another. The compartments may be arranged sequentially, as in *Water*, for example, or simultaneously, as in the 'combinations' of *Gayety*."[51]

Happenings, that is, operated much like Rosenquist paintings in providing an overall structure that comprised utterly disparate images, scales, and actions. It might be argued that the autonomy of the images and actions in the Happenings' or paintings' compartmented structures reflected a dispiriting sense of modern alienation and isolation. Yet, according to the reviews and spectator responses at the time, this was not the case. Even when the subject was the grit and brutality of the city or the anonymity of mass production, in these condensed formats the very juxtapositions of so many widely different things (in the paintings) and actions (in the Happenings) instead created a sense of vitality, abundance, and variety. The compartmented structure created a feeling of openness and opportunity that rang metaphorically democratic. For in the realm of radical juxtaposition, anything could appear next to or after anything else; no hierarchical logic of perspective, plot, or character development dictated artistic choices.

Two different types of compartmented structure are illustrated by examining in some detail the two 1963 Happenings that Kirby mentions. In Robert Whitman's Happening *Water* (which took place in Los Angeles in a temporary construction built on a large driveway in front of a private double garage), among other activities, water flowed into the performance space from a hose lying on the floor, a man squirmed into the space through a suspended silvered inner tube, and a woman entered. The two washed themselves and one another—using shampoo, soap lather, shaving cream, and whipped cream—and then rinsed off with a hose. The man showered with purple, white, and green liquids dumped from three buckets suspended at diminishing heights. Then four women dressed in cumbersome burlap costumes that covered their entire bodies (except for an arm or a leg) crossed the space, occasionally colliding with one another or falling. A shadow play showed a woman in a bathtub or eating an apple, a man holding a hose, and an arm or leg being washed. Then a color film showed images of water and then a woman in a variety of brightly colored dresses. The same woman, live, moved in tandem with her filmed image.[52]

For the moment I want to put the obvious sensual meaning of this performance aside in favor of its egalitarian significance. Like the Vreeland layouts in *Vogue* and Rosenquist's billboard-like paintings, in these singular images, arms and legs, separated from the rest of the body, took on new

importance and appeared almost to have lives of their own. And although, as the title of the Happening suggests, there was a definite link between the various images, it was not a causal link, but a thematic one; the sequence of events told no story, and the order might have even seemed somewhat arbitrary. The fragmented and masked bodies, the man and woman interacting and acting solo, the use of shadow and film images, and the interaction of the woman with her own film "double" cumulatively created a sense of mystery (balanced with satisfaction) exactly because their roles and relationships were never clearly delineated. Not only was there no story, there also were no traditional characters. So the images accumulated, rather than unfolding in a causal chain of plot development and character interaction; yet they did not accumulate aimlessly. The rhymes and repetitions in the imagery did create a structure. And, significantly, the structure that emerged as the work unfolded in time was that of equivalences, stated in the form of paratactic metaphors—e.g., the live woman and her film double; water and other kinds of liquid; inner tubes, hoses, and body parts.

In Claes Oldenburg's *Gayety* the compartments were ordered simultaneously, rather than in series. The bulk of the performance consisted of six different combinations of up to six simultaneous activities in different parts of the space, which represented a map of Chicago. Oldenburg described these actions as "all the elements of experience in representative situation, either plain or enigmatic, demonstrating such categories as weather, climate, geography, education, culture, poetry, homelife, crime, products, food, traffic, heroes, art, entertainment, and so on." In one of these "combinations," for example, among other activities a man in a helmet and rubber flippers silently recited poetry, while a second man repeatedly collected bottles and beer cans into a sack, then emptied it from the top of a ladder. A third man played a patriotic song on the trombone, while a woman festooned with tools climbed a ladder, and another woman kneaded dough and shouted at the silent poet to be quiet.[53]

Gayety enacted the leveling created by modern urbanization. It was meant both to parody and reproduce (in a new form) the traditional civic pageant. Explaining the Happening's structure, Oldenburg writes: "The relation of the incidents is fortuitous as is the case in real life. Imagine a map where all that goes on in the city can be seen from above at once, such as the fire charts of the fire dept or the multiplicity simultaneity of the taxi or police radios. A city is overlay upon overlay of incident. Unfortunately I am limited to typicalities, but the spectator may imagine the numbers."[54] The use of the compartmented structure was an analogy for the mélange

of activities, sounds, and sights, as well as people and their social roles, of modern urban postindustrial life, all of which had "an equal right" to be represented in art.

The leveling and diversity forced by urbanization was here seen not as a negative force that robbed people of culture and homogenized them, but as a galvanizing source of creative energy with multiple points of entry. The choreographer Steve Paxton comments: "We'd come to the point where we were saying, 'Reality seems to be made up of lots of different pieces of things.' As a dancer, for instance, you might go to a ballet class and study something that's traditional and old, and then walk out on the street and be assaulted by rock-and-roll, see odd people on the subway. . . ." Furthermore, for Paxton all of these experiences were equally valuable, and their diversity could be encompassed by a single imagination without any need to impose external unification. "You [had] a sense of a whole picture that was happening." [55]

While the diversity and simultaneity of the megalopolis is not necessarily democratic—indeed, Oldenburg himself often created images of urban violence and poverty—there is a strand of urban thought that sees cities as places of opportunity and accessibility. As the ethnographer Ulf Hannerz has put it, despite the often glaring social inequities in the modern city, the political hierarchies of status and role, and the fact that it was to sell their labor that people originally settled in industrial cities, there is nevertheless a sense in which the very juxtaposition of different people and different cultures has both an equalizing and a vitalizing effect. "In whatever terms people are set apart from each other or thrown together according to other principles of organization, those who end up in the city also rub shoulders with each other and catch glimpses of each other in their localized everyday life. And this may not just be accessibility added to diversity; it may be accessibility *in* diversity, and diversity *in* accessibility." [56]

The kind of disjunction created by radical juxtaposition is an artistic strategy that has different import at different cultural moments. As Susan Sontag pointed out in her analysis of Happenings, the Surrealist use of radical juxtaposition as a formal strategy was not only linked with the discontinuities of modern urban life, as Oldenburg suggests of his pieces, but also with the Freudian technique of free association for the purposes of plumbing the unconscious. For Sontag, Kurt Schwitters's Merz assemblage of a city block's refuse exemplifies both of these interpretations combined:

[Merz] recalls Freud's description of his method as divining meaning from "the rubbish heap . . . of our observations," from the collation

of the most insignificant details; as a time limit the analyst's daily hour with the patient is no less arbitrary than the space limit of one block from whose gutter the rubbish was selected; everything depends on the creative accidents of arrangement and insight. One may also see a kind of involuntary collage-principle in many of the artifacts of the modern city: the brutal disharmony of buildings in size and style; the wild juxtapositions of store signs; the clamorous layout of the modern newspaper, etc.[57]

That is, not only did compartmented structure seem an apt metaphor for describing the early twentieth-century modern city; for the Surrealists it also served as a metaphor for the workings of modern consciousness. And importantly, as Sontag suggests, in the archaeology of both city and consciousness, everything matters equally—everything has a significance that can be uncovered. By the Sixties those metaphors, consciously inherited by a later avant-garde generation, had been somewhat reworked. The collage technique implied not so much the dislocations of a disembodied modern consciousness, but, in a different symbolic archaeology, the multiple possibilities of a concrete postmodern worldview. And the rhetoric of egalitarianism, linked to the collage technique, seemed to speak to the fulfillment of those multiple possibilities at a culturally expansive and effervescent moment when the world, and art with it, seemed capable of moving in any direction. Freed from causality, radical juxtaposition seemed quite assertively to thrust its individual components upon the world. That is, it did not argue for or explain "equal rights"; it seized them.

Another sense in which radical juxtaposition is egalitarian relates to the earlier category of leveling distinctions. Like the early Soviet filmmaker Eisenstein, Cage taught that with collage (in film, montage) the artwork is ultimately made not by the artist but in the eye (mind) of the spectator. "What this nonintentional music wants to do," Cage wrote, "is . . . to make it clear to the listener that the hearing of the piece is his own action—that the music, so to speak, is his, rather than the composer's."[58] This is, theoretically, a form of parity in which the spectator is put on a level with the artist. As with the other techniques of antihierarchical leveling, for these artists the use of compartmented structure itself was meant to produce an equalizing political effect.

The Sixties artists echoed both Eisenstein and Cage in their faith in the spectator's contribution to making and understanding the collage artwork. Al Hansen recalls that he originally took Cage's experimental music course not to become a composer but to augment his education as an experimen-

tal filmmaker. On the first day of class, he explained to Cage that it was reading Eisenstein's writings that brought him to Cage's class in the first place. If, as Eisenstein wrote, all art forms meet in the film frame, then surely to know more about experimental music would help a future film director. This explanation, Hansen remembers, may have baffled some of his fellow students, but it pleased Cage. But Hansen reports that Cage's class eventually changed his own views about film and the workings of art: "Actually, by the time I had finished the course, I realized that all art forms do not meet in the film frame, but in the eyeball. In the head of the observer, for better or worse. Therefore, in the happenings—which I developed as a way of overlapping and interpenetrating art forms in the hope of finding a new one, without at first realizing that the happening was the form itself—I realized my solution." [59]

Thus, the values of egalitarianism dictated that all materials and even all artists and all artworks have equal opportunity and, at least in theory, equal worth. The method of radical juxtaposition, together with the inclusion of the ordinary, at least seemed to guarantee that all materials have their fair share of representation.

5

Dreaming Freedoms

In 1963 freedom was a vital political issue charged with artistic conse-
quences for both the mainstream and the avant-garde. Part of the avant-
garde's utopian vision was that liberty could be found within community.
But, in fact, the very concept of freedom sets autonomy and the notion
of individualism in conflict with the bondedness of community. For social
life is a potent source of restraint, yet, paradoxically, total freedom would
mean the humanly unrealizable (and unbearable) state of complete isola-
tion. Thus, there is a deep ambivalence in Western culture toward freedom
and social life. The dream of community itself may be incompatible with
the dream of freedom, a contradiction the avant-garde sought to dissolve.[1]

The Sixties artists constructed an art that reimagined daily life in terms

of achieving both liberation and community. If such a solution ultimately proved illusory, in 1963 it seemed necessary—and it still seemed possible, given the booming economic infrastructure—to find a model that would make these imaginings concrete.

That this dream arose in the early Sixties is not accidental. For if the contemporary consumer market has replaced the earlier capitalist production sphere as the locus of self-realization—making freedom of choice available for the first time to the many (but not without creating massive social problems)—then the notion of freedom in our time is inextricably linked to economic abundance, particularly as expressed through mass consumer culture. Hence, the cold war contrast between a culture of democratic freedom and one of communist repression often took the very graphic form, in official rhetoric, of a contrast between plenty and shortage. And in the fine arts and commercial arts in the United States the image of abundance was clear in both official and unofficial strata, from the glut of advertisements for food, clothing, and consumer durable goods in the mass media to the reworking of their images in Pop Art canvases to the proliferation of objects in dances and Happenings. The sense of a cornucopia of goods and resources was unquestioned, even by most oppositional subcultures. Other arenas of the culture may have been contested, but it seems there was a common assumption of infinite wealth. Social critics like Michael Harrington in *The Other America* found the wealth unevenly spread, but they took for granted a continuing flow of natural wealth into the future.[2] In his essay "The Beer Can by the Highway," the cultural historian John Kouwenhoven speculated that America's "untidy abundance" was not a prerequisite to democratic freedom, but that, on the contrary, democracy creates abundance.[3] Even an anarchist like John Cage spoke of the riches available to all if only you accepted the world around you.

In fact, the very structures that expressed community in the avant-garde were also structures of plenitude, even excess: anthologies, group concerts, festivals, marathon omnibus performances (Yam Day, *Vexations,* The Pocket Follies), performances of "one thing" continuing at great length, simultaneous performances, multimedia, films made of multiple projections, the dance series entitled "Surplus," Oldenburg's The Store, and Fluxshop. Fluxus also specialized in "treasure hunts" and tours of the city, where the entire metropolis became its stage. Susan Sontag spoke of Happenings as "object-clogged."[4] Underground films showed people "hanging out" in the endless leisure time made possible by a booming economy. In pastiche performances—James Waring's and Aileen Passloff's dances and

theater pieces, Al Carmines's musicals, David Gordon's *Random Breakfast,* the eclectic repertory at the Caffe Cino—history itself became a bottomless treasure chest. It is not surprising that popular consumer culture, reaching a peak in the early Sixties, fascinated the artists of the period and often became the subject of their art. But even where popular consumer culture was not the explicit theme of an artwork, the prevailing permissiveness of the period—the recurring question "Why not?"—symbolized the availability of multiple options, a freedom of wide-ranging choice that was rooted in economic abundance. The artists may not have had the financial resources of an opera company or Hollywood studio, and they even may have seen the resources of those institutions as corrupting, but if your attitude is that anything can be art, then there are a great many resources available to you, wherever you turn. And this thrifty attitude of "making do," when combined with an economic base that supported artists on part-time jobs and networks of friends that fed one another, created an alternative economics that sustained a profusion of avant-garde art.

The Sixties avant-garde approached the theme of freedom differently than had their forebears, the avant-garde of the Fifties. The music of John Cage, Morton Feldman, and others, Merce Cunningham's dances, and Abstract Expressionist painting seemed to many to be "about" freedom, but in abstract ways. Those artists' various methods served as metaphors for freedom—accepting chance, allowing musicians in a group work to make artistic choices unforeseen by the composer, fragmenting the unity of the body so that every part had local autonomy, using all-over spatial plans in ways that seemed to free the stage or canvas from the hierarchy of perspective.

Cage viewed the performance of his and other composers' works as paradigms for a society organized according to utopian principles that reserved autonomy and spontaneity to the individual. Even where this was not necessarily true in terms of the actual artistic process, the look of the finished work often suggested such a social configuration—for example, Cunningham's dances, which involved chance in the choreographic process but usually ruled out improvisation by individual performers, or the seemingly inimitable, unpremeditated drips of a Jackson Pollock painting that in fact could be repeated. This was partly the result of "liberation" of formal elements—sounds, body parts, space—from the prevailing conventions in their respective art forms. The rules of harmony, symmetry, variety, and phrasing in music and dance, perspective in visual art, and so on, were deliberately violated. And if the organization of the material by

artistic conventions was taken to stand for social constraints, then when those conventions were broken, freedom seemed to have been won.

But the generation that followed those artists of the Fifties sought to give freedom more concrete form, partly through forsaking modernist abstraction and introducing specific political content, and partly through further heightening of the metaphoric emphasis on liberating formal methods.

This chapter focuses on the theme of freedom as manifested in the Greenwich Village avant-garde art world in distinctly different, but sometimes related, political/cultural arenas. One was the civil rights movement, which christened itself the Freedom Movement—a brilliant tactic that in the midst of Civil War centennial commemorations reminded the country that African Americans had continued to suffer a full century of discrimination since the abolition of slavery. A second was the relationship of the art world to cold war rhetoric, which posed stark contrasts between communism and capitalism, East and West, in terms of exercising political, economic, artistic, and personal freedom. Third, some sectors of the art world, especially the film world, resisted the official line on America's democratic freedoms by repeatedly challenging censorship laws and testing the limits of free speech. And fourth, in direct response to the threat that the cold war might heat up, the peace movement criticized the militarism of the state.

First, however, I want to discuss another aspect of freedom for the avant-garde—the realm of play, which connected art, community-building, and freedom in a utopian vision of an alternative culture. The topic of play—specifically, the redefinition of art as play—influenced both the style and the content of avant-garde culture.

Art Is Play

Art as liberating play was an integral part of the reimagined community of the Sixties avant-garde. The artists aimed to restore to both work and play a prelapsarian, precapitalist, unalienated role in daily life, simultaneously cementing the bonds of community warmth *and* loosening whatever fetters were created by social structure. Furthermore, the artists proposed, it was through art that this unalienated vision could be realized—but an art that was playful rather than serious, in which public and private life were transposed or merged, and in which both work and play were freely chosen. However, this neo-Romantic vision was in no way nostalgic or conservative. Although it grew out of a consumer culture of leisure and abundance, it was linked to progressive, even subversive views of social relations and the body.

Diverse forms of play and games were seen as emancipatory models for art. One was the unrepressed behavior of children in such works as Philip Corner's *Brass Orchestra Baby Directors* (in which a four year old moved beads on an abacus-like object that in turn served as a score for a brass orchestra) and Ken Jacobs's film *Blonde Cobra,* in which Jack Smith dresses up as an oversized baby, plays peek-a-boo, sings out of tune, and, in a falsetto voice, tells a long story about a little boy waiting for his mother to come home.[5] Infantile play releases one from the norms, restrictions, and inhibitions of proper adult behavior, making possible the pleasures and outrages that society ordinarily bans. In this way, infantile play is related to the second form of play, festival, which allows licentious behavior wildly to exceed all social restraints.

The festival was a popular form in 1963–64, from Fluxus festivals to Charlotte Moorman's First Festival of the Avant-Garde. The form reached its apotheosis, however, in the Yam Festival organized by Allan Kaprow, Robert Watts, and George Brecht and sponsored by the Smolin Gallery. The Yam Festival comprised a number of actual performances, from "Yam Day"—an epic omnibus performance, with about 140 works by thirty-seven artists at the Hardware Poets Playhouse, that began at noon on Saturday, May 11, and ended sometime on Sunday—to various tours by Ben Patterson, to Alison Knowles's *Yam Hat Sale* at the Smolin Gallery May 9–11, to the picnic-like afternoon of events at Segal's Farm on May 19, to Robert Watts's *Spring Event Two* at the Smolin Gallery on May 25, to Michael Kirby's *The First and Second Wilderness* on May 28, to daily tournaments and intermissions at the Kornblee Gallery from May 21–29. The Yam Festival also included instructions for conceptual performances for particular days on the calendar of events.

A third form of play was the use of game structures, including those involving chance operations. The use of game structures—a specific form of play involving rules—had several direct sources. John Cage's chance charts and problem-solving methods influenced composers, Fluxus artists, Happenings-makers, and choreographers. Game structures were used in Happenings from the very first, especially in Kaprow's pieces. In theater, they were used by Viola Spolin. In 1963 Spolin published her collection of theater games for the first time; the book became a bible for non-realistic actors.[6] The Open Theater devised its own collective "games" and "rituals," amalgamating Spolin's games with Nola Chilton's "sound and movement" exercises, many of which involved games of imitation.[7] Furthermore, the dancers, musicians, and visual artists who had taken Anna Halprin's dance workshops on the West Coast or collaborated with her—

including Simone Forti, Robert Morris, Yvonne Rainer, Trisha Brown, and La Monte Young—had learned her game-task approach to generating movement.[8] Simone Forti, who by 1963 was occupied full-time with Robert Whitman's Happenings, had earlier in the Sixties created several "dance constructions" based on games and children's playground activities.[9] The fundamental paradox of games that seemed to empower these artists was their capacity to create realms of freedom within the strictures of rule codes.

Somewhere between games and toys were the boxes that captured the imagination of many artists—in the spirit this time not so much of Cage, but of Joseph Cornell and Marcel Duchamp. Fluxus boxes of all kinds flourished, from Chieko Shiomi's "endless box" to Ay-O's *Finger Box* to Ben Vautier's "mystery envelopes," to the collective work *Fluxkit*—an anthology of twenty-eight two-dimensional and three-dimensional objects (including the three mentioned) by various artists, collected and distributed as multiples in attaché cases.[10] *Fluxus Yearbox,* initially planned as a second volume of *An Anthology,* included essays, scores, photographs, booklets, a record, some film footage, and other objects, housed in a wooden box.[11] One of Robert Morris's earliest sculptures was *Box with the Sound of Its Own Making* (1961), a wooden cube that contained a tape recorder playing the sounds of the sawing and hammering that Morris had done to make the cube. This box was on display in Morris's first one-man show at the Green Gallery in October 1963 with three other, more playful boxes: one that opened to display a picture of itself; the *Plus and Minus Box* (with two doors that opened to show a breast form with an erect nipple and one with a dimple where the nipple should be); and the *I-Box,* with a nude photograph of the artist inside an I-shaped door.

A fourth arena of play whose significance was plumbed by Sixties artists was sports, which lend power to the athletic body and foster teamwork. The early Sixties artists embraced sports imagery as part of popular culture both as a form of mass entertainment in itself and in terms of media representations. Although sport may at times in history be seen as an arduous discipline for the body or as a frightening regimentation that sacrifices individuality to the goals of the group, its representation in the avant-garde stressed other meanings. Thus, performances like Walter de Maria's *Piece for Terry Riley* (in which the eponymous composer "plays" a baseball player's equipment like a musical instrument), or Robert Rauschenberg's *Pelican* (a dance in which two men on roller skates partner a woman on pointe) provided playful visual emblems of the cultural significance of sports—their mythological quality as well as their iconography of power, speed, and

freedom. Also, choreographers like Judith Dunn (in *Speedlimit,* based on wrestling) and Yvonne Rainer (in *Terrain,* with various ball games, and in other dances) looked to sports activities as a movement source for a dance vocabulary that would not be gender-identified. In this sense, sport became an emancipatory path for women's bodies in particular.[12] In these performances as well as in Pop and other visual art—for example, Andy Warhol's *Baseball* (1962) and Robert Rauschenberg's *Barge* (1962–63) and *Junction* (1963)—the early Sixties artists seized on sport as a democratic icon of accessibility, community, and freedom. In particular, sport represented an arena in which the body asserted freedom in eloquently somatic terms.

Thus, art was recast by these artists as something infantile, fun, and liberating, rather than something adult and serious. In many ways this fit with the thinking of Jean-Paul Sartre, Johan Huizinga, and other contemporary theorists.[13] This preoccupation suggested a road to freedom itself, reclaimed as a path to be hewn by artists, rather than by politicians.

Looking back in 1965 at the first two seasons of the Judson Dance Theter, Jill Johnston wrote an entire column entitled "Play," in which she extolled the wholesale expropriation of the ludic.

> From its inception the Judson movement was permeated by a new sense of dance in terms of play. Seeing prospects of more making things merrier, I see this in terms of dance as a merry activity. In the dim past, dance was a merry activity, and it still is where the folk assemble in rituals of pleasure and invocation, like at parties and on street corners; and I think the Judson movement in dance . . . represents a return to merriment where it has not existed in the torture chambers of its predecessors. I don't mean that Judson choreographers have been sitting around with all-day suckers. Modern choreographers are as serious about their work as choreographers have been in the past. But modern choreographers enjoy themselves at parties, and in their formal presentations they often make a play on play and other aspects of pleasure.
>
> The demonstration of play as a mode of action central to dance is a significant regression. Central to play is improvisation. To improvise is to compose on the spur of the moment, as the dictionary says. Children compose things offhand in this manner and dont [sic] worry about alternate ways of behaving. When children like something they've done, they repeat it, thus achieving a set form, such as hopscotch or red-light. Adults who regress to childhood ways do the same. . . .

Johnston here evokes Huizinga, with his view of play as a way to cross a metaphysical threshold into an orbit of pure freedom, and, as well, with his nostalgia for ancient folk festivities linked to a sacred order. However, unlike Huizinga, she sees the modern age as possessing its own, equally potent, spaces for communal pleasure. And she concludes by connecting the will to pleasure and freedom—and the romantic primitivism that associates both pleasure and freedom with childhood—to a distinguished avant-garde tradition, to which the artists that she champions are clearly heir.

> The moment of no return in the history of modern art was when the 19th century romantics questioned man's rational estate and made certain hallelujahs to the child in man. In France, the early 20th century fathered forth a number of artists willing, as Roger Shattuck says, to accept the child's wonder and spontaneity and destructiveness as not inferior to adulthood. . . . Satie himself said that he would "like to know the kind of music a one-year old child would compose."[14]

To pose art as play was a positive value because it was transgressive in two ways. It bucked the values of mainstream culture that considered high art serious business, and at the same time it challenged the pomposity of the previous generation of avant-garde artists (the generation of the Abstract Expressionists, modern dancers, and realist theater) by returning to an avant-garde "tradition" of pleasure of the 1910s and 1920s. Moreover, although in many intellectual theories current in the early Sixties play and art were posited as relatives, art was supposed to be the serious cousin, the mature embodiment of play's positive cultural values. The Sixties avant-gardists dismantled that relationship, making art that participated directly in the euphoria of play. Embracing regression, infantilism, and the amoral pleasures of the polymorphous perverse body, artists embraced a view of art antithetical to the mainstream and to the previous generation of avant-garde artists, whose seriousness defined their style.

An important socio-economic factor in the appropriation of play and pleasure was the postwar baby boom and the rise of youth culture in the early Sixties. Adolescents spent a record total of $22 billion in 1963, most of it in leisure pastimes.[15] Games and play were popular and interesting to this generation of artists partly because many of them *were* kids, or not much older than teenagers, and the culture at large was in the process of prolonging childhood and adolescence as long as possible. At the same time, all of American society was, in this era of abundance and technological advancement, confronted with an astonishing increase in leisure time

that provoked far-ranging debate about the cultural consequences of a new balance between work and play. The avant-garde artists participated in that debate with their ludic preoccupation.

An intellectual factor influencing the fascination with game structures, in particular, was the rise of structuralism in linguistics, literary criticism, and anthropology, and the popularization of mathematical models of game theory. A cultural factor in the interest in sports imagery was the feeling that this was the end of an era of American sports. They were beginning to be overcommercialized and, some felt, overprofessionalized. If play, games, and sports were seen as the locus of the body electric, in sports this was a locus that was already larded with nostalgia, as it began to slip into a time past, and as even what was exalted as the free American athletic body began to be seen as subject to institutional repression.

Finally, in the urge toward folk culture that imagined social relations as integrated and holistic, play was seen, oxymoronically, as unalienated work. Play is often distinguished from daily life, as well as from work, but it was crucial to the project of these artists to reinstate play in art *as part of* daily life. Both work and play were reinstalled as unalienated labor and as uninhibited revelry. And art was a means to tap into both of these realms. Art did not just quote work or play, or project them as idealized transcendental states or as abstract forms to generate art; it *reactualized* them. Art was not posited as *like* play; it was thought to *be* play. Furthermore, art, work, and play were posed as a set of equivalents, not opposites. It was this unity that was considered liberating. Thus, in the ethos of the period, art was seen as a social space that united work and play to produce freedom.

Black Art and Art About Blacks
The civil rights movement was an important arena of subcultural struggle in 1963–64. Yet relatively few African Americans were involved in the Greenwich Village avant-garde worlds of Happenings, dance, Off-Off-Broadway theater, and visual arts. Here I want to examine more closely the participation and representation of African Americans in the avant-garde. Although they were a minority in the avant-garde, that there were black participants in this movement at all was itself a signal that the demographics of American art had changed under the pressure of civil rights activism. The white avant-garde was being opened up by and to blacks, yet there also was a renewed separate search for aesthetic identity by African American artists, reminiscent of black nationalist currents in the Twenties. In light of roiling racial violence, and catalyzed partly by the writings of Malcolm X and partly by the frustrations inevitably brought on by the limited enfran-

chisement won by the civil rights movement, this tendency would lead by the mid-Sixties to an entirely separate black avant-garde. This black vanguard arts movement was concerned with different content, styles, and audiences than the predominantly white early postmodernists.

But in 1963, despite the sense that the liberal civil rights movement was coming to a turning point, and despite the seeds of later Sixties political/cultural separatism already planted in the culture, this bifurcation was not yet sharply drawn. Although blacks and whites generally did occupy separate aesthetic domains, as they always had in the segregated history of American arts, at this particular moment those arenas briefly overlapped. Greenwich Village was already a place where blacks and whites could mingle socially. The Beat Generation of the late Fifties was an integrated one in which not only white and black poets met, but also, as Norman Mailer pointed out in "The White Negro," white writers and other hipsters appropriated elements of black cultural style, from marijuana to sexual freedom to jazz prosody.[16] Furthermore, the tolerance of much of the Village population for nonconformity in general attracted interracial couples—artists and nonartists. Although the white ethnic population in the Village might (and sometimes vociferously did) object, it was well-known by 1963 that "at a time when the attention of the world is focused on racial strife in America, Greenwich Village and a few other Bohemian strongholds are the only communities in the country where interracial couples can live comfortably."[17] Although the avant-garde of the early Sixties was predominantly white, it was nevertheless part of a Greenwich Village publicly committed to the civil rights movement and to racial integration. The Village was a place where interracial arts projects, like interracial couples, could "live comfortably."

LeRoi Jones was a notable African American voice in the Village avant-garde. He wrote poetry and plays and as a music critic provided a link with the predominantly black avant-garde arena of new jazz. As Jones/Baraka tells it, his increasing attraction to theater was actually a product of his growing racial and political consciousness.[18] Ironically, then, the very impulse that initially drew him into the Village theater scene eventually led him away from the white avant-garde, out of the Village, and into Harlem to become one of the most important theorists, playwrights, and producers of the revolutionary black theater movement.[19] By the spring of 1964, with the then-current notoriety of his play *Dutchman,* Jones became known as an African American playwright with a radical political vision. His departure in 1965 from Greenwich Village and its somewhat integrated avant-garde was paradigmatic of the shift by African Americans to political

and aesthetic separatism; it also drastically shrank the African American representation in the downtown avant-garde, leaving the Village bereft of its leading black voice.

As in the mainstream arts, in the avant-garde the theater tended to be the arena where there was significant African American representation. Ellen Stewart, for instance, the founder of Cafe La Mama and an African American, was (and continues to be) one of the most important producers of Off-Off-Broadway theater. In the 1963–64 season, blacks and their quest for freedom and equality entered the limelight in theater venues from Broadway to the East Village. In part, this had to do with the determined effort on the part of Actors Equity since the Fifties to integrate the American theater and to provide more jobs for black actors.[20] In part, it had to do with the increased number of productions Off- and Off-Off-Broadway generally. But it also had to do with a new focus on dramatic material that aggressively put African Americans center stage in an attempt to produce different racial relations in the United States. That is, the point was to project a progressive image toward which the culture could move, rather than merely representing the status quo. The total number of jobs available to African American actors jumped that year from 51 to 168 on Broadway and from 26 to 116 Off-Broadway. Twenty-four productions on Broadway and twenty-seven Off-Broadway employed black actors, and sixteen Broadway productions and eleven Off-Broadway had integrated casts.[21] But the distinctions in the ways African Americans were represented in those different venues were vast, and Off-Off-Broadway was an even farther remove.

In 1963 Josephine Baker, the great comic and erotic revue dancer, film actress, and torch singer of the Twenties who had for nearly half a century been an expatriate living in Paris, returned home triumphantly to speak on civil rights and to tour the country with her show. Baker, active in the French Resistance during World War II, had long been outspoken on the subject of civil rights. She was a featured speaker at the March on Washington in August 1963, where she celebrated the prospect of integration. Later, she said that the March made her fear of American whites disappear. "For the first time in my life I feel free. I know that everything is right now."[22] That winter, Baker sang and danced in a spectacular Broadway display that also featured the Trinidadian dancer Geoffrey Holder, the Aviv Dancers, and the Larl Becham Trio (according to the program, a "primitive and modern dance group"). But the image Baker projected in her Broadway performances, with her designer costumes and entertaining melodies, recalled her life as a glamorous Parisian entertainer more than her political activism.[23]

That season also saw revivals of two musicals for black performers from the Thirties and Forties: *Porgy and Bess* at City Center and a revival of *Cabin in the Sky* at the Greenwich Mews Theater.[24] Black musicals only in the sense that they had African American casts, both were written and scored by whites. Each was criticized in its time as a stereotyped white vision of black life and black music, more appealing to white than black audiences. Baker's concert and these two shows were remnants of an earlier age of black Broadway entertainment marketed as exotica for white audiences.

But several new musicals written by African Americans for African American performers and, importantly, African American audiences emerged that season as well. The venerable poet Langston Hughes provided a crucial historical link between the Sixties and the golden age of black musicals during the Harlem Renaissance in the Twenties. Hughes had since the Fifties spearheaded a movement toward reviving the authentically black musical, but revised for the era of civil rights. His *Black Nativity* (1961), a version of the Christmas story that pioneered the use of gospel music on Broadway, had already stirred controversy over its use of the term "black" (rather than "Negro").[25] Hughes wrote two productions in the 1963–64 season. The contrast between them sets in bold relief the values of Broadway versus downtown theater. *Tambourines to Glory,* adapted from Hughes's novel, moved gospel from incidental music to the center of the musical's plot, which was set in a Harlem storefront church that becomes an opulent but corrupt showcase for evangelism. This was, in a sense, a genuinely African American version of the backstage musical genre.[26] However, in a production in Greenwich Village Hughes offered a much more explicit castigation of American racism. Less than two months after *Tambourines to Glory* closed on Broadway to enthusiastic reviews, Hughes's *Jerico-Jim Crow* opened at the Village Sanctuary (an ecumenical building shared by a synagogue and a Presbyterian church), on Thirteenth Street. It was cosponsored by the Congress of Racial Equality (CORE), the NAACP, and the Student Nonviolent Coordinating Committee (SNCC). In it, the history of African Americans from slavery to sit-ins was told through musical vignettes. The format of the musical reminded reviewers of Martin Duberman's *In White America*—but this time the story was told from a black point of view.[27]

In terms of serious drama, James Baldwin's fiery *Blues for Mister Charlie* was an anomaly on Broadway. A fictional story set in the real-life milieu of southern racial violence—and kangaroo southern justice—it was based on the actual unpunished murders of Emmett Till and Medgar Evers.[28] This was a different picture of United States, indeed, than that offered by the

other nonmusical Broadway offerings of the season, such as an adaptation of Edgar Lee Masters's *Spoon River Anthology* and Neil Simon's *Barefoot in the Park*.

Meanwhile, several young black playwrights downtown were also making waves with new dramas. William Hairston's *Walk in Darkness*, about an African American soldier stationed in Germany and the tragedy of intolerance toward his interracial marriage, was soon forgotten.[29] But LeRoi Jones's *Dutchman*—about a lethal interracial flirtation—and Adrienne Kennedy's *Funnyhouse of a Negro*—about the fragmented inner life of a young black woman poet—ushered in a new black theater movement.

Both were written in a playwriting seminar Jones and Kennedy took with Edward Albee, and both were given workshop productions in January 1964.[30] When *Dutchman* was produced later in the season in an extended run at the Cherry Lane Theater, altogether three LeRoi Jones plays opened Off- and Off-Off-Broadway in one week: in addition to *Dutchman*, *The Eighth Ditch* at the New Bowery Theater and *The Baptism* at the Writers' Stage.[31]

Recent gospel musicals had portrayed the black church as the mainstay of African-American culture—an institution able to provide spiritual comfort in ways that were not necessarily conservative and indeed were compatible with the progressive civil rights phase. In contrast, *The Baptism*, an absurdist comedy of religious transgression, was a searing indictment of Christianity altogether. It features a minister described in the cast list as "pompous, . . . generally ridiculous" and a fifteen-year-old boy who asks to be baptized, confessing that he masturbates every time he prays. Its characters also include a homosexual who dances and comments on the action and an old woman, a religious hypocrite, who denounces the boy and swoons in ecstasy as she describes in erotic detail witnessing his sin. There is a chorus of young women—"young sleek 'Village!' types"—who proclaim the boy to be "the Christ child come back," their holy husband. With the old woman and the minister, they turn on him murderously when he denies it. Finally, there is a messenger—a "motorcycle stereotype"— sent by God to bring the boy back home (it seems he really *is* Christ), since "the man says you just blew your gig." The messenger announces that God intends to destroy the world as soon as the bars close, whacks the resisting boy over the head with a tire iron, and carries him away, and the homosexual, mistaken for dead, crawls out of the pile of lifeless bodies and makes plans to cruise the bars on 42nd Street.[32] Religion, Jones seems to say, is no salvation but a travesty of human relationships.

The Eighth Ditch, written in 1961, in many ways anticipates *Dutchman.* A short play in two scenes set in a tent at a Boy Scout camp, it concerns the seduction of 46, who is "what's known as a middleclassed Negro youth" by 64, "an underprivileged negro [*sic*] youth." Like Lula in *Dutchman,* 64 is experienced, domineering, and preternaturally wise—especially about 46, his history, his desires, and his future. Though "underprivileged," 64 is poetic, philosophical, and intellectually sophisticated. He speaks in cryptic images and lists the variety of blues he's got: "Abstract Expressionism blues. Existentialism blues. . . . Kierkegaard blues. . . . newspaper blues. Or, fool, the blues blues. . . . Got poetry blues all through my shoes. . . . I had the Kafka blues . . . and give it up." When 46 asks him who he really is, 64 replies mysteriously, "The Street! Things around you. Even noises at night, or smells you are afraid of. I am a maelstrom of definitions. I can even fly." As in *Dutchman,* the dynamic of seduction in the two scenes moves from leisurely and private to frenzied and public, as by the end of the play three other Scouts crowd in on the boys' lovemaking to demand, "We gotta get some too."[33]

The action in *The Eighth Ditch* may be not so much a sexual seduction as a spiritual fusion; 46 and 64 may be aspects of the same self. Baraka has stated that they are " 'the same person,' a 'kind of schizophrenic thing. . . . The different element, that is, I guess, the petit bourgeois background caught between the working class and the aspiring bourgeois.' "[34] And indeed, 64's insistence that "I want you to remember me . . . so you can narrate the sorrow of my life. . . . I want to sit inside yr head & scream obscenities into your speech," and 46's suspicion after they have sex that now "I guess I'll get pregnant" powerfully suggest that sex here is besides the point; it is a metaphor for the recognition and acceptance of multiple, not always desired, components of the self. Once 64 "enters" 46, they form a new, integrated identity that 46 will give birth to. Since the action of the play takes place in 1947 and makes reference to what might be seen as events in Jones's own life, one might even assume that 46 and 64 are both autobiographical figures. As in *Dutchman,* the middle-class intellectual engages in agonistic struggle with his own inescapable ethnic heritage—"the blues people"—and seeks to give birth to himself as a truly black intellectual, taking on the political burden of "narrating the sorrow" of all black people's lives.

Dutchman was the play in which these concerns sharply crystallized. Set in the New York subway, "the flying underbelly of the city," as its classic opening line has it, the play resonates with mythic and literary allusions, but, sizzling with visceral immediacy, it is anything but academic. Clay, an

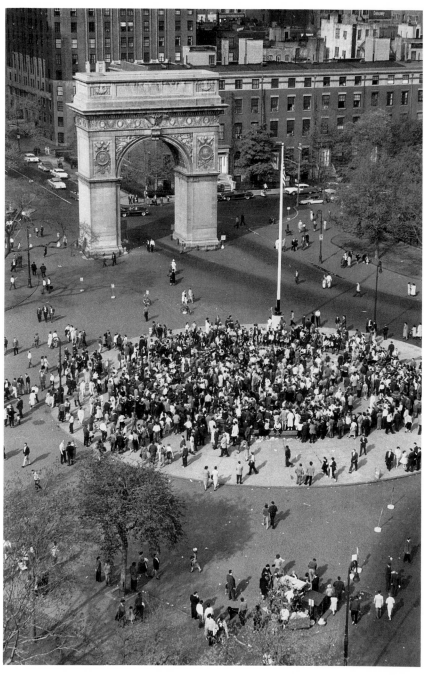

"Washington Square on a summer's afternoon," from Fred McDarrah, *Greenwich Village* (1963), p. 25. By permission of Fred W. McDarrah.

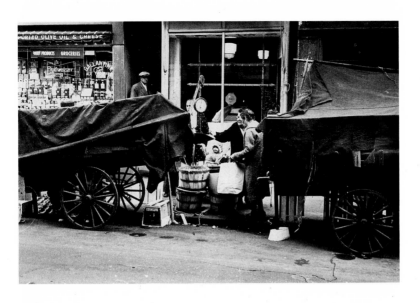

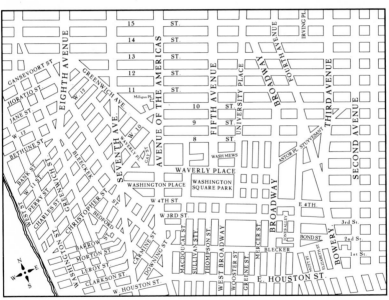

"Bleecker Street pushcarts," from Fred McDarrah, *Greenwich Village* (1963), p. 59. By permission of Fred W. McDarrah.

Map of Greenwich Village, 1963.

San Gennaro Festival. By permission of Fred W. McDarrah.

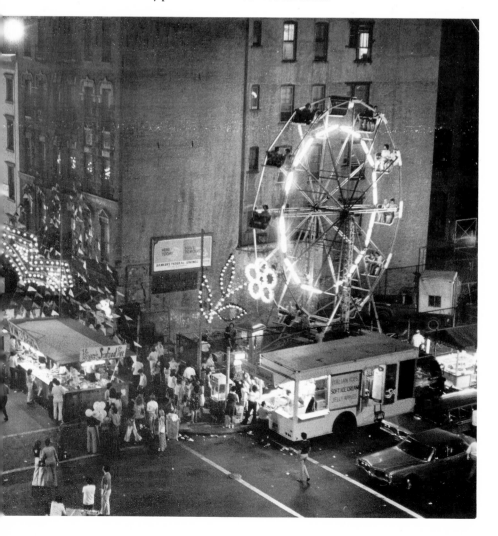

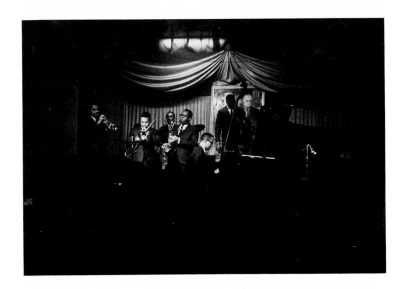

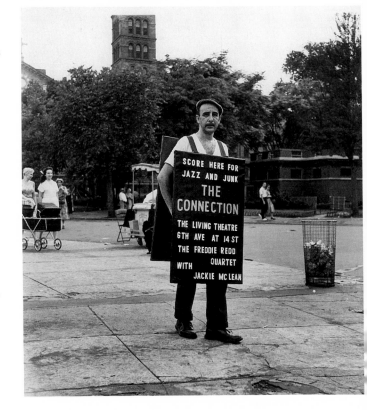

Jazz Gallery, St. Mark's Place, from Fred McDarrah, *Greenwich Village* (1963), p. 85. By permission of Fred W. McDarrah.

Sandwich board for *The Connection*, from Fred McDarrah, *Greenwich Village* (1963), p. 87. By permission of Fred W. McDarrah.

Facing page: "Mac-Dougal Street at night, a perpetual street fair," from Fred McDarrah, *Greenwich Village* (1963), p. 57. By permission of Fred W. McDarrah.

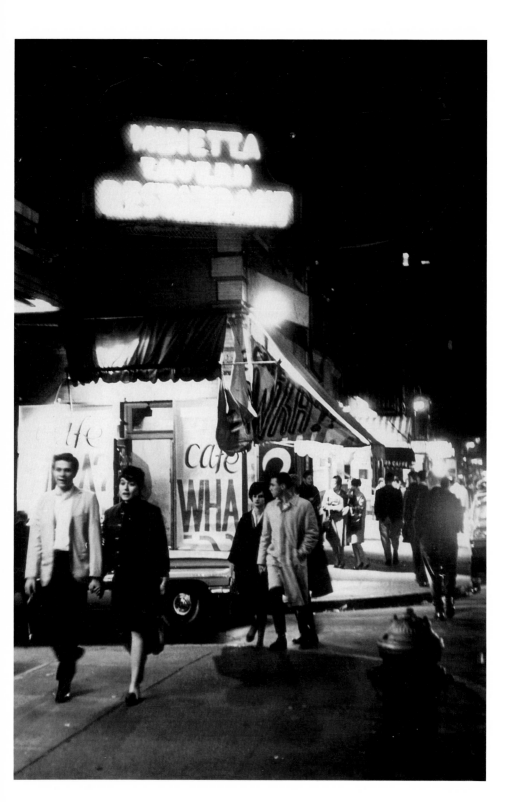

Judson Poets' Theater: *What Happened* by Gertrude Stein, directed by Lawrence Kornfeld. Al Carmines is at the piano, Arlene Rothlein sits on the piano, and Lucinda Childs is carried aloft. Photo © 1963 Peter Moore. By permission of Peter Moore.

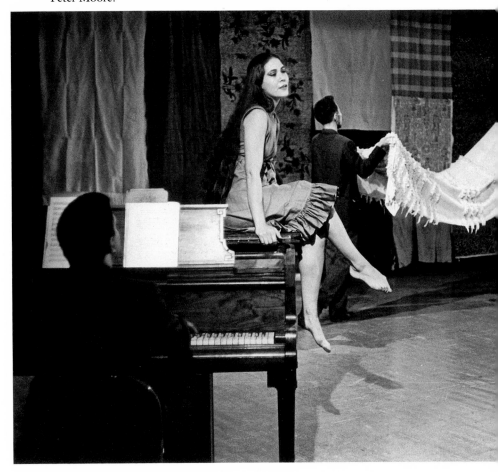

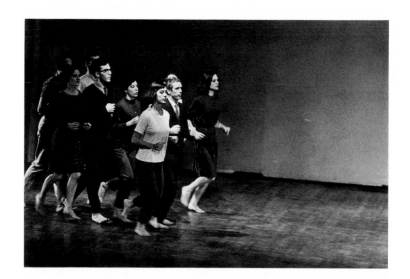

Yvonne Rainer, *We Shall Run* (1965 performance at the Wadsworth Atheneum, Hartford, Connecticut). *Left to right*: Sally Gross, Tony Holder, Deborah Hay, Yvonne Rainer, Alex Hay, Lucinda Childs; *left to right, partially hidden:* Robert Rauschenberg, Joseph Schlichter, Robert Morris. Photo © 1965 Peter Moore. By permission of Peter Moore.

Barbara Dilley and son in Steve Paxton's *Afternoon*. Photo © 1963 Peter Moore. By permission of the Archives of Experimental Art.

Caffe Cino. By permission of Fred W. McDarrah.

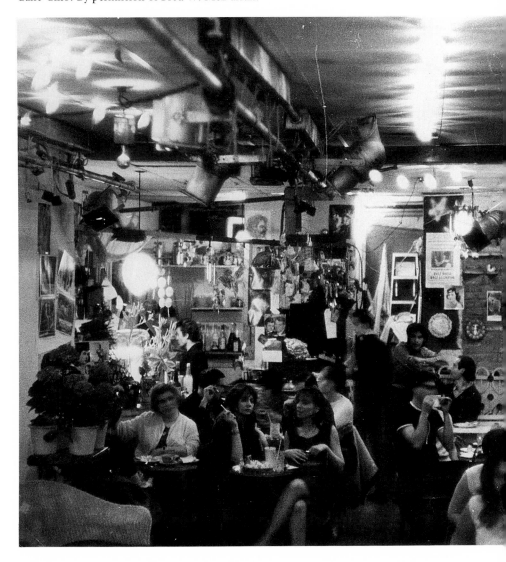

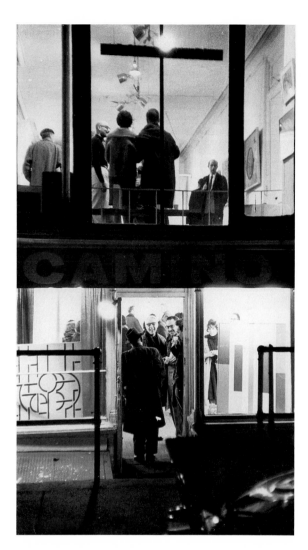

"A Friday night opening on 10th Street. Upstairs, Aegis Gallery; downstairs, Camino Gallery; Littlefield and Dworzan in the doorway," from Fred McDarrah, *Greenwich Village* (1963), p. 73. By permission of Fred W. McDarrah.

Fluxus Editions of George Brecht's *Valoche/A Flux Travel Aid*. Photo by Brad Iverson. Courtesy of the Gilbert and Lila Silverman Fluxus Collection, Detroit.

La Mama's Ellen Stewart (*center*) at home in 1969. *Left to right:* Wahundra, Victor Lapari, Ellen Stewart, Leonard Melfi, Chin Yee. From the private collection at the La Mama E.T.C. Archives and Library. Courtesy of Ellen Stewart.

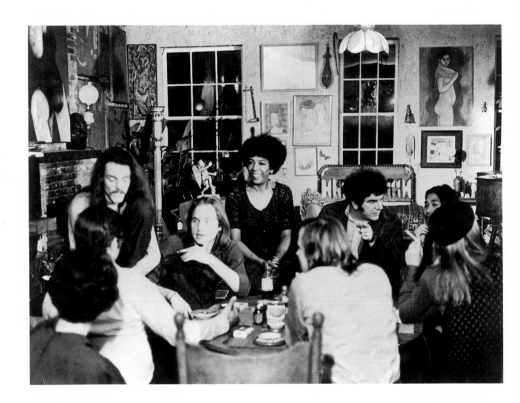

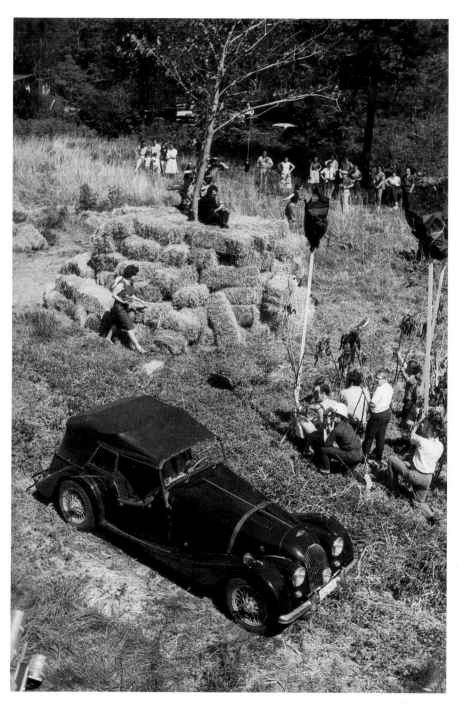

Allan Kaprow, *Tree*. Photo © 1963 Peter Moore. By permission of Peter Moore.

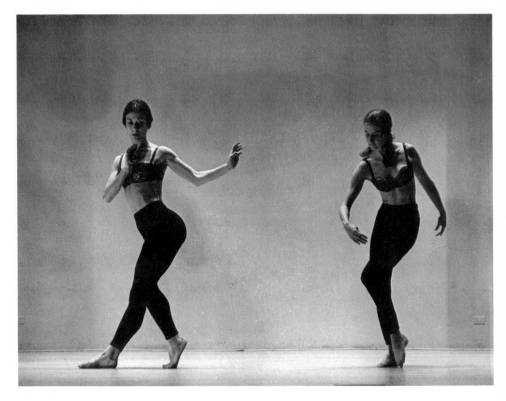

Jack Smith in Ken Jacobs's *Little Stabs at Happiness*. Courtesy of Anthology Film Archives.

Yvonne Rainer and Trisha Brown in "Duet" section of Rainer's *Terrain* (at Judson Hall). Photo © 1963 V. Sladon. By permission of V. Sladon.

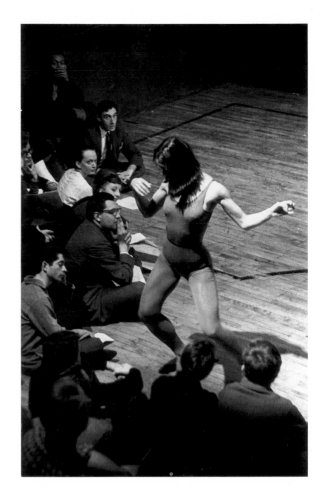

Yvonne Rainer, *Three Seascapes.*
In the audience: Al Carmines (in
glasses); *to his left,* Gretchen
Maclane; *to her left,* Jennifer
Tipton. Photo © 1963 Al Giese.
By permission of Al Giese.

Taylor Mead in Ron Rice's
*Queen of Sheba Meets the Atom
Man.* By permission of Anthol-
ogy Film Archives.

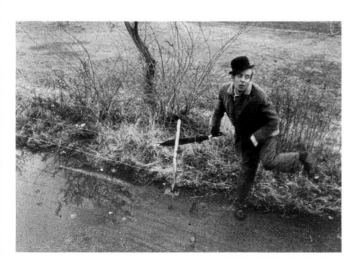

Roy Lichtenstein, *Drowning Girl.* © 1963 Roy Lichtenstein. Courtesy of the Museum of Modern Art.

Andy Warhol shows his Brillo boxes at the Four Seasons' showing of Pop Art. He is flanked by model Robin Mac Donald (*left*) and artist Jane Wagner (*right*). By permission of AP/Wide World Photos.

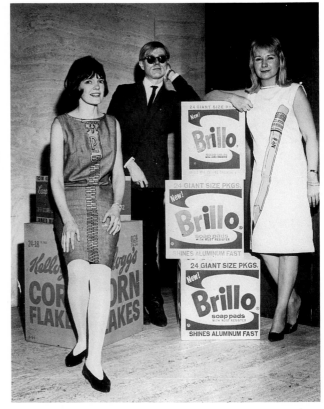

Tom Wesselmann, *Still Life #28* (mixed media, collage, and live TV on board). © 1992 Wesselmann/VAGA, New York. By permission of VAGA. Courtesy of Sidney Janis Gallery, New York.

Claes Oldenburg, *Bacon, Lettuce, and Tomato* (mixed media). Photo by Geoffrey Clements. From the collection of Conrad Janis. Courtesy of Sidney Janis Gallery.

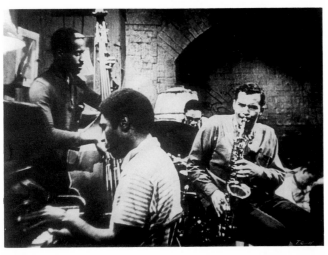

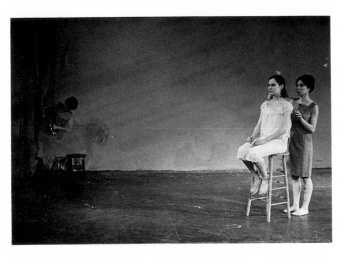

Facing page, top to bottom: Kenneth Anger, *Scorpio Rising.*

Scene from Shirley Clarke's film *The Connection.* Courtesy of the Wisconsin State Historical Society Film Archive.

Judith Dunn, *Acapulco. Left to right:* Judith Dunn, Lucinda Childs, Deborah Hay. Photo © 1964 Peter Moore. By permission of Peter Moore.

Below: Robert Rauschenberg, Carolyn Brown, and Alex Hay, in Rauschenberg's *Pelican* (at the 1965 First New Theater Rally). Photo © 1965 Peter Moore. By permission of Peter Moore.

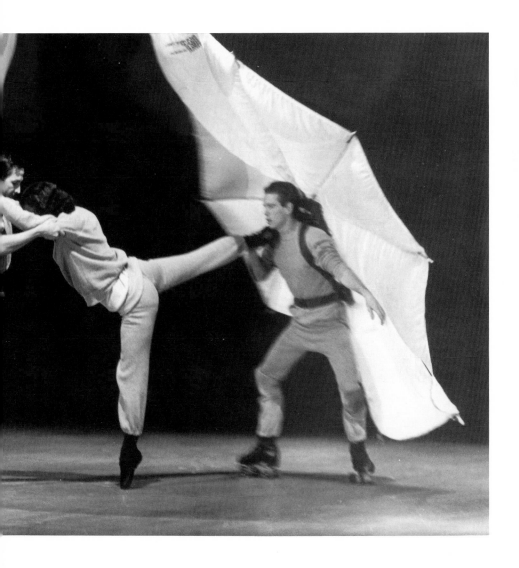

Jennifer West and Robert Hooks in LeRoi Jones's *Dutchman*. Photo by Alix Jeffry. Courtesy of the Billy Rose Theater Collection, the New York Public Library for the Performing Arts, Astor, Lenox, and Tilden Foundations.

Shirley Clarke shooting *The Cool World*. Courtesy of the Wisconsin State Historical Society Film Archive.

Jack Smith's *Flaming Crea-tures.* Courtesy of Anthology Film Archives.

Yvonne Rainer and William Davis in "love" duet, part of "Play" in Rainer's *Terrain.* Photo © 1963 Al Giese. By permission of Al Giese.

Kenneth H. Brown's *The Brig,* with the original cast of the Living Theater production by Julia Malina and Julian Beck, from the film by Jonas and Adolfas Mekas. Courtesy of Jonas Mekas.

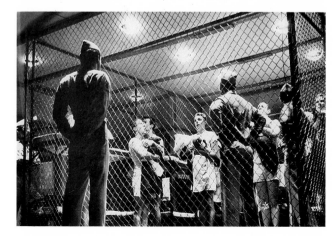

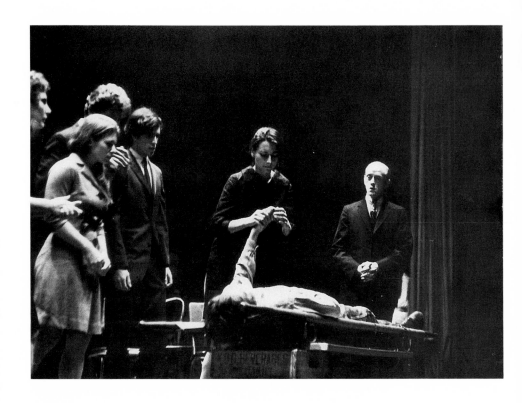

Open Theater. By permission
of Fred W. McDarrah.

Robert Indiana in Andy
Warhol's *Eat*.

Allan Kaprow, Cave Plan for *Eat*. By permission of Allan Kaprow.

Allan Kaprow, *Eat*. Photo © 1963 Peter Moore. By permission of Peter Moore.

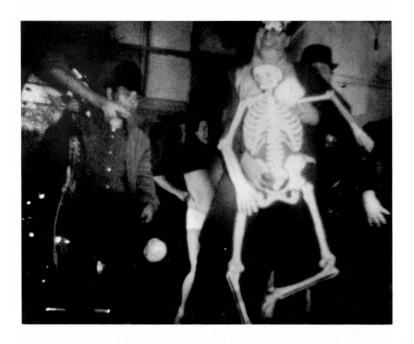

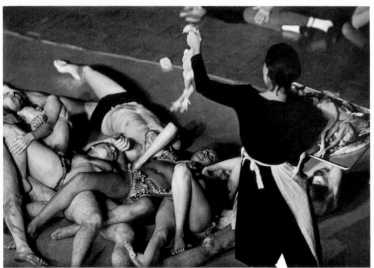

The party scene in Kenneth Anger's *Scorpio Rising*.

Carolee Schneemann, *Meat Joy*. Photo © 1964 Peter Moore.
By permission of Peter Moore.

Andy Warhol's *Kiss.*

James Anderson, Gretel Cummings,
and Fred Herko in Rosalyn Drexler's
Home Movies. Photo by Van Williams.
Courtesy of the Billy Rose Theater
Collection, the New York Public Library
for the Performing Arts, Astor, Lenox,
and Tilden Foundations.

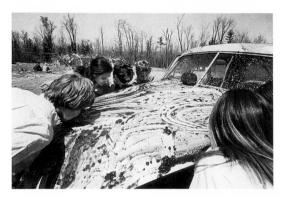

Allan Kaprow, *Household*. Photo by
Sol Goldberg/*Ithaca Journal*. By
permission of Harry Abrams.

Letty Eisenhauer in Ben Patterson's
Lick Piece. Photo © 1963 Peter Moore.
By permission of Peter Moore.

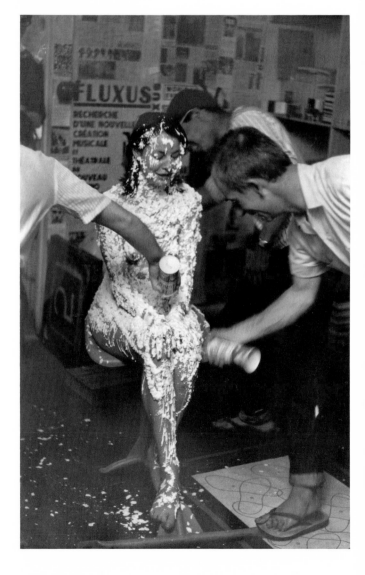

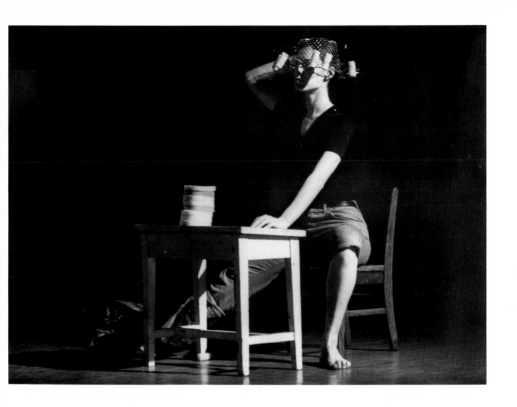

Alex Hay, poster for Judson Dance Theater Concerts #6 and #7. Courtesy of Yvonne Rainer.

Lucinda Childs, *Carnation*. Photo © 1964, 1991 Peter Moore. By permission of Peter Moore.

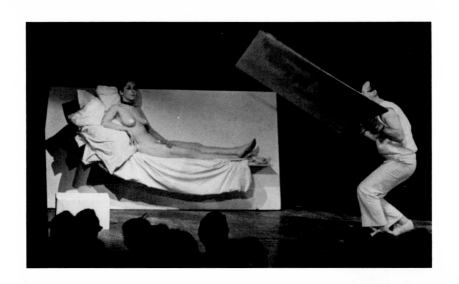

Carolee Schneemann and Robert Morris in Morris's *Site*. Photo © 1964 Peter Moore. By permission of Peter Moore.

Steve Paxton and Yvonne Rainer in *Word Words*. Photo © 1963 by Al Giese. By permission of Al Giese.

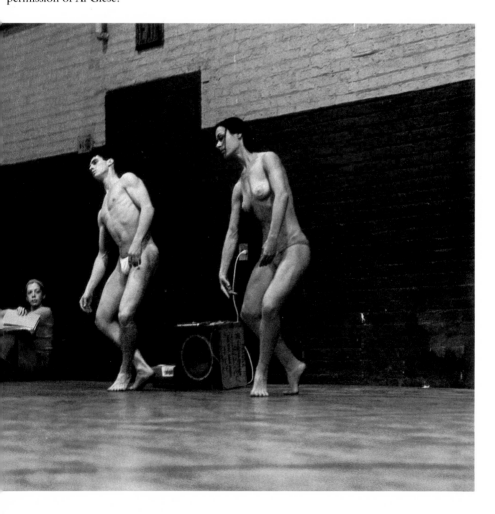

Stan Brakhage, *Thigh Line Lyre Triangular*. Courtesy of Anthology Film Archives.

Neil Flanagan in Lanford Wilson's *The Madness of Lady Bright* at Caffe Cino. Photo by James Gossage. Courtesy of the Billy Rose Theater Collection, the New York Public Library for the Performing Arts, Astor, Lenox, and Tilden Foundations.

Facing page: George Segal, *Woman Shaving Her Leg* (plaster, metal, porcelain, masonite). Collection of Mrs. R. Mayer, Chicago. © 1992 Segal/VAGA New York. By permission of VAGA.

James Waring, *At the Hallelujah Gardens. Left to right*: Yvonne Rainer (*rear*), Arlene Rothlein, Diane Cernovich, and Waring. Photo © 1963 Peter Moore. By permission of Peter Moore.

Stan Brakhage, *Dog Star Man*.

Judson Memorial Church seen through the Washington
Square arch. Photo by Elain Christensen. Courtesy of
Judson Memorial Church, New York City, with the
permission of Elain Christensen.

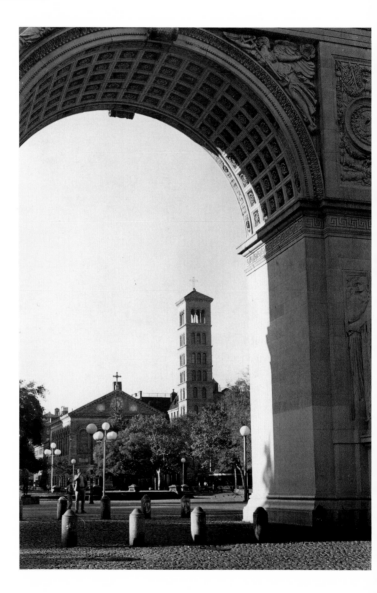

African American intellectual, is approached by Lula, a white woman, on the subway. She eats apples and offers him one; he confesses he dreamed of being Baudelaire. She seems to know everything about his past and she projects his future, too. Like Wedekind's Lulu, or the apocryphal Lilith, she is a dangerous seductress whose love spells death. But like the mythic Flying Dutchman, she also seems doomed to ride her ship—the subway—forever, searching for a futile love. During their impossibly long train ride, first Lula stirs Clay up sexually and then, when the seduction reaches a fevered pitch, she incites him with exhortations and insults to racial anger. When he pours forth the rage of an entire people and predicts a violent black revolution, she stabs him and orders the other subway riders to throw the body out of the car, only to eye the next young black man who enters the car and, we assume, to begin the ritual again.

Dutchman is a complex multilayered work about freedom and domination. On one level, it is a sexual struggle between a man and a woman, or, as the apple-eating suggests, between Man and Woman. But as in *The Eighth Ditch*, agonistic sex here also serves as a metaphor for other struggles—between parts of the self, or between parts of the nation. In many ways Lula seems to be Clay's conscience, or, perhaps, his unconscious. When she admonishes him for being an Uncle Tom or makes fun of his middle-class aspirations, when she tells him secrets about his past, when she urges him to "break out. Don't sit there dying the way they want you to die," she seems less a taunting outsider than part of his own soul. Yet, most often, she is the part of him that is white and middle-class. And in that sense, Lula is white America to Clay's black America—taunting yet seductive, envious yet repressive, and ultimately possessing the reins of power that control life and death.[35]

Besides these plays by African American authors, a number of political plays about blacks by white authors were also part of the Village repertory in the 1963–64 season. Two were by foreign playwrights: Jean Genet's *The Blacks,* a play with prescient incendiary revolutionary rhetoric, and Athol Fugard's *The Blood Knot,* a drama of two brothers—one light-skinned and one black—in South Africa.[36]

In White America, which opened at the Sheridan Square Playhouse in October 1963, was written by Martin Duberman, a white history professor at Princeton University.[37] Duberman tried to avoid the pitfalls of his own situation—a white historian's presumption to speak for African Americans—by creating a play out of excerpts from authentic historical documents that represented both white and black voices. Although the play was driven forward by chronology, the underlying format was collage. As *Jerico-*

Jim Crow would shortly do in emotionally rousing musical vignettes, *In White America*, through the cold, glaring facts of historical evidence, traced the story of African Americans from the slave trade to the sit-ins. It began with a slave ship doctor's report on the abominable physical conditions of the human cargo and ended with Elizabeth Eckford trying to attend high school in segregated Little Rock; it included excerpts of documents ranging from slave narratives recorded by the Federal Writers' Project, *The Confessions of Nat Turner*, and Mary Boykin Chesnut's *A Diary from Dixie* to proceedings of Ku Klux Klan trials and speeches by Sojourner Truth, Booker T. Washington, and Marcus Garvey. Punctuated by African American spirituals and folk songs, the text began and ended with the integrated cast intoning "Oh, Freedom!" *In White America* made abundantly clear that 1963, the centennial year of the Emancipation Proclamation, had still not witnessed the true liberation of the African American. Critics noted in particular Duberman's revisions of official history that had whitewashed racist attitudes of Thomas Jefferson and Woodrow Wilson. The *Newsday* critic Al Cohn remarked that "freedom is the key to Duberman's play—the freedom which has eluded the Negro since his ancestors were beaten, shoved and squeezed into slave-trade ships 200 years ago and brought to this country from Africa."[38]

Still, *In White America* appeared sweetly liberal compared to the rage of Jones's *Dutchman*. For many, Duberman's play was clearly a play by a white (however well-intentioned) that showed black history (however well-revised) to predominantly white audiences. It roused pity and galvanized good intentions, and it ended by implying optimistically that sit-ins and civil rights actions would end segregation and gain African Americans their full human freedom. But *Dutchman* predicted revolution in the streets. If *In White America* reflected the present condition of racist society, *Dutchman* was engaged in actively agitating for black revolutionary consciousness.

Besides these plays specifically about the African American condition, several downtown plays on other themes included black cast members. For instance, the Living Theater's production of *The Connection* incorporated music by the Freddie Redd Jazz Group, and that play's cast (as well as that of *The Brig*) was integrated in a completely nonsymbolic way. The Judson Poets' Theater production of *Miss Right* had an integrated cast. So did the JPT production of Drexler's *Home Movies*, with its deliberately stereotypical black servants. Barbara Ann Teer (who would become an important figure in the black theater in Harlem in the later Sixties), appeared as Violet, the black maid, and James Anderson played the deliveryman.

Outside New York, 1963 saw the founding in Mississippi of the Free Southern Theater by three black actors and directors who were also civil rights workers—Gilbert Moses, Doris Derby, and John O'Neal. They were soon joined by a white director, Richard Schechner, as well as by other actors, black and white. Linked to the Freedom Movement, the Free Southern Theater's purpose was "to bring live, integrated and relevant theater to those who have no theater."[39] The actors and director spent their first few months organizing financial backers for their project, put their lives on the line when they toured their first production—Duberman's *In White America*—through rural Mississippi in the summer of 1964, and by that autumn were touring Mississippi, Louisiana, Alabama, Tennessee, and Georgia with Ossie Davis's *Purlie Victorious* and Samuel Beckett's *Waiting for Godot*. Although based in the South and aimed at southern black audiences, at first the Free Southern Theater counted on New Yorkers—in both the theater world and the civil rights community—for its financial and political support. In fact, Stuart Little wrote in August 1964, shortly after a fund-raiser in the New York theater community, "the Free Southern Theater is probably better known in New York than it is in Mississippi. It has engaged the loyalty of a good section of the New York theatrical community." As well, the group held auditions for actors in New York when the theater expanded that fall.[40] Although its relationship to the New York theater world was problematic in terms of the group's internal debates—whether the theater should perform in New York, even for political events, was a contested issue—nevertheless it was part of the New York theatrical landscape.[41]

In the other arts the group Fluxus was another exception to the generally Euro-American demographics of the avant-garde, with members including the African American composer Ben Patterson, the Japanese artists Yoko Ono and Takehisa Kosugi, and the Korean video artist Nam June Paik. In the visual arts and Happenings the figurative painter Bob Thompson joined the Martha Jackson Gallery on his return from Europe in late 1963. Friendly with LeRoi Jones, the writer A. B. Spellman, and the jazz musicians on the loft scene, as well with as the new primitivists at the City Gallery (Jay Milder, Christopher Lane, and Red Grooms), Thompson used musical rhythms to shape the vivid colors and jagged forms on his canvases. Often he quoted Renaissance masterpieces, reworking the human figures in a violently Fauvist palette.[42] Although in the late Fifties Thompson performed in several of Red Grooms's Happenings, he never was drawn toward making performances himself.

But there were no black underground filmmakers, although black actors

and actresses, as well as explicitly black themes, appeared in films by Jonas Mekas, Ron Rice, Shirley Clarke, Michael Roemer and Robert Young, and others. There were no downtown black dancers (although the jazz composer Cecil Taylor participated in the first Judson concert, collaborating with choreographer Fred Herko). Choreographer Gus Solomons, whose work by the late Sixties was abstract, mathematically structured, and often tailored for unusual spaces, in the early Sixties showed his work uptown and danced in the modern dance companies of Martha Graham, Pearl Lang, Donald McKayle, and Joyce Trisler. There were no black Happenings-makers; no black Pop artists.

Clearly, some of the reasons for that relative absence have to do with limited access and training opportunities available to African Americans before the civil rights years. That is, many black artists may not have had a taste for the kind of iconoclastic activity—the product of some measure of educational privilege—in which the white artists reveled. But also, already the interests of many middle-class black artists who might have participated were drawn in other directions. Some, in keeping with the integrationist temper of the times, were not particularly attracted to the avant-garde because it was too marginal; they believed African Americans should penetrate mainstream American culture. (Indeed, for the first time it seemed that they could.) [43]

But some blacks were drawn away from both the white mainstream and the white avant-garde in more overtly political directions, affirming a separate black culture, as LeRoi Jones would do by early 1965. In dance, Alvin Ailey in the late 1950s organized a company for black dancers, choreographing highly expressive works that plumbed traditional African American music, from gospel to the blues. His signature piece, *Revelations,* choreographed to spirituals and gospel, is rooted in the musical and movement experiences of the black church. This was a far cry, for instance, from the white avant-garde's experiments with separating music from the dance or using chance techniques to subvert expression—from indulging, some felt, in overintellectualizing dance.

The white avant-garde was inspired by the black movement for equality and freedom in both direct and indirect ways. For some white artists, like Philip Corner and Jackson Mac Low, a staunch commitment to social and racial justice led to both political and artistic action in the civil rights struggle. White artists welcomed and at times aggressively sought black participation as a symbol of an ideally integrated American society—as in *The Living Premise,* an integrated revue by the improvisational comedy group The Premise. Various avant-garde music concerts (like the Two Sun-

day Evenings for Mississippi, organized by Tone Roads) included work not only by white musicians John Cage, Philip Corner, La Monte Young, and Morton Feldman, but by black jazz artists Archie Shepp and Ornette Coleman. The first Tone Roads concert, devoted to music by Charles Ives, included "The Anti-Abolitionist Riots," clearly a relevant political choice in the context of the new Freedom Movement. At the Five Spot the owners organized "Sit-in for Freedom" jazz concerts in October 1963. The Martha Jackson Gallery held a benefit sale for CORE in May 1963 and displayed paintings by a young white art teacher at the University of Mississippi, which had been banned from the university's art gallery for their unconventional depictions of the riots during James Meredith's enrollment.[44] James Rosenquist's *Painting for the American Negro* (1962–63) among other images showed black athletes and the outline of a white figure, taken perhaps from an advertisement, resting his feet on the head of a black man— i.e., literally "keeping the black man down." Andy Warhol made multiple images of the Birmingham riots. And Dick Higgins wrote a score for a rule-game performance, *The Freedom Riders,* involving an integrated cast playing personae from the entire spectrum of class and political positions.[45]

Shirley Clarke's 1963 film *The Cool World,* based on Warren Miller's novel, was about black youths caught up in street drug deals and gang violence. A fiction shot in documentary style on the streets of Harlem, it featured semi-improvisatory performances by both downtown actors (Carl Lee and Gloria Foster, as two of the adults) and neighborhood kids (including Hampton Clanton, Yolanda Rodriguez, Clarence Williams, Gary Bolling, and Bostic Felton). Punctuated with jazz riffs composed by Mal Waldron, the film itself, with its abrupt cuts, fragmented narrative, and nervous energy, seems to embody a jazz structure. Although made by a white director, both its jazz structure and its cinema verité style—in particular the on-location shots with extensive local detail and the extraordinary acting by the young nonactors—create a sense of authenticity. And the tragedy of the young hero's fate—trapped in a destructive ethos of "cool" gang machismo—is not treated as ghetto pathology but as firmly located in a larger social milieu of racism and segregation.[46] Michael Roemer and Robert Young's *Nothing But a Man* also showed life, this time in the South, from the point of view of black characters.[47] Both these independent films by white directors attempted to describe the lives of African Americans and to give space to a black perspective on American culture.

To be sure, mainstream culture also decried the situation of blacks— as in Robert Mulligan's powerful film adaptation of Harper Lee's novel *To Kill a Mockingbird* (1962), showing racial violence in the South from a

white child's point of view. But the avant-garde took more extreme positions, from the ritual violence of Jones's plays to the black viewpoints of the Clarke and Roemer-Young films. The absurd cartoon of the overly servile, overly sexy black maid and the overendowed black delivery man in Drexler's *Home Movies* seems deliberately drawn in exaggeratedly bad taste as racial stereotypes in order to spoof white liberal values in the most transgressive terms.

Besides these works made in the context of the civil rights struggle, white artists adopted, perhaps not always consciously, elements of African American art and performance. These included improvisation and the fusion of the arts usually considered separate in the Euro-American tradition. A number of those elements by now permeated American popular culture (albeit often in distorted form—for instance, in the stereotyped humor inherited by vaudeville, radio, films, and television from the nineteenth-century minstrel show). And avant-garde artists were involved in appropriating popular culture. Thus, the increasing Africanization of American culture took place on at least two bands of the cultural spectrum—from mainstream mass entertainment (in the form of rock and roll, social dancing, comedy, and sports) to avant-garde allusions.

Improvisation, in particular, was seized on by avant-garde artists as a potent emblem of freedom. Other traditions of improvisation were available in the culture. For instance, on the West Coast the San Francisco Mime Troupe practiced commedia dell'arte techniques, and Yvonne Rainer's descriptions of her free-associative techniques resemble Surrealist methods. But it was the African American tradition, particularly as manifested in jazz, that the avant-garde prized.

Jazz itself was engaged in renewing its central practice of improvisation. LeRoi Jones wrote about the new "free jazz" avant-garde as a movement toward the liberation of that music from commercial formats and formal conventions.

> What Coleman and Taylor have done is to approach a kind of jazz that is practially nonchordal and in many cases atonal. . . . Their music does not depend on constantly stated chords for its direction and shape. Nor does it pretend to accept the formal considerations of the bar. . . . In a sense, the music depends for its form on the same references as primitive blues forms. It considers the *total area* of its existence as a means to evolve, to move, as an intelligently shaped musical concept, from its beginning to its end. . . .

"This approach liberates the improviser to sing his own song really, without having to meet the deadline of any particular chord."

For Jones, these liberatory methods stand for—perhaps even produce— radical existential change. This in turn fuels social change. "The implications of this music are extraordinarily profound, and the music itself, deeply and wildly exciting. Music and musician have been brought, in a manner of speaking, face to face, without the strict and often grim hindrances of overused Western musical concepts; it is only the overall musical intelligence of the musician which is responsible for shaping the music. It is, for many musicians, a terrifying freedom."[48]

The African American tradition of musical improvisation was translated into theater, dance, and other artistic practices of the white avant-garde. For instance, working on *The Connection*—a play that not only incorporated African American jazz musicians in its cast, but took the improvisatory structures of jazz as a basis for dramatic form—was an epiphany for the Living Theater. Directing the play, Judith Malina developed the text even further by having the actors improvise both dialogue and actions. According to Julian Beck's recollection: "We, who had sought to develop style through variations of formal staging, found suddenly in the free movement and the true improvisation of *The Connection* something we had not formerly considered. . . . An atmosphere of freedom in the performance was established and encouraged, and this seemed to promote a truthfulness, startling in performance, which we had not so thoroughly produced before."[49] Improvisation thus stood for both liberation and authenticity.

Joseph Chaikin based the Open Theater's early work partly on the games and improvisations he had learned from Viola Spolin. But eventually Chaikin refined a particular technique of improvisatory sound and movement that he called "jamming," clearly a reference to jazz practice.

Jamming is the study of an emblem. . . . [It] becomes a kind of contemplation of that emblem. The term comes from jazz, from the jam session. One actor comes in and moves in contemplation of a theme, traveling within the rhythms, going through and out of the phrasing, sometimes using just the gesture, sometimes reducing the whole thing to pure sound, all of it related to the emblem. Then another comes in and together they give way and open up on the theme. During the jamming, if the performers let it, the theme moves into associations, a combination of free and structured forms.[50]

In many ways, the concerns of the white avant-garde were simply irrelevant to the concerns of black artists in the early Sixties, despite the avant-garde artists' interest in and appropriation of American popular and folk traditions. In spite of their own attacks on the bourgeois values of Euro-American high art, the concerns and the practices of the white avant-garde still grew inexorably out of that high art tradition. Most African American artists were interested in consciously building on, celebrating, and contributing to a specifically African American culture. That is, while American culture in general and the avant-garde in particular were becoming Africanized, black artists, in advance of the Black Power movement of the later Sixties, were resisting Europeanization. And while white artists sympathized with African Americans and used African American symbols and techniques to shape their own quest for freedom, white and black artists could not help but have different artistic and political agendas.

In looking back, while it is easy to see the spaces where blacks and other people of color were absent, 1963 is still striking as a fleeting moment when, relative to the Fifties avant-garde, the racial situation had suddenly changed. First of all, there *were* more African American artists, and there were more outlets for their work. Second, there was more socially committed art, by both blacks and whites, demanding freedom for African Americans. Third, there was a growing racial consciousness—at a time when, despite the fight for integration among liberals, many blacks were already beginning to feel caught in the more radical paradigm shift from integration to separation that was not yet strongly articulated as cultural separatism or Black Nationalism. So 1963, in particular, was a time of flux, when blacks were attracted to the art world, when the art world opened itself up both to racial integration and to African American cultural influence, and when blacks and whites introduced themes of integration and liberation. As in the rest of the civil rights movement, and as in so many ensuing political arenas in the art of the Sixties, the mainstream did not seem to offer enough quickly enough. So in 1963 the predominantly white avant-garde arena was still able to serve as a space for radical cultural criticism, although only partly so along racial lines.

Cold War Rhetorics

American cold war discourse posed stark contrasts between communism and capitalism in terms of exercising political, economic, artistic, and personal freedom. Cold war rhetoric, however, could not completely mask some glaring absences of liberties in the United States. The Freedom

Movement was one oppositional arena that challenged the complacency of that rhetoric. Two other arenas concerned the early Sixties avant-garde—free speech and the protest against militarism. To give context to the discussion of obscenity and censorship, the contrasting rhetorics concerning Soviet vs. American policies on artistic freedom need to be examined. In particular, the disparity will be noted between overt American criticism of Soviet attitudes toward art as propaganda and covert American participation in our own use of ideologically charged art.

The 1963–64 season was one in which Soviet and American artists and audiences had a chance to inspect one another's policies and practices at close range. The thaw taking place in the Soviet Union since Joseph Stalin's death by the late Fifties had resulted in unprecedented liberalism in the Soviet Communist party's official position on literature and the arts. After the Cuban missile crisis, the United States was relaxed enough to let the cold war re-form itself as a cultural competition. By 1963 all sorts of cultural exchanges were taking place. Theater groups, dance companies, playwrights, poets, and critics paid reciprocal visits to one another's cultural centers. Journalists here reported on the swings of the cultural barometer there. And in 1963–64 there was much along these lines to report. In December 1962 Nikita Khruschchev, shocked by abstract paintings at an exhibition in Moscow, began a crackdown on liberal tendencies in art that seesawed throughout 1963 and 1964, throwing the contrast between East and West into even bolder relief.

The cultural exchanges of 1963 and 1964 climaxed in 1965 with a visit to the United States by the Moscow Art Theater. Cofounded in 1898 by the legendary director Konstantin Stanislavsky (with Vladimir Nemirovich-Danchenko), by the Sixties it was a Soviet cultural treasure. Mainstream American theater (and by the Sixties, Hollywood acting as well) was staunchly grounded in Method acting—the American version of Stanislavsky's teachings. So this visit was a signal event, providing an opportunity for American theater artists to measure their skills against the heirs of the Russian master. But the avant-garde had a different agenda. In MAT's visit they saw the trajectory of realist theater since the turn of the century, and they reasserted an alternative trajectory, away from realism and its associated techniques. For the Judson Poets' Theater director Lawrence Kornfeld, for instance, the Moscow Art Theater's productions simply looked artificial. No amount of illusionistic accuracy could achieve the authenticity of pure presence. In contrast, he thought, downtown artists—not only at his own theater, but at the Living Theater, Caffe Cino, Cafe La Mama,

the Judson Dance Theater, and in Happenings—were involved in producing a *different* kind of realism. It was "ultra-realism," a search for concrete presence in performance, "because we believed that what was happening there and then, with what we had, was what we could do, and that was our art."[51] In other words, Stanislavskian actors turned presence into an interpretation of the text, while the Sixties avant-gardists made a new text out of presence. The kinds of experiments that took place Off-Off-Broadway seemed, in this season, triumphantly to prove the avant-garde's freedom from the hidebound conventions of both Broadway and Moscow.

Ironically, despite the widespread popular image of the contrast between American abundance and Soviet shortages, Russian art, harking back to the nineteenth century, still stood for the outmoded forms of imperial art—elitist, virtuosic, extravagant, and retrogressive. Like the Moscow Art Theater, with its Chekhovian portraits of a decaying nineteenth-century Russian bourgeoisie, the Stars of the Bolshoi Ballet, on tour in the United States in October 1963, represented Russian art in full flower. And even more than the liberal, bourgeois theater of the reformer Stanislavsky, the glittering splendor of this imperial art form, recuperated by the communists for complex historical reasons as popular art, contrasted markedly with the democratic aspirations of postwar American art. Later in the 1963–64 season, plans were announced for a wealth of future importations of Russian dance: tours by the Kirov Ballet, the Moiseyev Dance Company with its theatricalized folklore, and the return of the Bolshoi, all spearheaded by impresario Sol Hurok.

In the American press the hierarchy and feudal strictures of tsarist Russia clinging to Soviet art became conflated with that of modern communist bureaucratic Russia, and both were then, simultaneously, posited as the opposite pole from the expression of equality and freedom in American art. Audiences could admire the visiting Russian artists, but the press never let them forget that the culture they brought with them was the product of a repressive system. New York in 1963 saw, for the first time, Rudolf Nureyev—the ballet star who had defected from the Soviet Union and the Leningrad Kirov Ballet in 1961. He appeared on tour with the British Royal Ballet, where he now worked in an already renowned partnership with the ballerina Margot Fonteyn. Nureyev was as famous for his leap to freedom as for his emotionally charged dancing. Invariably, articles on his visit to the United States emphasized the high political drama of his defection.[52]

But at the same time that we were reminded of the social costs of *their*

art and the range of freedom in *ours,* the edge of omnipresent competition raised anxiety that in some arenas Soviet art might surpass ours. Like August Hecksher, who noted that Krushchev attended the opera during the Cuban missile crisis, the dance critic Walter Terry used the example of the Moiseyev company to urge a reexamination of American cultural practices. "The American debut of the Moiseyev Dancers electrified—and stunned—many Americans, even in government circles. Where was our American equivalent to this remarkable theatrical exploitation of Soviet folklore?"[53] New York's Senator Jacob Javits, arguing in Congress for federal funding for the arts, put it even more baldly: "[Exporting culture] has become urgent now when the arts have become a factor of national prestige in the competition between the Communist bloc and the free world."[54]

However, for the most part, culture gap anxieties were mitigated by the ideological competition that they masked. On the dramatic stage every appearance of Russian or Soviet art became an occasion to meditate in public on the repressiveness of the Soviet regime and thus simultaneously to champion American democratic freedom. The Soviet Union was at that time undergoing a cultural thaw, surpassed only by the events of glasnost and perestroika in the 1980s which led to the breakup of the Union in the early 1990s, and the Sixties thaw was itself underpinned by a spurt of Soviet economic growth. Yet the American media persisted in casting every report, on events both in the Soviet Union and New York, as proof positive that Soviet culture was grim and gray and tolerated no human liberties, not even in what might be thought of as the "virtual" realm of artistic action—an arena our culture, at least in its official form, persisted in seeing as sealed off from everyday life and politics. In contrast, these reports implied—or sometimes stated overtly—American art celebrated freedom by being apolitical. What went unmentioned was that it was in great measure because of the McCarthy anticommunist witch-hunts that American art had become largely apolitical in the Fifties. To some, the detachment of American art from politics was not a measure of freedom but rather of apathy, or even repression. But this radical view was not represented in the mass media.

Sometimes, however, political commentaries in arts coverage by the mainstream media were posed as conciliatory, as if the arts themselves might even provide a common ground for détente—a grass-roots terrain tread on by the common man, somehow free of governmental authority of any persuasion. "There's [some]thing the Russians and we can agree on," Howard Taubman wrote in his review of the Obratsov Puppet Theater's performance on Broadway in October 1963. "We don't need a treaty or

the advice and consent of the Senate to sanction the enjoyment of Sergei Obratsov's Russian Puppet Theater."[55]

Altogether, the importation of Russian theater and dance that season was so omnipresent that Taubman, recommending to his readers the run of the Moscow Circus at Madison Square Garden, wondered "who, by the way, is amusing the Muscovites?"[56]

On the other side of the exchange were the American groups sent to the Soviet Union. The tour by Obratsov's troupe was in answer to Bill Baird's Marionette Theater's tour of the U.S.S.R. in June 1963. The Moscow Circus followed up on a package of selected acts from the Ringling Bros. and Barnum & Bailey Circus that was exported to the Soviet Union in July of that year. In autumn the Joffrey Ballet had an unexpected success in Leningrad, "home of all that is traditional and aristocratic in Russian ballet." It was even suggested that American cultural ambassadors could become somewhat subversive cultural missionaries, importing freedom of expression—craftily packaged in American artworks—to the Soviets. When the New York City Ballet visited the Soviet Union and danced George Balanchine's formalist ballets, Walter Terry reported, younger artists were wildly enthusiastic, and the well-respected ballerina Galina Ulanova, a member of the older generation, was moved to call for the establishment of Soviet experimental ballet theaters.[57]

No matter what the swings in policy, no matter how many external signs of well-being, and despite government support for the arts, the official American view was that Soviet intellectual life was doomed to be stifled, for its arts were not free. Brooks Atkinson reported:

> Despite . . . varied cultural events, Moscow is a dull city. It is the capital of a nation sealed off from the free world. Everything in the city— dramas, paintings, books, newspapers, magazines—repeats the same ritualistic message: the virtues of the Communist party, the triumphs of Soviet Russia, the joyousness of the future. . . . In Stalin's day the controls were absolute and pitiless. Under Khrushchev they are infinitely more humane. . . . The new liberalism is a fact of life that can be recognized everywhere.
>
> But it is not in the nature of the Communist party to be liberal. . . . Although it has relaxed some of the surface controls in the past few years, it cannot afford to soften at the center. That is why this booming, expanding, busy city is backward in the arts and in the discussion of ideas. Marxian socialism is building a dynamic community that is intellectually stifled. In Moscow it is difficult to remember that some-

where outside the long circle of Soviet borders, free people are reading what they like and gaily discussing everything under the sun.[58]

Both the mainstream and the alternative presses followed with great interest the shifting policies of the Soviet state that year on artists' expressive freedom, particularly in literature and visual art. The issue had to do partly with the government's ideological control over artists' work and partly with related questions of style: abstraction vs. socialist realism. Khrushchev's taste dictated some of these shifts. When liberalization allowed for an exhibition of modernist art late in 1962, Khrushchev complained that the painters were "all pederasts." And his candid opinion of jazz was that "it's like gas on the stomach."[59] This, to Americans, was nothing but communist philistinism. But Soviet artistic policies kept oscillating over the next two years, and by the autumn of 1964, the *New York Times* went so far as to report that Khrushchev's earlier attacks on nonconformist artists and intellectuals had been undertaken unwillingly.[60]

For all of the cultural curiosity about Soviet life and art, and for all of the criticism of Soviet policy linking the arts to state ideology, outside of the arguments in Congress over cultural competition, not much was said about the ways in which American art on both the official and unofficial levels also participated in ideological warfare, promoting a certain brand of national chauvinism. That is, Soviet art was castigated as propaganda, no matter how subtle, for communism. But it was only intermittently acknowledged that American art might be seen to propagandize for capitalism. On the one side, art was a weapon, and that was bad; on the other side, art was seen as neutral, and therefore good—as if *that* position were not also a weapon in its own way. In particular, official representations pointed with pride at the liberties that American artists exercised; their work, it was said, was untrammeled by state requirements for or restrictions against content and style.

In the United States—partly as a result of the Soviet brouhaha over the political implications of style—official culture embraced the Soviet dissident view: abstraction became the badge of the artist's expressive freedom in an enlightened culture. Abstraction's difficulty and intellectual nature, it was implied, did not threaten the body politic here but in fact pointed to democracy's ability to tolerate—even to welcome—multiple styles and voices, from the popular to the esoteric. What might have been scoffed at in official circles in the philistine Fifties had become totally acceptable, even exemplary, in the sophisticated Sixties. That is, abstraction was the emblem of both our sophistication and our liberal tolerance. Still further

proof of our democratic enlightenment, the official line went, was the fact that none of the multiplicity of styles or voices was privileged as the only correct one. Not only did we have a multiparty political system; we also had a multischool art system.

In retrospect, it is telling that—although no one remarked on it at the time in quite this way—abstraction *had* become mainstream, official American art, maybe precisely because it *was* an ideological weapon in the cold war competition.[61] It signaled both our distinction from Soviet censorship and our support of Soviet dissident activities. And so our own "dissident" avant-garde (that is, the generation after Abstract Expressionism), paradoxically enough, turned toward a new realism—not necessarily of the rosy socialist, monumental poster variety (and not necessarily to adopt a pro-Soviet or pro-socialist politics) but in some ways strikingly parallel to it. If modernism was characterized by abstraction, the American avant-garde of the Sixties created a postmodern, antiabstract, new realist art that—like Soviet art—was inspired by mass and folk culture.

After all, a Warhol Campbell's soup can had more in common with a Podlyasky tractor than with a Pollock landscape of lines and drips. The common objects in American Pop Art paintings—a profusion of packaged foods, ultramodern kitchen appliances, and mass media images— were different objects from those on Soviet socialist realist canvases, but they were equally concrete in their representation. The early postmodern dancers used techniques of the body light-years away from Russian ballet; their means were impoverished relative to the official Soviet dance companies; and they eschewed the narrative so prevalent in exemplary socialist ballets. Yet they also criticized the abstraction of both Balanchine's modern ballet and Cunningham's modern dance. In theater, on the other hand, where the prevailing mainstream style in the United States already was realism, the Sixties avant-garde made a move from personal to political problems, as in *The Connection* and *The Brig,* and from psychologism to the physical concreteness of the Open Theater, Caffe Cino, La Mama, and the Judson Poets' Theater. I am not claiming here that the exact content of these artworks—for instance, sex, drugs, technology, and the icons of advanced industrial capitalism and its culture of consumption—could be found in socialist realist artworks. But as George Maciunas hinted in his positive assimilation of Fluxus to Soviet art, ironically there was a shared antiabstractionist bias in the concrete arts of the Soviet rear guard and the Greenwich Village avant-garde.

Obscenity and Censorship

Once American avant-garde art moved from the modern to the postmodern by reinstalling figurative content (in visual art), by igniting political issues (in theater), and by introducing previously taboo material (in literature, dance, and film), it was not easy for the state to remain blissfully indifferent. Artists in the early Sixties fully exercised the freedom of expression that was constantly invoked by official American culture during this period. The unofficial culture—the avant-garde—tested every limit of expression with their arts of abundance and excess: by unrestrainedly representing sexuality and using obscene language, sometimes simply by presenting naked bodies, sometimes by making strident political criticisms. And when they did, the repressive arm of the American state's agencies readily moved into action, although usually only the alternative press reported it. As in the Soviet Union, sometimes dissident New York artists also had to go underground (of course, the ramifications of censorship and underground status here were much less violent).

This clash between avant-garde artists and the state was most conspicuous in the film world, which emblematically christened itself Underground Film. In the 1940s and 1950s, avant-garde film was involved in an aesthetic of interiority, a "symbolist-surrealist cinema of intellectual meanings," as Jonas Mekas put it. In the late Fifties, a political "cinema of 'surface' meanings and social engagement" arose. But the new cinema of the Sixties, characterized by "disengagement and new freedom," was thought to be political in more profoundly radical ways, challenging sexual mores, family life, and the work ethic—the very glue of social life.

In May 1963 Mekas announced the launching of a cinematic revolution. This was a revolutionary movement that had Marcusean overtones in its emphasis on bodily liberation. Mekas proclaimed:

> Ron Rice's *Queen of Sheba Meets the Atom Man;* Jack Smith's *Flaming Creatures;* Ken Jacobs' *Little Stabs at Happiness;* Bob Fleischner's *Blonde Cobra* [are] four works that make up the real revolution in cinema today. These movies are illuminating and opening up sensibilities and experiences never before recorded in the American arts; a content which Baudelaire, the Marquis de Sade, and Rimbaud gave to world literature a century ago and which Burroughs gave to American literature three years ago. It is a world of flowers of evil, of illuminations, of torn and tortured flesh; a poetry which is at once beautiful and terrible, good and evil, delicate and dirty. . . .
>
> These artists are without inhibitions, sexual or any other kind. These

are, as Ken Jacobs put it, "dirty-mouthed" films. They all contain homosexual and lesbian elements. The homosexuality, because of its existence outside the official moral conventions, has unleashed sensitivities and experiences which have been at the bottom of much great poetry since the beginning of humanity.[62]

Rice's unfinished film *The Queen of Sheba Meets the Atom Man,* shot in black and white, stars Taylor Mead, Winifred Bryant, and Jack Smith, with appearances by Julian Beck, Judith Malina, and Jonas Mekas. Mead, the mad-scientist-poet-Atom Man, is a classic movie clown. He grotesquely misuses objects—in the opening scene he starts his day by combing his knit cap, washing his hands with Vaseline, relieving himself in the sink, and cooking heroin for breakfast. Later he nibbles a football and a magazine, strokes a banana erotically, powders himself and Bryant with Ajax, and uses a candelabra for a dildo and an enema bag for a teapot. Often, his eyes are crossed, his tongue hangs out, and every muscle in his body seems to be in spasm. He spends his day serendipitously discovering the city with Bryant, succinctly described by Sitney as "a colossal black woman. . . . [who] plays an alcoholic odalisque."[63] Mead slavers over a model of an atom at the Union Carbide "World of the Future" and goes into a mad-scientist routine in a lab (of sorts). Later, he visits the Guggenheim Museum, where he imitates the poses in various artworks (even the cubist ones). After he sees Laurence Olivier's *Hamlet,* he comes home to satirize it with Smith and Bryant. Mead sells his poetry on the street and then holds up a policeman who busts him for drugs. Eventually, in a cluttered apartment, Jack Smith joins Mead and Bryant for an orgy that involves masks, a bear rug, elaborate costumes, musicmaking, dancing, wrestling, much consumption of food, and a great deal of giggling, poking, prodding, and mauling of body parts. In the sound version the film ends with Bryant organizing an ecstatic communal dance in Googie's Bar off Washington Square in Greenwich Village, conspicuously in violation of the No Dancing sign on the wall.[64] Rice's picaresque film shows the body finding its freedom by playfully creating the festive and the extravagant in everyday life.

Smith's own *Flaming Creatures* is an extravagant, plotless, black-and-white vision of androgynous bodies indulging in dancing, posing, cross-dressing, sexual orgies, and campy vampirism. There are lavish quotations from popular culture both in the visual imagery, with its references to Hollywood genre films (the vampire that resembles Marilyn Monroe rising from its coffin, the Spanish dancer, the Arabian harem) and in the sound track (from lipstick ads to big band jazz, country and western, and rock

and roll).[65] These, however, are mixed with references to high culture—quotations of Whistler and Ingres paintings and the sounds of a romantic violin. In bestowing on *Flaming Creatures* the Fifth Independent Film Award given by *Film Culture*, Mekas wrote: "In *Flaming Creatures* Smith has graced the anarchic liberation of new American cinema. . . . He has attained for the first time in motion pictures a high level of art which is absolutely lacking in decorum; and a treatment of sex which makes us aware of the restraint of all previous film-makers."[66]

Susan Sontag's review of *Flaming Creatures* in the *Nation* brought the film out of the underground into the media spotlight. Sontag notes that with his visual generosity Smith operates from an antimodernist, anti-ascetic position. Sontag implicitly connects Smith's amoral, liberatory gestures with abundance. For the film, on the one hand, proliferates rich images, and, on the other—partly because what those images picture is a cornucopia of androgynous bodies, textures, sounds, and objects, that is, of sensuous pleasures—it overflows the bounds of conventional morality. In short, the unlicensed pleasures of the body are presented as unequivocally available for consumption. In Sontag's view, the film's freedom also comes from its deliberate primitivism, its breaking loose from the shackles of technique—for instance, in its shaky camerawork. That is, the film departs from modernist values in *both* its abundance and its amoral sensuality, and these are connected to liberation from technical and aesthetic conventions.

For Sontag, the film's "obscene" aspects are tokens of cultural ambivalence—they are simultaneously the film's artistically redeeming features *and* what would relegate it to marginality. "The only thing to be regretted about the close-ups of limp penises and bouncing breasts, the shots of masturbation and oral sexuality . . . is that they make it hard simply to talk about this remarkable film; one has to *defend* it."[67] But of course the film is remarkable exactly because it stepped into taboo territory.

The two other short films that Mekas singles out, *Little Stabs at Happiness* and *Blonde Cobra*, both by Ken Jacobs,[68] feature Jack Smith's singular performances, as he improvises stories, songs, dances, and camp posturing that plumb the depths of sexual/psychic existence. The desultory *Little Stabs*, like Rice's *Queen of Sheba*, savors the small epiphanies of urban peregrination as it ranges over the metropolitan landscape to record mundane activities in a loft, on a cobblestone street, on a Chinatown sidewalk, and on a rooftop. In *Blonde Cobra*, Smith tells stories about a little boy and about the sexual transgressions of Sister Dexterity and her fellow nuns in the dream of Madame Nescience. He mutters and sings about ravishing a corpse. He listens to the radio, laments the meaninglessness of his life,

and sings an existentialist-maudit ballad to the effect that "God is famous but evil is practical; evil works." The visual track shows various scenes, in both black and white and color, of Smith posing, dancing, and dressing up in his "crummy loft," intercut with long stretches of black leader. Both Jacobs films share with *The Queen of Sheba* a claustrophobic sense of urban interiors, squalid but, like a junk shop of the mind, capable of creating a space for fantasy and free play.

In sorting through Mekas's polemic, one can see that there were several different but related aspects of freedom he celebrated as an avatar of the new cinema in his *Village Voice* column—not only in these four films, but in those that followed during the 1963–64 season (including Gregory Markopoulos's *Twice a Man;* Barbara Rubin's *Christmas on Earth;* Kenneth Anger's *Scorpio Rising;* Andy Warhol's *Blow Job, Sleep,* and other films; Storm de Hirsch's *Goodbye in the Mirror* and *Divinations;* Jack Smith's *Normal Love;* and Stan Brakhage's *Dog Star Man*). One was the Baudelairean content of bodily perception, often through polymorphous perverse sexuality (see chapter 6). Another was the seemingly oxymoronic freedom of low budgets, which according to Mekas relieved the filmmaker of the constraints set by producers and financial backers and offered challenges to the imagination. A third was the advent of women directors, whom he credited with adding new sensibilities to the underground cinema. And a fourth was the liberation of cinematic technique, an antitechnique that broke all the established conventions. Mekas's analysis of freedom, then, is connected to bodily awareness, gender diversity, antielitism, abundance, and transgression.

For Mekas, money could only corrupt art. Discussing *Flaming Creatures* in a June 1963 column, for instance, he noted that this important work, "certainly one of the most beautiful and original films made recently anywhere," was produced at a cost of only $300. "That," Mekas proclaimed, "is the freedom of the underground film-maker."[69] Like the Becks, Mekas criticized the capitalist money system. It was, he suggested, a prison that artists could choose to liberate themselves from.

The young women directors Barbara Rubin, Storm de Hirsch, Naomi Levine, and Linda Talbot, who emerged in the early Sixties, were for Mekas the sign and the hope of a new affective capacity in the films of the underground. He predicted that these women would liberate cinema from the machismo of industry production. It was, Mekas wrote, no coincidence that "women are coming to cinema" at the same historical moment when male avant-garde sensibilities were changing. In a protofeminist mode, Mekas declared that what we would now call "equal opportunity hiring"

for women directors in avant-garde cinema democratized the movement and introduced a different voice—that of expressivity. "Now cinema has become accessible to all. Now new sensitivities are coming to cinema."[70]

These new, liberatory sensitivities were, for Mekas, located in the cinematic technique of the new film, a spontaneous, varied, energetic, and abundant style that seemed to him uniquely and quintessentially American. In a column in August 1963 he analyzed the "Changing Techniques of Cinema." Mekas specifically yoked freedom of technique to moral freedom. In his view, the new cinema rescued artists and viewers from the tedium of bourgeois respectability embodied by the European cinema. Camera movement broke with traditional steadiness to embrace a range from complete immobility to rapid, ecstatic high speed. "There is no such thing as a 'normal movement' or a 'normal image,' a 'good image' or a 'bad image.'" Lighting broke with "proper" exposure and could now range from underexposure to overexposure, from pure white to pure black.

For Mekas, these technical liberties were part and parcel of a cultural revolution, one that brought not only political freedom, but human fulfillment. "These new happenings in our cinema reveal that man is reaching, growing into new areas of himself, areas which were either deadened by culture, or scared, or sleeping. Add to what I already mentioned the complete disregard of censorship, the abandoning of taboos on sex, language, etc., and you'll have some idea about the scope and freedom of what's going on."[71] Thus, formal liberties were linked to freedom of content, which in turn was tied to political liberties, in particular freedom of speech.

Not surprisingly, given the outrageous transgression of bourgeois morality in the activities represented in the films and the inflammatory rhetoric surrounding them, soon after Mekas announced the onset of this cinematic revolution the political contradictions were heightened. First, the Bleecker Street Cinema canceled the Monday midnight Film-Makers' Cooperative screenings on the grounds that "the independent cinema was ruining the 'reputation of the theater.'"[72] Then in his August 22 column Mekas noted that after the Film-Makers' Showcase moved to the Gramercy Arts Theater, state repression had reared its head.

> The censors and the licensors are on our backs. They have interfered with our work. They have disregarded the fact that most of the films screened are unfinished works-in-progress and cannot be submitted for censorship or licensing. They are following blindly the dumb letter of bureaucracy.
>
> They say we are corrupting your morals. We would be glad if we

could. It would do good to some. Those must be very sick souls which can be angered by beauty; shaky and suspicious are the morals which can be upset and "corrupted" by beauty. . . .

For Mekas, any glimmer of support for the arts by the official bureaucracy was simply hypocritical.

There are loud talks going on in Washington and in the Mayor's office about helping culture and the arts. There is even an Office of Cultural Affairs in New York. When we called this office and asked them to get the censors off our backs, we were told, hastily, the office being very busy with culture, to write a letter. We say: To hell with letters. . . .

These would be terrible times if the film-makers had to hide their films from the police and some of the best of our artists had to show their work only in secret undergrounds. That would be terrible. But that's where we find ourselves today! . . .

City, state: Do something for the arts besides talking and having offices for arts and culture.[73]

In January 1964 Mekas, P. Adams Sitney, and Barbara Rubin brought a number of "underground" films to the Third International Experimental Film Exposition in Knokke-Le Zoute, Belgium. *Flaming Creatures* had already been eliminated from the festival because of its taboo subject matter, but Mekas had brought a print with him anyway. He held a guerrilla screening, which was interrupted by Belgian authorities. This led Mekas to question the very nature of the alleged artistic freedom in the Western world, where certain films could not be freely viewed by the public but must be shown only in private societies (like Cinema 16). This event strengthened his determination to resist state control of the arts.

We were not fighting for this particular film, but for the principle of free expression.

It has become very clear, after the experiences at Knokke, that it makes no sense to hide art under a film society membership or another cloak. To look for ways of getting around the law, instead of facing it and provoking it directly and openly, is dishonest. That's why bad laws exist. If Knokke left any lasting impression on me, it is the realization of the dishonesty of artistic "freedom" that is relegated to clubs, societies, membership groups. . . . Some Belgians told me: "We thought that there was no censorship in Belgium. Now, after Knokke, we know that there is."[74]

The point was, of course, that there was legal censorship in the United States too. This was fact. But it also was true that in the early Sixties censorship had suddenly become much less restrictive than it had been—at least in New York—for forty years. Thus, there were rapidly rising expectations, resulting from recent radical changes in the state licensing law, that totally unlimited freedom of expression soon would be gained.[75]

In *Burstyn v. Wilson*—a 1952 case centering on the putatively sacrilegious nature of Roberto Rossellini's film *The Miracle*—the Supreme Court had set a new precedent by ruling that motion pictures were covered under First Amendment rights. In 1962 Shirley Clarke, whose 1960 film adaptation of the Living Theater's production of *The Connection* was initially refused a license on the grounds of obscene language (the use of the word "shit" in reference to heroin), won her New York State case. Although Clarke remembers that "this case finally broke the back of censorship," there were still pitched battles between filmmakers and the censors in 1963–64.[76] One could now say "shit" in the movies, but sexual deviancy was certainly not allowed to be seen.

A key 1961 U.S. Supreme Court case, *Times Film v. Chicago,* had arisen when the Times Film Corporation refused to participate in precensorship. The company sent in a licensing fee without submitting the film for approval, and when the licensing board refused a permit, the company sued.[77] Mekas used a similar but more extreme civil disobedience tactic when he refused to participate in the licensing process altogether for the Film-Makers' Showcase screenings.

In March 1964 the Gramercy Arts Theater screenings sponsored by the Film-Makers' Cooperative were closed down by the license department. Then Mekas was arrested twice, first for showing *Flaming Creatures* and then Jean Genet's *Un Chant d'Amour,* which depicted homosexuality in prison. The New Bowery, the Gate, and the Pocket theaters also were closed. In his *Voice* column following the first arrest, Mekas likened the violation of artistic free speech issues in these arrests to Soviet censorship and repression. He reported:

> The police, licensors, censors, district attorney detectives, and criminal courts finally got interested in the arts. The arts are really jumping in this town. That's what I call action. Mayor Wagner and Governor Rockefeller have obviously learned something from the Russians. They are on the warpath against rats and artists. The Living Theatre is still closed. . . . The poetry readings have been clubbed all over town. Now the independent film-makers are under attack.

Mekas, however, iterated his stand. The film vanguard would not buckle under this harassment. "The Co-op screenings have been and will continue to be unlicensed because we do not believe in licensing works of art. It is very possible that most of our films could safely pass the censors. But that's not the point. There are other works which wouldn't pass, and we are not willing to sacrifice a single one of them. . . ." After this preamble "On Obscenity," Mekas issued an "Underground Manifesto on Censorship." He wrote that art should be exempt from the judgments of the state; that it should be available to the public without licensing or restrictions of any kind. Furthermore, he called for artistic civil disobedience, declaring that the artist has a moral responsibility to challenge laws that abuse people's rights to freedom of expression.

> The new American film-maker does not believe in legal restrictions placed upon works of art; he doesn't believe in licensing or any form of censorship. There may be a need for licensing guns and dogs, but not works of art. . . . Our art is for all the people. It must be open and available to anybody who wants to see it.
> The existing laws are driving art underground. . . .

But from the underground, Mekas promised, artists would continue to engage in civil disobedience.

> It is our duty to bring to your attention the ridiculousness and illegality of the licensing and obscenity laws. The duty of the artist is to ignore bad laws and fight them every moment of his life. The duty of the citizen and artist is not to let the police and the law abuse the rights of people, both the Constitutional rights and the unwritten moral rights.
> We say that the courts, by taking these decisions into their own hands, are abusing man's basic freedom of expression. . . .[78]

In the prevailing climate of civil liberties agitation Mekas even compared the filmmakers' struggles for free speech to the Freedom Rides organized by CORE against segregation in the South. In his column summing up the year 1964 he noted, "February: *Flaming Creatures* is introduced to New York via the Gramercy Arts Theatre, and it soon becomes a manifesto of the New Sexual Freedom riders."[79] The implication was that, like the civil rights workers in the South, the filmmakers were deliberately planning extremist political tactics to challenge repressive laws and to test the enforcement of progressive ones. Thus, Mekas explained: "There is nothing

surprising about the fact that suddenly this wave of 'obscenity' has flooded the arts. . . . This is only the beginning, the very first blabberings of frankness. . . . We can see small outbursts of it in some of the recent art shows; in poetry; in *Fuck You* magazine; in cinema; with the opening of LeRoi Jones's play *The Eighth Ditch* at the New Bowery next week, in theatre."[80]

And, he might have added, among other works in 1963–64 in Yvonne Rainer's "love" duet in the dance *Terrain*—in which she and Bill Davis moved through erotic poses from Kama Kala sculpture while repeating, in flat voices, "I love you," "Why don't you love me?," and so on. Or Rainer's and Steve Paxton's dance *Word Words*, an abstract movement combination performed first as a solo, then as a duet, with the two dancers dressed in as little as the law would allow (G-strings for both, and pasties, as well, for Rainer). Or Carolee Schneemann's orgiastic dance-theater piece *Meat Joy,* for men, women, raw fish, plucked chickens, hot dogs, paint, and pop love songs. Or David Gordon's *Random Breakfast,* in which, among other activities, David Gordon danced a Spanish dance in drag, Valda Setterfield performed a satiric striptease, and then, dressed as a nun, said "shit" and "fuck" and pushed a cream pie in her own face. Mekas also might have mentioned the Caffe Cino production of Lanford Wilson's play *The Madness of Lady Bright,* a tragic monologue by an aging homosexual drag queen, which ushered in the gay theater movement. Or Robert Morris's *I-Box,* a small cabinet with a door shaped like the letter I that opens to reveal a full-length nude photographic self-portrait of the smiling artist. Or Kenneth Anger's motorcycle film *Scorpio Rising,* a fusion of pop references, sadistic violence, and religious parody. Or Barbara Rubin's film *Christmas on Earth,* a film featuring both gay male intercourse and a close exploration of female sexual parts.

By 1965, however, the tide had turned. If in the 1963–64 season, the avant-garde film had outraged the bourgeois and the critics, as well as the law, by the following season it had already become fashionable, co-opted by the mainstream. The vanguard army had opened a path now swamped and tainted by the establishment. Again, Mekas describes this development in military terms.

In 1964, film-makers left the underground and came into the light, where they immediately clashed with the outmoded tastes and morals of the Establishment, the police, and the critics. . . . By autumn, however . . . the magazines and the uptown decided to join the underground and make it part of the Establishment. These new tactics of

the Establishment brought an obvious confusion into the ranks of the underground. The year 1965 starts with the underground directors, stars, and critics regrouping and meditating. There are three choices: 1. to be swallowed by the Establishment, like many other avant-gardes and undergrounds before them; 2. a deeper retreat into the underground; 3. a smash through the lines of the Establishment to the other side of it (or above it), thus surrounding it.[81]

As in the movement to gain civil rights for African Americans, expectations were rising in regard to the issue of free speech faster than they were being met. This gap was felt especially keenly in the film world. For on the one hand, the strict censorship laws that had for several generations driven sexual content and other forms of "obscenity" into hiding were being gradually dismantled. On the other hand, far stricter controls still were imposed than were placed on the print media. Already by the mid- and late Sixties, this content would be perfectly acceptable in film, and even Hollywood would be presenting both avant-garde material and techniques (as in *Easy Rider*). But in the 1963–64 season the frankness of vanguard practice sent shock waves through the culture, and in doing so pushed a wedge into the widening gap of permissiveness. The rhetoric of liberation in these "films from the underground" and in the writings of their champions anticipates that of the counterculture of the late Sixties in calling for total expressive freedom and, especially, in connecting total freedom to the untrammeled body and the sexual imagination.

In the struggle over obscenity and censorship, the avant-garde set itself in opposition to American Establishment ideology. Yet, ironically, in its very textures—its celebration of abundance, leisure time, and personal freedom—it was an unwitting icon of the American alternative in the cold war debate. Thus, there was a paradoxically patriotic tone to even the most transgressive avant-garde art. In this way, the oppositional culture of the early Sixties differed from the more overtly anti-American counterculture of the late Sixties and was more like the Popular Front leftist culture that tried to unearth, celebrate, and protect what had been marginalized by official American culture.

Pop Art and underground film pictured a landscape of American popular culture that to some may have seemed cheap but that glistened with vitality. Indeed, the cheapness of popular culture was a mark of its working-class affiliation and thus served as an affront to the elegance of bourgeois taste. The films may have travestied Hollywood, but they did so lovingly.

Happenings and Off-Off-Broadway theater appropriated American folk traditions. Downtown dances sang the American body. East Village poetry and new music captured American accents and rhythms. It was as if an entire culture—including even the oppositional subculture—had suddenly awakened from a collective inferiority complex and now felt empowered to produce and comment on its own identity. The democratic values of equality and freedom were two crucial components of that identity.

I have already mentioned Andy Warhol's cross-country trip to Los Angeles in the summer of 1963 and his "discovery" of American vernacular culture and Hollywood myths. The excitement wrought by listening to the Top Forty and watching the landscape of commercial signs, now reconceptualized as "the original Pop Art," made him think differently about American culture.

> I was lying on the mattress in the back of our station wagon looking up at the lights and wires and telephone poles zipping by, and the stars and the blue-black sky, and thinking, "How could an American debutante marry a guy and go off to live with him in Sikkim?" . . . I'd just been reading about Hope Cooke. How could she do it! America was the place where everything was happening. I never understood, even, how Grace Kelly could leave America for Monaco. . . . I didn't ever want to live anyplace where you couldn't drive down the road and see drive-ins and giant ice cream cones and walk-in hot dogs and motel signs flashing! [82]

Flippantly eulogizing American consumer culture, Warhol, like other avant-garde artists, may have participated in international politics with an innocent brand of cold war nationalism. Indeed, Donald Kuspit later accused the Pop artists of boosterism and consumer fetishism.[83] But their interest in everyday life did not blind the avant-garde to the gaps in Establishment rhetoric. On the home front the avant-garde operated as an oppositional culture, criticizing official stories about freedom. For while avant-garde artists thrived on—and could not have made their art without—the abundance and freedom that American culture offered, they were aware of the often unstated limits to that freedom. And they pressed against those limits with their art.

Society as Prison
The prison was both subject of and metaphor for another sphere of freedom contested by the avant-garde. Here, Judith Malina and Julian Beck,

anarchists and directors of the Living Theater, were conspicuously active. The organizers of the New York General Strike for Peace, they were committed pacifists, working since the late Fifties with such other peace movement activists as Bayard Rustin, Dorothy Day, and Ammon Hennacy. Malina was sentenced to a brief incarceration in the mental ward of Bellevue Hospital after a War Resisters' League demonstration in 1955. Both Malina and Beck were thoroughly radicalized after being jailed in 1957, with ten others, for a *Catholic Worker* action protesting an air raid drill.[84] Monday night events at the Living Theater often included screenings of antiwar films and other peace movement activities, which were frequently benefits for pacifist organizations such as the Greenwich Village Peace Center and the New York Strike for Peace.[85] Out of the Becks' own experiences in prison came their protest against the jailing of dissidents and their criticism of the prison conditions they themselves had encountered and of prisons as part of the military-industrial complex. A Jail Poets' Reading took place at the Living Theater on September 9, 1963, featuring Taylor Mead, Jackson Mac Low, John Weiners, Ray Bremser (in absentia), and others.[86] But the Living Theater's most sustained and articulate blow at the prison system, its connection to the military, and all that it implies about social and political oppression was its production of Kenneth H. Brown's play, *The Brig*.

The Brig opened at the Living Theater on May 13, 1963. It proved to be the last play the Becks would produce at their theater on Fourteenth Street. This grueling play was an unlikely but utterly apt marriage of ultra-realism with the abstraction of an Artaudian Theater of Cruelty. For in trying to create as accurately as possible the physical realities of a U.S. Marine prison in Japan, as described minute-by-minute in a single day by the playwright, director Malina and designer Beck created a terrifying ritual—dark, throbbing, and claustrophobic—of human brutality. Even the abstraction of its dehumanizing process was true to fact. Moreover, part of its terror was that this was an everyday brand of brutality, although normally hidden from most of the public.[87]

The play opens at four o'clock in the morning. A new prisoner, Number Two, is being initiated into the authoritarian conduct of the brig. Awakened by one of the guards, he is called to the turnkey's desk, but every one of his actions, even before he gets out of his "rack," is criticized, corrected, and shoved into shape. The scene takes place in dim light.

Tepperman. Wake up, Two. [*In a low, almost whispering, but stern tone.*] You better move, boy.

Two [*loud and clear*]. Yes, sir.

Tepperman. You better speak low, boy, when the lights are out in the compound. You want to wake up the other maggots? [*Pause.*] You better answer me, boy.

Two. Yes sir. I mean no, sir.

Tepperman. I don't think you know what you mean, Two. Put your shoes on. Don't you know that bare feet never touch the deck? They make it greasy. [*Pause.*] Put your shoes on and report to me at the turnkey's desk. And don't request permission to cross the line, boy.[88]

When the new prisoner (who, like the others, has been stripped of his identity and is known only by a number) reports to the turnkey's desk, wearing only his boots and underwear, he is sadistically humiliated by two guards, beaten with a billy club, and sent back to bed.

Then the official day begins. White lights glare, a guard wakes the prisoners by crashing a tin garbage can along the fence, and the inmates jump to attention. The Warden greets them sardonically.

The Warden. Good morning, kiddies. This will be another glorious day in the history of the United States Marine Corps. I want you to get dressed, make your racks, get your soap and towels, and line up on the white line for washing your little handsies and facies. Is that clear?

All prisoners. Yes, sir.

The Warden. I can't hear you.

All prisoners. Yes, sir.

Warden. I still can't hear you.

All prisoners. Yes, sir.

Warden. Get hot.

At once there is a flourish of activity in the compound. The prisoners proceed to get dressed and get in each other's way as one makes the bottom bunk and one makes the top one. They make up their bunks in military fashion and take their field jackets, manuals, and caps from the floor, where they are put overnight, and place them at the head of their bunks. They then take their towels from the rear of their bunks, run to their respective numbered boxes, pick up a small plastic box containing soap, and form a line very close to one another standing at attention, the first man with his shoetips touching the white line inside the door to the compound.

The Brig falls silent once more.

Tepperman. Sound off.

The prisoners from front to rear in line begin to exclaim one at a time: "Sir,

Prisoner Number One, sir," "Sir, Prisoner Number Two, sir." *And so on, through* Number Ten.

Tepperman. All you maggots cross the white lines into the head, wash, and get in front of your racks on the double.[89]

And so the day goes. The prisoners dress, make up their bunks, wash, use the head, clean the compound, eat, go outside, smoke, drill, reenter the brig, are searched, use the head, go on work detail, exercise, eat, are frisked, use the head, clean the compound, march in place, write letters, shower, and go to bed. But every action, even every step they take is hedged about with requests and rules. Every entrance and exit has a white line in front of it, and permission must be asked and granted each time the line is crossed. Every action must be done efficiently, in the proper posture, with the proper gestures, according to the rules—or punishment ensues. Every action is also an occasion for the guards to humiliate the inmates by reminding them of their completely debased status.

Not only are they called "children," "boys," "a mess," "idiots," "maggots," "lice," or "insects"; they are made to repeat and agree with these epithets. They cannot speak to one another; they speak to their guards only when spoken to, and only what has been prescribed. They must constantly show their deference to the prison authorities, and they are relentlessly beaten or given other sorts of cruel punishments for the smallest infractions of what seem like utterly arbitrary rules. In several instances their servility is symbolically enacted, as when one prisoner is made to confess his crime—putting on his field jacket without being told to—to a toilet, which like the prisoners is known by its number, or when another prisoner is made to get down on his knees and put his nose on the white line.

There are incidents that break up the deafening, deadening routine of the brig. One prisoner is freed—let go early for good behavior—but not before he is made to undergo the ritual of humiliation one last time. Another prisoner goes crazy and is taken away. A new prisoner arrives and is properly inducted. But overall the net effect is of a numbing regularity that breaks the spirit by mercilessly disciplining the body.

That was exactly the point of staging the play in the raw, pitiless manner that the Living Theater chose. The barbed-wire fence insinuated a concentration camp; the din of marching feet, barked commands, and clattering metal was excruciating; the tedious repetition of tasks and sadistic jibes was heavily oppressive. Patterns of movement and sound predominated over text, giving the violence a ritualistic quality. "It is intended," Beck wrote, "not only to affect the mind but to affect the viscera. It is the torment of

Artaud . . . it is unbearable rather than compatible; it is horror rather than beauty; it is hysterical rather than reasonable. It aims to undo you rather than compose you. . . . *The Brig* assaults."[90]

Whether they hated it or admired it, the critics were unanimous in admitting the power of the production. Howard Taubman, the *New York Times* drama critic, deemed the play "a far cry from drama," and the production "a painful evening in the theater." "If 'The Brig' bears any resemblance to the truth, it must be hell to serve a sentence for wrongdoing in the Marine Corps," he wrote, but "it's almost as gruesome to sit through Kenneth H. Brown's play." Still, Taubman exclaimed, "If what happens on the stage of the Living Theater is a true representation of conditions in the brig, the President or his Secretary of Defense ought to order an investigation forthwith."[91] George Freedley was surprised by his own response to the play: " 'The Brig' is shocking to the point that one is moved in spite of all one's rational judgments."[92] Michael Smith, writing in the *Village Voice,* made a virtue out of what several mainstream critics saw as *The Brig*'s deepest flaw. He praised the production as brilliantly obsessive.

> It is true that "The Brig" isn't a play. Neither are all the events in the Judson dance concert series dances, nor are Jim Dine's pictures paintings, nor in conventional terms are even John Cage's compositions always music. But it is meaningless to criticize any of these works in terms they don't use. . . .
>
> Instead of permitting audience-members to identify with characters on an individual basis—essentially a sentimental approach—"The Brig" engages the audience directly with its characters' situation—an approach advocated by Brecht. I am not so much shown a representative of myself suffering in the situation as I am taken personally into the situation and made to suffer through it myself. . . .
>
> The play achieves its political impact because it is not horrifying. One feels inhuman in watching this play and not being horrified; and yet this brig is the direct and inevitable outcome of the Marine Corps system, which is the outcome of . . . everything. . . . In order to be horrified by "The Brig," in short—in order to be human in this context— one must embrace anarchy.[93]

Thus, for Smith, the production was successful in its political suasion.

What was especially disturbing to the critics and to the audience was that Malina's meticulous verisimilitude made her cast suffer the actual blows and indignities of the play's characters. Using *The Guidebook for Marines* as her supplementary text, Malina writes that she forsook her customary

"atmosphere of permissiveness and informality." She decided to discover the meaning of this play, with its "sense of total restriction," by simulating the authoritarianism of the brig itself. "Practice authority as though it were rare. . . . We were going to set up villainy in a safe boundary as a biologist might use a Petri dish to grow a foul and noxious growth within a safe situation. We isolated it." And so Malina's rehearsal technique was established.

> I prepared a set of "Rehearsal Regulations" which followed the form of the "Brig Regulations" that circumscribe the prisoners' action in the Brig. These "Brig Regulations" invented by the U.S. Marines are so basic to the action that we decided at the very beginning to print them in each program so that the spectator has the basic stage directions of *The Brig* in his hands.
>
> These rehearsal rules imposed no requirements on the actor that the ordinary customs of the theatre do not demand of him, such as promptness, proper dress, silence. In the same way, the "Brig Regulations" are only the rules of military discipline imposed with cruelly demanding perfectionism. The free and easy spirit among us had to be transformed by the sacrifice of our intimacy (just for the time of rehearsal) to the cold, hard, way of the world. The rehearsal breaks and later the intermissions, where we resumed our friendly natures, would become paradisiacal interludes of life in the cold Brig world. . . . We used the techniques of evil as the innoculist uses the fatal virus. We absorbed it and we survived.[94]

The regulations delegated to the authority of the stage manager the responsibility to call breaks and restore rehearsal times. They instituted various aspects of rehearsal discipline, such as signing in, not eating or talking during rehearsal, and smoking only in prescribed areas. They also imposed penalties—extra work—for infractions of the rules, such as lateness, absence, misconduct, failure to pass clothing inspections, and loss of clothing or props. In addition, the company drilled daily.

Malina presented these regulations to the company with the proviso that if any one actor objected to any part of them, they would not be instituted. The entire company agreed to follow them. Malina explains, "to relieve the inevitable tensions we also instituted a five-minute break period which *any* actor could call at *any* time that he felt in need of freedom from the tensions and formality. Breaks were often called. They were never abused."[95]

The Guidebook for Marines was one inspiration; Malina's international pantheon of theatrical muses—Meyerhold, Artaud, and Piscator—were

three more.[96] In Malina's vision of inspiration, as she narrates it, the specter of the Russian experimental director Vsevolod Meyerhold appeared to her, and she addressed him:

"Alas, you called your whole life a 'search for a style,' pursuing that search through honor and disgrace. Now, at last, I have found the play in which the actor is biologically and mechanically enmeshed inside the construction of wires and white lines.". . . .

He knew something psychophysical was at stake; that the way back to the sensibilities of the spectator must be through referring again to the human body standing there trapped before him. . . .

The Brig is a Constructivist play. The construction of the set dictates and directs the action by the power of its vectors and its centers of gravity. It was designed by the architects of ancient military prisons, Masonic craftsmen of dungeons and towers. From these fearsome structures the utility of minimal construction and maximum security is in direct descent. . . .

In *The Brig,* Vsevolod Emilyevich, without damaging the actor's powers, but rather bearing them up, the structure enforces that rhythmic discipline of the actor's body, which you called "bio-mechanics."

For Malina, the French actor and director Antonin Artaud was "my madman muse, never absent from my dreams," to whom "I speak in a private language." His theories of the actor's physicality, of the importance of sounds, and of emotional extremes, were key to staging *The Brig*.

He it was who demanded of the actor the great athletic feats: the meaningless gestures broken off into dances of pain and insanity; who cried out in his crazy-house cell for a theatre so violent that no man who experienced it would ever stomach violence again. . . .

Artaud asks for a theatre in which the actors are victims burned at the stake "signaling through the flames"; in which "physical obsession of muscles quivering with affectivity, is equivalent, as in the play of breaths, to unleashing this affectivity in full force, giving it a mute but profound range of extraordinary violence"; in which "The overlapping of images and movements will culminate, through the collusion of objects, silences, shouts, and rhythms, or in a genuinely physical language with signs, not words, as its root."

O Antonin fierce and demanding, in *The Brig* I have seen the actor tax his body to that abstract athletic splendor where he looms on the precarious edge of the abyss of soullessness.

The German political director Erwin Piscator had been Malina's teacher at the New School.

My dear Mr. Piscator: once in a class you described the totally effective revolutionary play. My class notes tell me you called it *Die Stimme von Portugal*. You described how the performer sang the last phrases of a rousing chorus on freedom and how the people went singing out of the theatre and freed their native land from the oppressor. I have not yet found a play that can move the spectator to such commitment. But I have found a play so valid that when it was closed by the state because the theatre could not meet its financial obligations, the actors, the author, the stage hands, the box-office workers, the stage manager, the house manager, and the technicians were joined by some members of the audience in volunteering to be arrested on the stage with us rather than leave without protesting that this play should not continue to speak.[97]

On October 17, 1963, the IRS shut down the Living Theater for failure to pay back taxes. The directors, cast, crew, and staff of the theater insisted on remaining in the building to give that night's performance. They were locked in, and there they gave one last performance of *The Brig* to an audience that tunneled their way into the building through secret entrances. That night, too, Jonas Mekas filmed *The Brig*.[98]

To anyone today familiar with Michel Foucault's book *Discipline and Punish,* the parallels with *The Brig* and its 1963 production by the Living Theater are striking. Kenneth Brown and the Becks could not, of course, have known Foucault's study, for it was written a decade later. And yet *The Brig,* especially in its brutally ritualistic interpretation by the Becks, seems like an example made to illustrate Foucault's theory. Perhaps it is simply that both Brown and the Becks, on the one side, and Foucault, on the other, were accurate in their studies. Nevertheless, the two works complement one another so perfectly that it may be helpful here to use Foucault's ideas to illuminate *The Brig*.

Foucault begins his book with a spectacularly gruesome description of the torture and execution of the regicide Damiens in France in 1757. This image opens his discussion of public execution and the movement in the modern political era away from the eighteenth-century public spectacle and physicality of punishment. However, Foucault notifies us, it is not that cruelty or punishment has abated, simply that the method of punishment has been refined and its point of application displaced. The modern body

has become politically invested, and, instead of public spectacles, we now construct panopticons, like prisons, factories, and schools, where bodies are made docile—and power-knowledge relations set in place—through constant social discipline.[99]

What is discipline? It is, according to Foucault, "a political anatomy of detail" that has, historically, increased the body's productive forces while decreasing its political powers. One might have thought that Judith Malina had this phrase in mind while planning her production of *The Brig,* for the prisoners are constantly working while they are simultaneously stripped of all rights. In his chapter "Docile bodies," Foucault outlines the modern techniques of discipline as they have developed since the eighteenth century. They range from distribution in space (enclosure, partitioning, coding spaces into functional sites, and the ordering of multiple bodies in space) to the adding up and capitalizing of time (the dividing up of durations and isolation of activities, organizing these segments according to an analytic plan, finalizing the temporal segments, and drawing up series of these series) to all sorts of controls on activities (setting up time tables, temporally elaborating actions, correlating bodies and efficient gestures, articulating the relations between body and objects, reaching maximum efficiency).

In *The Brig,* time is completely segmented and routinized, and we are reminded of it by the scene divisions (in the film, titles announcing the times appear). The day begins at 4:30; the second and third scenes, after breakfast, start at 6:00; the fourth at 11:30; the fifth, military time, is at 16:30; and the last at 19:30. Space, too, is specialized, partitioned, and coded within the cramped confines of the brig. In fact, Brown offers a detailed floor plan in the play script, with the fenced-off prisoners' bunks, the officers' stations, right down to the garbage can in its place and boxes for razors and cigarettes in their place.[100] Also, the ritual of crossing the white line calls attention to every movement from one space to another, and thus the very movement between spaces automatically invokes and reifies the power relations in the brig. Beck's set, with its galvanized wire fence that kept the actor-prisoners in their bunks and its barbed wire that separated the audience from the stage, underscored the implacably claustrophobic enclosure, as do the close shots in Mekas's film.

The ranking of bodies in space was one of the most galvanizing images in the production. Malina describes the drill, which she saw as central to the staging, and which she instituted as a basic exercise in the rehearsal process:

Drill was taught according to Marine Corps tactics. Chic Ciccarelli, who played the Brig Warden, was a former Marine, and remembered with touching and terrible closeness the cold, hard exhilaration of the drill. Before each rehearsal the company drilled half an hour, after the lunch break, another half hour. We cleared the lobby of The Living Theatre, and there on the tile floors we marched endless hours. Startled ticket buyers often entered in the middle of a drill master's angry scolding. It was not the polite tone of a theatrical director discussing the character with the actor, it was Ciccarelli screaming, "Get your head up, you lousy maggot!"

Malina notes: "The drill however had an enlivening effect. The marching is a ritual of great beauty only grown hideous because it stands for the marches towards the fields of death in battle and because it has come to signify the loss of character that ensues when all of life becomes routed into this exactitude. And because you cannot stop." [101]

In addition to all these physical compartmentalizations and regularizations, the prisoners are infantilized. Not only are they, like children, subject to the schedules, spaces, and other ordering systems of their authorities, but they are subject to their slightest whims. This is underscored in the "field day" in Act II, scene i. First, prisoner number Two is humiliated, ostensibly for defining "field day" incorrectly. Although he has defined it correctly, it was not in Tepperman's exact words.

> *Tepperman.* . . . Tell us what it is. You are a new louse in my house and I know you never saw us have a field day, so you just tell us what it is.
> *Two.* It is a thorough cleaning of the living quarters, sir.
> *Tepperman* [*punching* Two *in the stomach*]. It is a sterilization of the Brig, Two. From now on you don't invent your own definitions, you memorize ours. Is that clear, Two? [102]

Then the Warden infantilizes the inmates, using the language of domesticity in which he is the father and the prisoners the children.

> *The Warden.* Those of you who have been in my house for more than a week are familiar with the field day. Those who are not will benefit by what I say. You will be told what to do only once, and you'd better understand the orders you are given and carry them out exactly as they are given you, because I like to live in a clean house. When you are finished, everything will look exactly as it does now, but it will be clean. If the field day is successful, you will be permitted to write letters for

one-half hour after dinner this evening. Is that clear, children?
All prisoners. Yes, sir.[103]

These instructions—or this prelude to the instructions, which are then
given in detail by Tepperman—resemble the children's game "Mother
May I?" Indeed, the ensuing field day, in action, seems more like a relay
race than a serious task—partly because of the arbitrariness of the actions
and sounds involved.

Yet this is more a warped parody of domesticity and play than an imi-
tation of it. For one thing, this family is distorted—it is a family only of
men, and it is hate, not love, that binds them. This is a community twisted
by the war machine and in turn by the society that uses men as cannon
fodder. It is one where both private and public acts have been perverted in
the most destructive and inhumane way. In this panopticon of the brig, the
guards have the power of total surveillance and control over the most pri-
vate acts of the inmates—their names, their bodily functions, the contents
of their letters, even their smiles. Yet the public aspect of the brig—its insti-
tutional architecture and its official, impersonal human relationships—has
been reclaimed through the use of domestic language as private. Things are
inverted as well by the odd paradox that although the brig is excessively
ordered with rules, it is utterly chaotic, and most of all in the scenes of
cleaning up.

In *The Brig* the surface of the body itself is subject to various indigni-
ties, from the loss of individuation in the uniforms and haircuts to inces-
sant beatings. Moreover, the prisoners' bodies are considered polluting.
At one point, Prisoner Number One accidentally runs into Tepperman
as he suddenly appears in a doorway. Tepperman recoils from him as if
contaminated.

> *Tepperman [long, loud, and all suffering].* Woe. You touched me, you
> lousy insect. You actually came in contact with my clothing, infesting
> it with the disease of your stinking self. Now I will have to take a
> shower.[104]

The regimentation of the body is both symptom and emblem of a com-
plete loss of freedom, one which, within this system, may only be regained
through the benevolence of the authorities (as when Prisoner Number
Five is allowed to leave early for good behavior) or through madness (as
when Prisoner Number Six freaks out, breaks with the system, reclaims his
own name, and is taken away).

As I noted, Beck and Malina had both been imprisoned for their pacifist activism. *The Brig* showed how the political violence of the armed forces operated even on its own members. For both of them, as well as for the more perceptive critics of *The Brig,* the play was a rallying cry not only against the military and its prisons, but against every oppressive structure in our culture. For Beck, the money system itself was a brig. And Malina wrote:

> The Immovable Structure is the villain. Whether that structure calls itself a prison or a school or a factory or a family or a government or The World As It Is. That structure asks each man what he can do for it, not what it can do for him, and for those who do not do for it, there is the pain of death or imprisonment, or social degradation, or the loss of animal rights. . . .
>
> Though the social structure begins by framing the noblest laws and the loftiest ordinances that "the great of the earth" have devised, in the end it comes to this: breach that lofty law and they take you to a prison cell and shut your human body off from human warmth. Ultimately the law is enforced by the unfeeling guard punching his fellow man hard in the belly.[105]

Malina was convinced that theater had a capacity for political engagement that the mass media, like film and television, lacked, because theater was communal. *The Brig*'s audiences would be inspired, having seen this violence in the theater—"in the clear light of the kinship of our physical empathy"—rather than alone with the television, to go out of the theater to change the world. "Violence is the darkest place of all. Let us throw light on it. In that light we will confront the dimensions of the Structure, find its keystone, learn on what foundations it stands, and locate its doors. Then we will penetrate its locks and open the doors of all the jails."[106]

For Beck, who had written that shortly before he first read *The Brig* that the purpose of the Living Theater was *"to increase conscious awareness, to stress the sacredness of life, to break down the walls,"* the point of the play was clear: "To break down the walls. How can you watch *The Brig* and not want to break down the walls of all the prisons? Free all prisoners. Destroy all white lines everywhere. All the barriers. . . . Yes, we want to get rid of all the barricades, even our own and any that we might ever set up.[107]

For Beck and Malina, the sadistic acts of institutions must be brought to light and witnessed in a community. Such acts of violence are a perversion of true domesticity and of the life-force, expressed in play. Such acts are also a violation of the body. Thus, freedom is defined as freedom from

incarceration and from surveillance of body and of spirit—whether in jails or in the other, even more insidious disciplines of the modern panopticon.

To be sure, in *The Brig* the Becks did not directly address the question of what the world would be like if all the prisoners were freed, or if there were no more authorities or institutions. They put their faith in their belief, as Malina later put it, that "natural man is . . . a good, beautiful, wholesome brute. . . . We want to say [men] can live together without [wars, prisons, and police]. . . . As long as we're inside the old order, we can't even think of the creative things we can do together."[108] The more aggressively the Becks pursued this line, especially after their return from Europe in 1968, the more their later performances, like *Paradise Now,* were criticized for naive utopianism. But as unrealistic as their solution might be, their description of the problem in *The Brig* was devastatingly true to life.

6

The Body Is Power

The early Sixties artworks are rife with impudent bodily images. Robert Whitman's sensuous Happenings, Tom Wesselmann's Great American Nude series, Claes Oldenburg's bulging soft sculptures, the Baudelairean cinema, the physicalized drama of the Living Theater and the Open Theater, the concretions of Fluxus, performance poetry, and, above all, the dance pieces by choreographers, composers, and visual artists asserted the concreteness, intimacy, and messiness of the human body as not only acceptable, but beautiful. Robert Whitman wrote of his Happenings, "I intend my works to be stories of physical experience." For Joseph Chaikin, the mainstream theater—and indeed, he insisted, mainstream society—had neglected the body; in the Open Theater one tried to "bring one's

body into [the work]."[1] Claes Oldenburg had written in an early statement that his view of art was firmly rooted in human anatomy:

> I am for an art that takes its form from the lines of life itself, that twists and extends and accumulates and spits and drips, and is heavy and coarse and blunt and sweet and stupid as life itself. . . .
>
> I am for art that is put on and taken off, like pants, which develops holes, like socks, which is eaten, like a piece of pie, or abandoned with great contempt, like a piece of shit. . . .
>
> I am for art covered with bandages. I am for art that limps and rolls and runs and jumps. . . .
>
> I am for art that coils and grunts like a wrestler. I am for art that sheds hair.
>
> I am for art you can sit on. I am for art you can pick your nose with or stub your toes on.
>
> I am for art from a pocket, from deep channels of the ear, from the edge of a knife, from the corners of the mouth, stuck in the eye or worn on the wrist. . . .
>
> I am for the art of sweat that develops between crossed legs. . . .
>
> I am for an art that is combed down, that is hung from each ear, that is laid on the lips and under the eyes, that is shaved from the legs, that is brushed on the teeth, that is fixed on the thighs, that is slipped on the foot.[2]

The Oldenburgian body—and art—is comfortable, sloppy, erotic, and unpretentious.

By the late Sixties Yvonne Rainer summed up her choreographic investigations this way:

> If my rage at the impoverishment of ideas, narcissism, and disguised sexual exhibitionism of most dancing can be considered puritan moralizing, it is also true that I love the body—its actual weight, mass, and unenhanced physicality. It is my overall concern to reveal people as they are engaged in various kinds of activities—alone, with each other, with objects—and to weight the quality of the human body toward that of objects and away from the superstylization of the dancer. Interaction and cooperation on the one hand; substantiality and inertia on the other.[3]

For Rainer, as for Oldenburg, the "actual," unidealized body had been forgotten in art. Even dance, the art of the body, had been engaged in masking

human materiality, which Rainer was committed to installing center stage.

The way to the exaltation of the body (and the alternative that the physical body offered to the primacy of the verbal) had been pointed to earlier by artist/theorists such as Paul Goodman, who wrote, about his 1955 play *The Young Disciple:* "I have tried in this play to lay great emphasis on the pre-verbal elements of theatre, trembling, beating, breathing hard and tantrum. I am well aware that the actors we have are quite unable both by character and training to open their throats to such sounds or loosen their limbs to such motions."[4] The poet Charles Olson's seminal 1950 essay "Projective Verse" spoke of the poem as originating in the breath and celebrated "the *kinetics* of the thing."[5] But the Sixties artists took the knowledge and power of the body to new extremes. Their insistence on a festive, liberated, material body took many forms.

In a period when the body was becoming ever freer of social restrictions in such general American cultural domains as sexual activity, social dancing, and fashion, the artists took a vanguard position in stressing the primacy of bodily experience. They pushed artistic representations of the body to their symbolic and material limits. An array of potent bodily meanings was produced, meanings that were interrelated in their indulgence in every aspect of the human form and their imaginative oxymoronic reconceptions of the human form as a set of opposites. The effervescent body—with its emphasis on the material strata of digestion, excretion, procreation, and death—coexists in these artworks with the object-body, the technological body, and the botanic or vegetative body. The avant-garde artists dealt in various ways with the social classification of the body along racial and gender lines. They opened up new arenas of sexual expression. And their utopian project of organic unity also created a vision of the "conscious body," in which mind and body were no longer split but harmoniously integrated. The simultaneous affirmation of the body's substance and the metaphoric refiguring of it as a series of contraries, added to the wide-ranging exploration of its social meanings and possibilities, signal the extraordinary confidence and power that Sixties artists invested in the body. In their hands it became an effervescent body that exuded what they saw as the amazing grace of fleshly reality.

The Effervescent Body

In Alison Knowles's *Proposition,* performed at several Fluxus concerts, the artist made a salad for everyone in the audience. In a 1963 exhibition at the Sidney Janis Gallery, Jim Dine showed collage paintings with actual bath-

room fixtures as central elements. Allan Kaprow's *A Spring Happening* was a ritual of rebirth, with overtones of death. In Stan Brakhage's film *Window Water Baby Moving*, the filmmaker recorded the birth of his first child.

These works—concerned with food, eating, the digestive process, excretion, and the decay and birth of the human body—are exceedingly carnal. They detonate polite discourse with their gross references to the lower stratum of human existence. Knowles's act of feeding is a generous one, but it is also intimate. It overflows the boundaries of the stage and the performer's conventional physical isolation from the spectator. And it cements a human relationship between the performer and spectator with a gesture of alimentary incorporation, opening the spectator's body to the performer.[6]

This openness of the physical form is an important element of what, borrowing concepts from the British anthropologist Mary Douglas and the Russian literary critic Mikhail Bakhtin, I call the effervescent, grotesque body.[7] The effervescent, grotesque body is seen as literally open to the world, blending easily with animals, objects, and other bodies. Its boundaries are permeable; its parts are surprisingly autonomous; it is everywhere open to the world. It freely indulges in excessive eating, drinking, sexual activity, and every other imaginable sort of licentious behavior. And it is precisely by means of the image of this grotesque body of misrule that unofficial culture has poked holes in the decorum and hegemony of official culture.[8]

Like Duchamp's *Fountain* before them, Dine's bathroom fixtures install in the artwork references to the most private of actions, whose representation is ordinarily taboo in polite society and whose actual performance is hidden even from one's intimates. Here, Dine deliberately soiled the rhetoric of the beautiful and the sublime, not merely with humble images of the mundane, but with what is conventionally considered filth (whether it is the kind to be flushed away or the kind to be washed away). Furthermore, not only is there reference to the activities of the body's lower strata; despite the fixtures' cold, hard textures of metal and porcelain, there is in Dine's fixtures an unsettling physical resemblance between the plumbing—with its holes, bulges, and tubes—and the orifices and protuberances of the human body itself.[9]

In Kaprow's Happening, birth and death are viewed as intermingled, and both are seen unflinchingly as part of life. The audience was seated in a dark, claustrophobic tunnel. Through small slits in the side of their crowded "cattlecar," the spectators witnessed mysterious, often noisy events: metal barrels crashed through the outside space; machines rumbled; matches

flamed, hissed, and went out; two men jousted with wooden branches; a nude woman sprouted greens from her mouth, then was suddenly covered by a blanket. The critic Jill Johnston described the piece as taking place in "an ingenious womb," or perhaps a tomb. This happening, she remarked, was "like our ancestral rituals . . . [a] fertility rite" in its terrifying creative force.[10] Kaprow's imagery is connected to one of the important aspects of Bakhtin's grotesque conception of the body: it "degrades" the human form in a positive way. That is, bringing its subjects down to earth, it reembodies what official culture had disembodied, or etherealized.[11]

In our culture the act of birthing has been sanitized and denatured. Made part of the medical regime, rather than part of ordinary life, it is a private, almost secret event that takes place in the sanctum of the hospital's maternity ward. Although in recent years the maternity ward has opened up to fathers and immediate families, in the early Sixties, birthing was a private act, attended only by the mother, her obstetrician, and his nurses and other assistants. In Brakhage's film, this private act of birthing emerges publicly in all of its bloody detail, animal instinct, and human pain and excitement. It also is reclaimed as private not in the sense of secret medical knowledge, but private in the sense of domestic—something shared by the husband and father. Brakhage's film emphasizes the image of two bodies in one— in the pregnant belly and in the baby emerging from its mother's womb. The mother's body is no longer private, but literally open, sharing, begetting, and emerging. It is generous and generative, swollen to immense proportions and sowing new life in the world. It is a social and historical body, not an individual one, for it contains and continues the family and the community.[12]

Given the predilection of Sixties artists for the styles as well as the political import of folk and popular genres, it is easy to see why the image of the Bakhtinian grotesque body is central to their work. This body is a dialectical one that, always in the process of becoming, includes within it dual states—animal and vegetable, death and birth, childhood and old age. It is, moreover, an anticlassical body that, rooted in folk humor, "uncrowns and renews" all of official culture.[13] Above all, these forms not only emphasize "the material bodily principle" but harness it to a utopian conception where the disparate strata of cosmos, society, and body are unified. Thus, the effervescent body is a profoundly political symbol. It is the medium for a cluster of artistic genres that challenge elitist classical representation with their unbridled bodily images. But it is first and foremost a body of carnivalesque performance.[14]

Through the framework of the medieval festival, the folk constructed

an alternative world. Contrary to the official ecclesiastical or state feasts—which upheld the status quo, symbolically reinforcing hierarchies, values, prohibitions, and official histories—folk festivals, according to Bakhtin, "were the second life of the people, who for a time entered the utopian realm of community, freedom, equality, and abundance." [15] In the realm of carnival, these social values are vitally connected with play, with the fusing of life and death, and with the urgency of the visceral body. This multileveled connection of the body's power with the carnival and the subversion of official culture is the reason why, Bakhtin tells us, "the material bodily principle is a triumphant, festive principle, it is a 'banquet for all the world.'" [16]

When it becomes effervescent, the body constructed by the rules of polite conduct is turned inside out—by emphasizing food, digestion, excretion, and procreation—and upside down—by stressing the lower stratum (sex and excretion) over the upper stratum (the head and all that it implies). And, importantly, the effervescent, grotesque body challenges the "new bodily canon"—the closed, private, psychologized, and singular body—of the modern, post-Renaissance world of individual self-sufficiency. For it speaks of the body as a historical as well as a collective entity. "The grotesque conception of the body is interwoven not only with the cosmic but also with the social, utopian, and historic theme, and above all with the theme of the change of epochs and the renewal of culture." [17]

The Gustatory Body

Two exemplary works from 1963–64 powerfully illustrate a crucial set of effervescent or grotesque bodily images: the gaping mouth and the act of swallowing. Not only do these images symbolize the abundance of the festive banquet; they also lead through the passageways of the body from the head to the lower stratum. Both Allan Kaprow and Andy Warhol made works in 1963–64 entitled *Eat*. Warhol's was his film, black and white, and silent, in which the Pop artist Robert Indiana eats a mushroom for forty-five minutes. The camera does not move, nor does Indiana, much. Like Steve Paxton's dance for Robert Dunn's composition class in which he simply ate a sandwich, Warhol's *Eat* invited its audience to watch an aspect of daily life not usually singled out for attention in polite social intercourse. That is, usually we eat *with* others, and we are supposed to make it a social, not a physical event; we notice what they say, not how they put their food in their mouth. Moreover, unless they are children we are feeding, or lovers we are erotically engaging, it is usually considered rude to examine others

as they eat. To watch others eat is to claim intimacy with them, if not power over them. Certainly in Warhol's film the sense of the camera as a voyeuristic witness to this solitary, slow, sensuous activity—Indiana's fingers in his mouth look positively masturbatory—conflates eating with sexuality.

Allan Kaprow's *Eat,* a Happening, took place in a cave in the Bronx that had been used by the Ebling Brewery. As Michael Kirby describes it, the cave exuded a sense of decay. In it, Kaprow built an environment out of charred beams, wooden platforms and towers, and ladders, in which, at different stations, the visitors were offered wine, apples, fried and raw bananas, jam sandwiches, and salted potatoes. It is striking that Kaprow's map of the floor plan for *Eat* resembles a diagram of a uterus; Peter Moore's photographs show a wet, dark place with curved walls and ceilings. There is a distinctly organic sensibility in *Eat,* as if the participants themselves were inside a body. In fact, there are two movements of ingestion in the performance, as the cave "swallows up" the visitors and as they themselves eat what is offered to them inside the "body" of the cave.

Adding to this body symbolism is Kaprow's suggestive description of the work as "a semi-eucharistic ritual." Thus, the food itself—although not the prescribed wafer of the Catholic Eucharist—could be thought of as a body. And the wine—although it was both red and white—could be thought of as blood. Just as eating and sexuality are conflated in Warhol's film, here the imagery in the cave is an amalgam of digestive and reproductive functions—made even more extreme by the inside-out corporeal quality. That women served the wine to the visitors (unlike in a Catholic Eucharist where in the early Sixties a priest would usually perform the ministrations) and that women served much of the food adds to the iconography of reproductivity. Like mothers, who not only reproduce the species in the sense of procreation, but also by feeding and nurturing men and children, these women fed and cared for the visitors in this subterranean belly—somewhere between a stomach and a womb.[18]

For Peter Schumann, the sacramental aspect of food became inextricable from his concept of theater in the early Sixties. Naming his group Bread and Puppet Theater in 1963 directly addressed the issue of theater as both basic to human life and as something that should be as simple and nourishing as the staff of life. His homiletic folk theater style, with its sources in medieval diableries, delighted in the materiality of the body. Here, bread was the symbol of the simplicity and holiness of ordinary people's lives. It restored a substantial body to the theater, which Schumann criticized as too often concerned with surfaces rather than depths. Offering bread and

theater to audience members, Schumann has written, was meant to reach deeply into both body and soul:

> We sometimes give you a piece of bread along with the puppet show because bread and theatre belong together. For a long time the theatre arts have been separated from the stomach. Theatre was entertainment. Entertainment was meant for the skin. Bread was meant for the stomach. The old rites of baking, and eating, and offering bread were forgotten. The bread decayed and became mush. We would like you to take your shoes off when you come to our puppet show or we would like to bless you with the fiddle bow. The bread shall remind you of the sacrament of eating. We want you to understand that theatre is not yet an established form, not the place of commerce that you think it is, where you pay and get something. Theatre is different. It is more like bread, more like a necessity.[19]

Similarly, George Segal's *The Dinner Table* yokes food to spiritual communion. In this sculpture, four plaster figures sit contemplatively at a large round table, while two more figures stand over them. Two of the figures were modeled on the artist and his wife: Segal pours coffee, while his wife stands near the wall looking over the scene. The autobiographical incorporation of the artist's family heightens the intimacy of the sculpture. The act of eating here is drawing to a close. Dining has been a domestic occasion, a communal act of sharing that is peaceful and fulfilling. The gustatory body here—as in Kenneth Anger's film *Inauguration of the Pleasure Dome,* with its rituals of gift-giving and ingestion (see chapter 7)—creates community, forming bonds by rites of (literal) incorporation.

In the Happening *Mouth,* Whitman turned the primary emblem of the effervescent, grotesque body—the gaping mouth—into an entire landscape, in which detached body parts took on lives of their own. The setting itself resembled a large mouth (built of chicken wire, papier-mâché, and scrims, with a red "tongue" floor shading off to flesh color near the walls, and white chairs standing for teeth, upon which the spectators sat). Two women rode through in a cardboard car, disembarked, and had a picnic. They were joined by two fantastic animals and three sprites dressed in leaves, aluminum foil, and fur. When one of the picnickers left, the other lay down and went to sleep in this enchanted body forest. Red pieces of cloth fell to cover her, a woman dressed in water joined the other sprite creatures, and the four sprites began to dance and collide, while the animals silently watched. A large, white, tooth-shaped pendulum glowed red

and blue, three tubes marched through, and the pendulum opened to reveal a woman. Here, one is reminded of Rabelais's scene in which the author Alcofribas journeys into Pantagruel's mouth and discovers there an entire ancient universe—"a buccal underground," as Bakhtin puts it—surviving on the food that Pantagruel eats. The goings-on in Whitman's gaping *Mouth* turned the topography of the body into a microcosmic, mythic world.[20]

In early Sixties iconography the gustatory body symbolizes both spiritual and fleshly communion, and it is linked to the sexual body in various ways. One is the notion, raised by Kaprow's *Eat,* that eating is a "reproductive" activity. Another, raised by Warhol's *Eat,* is that eating itself, when framed as an intimate physical activity, is an erotic act. Further, as we shall see, food as an object serves as a metaphor for body parts that, when seen as autonomous, take on an erotic life of their own.

The gustatory body often seems to bring with it the figure of the nourishing woman. Robert Indiana said about his various paintings of the early Sixties that spell Eat: "The word 'eat' is reassuring, it means not only food, but life. When a mother feeds her children, the process makes her indulgent, a giver of life, of love, of kindness."[21] Such imagery has complex political significance. It seems today to be a clear example of sexist essentialism, but in this context it signals an affirmation of the value of nurturing over a macho worldview.

In Carolee Schneemann's *Meat Joy,* a performance she once described as "flesh jubilation," the figure of a nourishing woman appears. She is the Serving Maid, who toward the end of the piece carries in a tray of fish, raw chickens, and hot dogs and strews them over a pile of wriggling, half-naked performers. She unites the nourishing and sexual functions, for by bringing in raw food, she enables the erotic life of the performers to blossom. In Schneemann's *Looseleaf,* the aproned artist seated two men at a table and repeatedly served them small, sticky cakes. At first, they ate politely with knives and forks, but gradually their table manners broke down until not only had silverware been discarded in favor of fingers, but, like children at the table, they began to play with their food and smear it over one another's faces. The sound accompaniment included Schneemann talking about the body, perception, and her own artistic process as she moved from painting to performance.[22] Schneemann may be the nourishing figure here, but she is simultaneously an agent, rather than the object, in the artwork. She shows in her reflexive use of the body that the act of feeding has transformed her children/men into materials for her act of making art.

There is a fine line between the figure of nourishing womanhood and the sexist image of the erotic woman in Sixties art, however. The instructions for Ben Patterson's *Lick Piece,* for example, read:

> cover shapely female with whipped cream
> lick
>
> . . .
>
> topping of chopped nuts and cherries is optional.[23]

The woman, that is, offers food to eat but in the man's act of licking and swallowing, his erotic pleasure predominates over nutrition for two reasons: the whipped cream is spread over the surface of the body, requiring intimate contact for its consumption, and, as is well-known, whipped cream has little nutritive value, but instead symbolizes the luxurious pleasures of the senses.

In Rosalyn Drexler's irreverent play *Home Movies,* the sanctity of church and home is unfrocked. One of Drexler's strategies for this uncovering is the double entendre. And one of her favorite themes in the double entendre is the mixing of food and sex. Mrs. Verdun offers Peter, her husband's gay lover, some fruit as they sit on a bed. In doing so, she changes from a hostess to a seductress, for her offer is not the mother figure's replenishment, but the invocation of food as standing for body parts.

Mrs. Verdun. I think fruit is so nice in the summer, don't you?
Peter. Oh yes, I adore fruit in the summer.
Mrs. Verdun. So refreshing.
Peter. Succulent.
Mrs. Verdun. Ripe.
Peter. Juicy!
Mrs. Verdun. Dripping.
Peter. Ever so wet.
Mrs. Verdun. Would you care for a fruit?
Peter. But your bowl is so delightful to look at, I wouldn't dream of disturbing the arrangement. If, of course, you have more in the kitchen . . . I prefer peaches.
Mrs. Verdun. As soon as my maid is free, she'll serve us.
Peter. No hurry. I like waiting for my pleasures. Often, you know, the expectation is better than the realization. Although, when you have one in the hand, why wait for two in the bush?

Later, when Mr. Verdun returns, he makes the comparison between fruit and human flesh even more explicit when he warns Charles the intellectual,

who has been chasing the Verduns' daughter Vivienne around the stage farce-style, in the song "Don't Bruise the Fruit."

Do not bruise the fruit.
Do not bruise the fruit.
Do not bruise the fruit.
That my wife bore and I planted.
Do not expose the pit of that overripe production, or it will dry and become sere. [*Singing*]
It is the pit that holds the bitter almond.
The pit that keeps within it the true soft pit. Do not expose its surface to the breath you exhale and the teeth you dig with. . . . [*Singing*]
Let it lie!
Let it lie!
Let it be half-hard, underripe, green, and about to be. [*Singing*]
Don't feel how soft it is.
Don't bruise the fruit.
Don't bruise the fruit!
Smell it if you must, [*Singing*]
But don't lay your nose on it.[24]

The food imagery in Pop Art also shows food as festively interchangeable with bodies and body parts. For instance, in James Rosenquist's painting *Lanai,* the front grill of an upside-down car intersects a plate of glistening peach halves (probably fresh from a Del Monte can) on the left side of the canvas, while the car's rear end rests on the haunches of a woman in the White Rock advertising pose, kneeling at the edge of a swimming pool. The woman's face is hidden by the narrow blue panel at the right end of the painting, on which, Magritte-like, a half of a pencil hovers. We almost automatically identify the peaches with the curves of the woman's body, all the more so because the peaches are closer to flesh tone than the unnatural pink grisaille of the panel containing the woman. Also, the car formally links them. And the erect pencil confirms the interpretation. In another Rosenquist painting, *The Lines Were Deeply Etched on the Map of Her Face,* a hot dog with a stripe of mustard seems to penetrate the edge of the painting on the upper right; it appears both to point to and stand for the lower half of a man's body just below it on the canvas. Given the unidentifiable but clearly fleshy expanse against which these two items are placed (along with a giant checker and a fragment of a typewriter keyboard), again the phallic image seems an appropriate response. Marjorie Strider's *Diagonal Red* joins together imagery of the reproductive body, the erotic body, and

the food-body. In this painting, a lush red tomato—embodying the slang for a sexy woman—literalizes fruitfulness. It seems to give birth to itself, becoming three-dimensional as it emerges from the canvas.

Of course, not all alimentary art is sexual. For instance, in Ron Rice's film *The Queen of Sheba Meets the Atom Man,* Taylor Mead's orality is infantile rather than adult. All-consuming, he tries out every object he encounters by putting it in his mouth first—whether it is food or food packaging, human body parts, or furniture.

Moreover, in Sixties iconography the gustatory body often has an economic meaning: it is symptomatic of material abundance. Pop Art canvases and sculptures proliferate images of food—often in packaged form—as the teeming products of an affluent culture of consumption. Lichtenstein's *Roto Broil* and *Kitchen Range* are two appliances stuffed with food, and his *Refrigerator,* whose image is taken from a packaging insert, shows a smiling woman cleaning her empty refrigerator. She is happy, we infer, at the thought of all the food that the expectant refrigerator is waiting to contain. The groaning board in Wesselman's *Still Life #17* offers a range of foodstuffs, from Beefeater gin and Heineken beer to Horn and Hardart coffee, Del Monte tomato sauce, and a plate with a hot dog, hamburger, and potato chips. Behind those items stands the smiling figure of the omnipresent mother, the queen of Madison Avenue in the early Sixties, beckoning the spectator to partake of the feast. From Alex Hay's breakfast paintings to Robert Watts's chrome-plated lead hot dogs; from Andy Warhol's Campbell soup cans to Claes Oldenburg's mammoth BLT, hamburgers, slices of cake, and ice cream cones, these are images of food, but of a particular kind of food—food as an article of mass consumption. These are items in the burgeoning cornucopia of provisions sold by chain restaurants, processed by mass media, and fed to us by advertising's idealized mothers. They are images of gigantism, abundance, and effervescence, and if they are presented in an ironic tone, nevertheless their sensuous textures, vibrant colors, and monumental scale festively celebrate their ubiquity.

If in these works food took part in a carnivalesque confusion with sex, reproduction, and body parts, food also led to images of digestion and excretion as well as decay and death. For instance, in *Home Movies,* after Peter and Mrs. Verdun have discussed the charms of fruit in sexual terms, they go on to sing about its by-products.

Peter. . . . Once eaten, [fruits] are gone forever, and the gas pains they cause flutter and fuss inside like wings.

Mrs. Verdun drags Peter downstage, where they sing.
Mrs. Verdun.
 Like wings aloft,
 Caught in an intestinal updraft.
Peter.
 Like wings aloft,
 Caught in an intestinal updraft.
Mrs. Verdun.
 It's true, dear,
 That if something else
 Is caught in the whirl
 Of something else entirely,
 It just can't help itself,
 But must continue
 In the powerful current
 Of that particular thing.
Peter.
 Yes, we just can't help it;
 The route we go,
 A power stronger than will. . . .
 Till the explosion, then BOOM! Everything gives way and falls into
 small portions. Sometimes I think the good Lord created every-
 thing by chance, set off the cherry bomb and waited for the shapes
 to crack.[25]

If flatulence can be the subject of a romantic song, in early Sixties discourse
it can be, as well, a metaphor for holy cosmogony. Again, the grotesque
image of digestion and the body's lower stratum degrades what is lofty in
a positive, festive key, uniting physical and cosmic experience.

 In 1963 Steve Paxton began to use large plastic inflatables. In *Music for
Word Words* a twelve-foot square plastic room was deflated with a vacuum
cleaner to become a body-sized costume, a second skin. By 1965, with
The Deposits, and 1966, with *Physical Things,* the plastic had reached tun-
nel proportions. As in Kaprow's *Eat,* as members of the audience passed
through this organic-seeming tunnel, it distinctly began to resemble a di-
gestive tract. In *Physical Things,* inside and outside were further confused
by the sod, fake trees, and architectural embellishments inside the enor-
mous tunnel, which turned the body's insides into a grassy landscape. Also
in *Physical Things,* the transformation of the spectator into a participant in-

tensified the physical experience of the work. The bodily imagery is related, as well, to dances in the late Sixties that underlined Paxton's candor about the body by referring to medical imagery.

The Fluxus movement was particularly fascinated by bodily processes, from ingestion to excretion. The name Fluxus itself, as the Fluxus manifesto reminds us, comes from the word "flux"—whose primary meaning is "a) a flowing or fluid discharge from the bowels or other part . . . b) the matter thus discharged." Dick Higgins instructs the performer in his *Danger Music No. 15* to "Work with eggs and butter for a time." Despite his reference to himself as "hung up on the fantastic element in cookery," Higgins's interest in food has to do with a Fluxian insistence on art as part of everyday life in what he calls the Schweikian mode. About the work of Fluxus members, he wrote (as we have seen in another context):

> We like quite ordinary, workaday, nonproductive things and activities. . . . While Rome burns, I work with butter and eggs for a while, George Brecht calls for:
> *at least one egg
> and Alison Knowles makes an egg salad.[26]

Besides making salads of various kinds, Knowles also specialized in bean pieces. In 1964 Maciunas published multiples of her *Bean Rolls,* a tea tin containing a set of dried beans (and sometimes chickpeas or split peas) and small paper scrolls with information about beans. "Direct from the Gardens," the label read. "A minute study of the mundane," Jon Hendricks later called it, "a latter-day study of Monet haystacks." Two of the rolls read as follows:

> Bean: To commit suicide; Jan. 3, 1925, Flynn's Henry Leverage; extant not much used. Perhaps orig. and strictly, to shoot oneself through the bean, s. for head.
> Bean town: throughout the Under World, Chicago is Known by its nickname, "Chi," Kansas City, "Kay See" and Boston as bean town.

The rolls also included botanical descriptions of different kinds of bean plants, ads from L. L. Bean, and other bean ephemera. The *Bean Rolls* could be read at home or used as performance scores; Knowles's *Simultaneous Bean Reading* instructs a group of performers to read aloud from the *Bean Rolls,* inviting the audience to join in, while one person cuts up the scrolls being read.[27] The earthy bean, so rich with cultural and gastronomic reso-

nance, has continued to provide Knowles with material for her drily witty performances, graphic works, and writing up to the present.[28]

By the late Sixties, Flux Food events and Flux Feasts had become regular occasions for collective works. These included items both edible and inedible, from George Maciunas's distilled drinks and transparent food (colorless liquids and Jell-O, these had the smell and taste of tea, coffee, tomato juice, onions, beef, butter, ice cream, etc.), to emptied egg shells filled with surprising items (shaving cream, Jell-O, coffee, a dead bug), to color-coordinated or international banquets.[29]

Wolf Vostell's performances often involved feeding the audience food—or objects served as food. Vostell specialized in what he called "décollages." As Dick Higgins described them, "These are the opposite of collages. They involve ripping off or erasing, they suggest dying and metamorphosis." Vostell contributed a piece to an exhibition by several Fluxus members in Cologne that was a food version of a décollage. Unlike his television décollages, in which objects were actively wrecked and mauled, in this piece the food was destroyed by decomposition during the exhibition. Dick Higgins remembers it: "Vostell hung fish and suggestive items and toys in front of white canvasses, and lungs and chickens in front of two pieces. These last, naturally décollaged themselves, so that the gallery stank and could not allow the usual publicity activities, let alone any prolonged viewing and savoring of the show."[30]

The gustatory body for Fluxus easily became the excretory body. For instance, Nam June Paik proposed as a piece of "physical music" his *Fluxus Champion Contest,* "in which the longest-pissing-time-recordholder is honored with his national hymn." (The first champion, he noted, was "F. Trowbridge. U.S.A. 59.7 seconds.")[31] Ken Friedman writes about this important facet of Fluxus:

> Emmett Williams made a fine contribution to piss art in 1964. The piece was a concrete poem, a poem set in concrete. It was made of a child's play alphabet, each letter sunk down into the concrete slab that held the piece. Each letter was an animal or a symbol or a form of a word beginning with the letter itself. The letter "P," however, was a plastic sack marked: SYNTHETIC URINE. NOT FOR HUMAN CONSUMPTION. Synthetic urine is used for dyes and for teaching medicine. Emmett had a friend whose girlfriend sold synthetic urine. She supplied Emmett's Fluxpiss. . . .
>
> Not all Fluxus artists are big on piss. Yoshi Wada prefers farting.

George Maciunas and Geoff Hendricks favored shit. . . . There are also those of us who can't quite decide, such as Iceland's Dieter Roth. Roth favors piss and shit in equal measure. He sometimes even binds sheets of plastic filled with them into his books.

Some day, you might ask about the time we exhibited Dieter Roth books filled with piss, shit and ripe cheese at the General Assembly of the Unitarian Universalist Association in Boston.[32]

The gusto with which Fluxus, in particular, and the early Sixties avant-garde, in general, approached the digestive body ranges from the reverent—for instance, in allusions to the Eucharist and other ritual ingestions—to the utterly outrageous, as in the plethora of scatological references. In these works, symbols of incorporation—focusing on food consumption and often coupled with sexual gratification—nourish the spiritual body as well as the physical body. In addition, oral incorporation ritually constructs bonds of community. In early Sixties artworks, the gustatory body is seen as permeable, sensuous, and collective. Feeding serves as a locus for the body festively and transgressively to be turned inside out and upside down. The private is made public. And the concrete facts of bodily life are made food for thought.

The Racial Body
The effervescent, grotesque image of the body festively confuses biological categories, mixing animal, vegetable, and mineral, as well as outside and inside. It also ignores the boundaries of sociobiological classifications, mixing races and genders.

American culture in general was undergoing a radical shift toward Africanization in the early Sixties. American vernacular music and dances were deeply rooted in African American traditions, although often it took translation and appropriation by white performers—such as Elvis Presley or the dancing teenagers on Dick Clark's "American Bandstand" on TV—to make black style acceptable for mass consumption. While schools may still have been segregated, white schoolchildren were being initiated into one of the fundamental practices of the African American movement repertory, learning to separate hips from upper torso with the help of "hula hoops."[33] White teenagers—and even the First Lady—danced the Twist, a new incarnation of a venerable black dance known by other names in other generations. If parents criticized the dance as lascivious, it was because they recognized in it—however unconsciously—a bodily practice that chal-

lenged Euro-American culture by rejecting its dancing conventions. But white youth culture found in black music and black dancing a subcultural channel in which they could express their own aspirations toward independence. Moreover, in sports, in the movies, on television, and indeed, in every part of popular culture, African Americans were visible, vibrant, and articulate. Entrance to professional domains other than entertainment and sports was still restricted, and access to much of white society blocked at every turn, even for black professionals. And African Americans, and many whites with them, rightly chafed at those inequities, while the civil rights movement sought to correct them. But still, it was undeniable that, given the broad spread of black skills and styles throughout the realm of popular culture, American society was in many ways becoming more "Africanized" than ever before.[34]

Discourse on race, culture, and bodies was as complex and difficult in the early Sixties as it remains today, although not in the same ways. If today we stress roots and differences, in the early Sixties many liberals (both black and white) wanted to deny racial and cultural differences altogether in their fervor to gain equality for African Americans, assimilating blacks and whites into a homogeneous melting pot. But oddly enough, radical antiracist rhetoric departed from liberal homogenization in ways that were not always so far removed from racist talk. Blacks were mythologized as "closer to nature" or "bodies free of inhibitions" by those who emulated black culture as well as by those who hated and feared it. These differences from the etherealized bodies of Euro-American culture were seen as salutary by radical avant-gardists, for they meshed well with the avant-garde project of appreciating the body's concreteness. The aesthetic and social values of African American dance—its bent elbows and knees, its compartmented torso, its contrapuntal polyrhythms, its gravity-bound weight, and its sexual frankness—may have been considered awkward and salacious by Euro-American standards. The values of African American music—its repetitions, its improvisatory structure, its oral transmission, its emphasis on rhythm over melody, and its emphasis on the body as an instrument (both vocal and percussive)—may have been considered boring and unrigorous by Euro-American standards. Yet these different cultural values were embraced by the white avant-garde—and here, of course, they parted ways with racists who found nothing of value in black culture. Often the white artists adopted such values and techniques partly as a result of their own association with black artists, especially those in the jazz avant-garde. Beyond social connections, white artists studied and sometimes performed

jazz—both white musicians (like La Monte Young, Philip Corner, James Tenney, and Malcolm Goldstein) and white artists in other fields (like Larry Rivers and Michael Snow).

That there is an element of what might be called "essentialist positive primitivism" cannot be overlooked in examining the early Sixties avant-garde's attitude toward black artists and black culture. This was an aspect of modernism that was carried over into the early postmodernism of the Sixties. For example, Dick Higgins, someone indignant against prejudice, wrote in *Postface* (published in 1964) that he suspected even before he met Fluxus artist Ben Patterson that Patterson was black.

> Patterson married and went [from Germany] to France, as he had gone from the U.S. before, where he did not want to be a "negro art-ist" but just one Hell of a good one and, among other things, a negro. Only James Baldwin and Benjamin Patterson have ever attained that proportion. Actually Patterson's way of using periodic repeats and the blues feeling that this produced being so ingrained and natural struck me so much that when he first sent me a copy of methods and processes I wrote to him and guessed he was a negro.[35]

That is, essentialist positive primitivism assumed that there are favor-able qualities engendered by race itself, qualities that are linked with cre-ativity, energy, sexuality, and harmony with nature—in short, with the anti-Enlightenment triumph of the body over rationality.

Thus, the actor Roberts Blossom, in writing about his own experiments with theatrical "language," compared his break with theatrical convention to the difference between white and black body language and vocal style in what can only seem to us today a far-fetched metaphor based on this kind of primitivism. Blossom's romantic notion was that white culture—in particular American culture—suffocates expressivity, while African Ameri-can and other ethnic cultures may retain humanity's true and "natural," unsocialized language, sounds, and gestures.

> As we grow older our voices grow more strangulated, professional, machine-gunny, or deliberately slowed, our gestures indicative of ges-ture rather than live. As though to say, "Well, we drowned when we were twenty, but we must pretend it wasn't so." Why?
>
> America is an accumulation of the histories of man and their transference into: American. This means that everything—the whole history of the world—has been translated into: American pseudo-English. . . .

But Blossom acknowledged that there has been subcultural resistance to the homogenizing melting pot by African Americans, whose marginal status protected cultural difference. "Out of the freedom-in-isolation of certain Negro groups came bop talk and then, watered down, beatnikism. Freedom from what? The American whirlpool. . . . The melting pot is our souls, and it is boiling. ('Cool it, man.')"

For Blossom, it was specifically the rigidity and repression of the body that leads to "a denial of one's earliest push. . . . anxiety. . . . group schizophrenia."

> What's wrong? Our hearing-seeing-gesture-speaking. And so our feelings. And so. And so. How do we right it? What did the other languages have that we haven't? Ease. A recognition that the gesture is for the eye, the word-sound for the ear. This is precisely where our bridges to each other have become congested. . . . Necks became difficult to bend. Spines became rigid. Gestures became like telegrams in code instead of counterpoint to vocal melody. And vocal melody? Well, Negroes have it because they often remain untrained in the self-strangulation that is the custom among white people here.

For Blossom, what was urgently necessary was to invent a new "language," one that he proposed he might be inventing in his mixed-media theater. And although his theater had nothing to do with African American performance traditions, he proposed it as a theatrical language that would approach the freedom, concreteness, and relaxed, full-bodied quality he perceived in the exemplary spirit of black culture.[36]

Other works uphold the romantic view of African Americans as possessing an uninhibited physical grace, in tune with nature, unavailable to whites. Jonas Mekas's *Guns of the Trees* is an antiwar film in which a young white woman commits suicide in a desperate gesture against what she perceives as the insufferably militaristic American society of the late Fifties. In the film, two Beat couples are friends. The black couple represent easy intimacy, fertility, and peace—values the white couple have difficulty finding. Unlike Adolfas and the suicide Frances, with their Euro-American anxieties, the African Americans Ben and Argus laugh, enjoy sharing their spaghetti dinner and cheap wine with their friends (despite Ben's unemployment), and make love among the plants fruitfully, for Argus is pregnant.[37]

Similarly, in Ron Rice's *Queen of Sheba* the eponymous odalisque, played by the black actress Winifred Bryant, is above all represented as a generous body—exceedingly fleshy (and often undressed), a heavy drinker,

a sound sleeper, pantherlike in her movements, and moodily enigmatic. David James calls her an "African Queen" and refers to her "massive bulk and voracious appetites," in high contrast to the diminutive, sexually ambivalent Atom Man played by Taylor Mead.[38]

I want to stress that although they participate in the discourse of positive primitivism, the works I have singled out here were not racist in intention. On the contrary, these artists admired and often emulated the qualities they saw in African American culture. Like many African Americans who in the Sixties and Seventies turned away from the integrationist notion that blacks could and should assimilate into white culture, these artists appreciated the uniqueness and differences produced by African roots and tempered by the syncretism of African and European cultures. These overtones of positive primitivism were perhaps the inevitable by-product of white artists contesting not only the racist society they lived in, but their own traces of prejudice. The acute consciousness of racial difference advocated by the Black Power movement of the later Sixties, the search for roots in the Seventies, and more recent analyses of diverse multicultural formations has changed immensely the way in which we think about representations of "race" today. I do not mean here to charge these avant-gardists—whose embrace of black culture was radical in its time—with racism; I only want to say that they were willy-nilly products of their era, even as they divorced themselves from it and changed the world around them. And although these appropriations may now carry for some the taint of rip-off culture, for the Sixties avant-garde it signaled cultural respect, even envy. If the envy was there for the wrong reasons, and expressed in what now seems inappropriate ways, the respect was undeniable.

In 1957 Norman Mailer published his prophetic essay "The White Negro," outlining in sociological and political terms the attraction that the white avant-garde, in the form of Beat culture, had to African American culture, to jazz in particular, and to the sexual freedom associated with it.

It is no accident that the source of Hip is the Negro for he has been living on the margin between totalitarianism and democracy for two centuries. But the presence of Hip as a working philosophy in the sub-worlds of American life is probably due to jazz. . . .

In this wedding of the white and the black it was the Negro who brought the cultural dowry. Any Negro who wishes to live must live with danger from his first day, and no experience can ever be casual to him, no Negro can saunter down a street with any real certainty that violence will not visit him on his walk. . . . The Negro has the sim-

plest of alternatives: live a life of constant humility or ever-threatening danger.

But for Mailer, too, the estimable wisdom of the African American is romantically associated with "primitive" passions. And primitive passions are above all focused on the body. Antiracism begins to sound peculiarly like racist rhetoric. Mailer continues:

> In such a pass where paranoia is as vital to survival as blood, the Negro has stayed alive and begun to grow by following the need of his body where he could. Knowing in the cells of his existence that life was war, nothing but war, the Negro (all exceptions admitted) could rarely afford the sophisticated inhibitions of civilization, and so he kept for his survival the art of the primitive, he lived in the enormous present, he subsisted for his Saturday night kicks, relinquishing the pleasures of the mind for the more obligatory pleasures of the body, and in his music he gave voice to the character and quality of his existence, to his rage and the infinite variations of joy, lust, languor, growl, cramp, pinch, scream, and despair of his orgasm. For jazz is orgasm, it is the music of orgasm, good orgasm and bad, and so it spoke across a nation. . . . It was indeed a communication by art, because it said, "I feel this, and now you do too."[39]

For Mailer, as for so many white Americans, the African American body is the dancing body, the jazz body, the emotional body, and, inevitably, the sexual body.

LeRoi Jones, in his important book on the history of African American music, *Blues People* (published in 1963), supports Mailer's point (though not stating it as romantically) that the avant-garde was attracted to black culture because it shared an antibourgeois stance. In fact, in Jones's view the attraction was mutual.

> It was a lateral and reciprocal identification the young white American intellectual, artist, and Bohemian of the forties and fifties made with the Negro, attempting, with varying degrees of success, to reap some emotional benefit from the similarity of their positions in American society. In many aspects, this attempt was made even more natural and informal because the Negro music of the forties and again of the sixties (though there has been an unfailing general identification through both decades) was among the most expressive art to come out of America. . . .
>
> But the reciprocity of this relationship became actively decisive dur-

ing the fifties when scores of young Negroes and, of course, young Negro musicians began to address themselves to the formal canons of Western nonconformity, as formally understood refusals of the hollowness of American life, especially in its address to the Negro. The young Negro intellectuals and artists in most cases are fleeing the same "classic" bourgeois situations as their white counterparts. (231)

For Jones, even African American music in the form of jazz had to be questioned and renewed from a black avant-garde perspective.

The jazz of the late fifties and sixties, though it has been given impetus and direction by a diversity of influences, is taking shape in the same areas of nonconformity as the other contemporary American arts. In Greenwich Village, for instance, a place generally associated with "artistic and social freedom," based on willing (though sometimes affected) estrangement from the narrow tenets of American social prescription, young Negro musicians now live as integral parts of that anonymous society to which the artist generally aspires. Their music, along with the products of other young American artists seriously involved with the revelation of contemporary truths, will help define that society, and by contrast, the nature of the American society out of which these Americans have removed themselves. (233)

Furthermore, Jones, like Mailer, emphasizes the bodily aspect of the African American arts as central to their point of difference from Euro-American culture. He argues that "Negro music is *always* radical in the context of formal American culture" exactly because it is based on a "kinetic philosophy."[40]

Jones insisted that improvisation was key to African musical art and the early history of African American music, but it had been truly restored to jazz only by the avant-gardists of the Sixties. Writing about Ornette Coleman and Cecil Taylor as the important innovators of their generation, he noted:

What these musicians have done, basically, is to restore to jazz its valid separation from, and anarchic disregard of, Western popular forms. They have used the music of the forties with its jagged, exciting rhythms as an initial reference and have restored the hegemony of blues as the most important basic form in Afro-American music. They have also restored improvisation to its traditional role of invalu-

able significance, again removing jazz from the hands of the less than gifted arranger and the fashionable diluter. (225)

According to Jones, the freedom of the contemporary jazz musician in the improvisatory moment was fundamental to this transformation.[41]

Improvisation as an artistic technique, not only in jazz but in the other arts, was prized by the Sixties avant-garde for two reasons. It symbolized (perhaps even embodied) freedom. But it also relied on the wisdom of the body—on the heat of kinetic intuition in the moment—in contrast to predetermined, rational decision-making. This bodily knowledge stressed spontaneity, valuing rather than discarding the human imperfections of im-promptu creation; it also underscored the importance of group interaction. This was one of the valuable legacies that white avant-gardists inherited from African and African American performance modes.

The choreographer Trisha Brown later wrote about her own involvement with improvisation as simultaneously liberating and socially and artistically responsible:

> If you stand back and think about what you are going to do before you do it, there is likely to be a strenuous editing process that stymies the action. On the other hand, if you set yourself loose in an improvi-sational form, you have to make solutions very quickly and you learn how. That is the excitement of improvisation. If, however, you just turn the lights out and go gah-gah in circles, that would be therapy or catharsis or your happy hour, but if in the beginning you set a struc-ture and decide to deal with X, Y, and Z materials in a certain way, nail it down even further and say you can only walk forward, you cannot use your voice or you have to do 195 gestures before you hit the wall at the other end of the room, that is an improvisation within set bound-aries. That is the principle, for example, behind jazz. The musicians may improvise, but they have a limitation in the structure.[42]

If improvisation allowed for freedom of choice and action, nevertheless it was anything but anarchic. Brown saw improvisation not as an intu-itive surrender to the body's impulses, but as a rational plan for generating action in a cohesive community.

The composer Philip Corner began to think of music in a physicalized way as a result both of working with the dancers at the Judson Church and a fascination with jazz. For instance, in *Keyboard Dances,* he played the piano with his feet. In *Big Trombone,* Corner explains: "I was just playing

the trombone in a vigorous, physical way, organically related to the music itself. There were no gratuitous theatrics. I thought new music, in terms of a harmonic and rhythmic language, lacked a dimension jazz had—that is, a certain rawness. I wanted to create in my own terms something that had an unimpeded, uninhibited rush of physical energy." Both jazz and rock and roll had something the white avant-garde did not, Corner felt. It had a beat. And a beat, of course, connects art directly to the pulsing body.[43]

In the avant-garde, as in the rest of American culture in the early Sixties, the racial body was a political battleground. In some instances it was the goal of avant-garde culture literally to mix black and white bodies, as integrated casts on stage and on film became a desideratum of the civil rights movement. In other cases the goal was to value the aspects of African American bodies that had been devalued by mainstream society. But metaphorically speaking, the diverse bodies were already amalgamated culturally. Whites and blacks across the various social strata continued to participate willy-nilly in the two-way street of cultural borrowing that had made both Euro-America and African America syncretic processes for centuries. And that process was intensified with the meteoric rise of the mass media, especially television, after World War II. But the early Sixties avant-garde consciously participated in this fusion. In particular, white artists endorsed the special authority and knowledge that black culture has traditionally conferred on bodies. If the high arts of Euro-American culture for the most part etherealized the body, the high arts of African American culture—many of whose values had long since permeated the Euro-American popular culture that now inspired much avant-garde art—invested it with weight, power, and significance. And the avant-garde put its faith in the power of the body.

The Sexual Body

The ethos of liberation in the early Sixties found an important abode in the sexual body. Above all, the public representation of the body as erotic flesh in the avant-garde arts signified freedom from bourgeois conventions— both moral and artistic. For in genteel society, sexual activity is something private; in polite discourse, it is a taboo subject. It may be that in some ways the movement by the avant-garde toward erotic art reflected the sexual "revolution" that the entire country was beginning to experience (especially after the approval by the federal Food and Drug Administration of the birth control pill in 1960). And certainly erotic art was not unique to this generation; in invoking sex it was following an avant-garde tradition. But the representation of the sexual body in the early Sixties heterotopia

went beyond the simple reflection of changing social values or the repetition of a historical avant-garde shock technique. It anticipated and even contributed to the more enormous, radical sexual transformations yet to come. The transgressive step taken by the Sixties avant-garde was to make sex and sexuality brashly public, often even a communal affair. It created a space for a variety of sexual choices and experiences.

Andy Warhol's films—with their voyeuristic, unflinching, obsessive gaze, analogous to the multiple silk screens he favored in his visual artworks—put various subjects under scrutiny. From almost the very first, sexuality was one of those subjects. Like *Sleep, Eat, Haircut,* and *Empire,* Warhol's *Kiss*—his second film—is a case of monovision. At fifty minutes it is short compared to the six-hour-long *Sleep* or the eight-hour *Empire.* And, with kissing partners changing from one roll of film to the next, it has enormous variety compared to the single subject of those two films. But it is obsessive in its own way. Steven Koch described *Kiss:*

> It is silent. There are no credits or titles. Without announcement, the screen lights into a highly contrasted black-and-white close-up: A man and a woman are—surprise!—kissing. The lips of both are full, sensuous, crawling on each other, melding in intense sexuality. Their tongues slide and probe; the woman keeps her eyes open, gazing almost frenetically at the man's closed eyes as the kiss continues. It continues for a *very* long time. Sitting out in the audience, we watch and wait. We are perhaps aroused, but also a bit perplexed. . . . And suddenly the intense black and white of the image seems to flicker and whiten, then falters and is obliterated in a "white-out" before the kiss itself ends. A ragged piece of film end seems to flash by, as though the short film roll in Warhol's camera had simply run out. We see only whiteness for a moment, and then, with spectral insistence, the screen darkens again with the image of a new, long kiss.[44]

Several of these fixed, close-shot kisses were screened weekly, in serial fashion, at the Film-Makers' Showcase in 1963, as the short subjects preceding the evening's "feature" presentations. The next logical step for Warhol was *Blow Job,* described succinctly by Mekas as "a sustained closeup of a boy's face as someone, out of camera range, performs fellatio on him."[45] We never see the activity named in the title. Rather, the film is, as Koch put it, an "apotheosis of the 'reaction shot.'" We view only the hero's changing facial expressions as they register various levels of pleasure, suspense, and ecstasy. The voyeuristic style created by Warhol's passively stationary, silent camera was itself suggestive of sex. The camera cast its subjects in an erotic

light not only in these overtly sexual films, but also in *Sleep* and even in *Empire*. "An eight-hour hard-on!" Warhol exclaimed as the shooting of the Empire State Building progressed.[46]

Although in *Blonde Cobra* Jack Smith proclaims that "sex is a pain in the ass," this is merely an occasion for a visual joke: the scene has been shot in film noir style, and now the camera closes in on a shot of a knife phallically caught between Smith's nether cheeks. The point, of course, is to suggest the pains and pleasures of homoeroticism. For Smith in *Flaming Creatures*, in contrast, sex is joyous, indiscriminate, regenerating. Susan Sontag compared *Flaming Creatures* to a Bosch painting—"a paradise and a hell of writhing, shameless, ingenious bodies." But unlike the figures in Bosch, these brazen bodies, and those who view them, have no hell awaiting them—only paradise on earth.

What all these films share is that sense of shamelessness—an utterly un-muzzled celebration of sexual discovery, and often of gay, lesbian, bisexual, or group sexual adventure. Moreover, the very meaning of a word like "shameless" was reclaimed from a moral space of wickedness and sin. In regard to Barbara Rubin's *Christmas on Earth* Mekas wrote a deliberately fallacious, tongue-in-cheek piece of logic:

> A syllogism: Barbara Rubin has no shame; angels have no shame; Barbara Rubin is an angel.
>
> Yes, Barbara Rubin has no shame because she has been kissed by the angel of Love.
>
> The motion picture camera has been kissed by the angel of Love. From now on, camera shall know no shame.[47]

Not only were these films gloriously and unabashedly shameless; they went so far as to extol sexual transgression. To be "flaming," to be outra-geous, to be absolutely unembarrassed about any aspect of the body and its experiences was seen as life-affirming in its liberation from puritanical repression.

Long before the gay rights movement erupted in the late Sixties and early Seventies, the assertion of homosexuality appeared in various works of the Baudelairean cinema—from *Flaming Creatures* to Jean Genet's *Un Chant d'Amour*. Gay life appeared as subject at the Caffe Cino, too, not only thematically—in such plays as *The Madness of Lady Bright* and Robert Patrick's *The Haunted Host* (about a gay playwright living on Christopher Street in the Village)—but in the generally camp style of many of the pro-ductions. Pinpointing Caffe Cino as the first New York locus of gay theater,

William Hoffman (another gay playwright) writes about it in specifically libertarian terms.

> It is symbolic that among the Cino's first productions were *The Importance of Being Earnest* and plays by [Tennessee] Williams.
>
> Joe Cino became a play producer because many of his customers wanted to put on shows, and he and many of his customers were gay. Joe Cino did not have an obsession with homosexuality. He simply had an extraordinary largeness of spirit that allowed other people to explore, set other people aflame to express what they never had been allowed to before. . . .
>
> Both gay plays and gay theater were pioneered at the Cino from the beginning. Early productions can only be described as homosexual in style: a vivid, sexy *Deathwatch* (Jean Genet) and *Philoctetes* (André Gide). But pretty soon such writers as Doric Wilson, Claris Nelson, and David Starkweather wrote about characters who were specifically gay, closet gay, or bisexual.[48]

Camp style also became a hallmark of the Judson musicals in the Sixties.

Besides being a symbol and site of liberation, the sexual body in its festive, grotesque mode—fertile and permeable—was a figure of abundance, signifying a bountiful culture of easily available, limitless pleasures and perpetual leisure time. Hence the yoking of sexual desire to banquet imagery. As we have seen, the gaping mouth was a potent emblem in early Sixties artworks. It stood for the orality of consumption in several spheres: the culinary and the infantile as well as the erotic.

In Rubin's generous *Christmas on Earth,* even the film projection itself seems to be engaged in a sexual act. Consisting of two reels of black-and-white images superimposed—one forming a smaller square within the other—its two pictures rub against one another rhythmically, like two intimate bodies, to the accompaniment of rock and roll from a "live" radio. In the images themselves, there are at least four bodies, and the superimpositions multiply them. Thus, there is a seemingly endless array of breasts and penises, vulvas and exploring fingers—enough to belong to a crowd. Poked, prodded, handled; compared and contrasted; viewed and reviewed; engaging in heterosexual and homosexual partnering, all these interactive sexual parts appear as a living cornucopia, one that is not only teeming to begin with, but also engaged in the act of potentially proliferating even more humanity.

In *Home Movies,* each character is fairly bursting at the seams with sexual

desire—aimed at any and every nearby target. This is a French sex farce gone wild. Sexual desire here is assimilated, as we have seen, to food, to vegetative growth, and even to the explosive sensations of flatulence. It often causes people to erupt into song. And it respects the bounds neither of age, gender, race, nor church vows. As in *Christmas on Earth,* sexuality here is experienced as expansive and efflorescent.

Rainer's "love" duet in the "Play" section of *Terrain,* in which she and Bill Davis assumed erotic poses from Indian temple sculpture, also remarks on lovemaking as an activity of abundance—in two different ways. First of all, by assimilating this action to the other types of (more innocent) play in the dance, Rainer locates sex as part of leisure: pleasurable, playful, indulgent, and energizing. Second, by quoting a thesaurus of erotic postures from Indian temple sculpture, she notes the infinite inventiveness of the body in its sexual mode. Sex itself is seen as a kind of treasure chest that offers both satisfaction and imaginative variety. Moreover, Rainer here seems to offer an unemotional antidote to—and a dry comment on—the overeroticization of the pas de deux in ballet and Graham's modern dance.[49]

The apotheosis of libidinal plenitude in performance was Carolee Schneemann's ecstatic revels of the flesh, *Meat Joy.* Even in describing her earliest inspirations to plan the piece, Schneemann refers to bodily effervescence and abundance: "My body streamed with currents of imagery. . . . I continually felt dissolved, exploded, permeated by objects, events, persons outside of the studio."[50] Like so many avant-garde films and performances of the period, *Meat Joy* was accompanied by a rock and roll score. And, as in *Christmas on Earth,* the songs—with their formulaic lyrics about adolescent love barely masking a deeply propulsive, sexy beat—often served as ironic counterpoint to the much more graphic imagery in the performance. The popular songs were overlaid with a tape of Paris street noise—traffic and the cries of marketplace vendors. As members of the audience entered, Schneemann's voice was heard reading her own notes for the making of the performance, interspersed with French vocabulary lessons. The French lessons made reference to parts of the body, to scents both pleasant and unpleasant, and to human and animal characteristics. As they were read aloud, Schneemann's preparatory notes often took on a slightly pornographic edge, as the disembodied voice described dream images, a film scenario, and other visions both possible and impossible to realize in the performance, leaving the spectator's imagination free to fill in the gaps.

To the beat of the rock and roll collage, men and women undressed one another, wrapped one another up in paper, rolled around on the floor, painted one another, and as a group formed kaleidoscopic patterns with

their bodies. They cavorted with the fish, chicken, and hot dogs, and generally indulged in making a mess with paper, paint, and other objects. The immersion in bodiy sensations of all kinds, even the number of participants in these erotic rites, signify a sexuality of abundance and gratification.

Jill Johnston reviewed the performance, noting the primitivist imagery:

> Miss Schneemann prefers culture in its rudimentary state before and after the refinements of pride and parlor. What comes after is the garbage, and some of the junk culture artists would glorify our despicable remains. What comes before is not so easy to say, since sex, for one thing, can be as juicy in the parlor as people think it probably is in the cave. . . .
>
> The fish in "Meat Joy" could symbolize the watery matrix of our origins. It doesn't matter. The point of the meat and fish and paint was to demonstrate the sensual and scatological pleasure of slimy contact with materials that the culture consumes at a safe distance with knife and fork and several yards away in a gallery or a museum.[51]

The immersion in bodily sensations of all kinds, the enjoyment of flesh and other textures of all kinds, even the very number of participants in these erotic rites signify a sexuality of abundance and satiety.

In both *Meat Joy* and her film *Fuses,* Schneemann raises a third aspect of sexuality for the Sixties avant-garde. Not only does the sexual body stand for liberation and abundance; in its shamelessly public aspect it also is thought to create community (rather than the privacy of bourgeois sexuality). In *Meat Joy,* part of the point was the physical proximity of the audience. Performers might roll into them or join them momentarily, and they were constant witnesses to the erotic pleasures, the overwhelming smells, and the sensuous textures of the performance. Further, the sexual body here is part of a community exactly because it is free and abundant—that is, the eroticism is group, not couple, eroticism. This symbolizes a key Sixties ideal of community, one that by the late Sixties had been widely disseminated.

In Schneemann's film *Fuses,* sexuality is connected with domesticity. The film shows scene after scene of Schneemann and James Tenney joyously making love, intercut with flashing footage of the household cat. *Fuses* is related to Brakhage's films of domesticity and conjugal relations—including *Loving,* in which Schneemann and Tenney are the lovers; *Cat's Cradle,* which elides the figures of Schneemann and Tenney with the newlyweds Stan and Jane Brakhage; and *Wedlock House: An Intercourse,* in which Brakhage and his wife recorded one another arguing and themselves making

love. But domesticity in all of these films is turned inside out—made public—since the viewer becomes a participant in private moments. Moreover, the watchful eye of the cat in *Fuses* enhances the sense that the lovers are never engaged in a private act, although they are engaged in an intimate one. It is an act that is to be shared with viewers—both good to do and good to watch.

In 1964 Andy Warhol made *Couch,* a series of erotic encounters (including lovemaking, banana-eating, and talking) on a sofa by twenty or so visitors to The Factory, grouped in various permutations. Like *Kiss,* the film was a string of short takes, and also like *Kiss* the encounters were both heterosexual and homosexual, as well as interracial. But here the groupings were not all one-on-one. Moreover, the film suggested that this public, anonymous, and promiscuous eroticism went on regularly in The Factory even when the camera was not recording. *Couch,* that is, seemed to be an almost anthropological document of the sexual habits of life itself in the underground.

In Warhol's *Couch,* eroticism is made public by virtue of its exposure first of all to the camera's eye, but also to the onlookers who are part of the group scene. And in LeRoi Jones's *The Eighth Ditch* (see chapter 5) an audience of Boy Scouts inside the play itself ratifies the sexual union between the two boys, 46 and 64. In Al Hansen's *Hall Street Happening* two women made love. Of course, these voyeuristic formats might not look shocking to us now, but in the early Sixties, especially given the Hollywood practice of self-censorship, they were considered extraordinarily lascivious. The invitation to the audience to witness sex, especially group sex, prefigures the "Rite of Universal Intercourse" the Living Theater would perform in *Paradise Now* on its return to the United States in 1968, or the production of *Dionysus in 69* by the Performance Group. Both of these plays went even further by inviting the audience actually to participate in the erotic dance on stage.

One of the productions put on at the Caffe Cino in 1963 was Tom O'Horgan's "contemporary masque" *Love and Variations.* The subject matter of the play was described in a brief review by Michael Smith: "The theme of the work is stated by quick calculations based on a general orgasm incidence multiplied by the population of New York City reduced to a per-hour basis, a snap-of-fingers basis—etc." In this play, that is, nearly the entire city is seen to be engaging in sex simultaneously. "The variations," Smith advised, "outdo one another in perversity, and the whole show skitters along the brink of appallingly bad taste." But he concluded that "the whole thing can be nicely described as lewdly charming."[52] O'Horgan was

later to gain fame as the director of *Hair,* the rock musical that brought "hippie" culture to the mainstream when it moved from the Public Theter downtown to Broadway in 1968, notorious above all for its nude party scene.

In fact, the party is an occasion in which social rules are suspended and anything is possible, suggesting sexual freedom and sexual liaisons of all kinds. *Meat Joy* itself is framed as a party, given the rock song accompaniment, as is *Christmas on Earth*. Kenneth Anger's film *Scorpio Rising* not only has a rock and roll sound track, but actually features a costume party scene—to the song "Party Lights"—that Anger refers to as Walpurgis Party,[53] and that is compared in the film, through editing, to the Last Supper. Scorpio's party is a raucous gathering, replete with bare asses, unveiled erections, and slightly sadomasochistic events. And Death—in the form of a partygoer in a skeleton disguise—looks on. Death, the party, and communal sex also are linked in the play *Home Movies,* where on the occasion of the father's putative death a gathering takes place that is meant to mourn, but ends up leavened with desire. And in this comedy, lust and life defeat death, bringing the father back alive.

Thus, the sexual body symbolized empowerment: the dominion of the visceral body itself, claiming primacy over rationality, was seen as the locus of liberation, abundance, and community. According to this ethos, sexual ecstasy itself seemed to be authoritative, for it tapped into an almost religious state of "natural truth" and intense experience in the moment. It appeared to be a direct line to an ideal, Blakean eternal energy—a visionary exultation in the erotic unity of the self. And, particularly for women artists, to explore and celebrate sexuality was to galvanize the performance situation, setting loose the forceful yet transgressive powers of desire.

The Gendered Body

One of the borders the effervescent body subversively confuses is that of genders. But in the early Sixties avant-garde the arts were not united in this regard. Although many artists shared a project of responding to the popular iconography of the female body, their responses ranged along a spectrum, between bodies strictly compartmented according to mainstream gender codes and androgynous bodies blurring gender boundaries.

In Pop Art and Happenings, in particular, the predominantly male artists often seemed to adopt uncritically—even at times to salute—the dominant culture's representations of women both as a consumer and as a sexual object to be consumed. This was one end of the spectrum. Further along the spectrum were cases where such representations were made, but partly

in ironic tones. Another point along the spectrum—often in the works of women artists—was the figure of woman as essentially different from, and thus superior to, the male. And still further along were the images of women imprisoned by their culturally assigned roles as domestic creatures, fashion plates, or bodies bereft of minds.

But at the other end of the spectrum were the works by artists, predominantly women and gay men, who proposed equality between the sexes by transgressing the culture-bound question of gender divisions. They refused to draw deep distinctions between male and female bodies or actions, either by taking a unisex view of gender roles among bodies or by conflating and bending gender roles in individual bodies.

To us, living now in a culture that has been indelibly altered by more than two decades of feminist politics—although it is still a society where female bodies are embattled—it might be difficult to accept the idea that much of the art of the Sixties that was advanced in so many other ways could be sexist. Even the Archie Bunkers of the Seventies knew that women were capable of more than Hollywood and Madison Avenue were willing to grant them in the Fifties and early Sixties. Yet in certain arenas the images of the Sixties avant-garde were undeniably sexist. For the most part, even among the politically progressive (as the history of the New Left has shown) neither male nor female consciousness had yet been raised about the subtleties of female oppression.

Betty Friedan's book *The Feminine Mystique* was published in 1963. Its ground-breaking research was limited to white middle-class female frustration. But this book was a first step that would eventually lead to the opening of a Pandora's box of political ferment, with far-reaching repercussions for all women—and all men. The permutations and cultural influence of the research and activism that began with Friedan's influential book have yet to unfold fully. But it is important in thinking about the early Sixties to remember that it was not until 1968 that a full-blown feminist movement emerged—the movement that has wrought such deep-seated social changes in the United States as affirmative action hiring for women, two-career families, and the entry of women into the mainstream of professional and political life.

Compared to African Americans whose suffering from low economic and social status, restricted educational and professional opportunities, and persistent discrimination in every sphere of daily life was incontestable and publicly well-documented, the "women's problem" was only beginning to surface, much less be unraveled, in the early Sixties. Thus, that there was any progressive representation at all of female bodies in 1963, by either

men or women, is all the more amazing. And that there were zones where either the notion of the gendered body was called into question altogether, or the female body was redefined, was revolutionary, given the gender consciousness of the time.[54]

On the other side of the coin, in retrospect the artworks celebrating women's "femininity" as superior to "male culture" may appear to us now as an essentialist view of women's bodily powers, part and parcel of the "positive primitivism" that also set black bodies apart in an alternate realm thought to be richer than white male rationalism. However, as with the white romantic view of African American culture, this view must be contextualized. In its time this was a dramatic and radical way of asserting difference. It was also a step—like Marx's point that in moving from feudalism to communism a culture has to pass through capitalism—that seems to have served a historically necessary role in making a political battleground of representations of women.

Since the Victorian era, the middle-class "cult of true womanhood" in both Europe and America had created distinct, gender-identified social realms. As Nancy Armstrong and Leonard Tennenhouse have succinctly put it in their essay on conduct literature, "the primary difference between 'masculine' and 'feminine' then creat[ed] the difference between public and private, work and leisure, economic and domestic, political and aesthetic."[55] This was the set of divisions that *The Feminine Mystique* called into question. And it was this set of divisions that the avant-garde both reflected and challenged.

So at one end of the spectrum of avant-garde representations, the female body was stereotyped as consumer and consumed in the many ways that the culture at large pictured it: domesticized and made exotic; the passive subject of the male gaze in the fine arts and a fashion item; a symbol of fecund, animal-vegetable nature and of human sexuality. All of these stereotypes were interwoven, for they relegated women's bodies to strata that were trivial, passive, unassertive, Other. But at the opposite end of the spectrum, these stereotypes were radically criticized. Women were seen as resistant to passive consumption, as equal to men in their strength and skills. The very entry of women into performance asserted the female body as a public figure, the agent rather than the subject of the artwork. And, particularly by gay artists, femininity was proposed as a cultural category not only accessible to women.

Compare these two representations of the domestic female body: Allan Kaprow's *Household,* which upholds gender stereotypes, and Lucinda Childs's *Carnation,* which challenges them. In Kaprow's Happening, per-

formed at a dump outside Ithaca, New York, in May 1964, there was no audience. The participants met with Kaprow to learn their parts, then gathered at the site to perform them. The group's activities were divided according to gender in blatantly symbolic ways. First, the men built a tower while the women built a nest and hung laundry on a clothesline. When a wrecked car arrived, the men rolled it into the dump and coated it with strawberry jam, while the women screeched in their nest. The women licked the jam off the car, while the men destroyed the nest "with shouts and cursing." The men chased the women away from the jam-covered car, put bread on top of the jam, and began to eat, while the women screamed "Bastards! Bastards!" (Meanwhile, an undifferentiated army of people advanced, banging on pots and blowing police whistles.) Now the women took their turn, destroying the men's tower. Kaprow's scenario reads:

VIII. Women go to heaps of smoking trash, call sweet-songy come-ons to men.
Men fan out, creep low to ambush women.
People advance, banging and whistling.
IX. Women jump men, rip off shirts and fling them into smoking trash, run to men's tower mound.
Men roll on ground laughing loud: "Hee! Hee! Hee! Haw! Haw!"
People advance, banging and whistling.
X. Women take off blouses, wave them overhead like hankies, each singing own Rock 'n' Roll tune and twisting dreamylike.
Men hurl red smoke flares into smoking trash heap.
People circle smoking jam-car, become silent, squat down, eat jam sandwiches.
XI. Men go to wreck, take sledge hammers from people, pick up battering log, begin to demolish car.
Women watch from a distance and cheer men for every smash.
People eat silently and watch.
XII. Men jack up car, remove wheels, set fire to it, sit down to watch, light up cigarettes.
People light up cigarettes, watch car burning.
Women run out of junkyard, waving blouses, gaily calling "'Bye! 'Bye! G'bye!
'Bye!" They get into cars, drive away with horns blaring steadily till out of earshot.
XIII. Everyone smokes silently and watches car until it's burned up. Then they leave quietly.[56]

Kaprow's Happening, like so many of his works, is cast as tongue-in-cheek primitivism, a war between the sexes conceived as a caveman satire of domesticity—the women do the laundry and seduce the men, while the men make fire and flex their muscles in a show of physical power. Yet it is clear that this satire has no ulterior agenda in mind; the gender roles may be exaggerated for comic effect, but nothing in the performance points to an alternative domestic arrangement. The gendered universe remains intact. And while the women do, in the end, leave the men, in this fictional universe the way they leave the men is reminiscent of a Flintstone cartoon, Blondie and Dagwood in the comic strip, or the TV family situation comedies of the period. It reassures us that if the performance had a next installment the women would be back—probably loaded down with packages brought home from a shopping spree.

Quite different in meaning is Childs's *Carnation*. Here, the choreographer was, so to speak, assaulted by household objects. As she sat at her table handling familiar household items, got up to do a handstand, folded a sheet, and was threatened by a plastic garbage bag that would not behave, domestic routine was completely subverted. Like the Fifties horror movies in which one's entire family was transformed into aliens, here normal suburban housewifely activities suddenly took on strange proportions. Childs's body was imprisoned, reshaped, and sometimes invaded by sponges, hair curlers, a colander, a pillowcase, a sheet, and a garbage bag. She did the right things—stacking objects neatly, putting them together and taking them apart, folding them methodically. Nevertheless, the objects revolted.

As in Kaprow's *Household,* the images in *Carnation* often were comic, although here the comedy was rooted in the absurd independent life of objects. At times, too, the imagery became oddly and grotesquely beautiful—as when Childs, sitting at her table, her gaping, stretched mouth so full of sponges that the planes of her profile were entirely altered, began uncannily to resemble a cubist head in the manner of Picasso. But also, the dance was shot through with tragedy. For it made devastatingly clear the politics of gender in the Sixties: that women as domestic bodies are not the makers of culture. In this case, they seem not even assertive enough to be the consumers of culture. Rather, in *Carnation* women are pictured as living at the mercy of the domestic objects that actually consume them in the grind of daily life. Yet, finally, Childs seems to triumph. In her surrealistic work the female body ultimately identifies the tyranny of housekeeping and resists the demands of domesticity.

The liberatory eroticism of Barbara Rubin's extraordinary film *Christ-*

mas on Earth has been discussed. Here I want to point to another aspect of its imagery—the celebration of femininity as a powerful and alluring Other. A film that projects a fantastical, Orientalist sexual space where a woman is surrounded by her "harem" of men, *Christmas on Earth* produces an unusually exotic representation of the female body. The "heroine" of the black-and-white silent film—which is accompanied by a radio tuned, according to the director's instructions, to any rock music station—is a white woman recast as a woman of color. That is, nude and painted with dark body paint and decorated with geometrical designs, the woman seems to be a non-Western body. Moreover, she is sexually available in a way that white women are not supposed to be. She freely gives the gift, as the title suggests, of her sexual favors. But, liberated from sexual guilt, she also takes sexual gifts in return. The men attending to her are also painted, but they are represented as white. As well as transposing the woman's body racially, the body paint suggests a cultural transposition, for it seems reminiscent of the ritual body ornamentation of non-Western cultures. That is, while not a specifically recognizable pattern from an identifiable foreign country, the body paint suggests Middle Eastern or African practices—the exotic Other. At the same time that she seems to be a dark, "primitively" exotic female body, as she dances the woman's body also becomes configured as an abstraction of a face—her breasts become eyes, her pubis a mouth. Her body itself has oxymoronically become a mask, even as her nakedness and the camera unmask her most private body parts.

The female body as the subject (or theme) of the work of visual art is a time-honored tradition that has recently undergone extensive feminist scrutiny. Feminist analysis pays special attention to the way in visual art that the female body has traditionally been arrayed as an item of visual consumption for the spectator, assumed to be male.[57] Of course, no such analysis was in place in the Sixties. In fact, the feminist critique that arose in the Seventies and Eighties may be in part a response not only to the nudes of art history but to the work of the early Sixties visual artists who, abandoning abstraction and returning to figurative art, reinstalled the female figure in their artwork in ways that were not always positive. The (predominantly male) visual artists of the early Sixties cast the human figure in a new, postmodern light—making representations, so to speak, of the representations already in the culture. But along with appropriating images from Madison Avenue, they invoked the art-historical tradition of portraying the female figure. This took place in a number of ways along the spectrum of representation, from the elaboration of traditional versions of the idealized female nude, to complexly ironic explorations of the classic

figure, to the rejection of the female figure as the passive subject of the artist's gaze altogether.

For example, Tom Wesselmann's Great American Nude series mixed female imagery from Matisse, Modigliani, and other modern European painters. Vibrant colors and richly textured patterns surround his oda-lisques, with their strongly outlined flat forms and their acrobatic reclining poses. But what makes these nudes insistently American and postmodern is the unmistakably up-to-date environments they inhabit. *Bathtub Collage No. 3* features representations of a bright blue bathtub and yellow walls, adorned by a real plastic orange shower curtain, blue bath mat, and yellow towel, while another collage-painting, *Great American Nude no. 44,* has a red wall telephone and framed Renoir print attached to the canvas. The most salient characteristic of Wesselmann's nudes is that they have no features but mouth, nipples, and hair. That is, with no eyes or nose these women are shorn of individuality, seeming to be reduced to only oral and sexual parts. In this way, too, they are not simply art-historical nudes but resemble pinup girls in their emphasis on sexual characteristics.

Also quoting art history, George Segal's *Woman Shaving her Leg* brings Degas's workaday nudes to mind. But—unlike the idealized, lithe, and car-toonishly flat bodies of Wesselmann's decorative nudes—Segal's woman is squat and heavy-set. She is concretely there. Moreover, she is seen behind the scenes, so to speak—not smooth, hairless, and prepped for the male gaze, but in the awkward pose and unattractive act of hair removal. Even more so than Degas's women performing their ablutions, this is an uncom-promising representation of a physical body, with its unidealized surfaces and textures, occupying real space in fleshy proportions.

Robert Morris took the quotation of the art-historical female nude to an apotheosis when he created a living tableau of Manet's painting *Olym-pia* onstage in his dance *Site,* in which Carolee Schneemann posed as the naked Maja. Here the contrast between gender roles was underscored. The painting *Olympia,* of course, is anything but an idealized nude. In Manet's time the painting caused a scandal, for instead of classicizing the figure by generalizing her features, removing her body hair, and surrounding her with the obligatory draperies that—like the curtains on a proscenium stage—removed her from the spectator's world, the artist portrayed her as a contemporary working-class prostitute, shamelessly gazing from the picture frame.

In *Site,* this image was "constructed" onstage, as the artist/laborer (in the person of the choreographer) manipulated objects, eventually revealing the perfectly ordered live composition that quoted the famous painting.

Thus, another layer of meaning, in terms of gender roles, was added to the image: a woman as an item of sexual consumption, re-represented as an item of visual consumption, was shown as created full cloth by the male artist. The dance posed a contrast between women's and men's work. Traditionally, women's work takes place in the private, sexual sphere, whether as wives or prostitutes (although, ironically, the work time of the prostitute and the leisure time of her client coincide). Man's work, however, Morris's dance suggested, takes place in the economic sphere. In fact, as if to counter the charge that men who work in the world of art, culturally marked as feminine, are unmasculine, Morris compared his (and Manet's) work with that of manual laborers. *Site* recuperated the male artist's activity as safely masculine. The artist was shown as a construction worker. And what he constructed was the image of the sexual woman.[58]

It is perhaps fitting that Schneemann, the woman who played Olympia in Morris's *Site,* made artworks that challenged the assertive masculinity which Morris imputed to artmaking. Contrasting with these artworks by men that place women in the role of yet another object to be consumed, visually or otherwise, Schneemann's *Eye Body* was an attempt by a woman artist to use her physicality as an active part of the artwork. Schneemann describes the genesis of the work:

> In 1962 I began a loft environment built of large panels interlocked by rhythmic color units, broken mirrors and glass, lights, moving umbrellas and motorized parts. I worked with my whole body—the scale of the panels incorporating my own physical scale. I then decided I wanted my actual body to be combined with the work as an integral material. . . .
>
> Covered in paint, grease, chalk, ropes, plastic, I establish my body as visual territory. Not only am I an image maker, but I explore the image values of flesh as material I choose to work with. The body may remain erotic, sexual, desired, desiring but it is as well votive: marked, written over in a text of stroke and gesture discovered by my creative female will.

There was a social as well as aesthetic determination here, for Schneemann writes that she also meant to challenge what she saw as a closed male society of visual artists and critics. They created, she felt, an ostensibly neutral "male aesthetic" in which even the few women artists of the time were expected to participate. "In 1963 to use my body as an extension of my painting-constructions was to challenge and threaten the psychic territo-

rial power lines by which women were admitted to the Art Stud Club, so long as they behaved *enough* like the men, did work clearly in the traditions and pathways hacked out by the men." Yet women artists were in a double bind since, if they did make masculine art, they were seen as not fulfilling the social and artistic expectations for their own gender. "For years my most audacious works were viewed as if someone else inhabiting me had created them—they were considered 'masculine' when seen as aggressive, bold. As if I were inhabited by a stray male principle; which would be an interesting possibility—except in the early sixties this notion was used to blot out, denigrate, deflect the coherence, necessity and personal integrity of what I made and how it was made."

Among other images in Erro's photographs of *Eye Body,* one sees Schneemann lying naked on a plastic covering on the floor, her face bisected by a vertical line of dark paint and her body—oriented frontally toward the camera—covered not only with wavy lines of paint, but also with two snakes. She reclines comfortably, arms tucked behind the pillow that raises her head slightly. Though her eyelids are somewhat lowered, the angle of her head allows her to gaze directly at the spectator, and a slight smile hovers at her mouth. In another image, she stands, again naked, festooned with rope and rags. Here, her eye makeup has been exaggerated and her pouting mouth is outlined to the point where her features seem like creations traced on a neutral face. In yet another photograph, a long shot that allows one to discern little detail, Schneemann lies on her back on what looks like a fur rug, her legs raised in the air in a bicycling position. The view this time is from the side. While she crooks one arm behind her head, she holds the arm closest to the camera out from her body in such a way that her underarm cavity and the curve of her breast are open to the viewer—indeed they are emphasized, rhyming with the curve of her buttock. In all of these tableaux, Schneemann adopts the standard iconography of the cheesecake photograph—the pout, the unembarrassed gaze, the open postures, and the gestures that indicate where the viewer should direct his gaze—but she subverts them for another purpose.

Schneemann wanted to distinguish between the way she saw the female body represented as an object in Happenings and visual art and the way she tried to represent the female body as subject. Her view of the female subject was an essentialist one that placed women in the realm of primal nature. "I was using the nude as myself—the artist—and as a primal, archaic force which could unify energies I discovered as visual information. I felt compelled to 'conceive' of my body in manifold aspects which had

eluded the culture around me. Eight years later the implications of the body images I had explored would be clarified when studying sacred Earth Goddess artifacts of 4,000 years ago."[59]

But artists not only appropriated fine art models for representations of women. They also explored popular iconography of the female body, from fashion advertisements to comic books. Rosenquist's canvases show fragments of smooth, perfectly proportioned legs or manicured hands. Mannequinlike, these are body parts that could have escaped from the Fifth Avenue window displays that Rosenquist, Warhol, Rauschenberg, and Johns used to arrange. In Roy Lichtenstein's *Hopeless* we see a woman lying on her pillow with tears welling in her eyes as the bubble over her head shows her thinking, "That's the way—it *should* have *begun!* But it's hopeless!" This woman, and her sisters in other Lichtenstein works, have the enormous eyes and mouth, the diminutive noses, the even-toned (benday) peachy skin, and the lush wavy hair of comic-book heroines. Like those heroines, they also have mental lives ruled by their desiring bodies— waiting for the telephone to ring, the boyfriend to show up, or the latest wave of emotion to dissipate.

Other such female figures populate canvases, Happenings, and films. Warhol's various Marilyn Monroe and Jackie Kennedy multiples are like monotype machines, setting standards for feminine beauty. The characters that Pat Oldenburg played in Claes Oldenburg's performances, like the Street Chick, the City Waif, and the Bride, replicate the feminine stereotypes of American popular mythology. The bevies of pinup girls in Bruce Conner's films and collages are like catalogs of the culture's displays of gender differentiation; moreover, they are erotically implicated in anxieties of nuclear destruction (as in *A Movie* and *Cosmic Ray*), political disaster (*Report*), and psychosexual fetishism. In these works, as in Lichtenstein's portraits of comic-book women, the imagery is stylized, exaggerated, repetitive—to our eyes, outlandish. And yet nothing else in the works contravenes the standard social meanings of "the female." These are typical emblems of feminine helplessness, wiliness, and sexiness, only made more gigantic. Reproducing the iconography of mainstream culture, these transferences of female images leave gender codes intact.

The female body, then, was often represented as the subject or theme— the raw material—of artworks, both fine and commercial. Women's bodies also were viewed as "raw" in another, Lévi-Straussian sense, for they were represented as part of nature.[60] In Robert Whitman's *Flower* the human body was reconceived as partly botanic. A filmed image showed a woman tossing about in her bed linens, like a seed about to germinate. Later, four

women, in satin dresses and high heels, paced around the room. Manipulating their elegant dresses—which were layered like petals in white, red, blue, and gold—so that they constantly changed color, they seemed half fashion plate, half flower blossom. Throughout, images of birth mixed with images of vegetable fecundity.[61] A different aspect of nature was plumbed when female bodies mingled with raw animal parts in Vostell's *You*, as Lette Eisenhauer, bouncing on a trampoline among beef lungs, became increasingly blood-smeared.

In Stan Brakhage's film *Thigh Line Lyre Triangular*, the camera focuses on his wife Jane's face and vulva from a low angle shot near her feet. At first, the view seems a pornographic one, as unidentified hands probe her private parts. But then her pubic hair is shaved and she begins to birth a baby. What had been viewed at first as a controlled sex performance now becomes represented as a "natural," unpredictable, almost animal event.[62] Larry Rivers's *Pregnancy Drawing* is similarly fascinated with the fecund female body: partly taken from a medical textbook, and partly a portrait of his own pregnant wife, the drawing shows a fully developed fetus inside a transparent belly, and, in the manner of his *Vocabulary Lessons*, it labels parts of the body—the cervix, the uterine wall.[63] In Kaprow's *Courtyard*, a woman lies atop a mountain and seems to become a human sacrifice for nature's sake, as another mountain, upside down, descends from the sky to join the first mountain and swallows up the female figure.[64] In all of these works, gender divides the world into zones of specialty. Male equals culture; female equals nature.

But gender articulation is confused or challenged in many other works of the period, particularly in dance and film. Whitman's soft-textured metaphor for women's bodies in *Flower* stands in contrast to Paxton's *Afternoon*, where both men and women were compared to strong trees, as the costumes served to unify all of the performers—both human and arboreal—rather than divide them according to gender or species. As opposed to Vostell's *You*, in Schneemann's *Meat Joy* raw animal parts were assimilated to both male and female bodies, as couples cavorted among sausages, plucked chickens, and raw fish.

In Yvonne Rainer and Steve Paxton's collaborative dance *Word Words* the choreographers, dressed in the minimum costume allowed by law (G-strings for both, plus pasties for Rainer), performed an abstract sequence of movement in the structure suggested by the title. First, each did the phrase solo; then they performed it simultaneously as a duet. Although their nearly naked bodies may at first have drawn the audience's attention to the gender contrast between the two dancing bodies, the fact that they did

identical movements, with identical physical exertion, served as a refusal to differentiate. In the standard classical ballet pas de deux a similar formal structure is followed. First each dancer does a solo "variation," and then the couple dances together. But there the similarity ends. In ballet, the woman in her delicate tutu and satin toe shoes and the man with his bulging tights dance movements tailored to what in the genre's traditional technical vocabulary has become the "essence" of their genders: she has small, neat footwork and moves her arms gracefully, while he takes wide, powerful leaps and barrel turns and carries her around the stage. Her movement is restricted, while his signifies freedom. In modern dance, too—particularly in the Graham tradition—the genders were strongly bifurcated in terms of movement style and content. In contrast, with its straightforward postures uncoded by stereotypical gender trappings and performed identically by both dancers, *Word Words* used its minimal costumes not to reveal the body as separately gendered, but to strip both bodies down until they were seen as equal.

Similarly, in many Judson dances men and women were given equal work to do. In Trisha Brown's *Lightfall* she and Paxton both struck various sports-derived poses, perched on one another's backs, or jostled each other. Both were pictured as being equally capable of supporting the weight of another person and as having equal access to the vocabulary of sports movement; neither the movements nor the powers of the performers' bodies were classified according to gender.

In Rainer's *Terrain,* female-gendered movement was satirized in the "Duet" section, where Rainer did a women's ballet variation and Brown combined bump-and-grind routines with classical ballet arm movements— both dressed in black tights and black Hollywood Vassarette push-up bras. In the "love" subsection of *Terrain's* "Play" section, in which Rainer and Bill Davis assumed erotic poses from Indian sculpture, the postures were also gender-coded. But these were in dialectical contrast to the rest of the dance where the dancers' genders were inconsequential. All were dressed in black leotards or shirts and tights, and different ones were temporarily singled out as "stars" with white tops in different sections. Moreover, the dancers' movements, in some sections bound by rules or shaped by game activities, were often exchangable, done in unison, repeated, or in other ways impossible to code according to gender. Paxton's *Proxy* included a moment in which a woman lifted a man—an assertion of equal strength unheard of on the dance stage at the time.

Thus, one way to refuse gender coding is to treat the sexes identically. Many of the women choreographers—and some of the men—at the Jud-

son Dance Theater staked out in their particular art form an arena where women and men were represented as equally capable of physical action. That is, in this corner of the early Sixties avant-garde artworld, where women outnumbered men as creative artists, affirmative action in both job fulfillment and the representation of gender imagery foreshadowed the demands of the women's movement later in the decade.

However, another way of confusing genders is to mix or trade codes. For instance, the refined striptease that Valda Setterfield performed in *Random Breakfast,* which accentuated her femininity, was offset later in the piece by David Gordon's travestied Spanish dance—a hairy Carmen Miranda imitation in the manner of Milton Berle—and again by his version of Judy Garland singing "Somewhere Over the Rainbow."

Lanford Wilson explored the gender-bending role-playing of the homosexual transvestite world in his first important play, *The Madness of Lady Bright,* which opened at Caffe Cino in May 1964 and had an unprecedentedly long run. The play is a monologue by the character Leslie Bright—whom the stage directions describe as "a screaming preening queen, rapidly losing a long-kept 'beauty'"—punctuated by the interventions of a Girl and a Boy, who function as a chorus representing voices from the hero's past as well as his emotional states. Like a fading belle from a Tennessee Williams play, Leslie Bright is surrounded by keepsakes, mementoes, and memories; his bedroom is that of a woman, cluttered with nail polish bottles and lipsticks and featuring a bed with pink silk sheets. In the tradition of gay slang, he adopts feminine gender codings, referring to himself as "she," and addressing himself as "girl." And like a Williams heroine, he is slowly losing his mind over the impossibility of finding love. Alone and lonely, he desperately makes phone calls that are never answered. In between his unsuccessful attempts to make human contact, he imagines himself as Venus, Giselle, Miss America, and Judy Garland. But he also remembers the real lovers who left their autographs on his walls. "Lady Bright" may have been freed from his culturally assigned male gender role by choosing to cross the line to another one, but ultimately it seems he has simply traded one gender prison for another.[65]

The gender-bending of the Baudelairen cinema, however—exemplified by *Flaming Creatures*—is positively reinforced transgression. Here the confusion of gender roles is festively comic, liberatory, and pleasurable. Above all else, the "creatures" populating this film are outrageously androgynous, ironically never more so than when men travesty the female body. This was the revolutionary revision of gender about which Susan Sontag wrote: "The important fact about the figures in Smith's film is that one cannot

easily tell which are men and which are women. These are 'creatures,' flaming out in intersexual, polymorphous joy. The film is built out of a complex web of ambiguities and ambivalences, whose primary image is the confusion of male and female flesh. The shaken breast and the shaken penis become interchangeable with each other."[66]

Not only the sexual organs but, importantly, the grotesque aperture of the mouth looms large in Smith's iconography. As Stefan Brecht put it, the actions of the "creatures" involves:

> Lip-gymnastics, a mock-sensuality derived from the pout, demonstrating the lips' flexibility, humifiability and suction-power, a visual paean to cocksucking, grand rivalry for the cock of mouth with cunt, culminating in the second of the movie's grand Scenes, a universal elaborate putting on of lipstick, dark and glistening, the extreme close-ups revealing the grainy skin, stubble, bad teeth, epidermal pouches of these not-so-young queens: to the accompaniment of a woman's commercial recorded lecture on why and how to put on lipstick.[67]

The emphasis on orality, the festive androgyny, and the ecstatic group dancing in *Flaming Creatures* all point to the body as a site of simultaneous pleasure, community, and liberation. The film argues that when sexual pleasure is liberated from gender, the body becomes a space where anything is possible.

The body in the Fifties and early Sixties mainstream culture was almost always controlled and covered up. For an extreme instance, in the Hollywood film *That Touch of Mink* the Doris Day character breaks into hives at the very suggestion of premarital sex. The avant-garde arts produced a new image—unruly, festively promiscuous, candid, and confident—that by the late Sixties had become the cultural norm. In the Sixties the body generally was viewed—both by mainstream culture and the avant-garde—as invulnerable and immortal. Like Taylor Mead as the Atom Man, people were willing to ingest, inject, and in any other way incorporate anything into their bodies, from cigarettes, alcohol, illicit drugs, and reducing diets to plastic surgery and anti-wrinkle hormones. Now, in the Eighties and Nineties, we are seeing a backlash to this effervescent body that was invented in the early Sixties and spread to the mass counterculture by the late Sixties. Newspapers these days daily announce the dangers of every old-fashioned bodily pleasure—from food to alcohol to cigarettes to sex. Through safe sex, regimented exercise, "power dressing," healthy diets, and styled hair we find innumerable methods of keeping our bodies under strict control. And recently we have seen Congress and the National Endow-

ment for the Arts attempting to regulate even the ways in which bodies may be represented in art. In the context of the present mainstream mania for bodily control, when we look back at the Sixties, the ways in which those bodies produced by the avant-garde were allowed to run rampant all through the culture seem to us incredible, even impossible. But certainly a fascination with body discourse persists.

Clearly, both the works and the language of the early Sixties avant-garde point to an ideal of effervescence. They betoken an overflowing consciousness, a sense that the body's boundaries dissolve as it is permeated by images as well as by other bodies. That liberating ideal was taken up by the culture at large in the later Sixties, but in the Eighties and Nineties, for all sorts of political and economic reasons, effervescence is seen as a threat, not as a desideratum.

The confidence of post-World War II America created an intrepid social body in the Sixties. It also created an oppositional avant-garde, proposing even more outrageous bodies, reveling in an increased somatic consciousness of the here and now. In its expansive confidence, Pax Americana produced high expectations, rising faster than they could be fulfilled. Thus, the excessive and subversive avant-garde body was in part a product and a reflection of the very culture it criticized. But the effervescent body so far outstripped even the confident body of the dominant culture that it actually helped produce a new culture, overflowing into an alternative space of cultural imaginings made concrete. And the pressure of the effervescent body created a route into that space large enough for a mass counterculture to follow.

7

The Anxiety of the Absolute

Body and Consciousness

The effervescent body above all underscores the material quality of the body: its lower regions, its fluids, its exchanges of interior and exterior surfaces and depths, its procreative function, and its union with other bodies—in short, its fleshiness. But the bodies created by the early Sixties avant-garde included a conscious body that imbued corporeal experience with metaphysical significance, uniting head and body, mind and gut. In fact, for some of these artists it was precisely through the experience of the material body itself that consciousness could be illuminated and expanded: the conscious body was the "gate of perception" that, it was promised, could lead to the absolute. If heightened consciousness was the goal, how-ever, the rootedness of consciousness in the physical body precluded a

totally transcendental approach. The idea was not to rise above material life but to unite with it.

There were a number of sources for this tendency. Through Cage and others the Zen notion of at-oneness with the world through the technique of concentrated awareness influenced many artists, providing strategies for artmaking as well as the fine honing of consciousness. Furthermore, Norman O. Brown's influential analysis in *Life Against Death* articulated the possibility of a modern Dionysian body mysticism—a resurrection of the holy body—rather than an Apollonian flight from reality.[1] Drug culture, as well, expanded awareness through the chemical enhancement of the sensory channels. But even those who did not specifically subscribe to Zen, to other brands of mystical thought, or to mind-expanding drugs were committed to an understanding of the body that channeled intelligence directly through the skin, muscles, nerves, and organs.

For instance, Stan Brakhage's *Dog Star Man* is an epic journey. In it the filmmaker, as mythic hero, climbs a mountain and eventually chops down a tree. However, as in the Noh drama that partly inspired Brakhage, this seemingly simple action provides a pretext for a deeply extended body-centered meditation on the human soul. The journey is saturated with cosmogonic meaning on several levels, for the hero's body is a network of polyvalent symbols that flash from one layer of experience to another. At times his journey is seen—on a scale of space and duration ranging from the macrocosmic to the microscopic—as the solar system, as the cycle of the seasons, as the human life cycle, as a single day in a life, and as the split-second interior biorhythms of a human body. Work is compared to orgasm and to thought. The Dog Star Man, after his fall, becomes both child and father, man and woman. And as Brakhage notes, "the first period of birth [relates] metaphorically to spring, the springing into *per-son*."[2]

Like many of Brakhage's other films composed of superimpositions and rapidly edited montage, in parts of *Dog Star Man* various unrelated images are united and elaborated with paint splotches—which the filmmaker describes as creating patterns seen in "closed-eye" vision (that is, phosphenes, which are the flashes of light seen under the closed lids of the eyes, especially when pressure is applied to the retina). Also, they are amplified with other expressive techniques that suggest highly subjective states: scratches, tinted filters, slow or fast motion, shaky camera movement, and the use of a twisting anamorphic lens.[3] At the film's end, the titan is at one and the same time dissolved into the distant constellations and firmly ensconced in hearth and home; the depths of the body are assimilated to the cosmic

distances of the solar system as well as to the social unit of the family. The constellations, as in Greek mythology, are literally given bodies. Brakhage seems to say that it is only through our pulsating, struggling bodies that consciousness can be formed. Critical to Brakhage's cosmogony is the representation of consciousness through the "body"—the material—of the film itself. That is the act of viewing the film is the physical and epistemological struggle—analogous to the agon of the Dog Star Man—that trains the spectator to see.

In *Metaphors on Vision*, Brakhage wrote extensively about both the retraining of the eye to achieve poetic vision and the impossibility of the standard use of the movie camera to approximate that refined human organ. The eye, he wrote, must wrench itself free from its normal habituation to Western laws of perspective and scientific instruments such as the spectroscope and the prism. Brakhage describes his own experiments with untutored—or de-tutored—vision:

> My eye . . . beginning its non-color, life-giving, continually created coursing, follows rainbows, no thought of a pot of gold allowed the mind, pursuing light, seeking to stare straight into the sun, yet humbly shunning no reflections, searching even electrical filaments, all fires. . . . Under extreme non-concentration, fixed by effortless fascination, akin to self-hypnosis, my eye is able to retain for cognizance even those utterly unbanded rainbows reflecting off the darkest of objects, so transitory as to be completely unstructionable [*sic*], yet retaining some semblance in arrangement to the source of illumination, bearing incredible resemblances to eyelid vision, patterning their tonal dance to the harmonics of all closed vision. . . . I am stating my given ability, prize of all above pursuing, to transform the light sculptured shapes of an almost dark-blackened room to the rainbow hued patterns of light without any scientific paraphernalia.[4]

Just as Brakhage explored the extreme reaches of visual perception, so La Monte Young's music by 1964 was increasingly concerned with the infinitesimal gradations of perceiving sound. A jazz musician since adolescence, Young studied music composition with a student of Schönberg's and with Karlheinz Stockhausen. Directly after his trip to Darmstadt in 1959 where he met John Cage, Young became fascinated by music as minimal sound and as theater.[5] His proto-Fluxus compositions from 1960, several of which were published in *An Anthology*, evoke Cage's 4' 33" in their insistence that the audience listen actively—either to ordinary, usually nonmusical objects

or actions, or to "silence" itself. For instance, Young's *Composition 1960 #2* calls for the performer to build a fire for the audience to enjoy; *Composition 1960 #5* instructs:

> Turn a butterfly (or any number of butterflies) loose in the performance area.
>
> When the composition is over, be sure to allow the butterfly to fly away outside.
>
> The composition may be any length but if an unlimited amount of time is available, the doors and windows may be opened before the butterfly is turned loose and the composition may be considered finished when the butterfly flies away.[6]

Young's interest in the physical experience of duration is already evident in this and in other pieces of that period. In finding new ways to frame the experience of time's passing, Young impressed on the audience the recognition that temporal intervals form the basic material of music. Working with the composer Terry Riley in 1959–60 while they were graduate students at the University of California at Berkeley, Young became interested in another aspect of music—its texture. He spoke of "getting inside a sound"—a single sound, or perhaps 2 *sounds,* as one of his compositions was called.[7] These various sounds Riley and Young were drawn toward plumbing were, as Young describes them, "natural sounds, abstract sounds, interesting material juxtapositions such as metal on glass, metal on metal."[8]

The use of sustained, single sound events developing from this interest in sound texture—distinguishing Young's musical practice from a Cagean multiplicity of events—became Young's signature and was influential on the choreography of the early Sixties as well as many Fluxus works. By the time he moved to New York from California in 1960, Young's work was already well-known in avant-garde circles. In 1961 he organized a series of new music concerts at Yoko Ono's loft on Chambers Street, which included, among other events, an environment by Robert Morris, dance constructions by Simone Forti, and music and poetry by Philip Corner, Terry Jennings, Toshi Ichiyanagi, Henry Flynt, Joseph Byrd, Jackson Mac Low, and Richard Maxfield.[9]

Young was inspired by Cage, but his musical practice was also informed by the ethnomusicology he studied as an undergraduate at UCLA. Japanese and Indian music, in particular, introduced him to the simplicity of sound, sustained tones, repetition, modal scales, and use of a drone that would come to characterize his music. Repetition and austerity also characterized the "minimalist" music of his contemporaries Steve Reich and Philip

Glass—whose own music would emerge in the mid- and late Sixties—and those like Brian Eno in the Seventies and Eighties who were influenced by Young but crossed over into rock music.

By 1964 Young embarked on two new works that would preoccupy him for the next two decades or so: *The Tortoise, His Dreams and Journeys* and *The Well-Tuned Piano*. Important to both these works was the use of modal music with "just intonation"—the use of harmonically related natural frequencies—at volumes that made possible the perception of the resonant complex overtones (called partials or harmonics), that the vibrations of a single note actually comprise. It was through sustained notes and long performances, as well as the exploration of harmonics, that Young enabled the audience thoroughly to "get inside the sound." Ranging from three to five hours (*The Well-Tuned Piano*) to a potentially infinite work with sections continually added (*The Tortoise . . .*), these works used harmonic clusters, human voices, and electronic drones to create meditative pieces that engulfed the listener. His hope in *The Tortoise* was (as the name of his group, the Theater of Eternal Music, suggests) to create music of infinite duration—by adding to the piece throughout his lifetime and by creating music whose vibrations would never come to a stop.

Young's modal music was very much rooted in human anatomy. He has noted that he was attracted to just intonation because it is "natural" in that the intervals of its frequencies sound harmonious to the ears and are naturally produced by the "strings" of human vocal chords.[10]

In societies that have predominantly used modal music, the modes have traditionally been assigned to psychological states. Young has affirmed that his own music is intended to create such states.

> There is evidence that each time a particular frequency is repeated it is transmitted through the same parts of our auditory system. When these frequencies are continuous, as in my music, we can conceive even more easily how, if part of our circuitry is performing the same operation continuously, this could be considered to be or to simulate a psychological state. My own feeling has always been that if people just aren't carried away to heaven I'm failing.[11]

Thus, Young's use of amplified harmonics, enabling his musicians and the audience equally to perform "harmonic analysis by ear"[12] was meant to tune the participant—both maker and listener—into the frequencies and the harmonies of the cosmos.

Stasis, symbolized by the figure of the tortoise, fascinated Young and in a different way fascinated Andy Warhol. Writing about Warhol's films on

the occasion of the making of *Empire*, a view of the legendary Empire State Building from sunset to sunrise, Jonas Mekas noted that such a film, like *Sleep* and *Eat,* was meant, by its very stasis, to stir up a challenge to the limits of perception:

> What to some still looks like actionless nonsense, with the shift of our consciousness which is taking place will become an endless variety and an endless excitement of seeing similar subjects or the same subject done differently by different artists. Instead of asking for Elephant Size Excitement we'll be able to find aesthetic enjoyment in the subtle play of nuances.
>
> There is something religious about this. It is part of that "beat mentality" which Cardinal Spellman attacked this week. There is something very humble and happy about a man (or a movie) who is content with eating an apple. It is a cinema that reveals the emergence of meditation and happiness in man. Eat your apple, enjoy your apple, it says. Where are you running? Away from yourself? To what excitement? If all people could sit and watch the Empire State Building for eight hours and meditate upon it, there would be no more wars, no hate, no terror—there would be happiness regained on earth.[13]

Of course, the redemptive value that Mekas saw in such films was not necessarily shared by the audience members, as Mekas himself documented in one of his columns concerning the first screening of *Sleep* in Los Angeles. Mekas quoted a letter he had received from Mike Getz, the manager of the theater. Although five hundred people had attended the screening, spectators began walking out after the first fifteen minutes of the six-hour film, shouted at the screen, and demanded their money back, despite the sign that said "no refunds." Threatened with a riot, Getz finally gave away two hundred free passes to another screening.[14]

Yet Mekas showed a missionary zeal in bringing the message of film revelation to the public. Granted, the process of learning to see was not for everyone, he indicated. And it was irritating, even painful. But for Mekas it was an artistic, perhaps a moral, necessity.

In Mekas's view, film itself could achieve a bodily conscious state that might even be superior to the effects of controlled substances. In a column "On *Laterna Magica,* Superimpositions, and Movies Under Drugs," Mekas contrasts the stimulating work of the new filmmakers with his own experiences watching "boring" cinema under the influence of alcohol or marijuana:

The cinema of superimpositions is created by people whose perception—by whatever process—has been expanded, intensified (Brakhage is opposed to the use of drugs for the expansion of the mind and the eye's consciousness). Their images are loaded with double and triple superimpositions. Things must happen fast, many things. Lines, colors, figures, one on top of another, combinations and possibilities, to keep the eye working. All this is too much for an untrained eye, but there is no end to how much a quick eye can see.[15]

Later, Mekas wrote that "what some of the drug users take for an expanded consciousness is only an expanded eye, an increased ability of seeing." But thinking further about the matter, Mekas confessed that he realized vision and consciousness were intimately linked. While drugs are one way to liberate the eye, he pointed out that they are limited. For film can also educate the mind. "Does your consciousness exist separately from your eye? And what about music? Is music only for the ears? Is your consciousness connected with your ears? . . . Every one of our many senses is a window to the world and to ourselves. The eye, liberated from the inhibitions of seeing, gives us a new understanding of the world." Thus, consciousness for Mekas is firmly rooted in the concrete senses, in the experience of the body.[16]

While Mekas preferred the mind-expanding qualities of film art to those of chemical psychedelics, filmmakers such as Ron Rice, in *Chumlum,* and Harry Smith, in *Heaven and Earth Magic,* relate cosmic consciousness to drug-induced visions. (Indeed, in his 1963 note to his complete works in the Film-Makers' Cooperative catalog, Smith announces which of his films were made under the influence of which mind-altering drugs.)[17] Smith's animated black-and-white feature is composed primarily of images from Victorian-era catalogs and books, giving it the surrealistic quality of Max Ernst's collage books or Joseph Cornell's boxes. Among other things, the alchemical hermetic imagery involves allusions to the mystical body symbolism of the Kabbalah, the Orientalism of the philologist Max Müller, the hallucinations of brain surgery patients, and the metaphysical paranoid delusions of Daniel Paul Schreber, as well as scatological references to enemas (and the London sewers).[18]

In theater and dance, as well as film and music, artists of the early Sixties were turning to the physical body as the ultimate truth. For Joseph Chaikin the point of working in the Open Theater was to get at the body, an expressive terrain that traditional actors all too often left unexplored and that ordinary people simply ignored. In Chaikin's view, "all exercises must

start from and return to the body in motion." Moreover, the character on stage can be known only through the body. "All of one's past—histori-cal and evolutionary—is contained in the body," he wrote. "In America many people live in their bodies like in abandoned houses, haunted with memories of when they were occupied."[19]

Yvonne Rainer's constant championing of the intelligent body would by 1966 lead to her appropriately titled *The Mind is a Muscle*. "My body remains the enduring reality," she wrote in the program notes to that work. If in the theater, directors like Malina and Chaikin had to restore the vis-ceral body to thought expressed in verbal outpourings, in dance the task that Rainer and others set themselves was to show the opposite side: how bodies are instrumental to consciousness. Already in *Dance for 3 People and 6 Arms* (in which the dancers made decisions about the sequence of move-ments in performance), in *Terrain* (especially in the "Spencer Holst Solos," in which the dancers had to recite short essays by Holst while dancing precise sequences), and in *Dialogues* (in which four women engaged in both improvised and set dialogue as they performed complicated move-ments), the demand was made that the dancer be not just a dancing body, but a thinking dancing body. In *Some Thoughts on Improvisation*, Rainer went even further, delivering, while dancing, a monologue about the free-associative improvisatory decision-making process in performance. The compositional ideas or impulses, she explained in that text, had a purely physical basis. "They are the pulse and tongue of the body in the place, in the space of the place. They are the invisible strings that extend from outstretched fingers to the limits of the place. They are the heat that flows from the armpits to an object in the place. They are the swellings and contractions of the damp gaze that can be turned on and off."[20] Thus, consciousness for Rainer was formed in and by the material body. And performance was the site where body-consciousness thrived.

As noted, the concerns and preoccupations of the avant-garde artists with the conscious body run parallel to—and, indeed, may have been partly influenced by—Norman O. Brown's *Life Against Death*. The view of the body as the formative seat of knowledge is crystallized in the last chapter of Brown's book, "The Resurrection of the Body." In it, Brown synthesizes the tenets of psychoanalysis and Christian mysticism to project a history of consciousness. For Brown, psychoanalysis has been misunder-stood and misapplied. It should be understood not as a shallowly indi-vidual therapeutic measure, but as a potential system for political and historical transformation, for it takes as its starting point the repression of the self as a body. It is the emancipation of the body—so long sexu-

ally repressed, socially inhibited, and politically confined—that for Brown promises social and spiritual redemption.

> The resurrection of the body is a social project facing mankind as a whole, and it will become a practical political problem when the statesmen of the world are called upon to deliver happiness instead of power, when political economy becomes a science of use-values instead of exchange-values—a science of enjoyment instead of a science of accumulation. . . . Contemporary social theory . . . has been completely taken in by the inhuman abstractions of the path of sublimation, and has no contact with concrete human beings, with their concrete bodies, their concrete though repressed desires.

Brown invokes Marx's 1844 writings and appropriation of both Fourier's ideas about play and Feuerbach's ideas about the physical human body. Joining Marx and Freud, Brown envisions a new science founded on "an erotic sense of reality" that will liberate the body and thus the human race.

Rainer's *Terrain* exemplifies this concordance between the conflicting instincts with its solos on death and sleep, its group section generated by game structures, and its duets exploring erotic play and the dialectic of vernacular and "high art" dance—the dancing that savors the body and the dancing that etherealizes it. So, too, although in a completely different way, does the miniature story "Normal Love" by Jack Smith, a satire of pornographic purple prose.

After an orgy in the fields with cretins, pinheads, and a horse, the narrator finds himself in heaven—where bodies are anything but dematerialized.

> God's plump buns rested serenely on the ziricorn & rhinestone throne & he frowned at us through his long gold beard. We were in heaven. He ordered us all to line up, turn around, drop our pants, and bend over. We meekly obeyed. God then walked up and down paddling us with a ping-pong paddle. He concentrated chiefly upon the plump pasties, I noticed. He began to emit giggles and rushed from pasty to pasty paddling shit out of them. The freaks became overstimulated and soon we were in the middle of a gang fuck which spread over all the heavens. Saints and cupids dicked eachother [*sic*] with their wands, angels threw their legs open and the skies dripped come.[21]

In Smith's fantasia, erotic life injects death with a lusty vitality. The polymorphous perverse sensibility of the body gives it a vibrant power over life and death.

When the life and death instincts are reconciled, Brown predicts, delib-

erately using the rhetoric of Christian eschatology, repression will be lifted from the human body. It will be resurrected and transfigured. "The abolition of repression would abolish the unnatural concentrations of libido in certain particular bodily organs. . . . The human body would become polymorphously perverse, delighting in that full life of all the body which it now fears [and in]. . . . consciousness which does not observe the limit, but overflows."[22]

The Anxiety of the Absolute

The notion of the conscious body suggests a yearning toward spirituality, yet in the early Sixties avant-garde culture (both art and criticism) there is a distinct ambivalence toward the absolute—that is, toward some unitary higher truth or consciousness or some ideal of prelapsarian wholeness.

In terms of the artmaking itself, this ambivalence was expressed in the conflict between unity—the desire for authenticity, spontaneity, and the collective expanded consciousness of the community—and difference—the appreciation of heterogeneity, pluralism, and enhanced individuality. On the side of authenticity, disposing of matrices such as character and plot was seen as a way to get at experience more directly in Happenings, dance, and film. Improvisation and indeterminate structures in dance, music, and theater were thought to generate spontaneous responses to the situation at hand. Repetitive, meditative music, like La Monte Young's extended drones and rich harmonics or Philip Corner's socially conscious *Poor Man Music* (in which ordinary objects like rattles and shakers created a polyphonic steady pulse) served to expand perception. The visual intricacies of film (like the superimpositions favored by Brakhage, Anger, Rice, and others) were also thought to provide a pathway to authentic experience.

Movement, too, it was thought, could tune the mind-body to an "authentic" and intensified consciousness of energy flow and varying physical states. For instance, the techniques of "kinetic awareness" that Elaine Summers would eventually develop as a full-blown system of physical/ spiritual therapy—using anatomical studies and the verbal expression of emotional and physical states to heal the whole person and liberate his or her movement potential—had its roots in her *Dance for Carola* (dedicated to one of Summers's kinesiology teachers). In this solo dance (performed in silence) Summers changed from a standing posture to crouching and then back to standing again, all in sustained slow motion. The single task took eight to ten minutes. For Summers, the dance was a result of discovering a new energy pattern and body image that was authentically hers, one

that savored time and extended sensory impressions. Again, the ideal of expanded consciousness seemed to serve as the route to a utopian vision.

On the one hand, then, there was an urge toward sincerity, natural impulse, and harmonious union with the cosmos, achieved through the expansion of the bodily senses. On the other hand, any inklings that a unified, direct, and original experience of the world was indeed possible were countered by the Cagean affirmation of chaos. The embrace of such methods as collage and superimposition was meant to include multiple experiences and points of view—of multiple realities. Barbara Rubin, for example, suggested the preferred order for superimposing the two simultaneously projected reels of *Christmas on Earth,* but she also allowed that there might be other, equally valid ways of seeing her film, including the addition of color filters. Similarly, in the Judson Concert of Dance #5, held at the America on Wheels roller skating rink in Washington, D.C., several separate dances often were performed concurrently; in the tradition of viewing Cunningham's dances, it was up to the spectator to choose which piece—or which part of which piece—to pay attention to.

The images and structures of abundance so prevalent in the early Sixties also stressed the possibility of choice and difference. James Waring's *At the Hallelujah Gardens,* described as an "avant-garde *Hellzapoppin'*," which was a collaboration between the choreographer and various artists and Happenings-makers (including Goerge Brecht, Red Grooms, Al Hansen, Robert Indiana, Larry Poons, Robert Watts, and Robert Whitman, who provided the scenery, costumes, objects, and events) was an apotheosis of what I think of as "the embarrassment of riches" school of performance.[23] Riches, that is, supplied both artist and audience with choices, circumventing any necessity to settle on any ultimate way of making or seeing work.

The anxiety of the absolute was also expressed in the disposition not to judge, a legacy from the music classes of John Cage and the dance composition classes of Robert Dunn.[24] It also was evident in the widespread rejection of specialization and perfection. The Sixties artists' egalitarianism of choice, extolling of amateurism, and willingness to make mistakes implied a variety of approaches to art and to life, all of which were considered valid. There also was a growing suspicion of verbal means—of rationality itself. This was manifested in the theater, for instance, in the ever-increasing use by the Living Theater and the Open Theater of the actor's physical articulation and the emphasis on the "paralinguistic grease" of vocal tones, pitches, and other aspects of expression (over the semantic content of the verbal text). The very movement away from narrative altogether—whether

that of the plot line in theater, dance, and other performance genres, or that of the artist's interiorized biography in painting—signals an abhorrence of a privileged or centralized single point of view.

To a surprising degree, the aesthetics of the Sixties embody a paradox: in one direction there is a nostalgic urge toward unity—both social and cosmic—while in the other direction, there is the pronounced affirmation of disunity, disjunction, and fragmentation. The absolute in the Sixties stood for a variety of values toward which an entire generation seemed to be engaged in working out its ambivalence. On the positive side, it stood for wholeness, social bonding, and spiritual integration; but its by-products, weighing in on the negative side, were often authority, hierarchy, and dogmatism. Its univocal quality, while promising relief from fragmentation and alienation, also posed the threat of intolerance, inflexibility, and one-dimensionality. These are the contradictions of community writ large.

Against the Critic's Authority

Critics warned against the dangers lurking in these contradictions, not only for the practice of artmaking, but for the practice of art criticism. Calling for formalist criticism in "Against Interpretation," Susan Sontag lashed out against the overweening critics who would painstakingly extract every last bit of content from an artwork. Her call for an erotics of art that would replace hermeneutics—her repudiation of the prevailing "rules" for interpretation—was akin to the refusal of evaluation by the artists themselves, and by, among others, the radically relativist critic Jill Johnston. Judgment and interpretation alike, it was proclaimed, close off possibilities, reducing artworks and their reception to predictable, shallow codes of correctness.[25]

Johnston referred to the standard act of criticism as "pretending to be top man," or "riding a bike up and down the country hills in a race against a phantom judge." She proposed to reform her discipline by renouncing authority—for example, considering her own columns to be items of "lasting insignificance." But at the same time she extended her authority by opening up her field of criticism to almost any human action—or even any natural action. "I'll take a plot of level territory and stake out a claim to lie down on it and criticize the constellations if that's what I happen to be looking at. I also stake out a claim to be an artist, a writer, if that's what I'm doing when I get to the typewriter and decide that I liked something well enough to say what I think it's all about."[26]

Still, this extension of authority, she implied, was not exclusive, but open to others, if only they too were adventurous enough to seize the claim. For instance, she suggested that dancers should also be critics. That is,

by smashing the vertical hierarchies that separate art from criticism, artist from audience, and art from life, Johnston hoped to create a unified, if porous field of art activity. The coolly casual affiliations—now I'm a critic, now I'm an artist; I may write about something I see and then again I may not—and even the passivity suggested by her posture of "lying down" to look at art bespeak a reluctance to assert superior status as a uniquely qualified judge or specialist.

Johnston was as enthusiastic about the pluralism of choreographic method in the Judson Dance Theater concerts as she was about the self-effacing "insignificance" of her own views. Relativist claims such as Johnston's for the equal worth of competing viewpoints or methods surely were produced, in part, by the influence of liberal anthropology on the intellectual life of post-World War II America. The work of such anthropologists as Margaret Mead, Gregory Bateson, and Ruth Benedict in the Twenties and Thirties was widely popularized by the Fifties and Sixties. Moreover, an important aspect of those anthropologists' work was their polemical criticism of American culture in comparison with the possibilities unearthed in the "exotic" societies they studied. Anticipating the wholesale turn by the late Sixties counterculture to the everyday practices of non-Western societies (from the martial arts of T'ai Chi Ch'uan and karate to macrobiotic diets to Hindu guru devotion), while building on the tenets of already influential non-Western daily practices (like Zen Buddhism), the early Sixties avant-garde took a decidedly anthropological turn of mind in its cultural and artistic relativism.

Thus, Sontag, for instance, who was herself deeply influenced by the French school of structuralist anthropology, argued in "One Culture and the New Sensibility" against the purported splits between scientific and artistic cultures or high and low cultures in almost anthropological terms. She argued for the recognition of a nonliterary, nonhierarchical, pancultural sensibility that makes use of multiple forms of reasoning and value.[27] And Marshall McLuhan wrote of the necessity for a "retribalization" of the inhabitants of the "global village" of modern humankind. The cultural relativism of art—the promiscuous intermingling of "high" and "low" culture, as well as of Euro-American, African American, and Asian aesthetics—seemed to provide a strategy for political and cultural communion. In an era before the celebration of "roots" and calls for multiculturalism, there was an early postmodern pancultural ethos in which the deracinated traditions of various cultures were taken up as vital alternatives to American mainstream values.

In Search of Magic

Perhaps the postwar fascination with modern anthropology also is partly responsible (along with the Beat "dharma bums") for the move by artists in the direction of ritual, magic, and myth. Ron Rice, who proposed the founding of a "Dazendada" film group, called cinema a species of magic. "The witch doctor uses a weird looking black box, two circles of light metal form the shape of the box," he wrote in his diary.[28] For Rice, magic and ritual were bound up with the altered states of consciousness that drugs induce. The films he planned while living in Mexico (before his death from pneumonia in December 1964) include images of mescalin hallucinations, evoking ancient cosmic struggles. Rice's *Chumlum* was shot in New York City with the cast of Jack Smith's *Normal Love*—still in costume for that film—smoking pot, meditating, swinging in hammocks, and moving gracefully to the drone of the chumlum, a stringed instrument. The delicacy and transparency of the colors and textures take on a dreamlike density through superimposition. This, combined with the hypnotic drone of the chumlum, the rhythmic swaying of the hammocks, the Arabian trappings, the confusion of outdoors and indoors, the cosmic dance of the draped figures, and the swirling smoke, has the effect of unraveling an alternative time and space—an expanded bodily consciousness. As P. Adams Sitney suggests, "the film becomes [Smith's, the hashish smoker's] reverie in which time is stretched or folded over itself."[29] The film also seems to create a cosmic space in which the anomie of modern life is redressed.

If *Chumlum* is a dream in which the fragmented community is made whole, Kenneth Anger's *Inauguration of the Pleasure Dome* uses ritual structures, again with overtones of drug-induced visions, to create images that unify the shattered self.[30] The film, populated by modern-day figures disguised as pagan deities from various cultures, begins when Lord Shiva, waking, swallows a glittering necklace.[31] He crosses a threshold into a room full of mirrors, where he is transformed into 666, the Great Beast. Leaving the room, he meets Kali, or the Scarlet Woman, who gives him a statue of the devil and smokes a joint. In the various richly colored, intricately decorated, and slow-paced sequences that follow, a series of ritual ingestions of gifts ensues, creating a ritual of union through oral incorporation.[32] The ritual turns into an intoxicated feast, an orgy of movement and images, as superimpositions suggest the physical fusion of the celebrants, as the repetition of previous scenes suggests a "liminal" sense of time in which past and present are experienced simultaneously, and as the gods begin to dance.[33]

Inauguration of the Pleasure Dome envisions the utopian attainment of a higher unity. But even as Anger pictures the achievement of the absolute, he does so with iconography that is not fixed. In his descriptions of the various versions of the film, the characters have different names and their actions are described in various ways; many of the actions and objects are vague or obscure enough that one senses the viewer need not identify them precisely, much less decipher their emblematic references.[34] Perhaps this has to do with the mystical penchant for multivalent, often murky symbolism. But it also seems—especially when joined with the syncretic mix of deities from different religions in the film—to signal a relativist's tolerance toward how the absolute may be manifested. Anger later explained that "rather than using a specific ritual . . . I wanted to create a feeling of being carried into a world of wonder."[35] A similar eclecticism may be seen in other attractions to ritual performances in the Sixties avant-garde.

The turn to ritual was a way of finding performance structures that departed from the standard formats of Western secularized high culture. It also was valued as an obvious way to forge the bonds of community. Yet in the turn to ritual there was yet another set of contradictions signaling an ambivalence toward the absolute. For although the search for ritual was a search for wholeness, the bricolage nature of the rituals incorporated in these avant-garde works—the very gesture of choice and eclecticism—showed that the yearning for the absolute had to be conducted on one's own inventive terms. Thus, ritual—the traditional, self-annihilating means to the absolute—was given a highly individualistic turn in the form of the artist's extensive (and nontraditional) freedom to choose from a gamut of traditions.

The Access to the Absolute

The ritual eclecticism of this generation—which would reach even greater heights in the later Sixties—signaled a yen for some kind of spiritual expression. But if existentialism had pronounced God dead, the nineteenth-century suspicion that art could serve as a new channel for spirituality—that it was, perhaps, the modern transformation of religion—had become a commonplace by the early Sixties. The generation of artists who came of age in the Sixties easily adopted this view. Previous routes of access to the absolute—the Christian church, and even previous art such as the monumental psychic epiphanies of the Abstract Expressionists and early modern dancers—were considered inadequate. "New" religions—that is, old religions from other cultures, like Buddhism, Taoism, and Hinduism,

as well as such latter-day cults as Aleister Crowley's—offered an attractive alternative to some, providing as well themes, techniques, and images for art.

It seemed that the absolute had to be relocated—not only in alternative spiritual disciplines (including alternative therapies, like the Gestalt therapy advocated by Paul Goodman and others), but in the body and the senses, at times in the drug-induced consciousness, in the awareness of the world's often ordinary material presence, and in the bonds of community. As Philip Corner has pointed out,

> We were just as eclectic about [spiritual commitments] as anything else. But whatever held it together—whatever brought all these things together and people together—with all the diversity, whatever made these things belong together, was something that had to be—for want of a better word—spiritual, because it reflected an attitude or a state of mind, rather than a technique or discipline or prognosis for the future or program. It was a sense of being together and of sharing a similar adventure, which had an intuitive sense of an organic whole.
>
> I can't see any place where the whole twentieth-century sense of substituting art for religion was more manifest than in this [early Sixties] scene. Everything from Zen to transcendental meditation to Native American outdoor ritual was used as a model. As a common denominator in all these activities was something that was primordially religious—an aesthetic religion or quasi-religion. There was definitely a sense of using this [art] to heighten reality, to heighten experience, to heighten life, to connect with the ultimate meanings of existence. That permeated the whole scene.[36]

Given the emphasis on alternative spiritual commitments, it might seem paradoxical that, beginning in the late Fifties and continuing throughout the Sixties, but reaching an apogee in 1963, a Protestant church—the Judson Memorial Church in Greenwich Village—should serve as the epicenter of the New York avant-garde, with its antiauthoritarian, exceedingly corporeal, often transgressive art. But, in fact, strange as it may seem, there was a historical logic in this unlikely marriage.

The church had always had an unconventional ministry. A Protestant church in a predominantly Catholic neighborhood, it refrained from proselytizing and instead became socially and politically involved in the life of the community—including the arts. It was a progressive, liberal church, and in 1956 the new minister, Howard Moody, a self-proclaimed "Christian

atheist," very consciously carried the church's secularization even further. He plunged into Democratic reform politics, hosted civil rights meetings, and set up a youth center and a drug addiction rehabilitation program. In 1961, the year that Moody was elected head of the Village Independent Democrats, the parish played an active role in overturning a police ban on folksinging in Washington Square Park—after a year of protests and sit-ins. The Judson became a community center for nearly every sphere of daily life, and its parish grew.

Moody had hired an assistant minister, Bud Scott, to run the arts program in the late Fifties. In 1961 Scott left Judson Church to become a Catholic. It is significant that according to Moody, it was the very nature of Judson Church—its liberating secularism—that sparked Scott's departure. "I think he got hung up on the freedom of the situation here. There was such freedom, and if one requires some structural thing—well, I think Bud missed the structure and order of the church traditionally, which was not at Judson."[37] That freedom, however, was exactly what attracted the early Sixties artists to the ecumenical haven of Judson Church.

In 1961 Al Carmines replaced Scott as assistant minister. Carmines instituted the Judson Poets Theater, with the help of Robert Nichols, a playwright and architect. And the following year the Judson Dance Theater joined the roster. Carmines fostered a unique relationship between the avant-garde proceedings in the arts and the parish. In the Judson tradition, he did not expect to influence the (mostly atheist) artists in terms of religious conversion. Rather, he opened himself and his church up to learning from "the congregation of art."

> We had two principles [when we founded the Poets Theater]. One, not to do religious drama. Two, no censoring after acceptance. . . . [The fact that our plays are performed in] a church liberates me more than any other place would. I've discovered for myself that God doesn't disappear when you don't talk about Him.
>
> Like a lot of ministers, the real world was not part of my life. Ministers are often preoccupied with themselves. The theater broke it all open for me. A source of revelation.[38]

According to Carmines, the dancers introduced more revelations. Their innovations even changed the way that worship was conducted at the church. The modern church generally, Carmines suspected, had become too reliant on verbal knowledge. And his congregation's interactions with the dancers changed all that.

The Judson Dance Theatre gave us an experience where our ver-
bal facility was left bumbling—where our penchant to conceptualize
about meanings and philosophies was muted. It was good for us. It
opened again for us the springs of revelation muddied by rational,
verbal comforts. It took us in many ways beyond our depth, both
religiously and aesthetically; but where else should a church be?

The influence on our worship has become increasingly clear. I
doubt, for instance, if we would have had the courage to have a period
in our service which was simply opened up to the congregation for
statements and concerns—had we not first seen the insouciance with
which the dancers could allow the unexpected to enter their concerts.
The importance of the gesture, the movement, of the congregation
and of the liturgists, would have remained lost to us without them.
And certainly we would not have instituted the period of silence in
our service had we not seen silence made profound and aesthetic in
many concerts of dance in the sanctuary.[39]

When Moody called for a study of the worship service with a view toward
modernization, members of the congregation urged that the parish fol-
low the lead of the artists. The physical arrangement of the sanctuary itself
changed to a more informal and flexible configuration after the dancers
had burst open its conventional format in their concerts. Jazz, poetry, folk
music, dances, and Happenings-like performances were introduced into
the services, anticipating the late Sixties nationwide wave of jazz and rock
services in radical churches. And the pulpit, and ultimately the cross itself,
disappeared from the chapel.[40]

The liberating atmosphere of the church and the far-out ideas of the
dancers were mutually reinforcing. Typically, Yvonne Rainer remembers
that when she and Steve Paxton decided to perform *Word Words* nearly
nude, "We were afraid that in the church it would upset some people.
We asked Al Carmines; he said he didn't mind."[41] And when Rainer and
Robert Morris appeared totally nude—walking slowly while clinched in
an embrace—in Morris's *Waterman Switch* in March 1965, the church was
plunged into a controversy that threatened to oust it from the American
Baptist Convention. But Judson Church refused to back down from its
position on the artists' freedom of expression.[42]

With its progressive politics, its avant-garde arts events, and its refusal to
proselytize, Judson Church was considered by many "one of the most revo-
lutionary institutions in America," as Sally Kempton observed in *Esquire*
in 1966. Moody's transformation of the Baptist notion of Witnessing—

going out into the world to affirm one's faith—meant that the world also came into the Judson Church. In this sense, the church shared with the artists it supported a view of spiritual meaning rooted firmly in the material world. As choreographer Judith Dunn put it, "These dances [by the Judson Dance Theater] were made by the dancer meeting the world, not by his searching himself for some emotion to express." Even more radically, Moody advocated total secularization of the church in order to serve the outside world with "loving responsibility." An agnostic minister, he went so far as to wonder whether "the Christian church has any reason for existence beyond its usefulness to a community."[43]

The marriage of social work, arts advocacy, and urban politics may have seemed startling, yet the ministers at Judson Church found it perfectly compatible with their religious convictions. And, indeed, as Harvey Cox would write (about modern Christianity generally) in *The Secular City* in 1965, a worldly theology was the logical outcome of Protestant thought. The church, Cox wrote, has a threefold responsibility to society: proclamation, healing (and other forms of service), and promoting fellowship. It is the task of the church "to be the *diakonos* of the city, the servant who bends himself to struggle for its wholeness and health."[44]

Like other progressive churches in the Sixties, Judson Church made civil rights its mission.[45] In this and in its various other missions, notably the arts, the Judson was a leader, a paradigm of Cox's notion of an "eschatological community" that serves as "God's avant-garde." Moody himself referred to the multifariousness of the Judson activities as forging "not just a community center. A community."[46]

The ideal church, Cox wrote, "participates in a provisional reality: It is where the shape and texture of the future age come to concrete visibility." Like Moody and Carmines, Cox was secure in his conviction that if the church does its humble service, it need not force those it serves to acknowledge its name for God. "Perhaps for a while we shall have to do without a name for God," Cox wrote. "Rather than clinging stubbornly to antiquated appellations or anxiously synthesizing new ones, perhaps, like Moses, we must simply take up the work of liberating the captives, confident that we will be granted a new name by the events of the future." So Judson Church was then (and continues to be) radical, but like the artistic avant-garde it housed, it was not totally anomalous. Building on a venerable Protestant tradition of working for social change, it spearheaded a new form of that ethos that by the late Sixties would become more widespread.[47] There is a stark contrast between that tradition of social change and progressive arts patronage and fundamentalist churchman Donald Wildmon's reaction-

ary attack, in the late Eighties and Nineties, on freedom of expression in the arts.

Thus, in the heterotopia of Greenwich Village a church, rather than serving as an institution that promotes and preserves the status quo, became a central part of the avant-garde movement in the arts. In particular—and perhaps most paradoxically—it became a locus where the political and social meaning of art was often underscored, yet in a way that allowed for total freedom of expression.

Conclusion: One Culture?

The Sixties avant-garde was not entirely bent on destroying the past or the mainstream. Indeed, the eclecticism of the Sixties avant-garde—its relativist, egalitarian, collage vision—meant that, in terms of spiritual affiliations, there was even a place in it for Christianity. This type of spiritual syncretism was in fact a leitmotiv in the intellectual culture of the day. For instance, in *Life Against Death,* Norman O. Brown acknowledges that his vision of the true liberation of the individual from the repression of the senses has several branches: a Dionysian body-mysticism that seeks the resurrection and perfection of the body; the psychoanalytic, polymorphously perverse body of childhood; the "subtle," "spiritual," "translucent," even androgynous body of such Christian mystics as Jakob Böhme; and the "diamond" body of Oriental mysticism.

In *Irrational Man*—originally published in 1958, but by 1963 an enormously popular mass market paperback—William Barrett offers an account of European existentialism written for a general audience. Focusing on four philosophers—Kierkegaard, Nietzsche, Heidegger, and Sartre—he traces the roots of their views to ancient and early Christian philosophical traditions. He locates American postwar interest in existentialist thought in the anxieties of modern social and political formations. And he also shows how modern art testifies to the existentialist search for a new image of humankind, in particular to exonerate the irrational. But in his analysis, Barrett synthesizes the powerfully individualist philosophy of existentialism with the diametrically opposed eradication of the individual in Eastern thought.[48] This lively confusion of theories is emblematic of the era. For after having been deracinated, such radically antithetical cultural notions could be easily combined, and one could have individualism and cosmic unity all at once. Unlike the multicultural ethos of the Eighties and Nineties—in which an array of cultures is celebrated together yet viewed as a mosaic or quilt of discrete and quite disparate units—the early postmod-

ern eclecticism of the Sixties incorporated a liberal melting-pot approach to ideology and cultural practice.

In their search for a way to heal the various splits that Establishment culture had created—between mind and body, between artist and audience, between "high art" and "low art," between art and science, and between art and life—the early Sixties avant-garde opened up pathways to alternatives ranging from oppositional politics to undervalued subject matter and materials. The hybrid spiritual commitments to which many of the artists and intellectuals of the period subscribed were analogous to, even part and parcel of, their pluralistic, egalitarian, communal institutions and their aesthetics of pleasure and difference. For them, the absolute meant not a single truth but was refigured as unity in diversity and diversity in unity. The ultimate utopia was neither one truth nor one culture, but a recognition of multiple truths and multiple cultures. Yet this desire for heterogeneity resulted neither in homogenization nor in colorless banality. The culture they were engaged in producing transformed mainstream culture by quoting it, inverting it, uncrowning it, and pushing it in unexpected directions.

As I have tried to show throughout this book, the attempt to move beyond the heterotopia to create an antiabsolutist utopia was riddled with contradictions. There was an urge toward community, yet the traditions that ordinarily bind communities were constantly contravened. Instead, a hybrid alloy of traditions guaranteed that no hierarchy of beliefs or practices would prevail. Furthermore, both "high" and "low" cultures were valued. There was an urge toward extreme individual freedom, yet there was an equally strong desire for the glue of social communion. There was an overriding moral imperative toward equality, but at the same time eccentricity and difference were celebrated. A yen for spiritual oneness was viewed ambivalently. It seems the vibrancy of this early Sixties art was, in fact, partly the product of an array of paradoxes.

In looking at the different responses by the early Sixties avant-garde to mainstream culture, I have noted how at times it seems uncritically to reflect the larger culture, and at other times to declare war on it. Some works reproduced culture, mirroring the preoccupations, values, and beliefs of the affluent, optimistic early Sixties society of consumption in the United States. But other works, in their departures from the values and practices of the mainstream, actually produced a different culture, contributing to the formation of new values, beliefs, and practices. In Foucault's heterotopia, everything that already exists in a given culture "is simultaneously represented, contested, and inverted." In the heterotopia of Greenwich Village

1963, this dialectical activity was at its apogee. Using materials, methods, techniques, and ideas already present in the culture, the avant-garde also borrowed from history and from subcultural styles to unearth and explore alternative options previously latent or taboo. Yet, again paradoxically, their very fetishization of cultural choice was as American as apple pie.

In embodying these contradictions, the early Sixties avant-garde stirred up the contradictory situation of American culture generally. Poised on the brink of a new era, a fledgling superpower suddenly thrust into the limelight of world affairs, and a nouveau riche feeling its way along the cultural terrain, it was both confident and clumsy, expansive and untried. It was a society in search of a cultural identity that could keep pace with its economic and political flux.

Given this open field of possibility, the early Sixties avant-garde took on the attempt to remake American culture. They produced a rich body of work of unprecedented diversity, while advancing a mix of experimental ideas that would be widely disseminated by the late Sixties and Seventies. But if they sought to change an earlier image of the United States, they also, willy-nilly, reflected it, exalting abundance and freedom of choice even as they rejected the inauthenticity of consumer society. Children of what was, they became parents of what was to be.

Notes

Introduction

1 See, for instance, Fredric Jameson, "Periodizing the 60s," in Sohnya Sayres, Anders Stephanson, Stanley Aronowitz, and Fredric Jameson, eds. *The 60's without Apology* (Minneapolis: University of Minnesota Press, in cooperation with *Social Text,* 1984), pp. 178–209. Jameson sees the beginnings of the Sixties in the United States as formed by the seismic shifts in the Third World, and he claims that the Sixties began in 1959 with the Cuban Revolution, but he also notes the assassination of John F. Kennedy and the fall of Nikita Khrushchev (1964) as key events in the political imagination of postwar radicals and the youth culture. On the other hand, the British journalist and observer of American politics Godfrey Hodgson writes (in *America in Our Time* [New York: Random House, 1976], p. 136) that 1963 was a watershed year, dividing "a time of consensus" (1955–63) from "a time of crisis" (1963–65), which was then followed by "a time of polarization" (1965–68).

2 Two catalogs for retrospective exhibitions of the period are good surveys. Barbara Haskell, in *Blam! The Explosion of Pop, Minimalism, and Performance, 1958–1964* (New York: Whitney Museum, in association with W. W. Norton, 1984) provides a brief documentary overview of events and exhibitions, including very useful chronologies. Sidra Stich, *Made in U.S.A.: An Americanization in Modern Art, the '50s & '60s* (Berkeley: University of California Press, 1987), is a suggestive iconographic analysis of the visual art of the period. While Stich does not specifically isolate New York artists, most of her examples inevitably come from New York, where the majority of artists worked.

3 See Elizabeth Kendall, *Dancing: A Ford Foundation Report* (New York: Ford Foundation, 1983), esp. pp. 24–26.

4 *Congressional Record,* Senate, December 20, 1963, p. 25268. Quoted in Edward C. Banfield, *The Democratic Muse: Visual Arts and the Public Interest* (New York: Basic Books, 1984; a Twentieth-Century Fund Essay), p. 56.

5 *Music Journal* (March 1963). Quoted in Banfield, *The Democratic Muse,* p. 57.

6 Russell Jacoby, *The Last Intellectuals: American Culture in the Age of Academe* (New York: Basic Books, 1987).

7 See Arthur Danto, "The End of Art," *The Philosophical Disenfranchisement of Art* (New York: Columbia University Press, 1986), pp. 81–115, for a slightly different assessment of how the progressive thrust of art history—i.e., the modernist avant-garde—ended in the 1960s when art entered what Danto calls a "post-historical" phase corresponding to the postmodernist refusal of innovation in its appropriation and recombination of old forms.

8 Stanley Aronowitz, "When the New Left Was New," in Sayres, Stephanson, Aronowitz, and Jameson, *The 60's without Apology,* pp. 11–43.

9 See Harold C. Schonberg, "Creator of 'Nude Descending' Reflects After Half a Century," *New York Times,* April 12, 1963, p. 25; John Canaday, "1913 Armory Show Is Back for Anniversary," *New York Times,* April 25, 1963, p. 27; John Canaday, "The Birth of Modern Art," *New York Times,* May 26, 1963, sec. 6, pp. 66–67.

10 Of course, artists had experimented with cooperative ideals in the past, but usually—as with William Morris and the early Bauhaus—they were inspired by a nostalgic view of an idealized medieval past.

11 See Todd Gitlin, *The Sixties: Years of Hope, Days of Rage* (New York: Bantam, 1987); William L. O'Neill, *Coming Apart: An Informal History of America in the 1960's* (New York: Quadrangle/New York Times Books, 1971); Milton Viorst, *Fire in the Streets: America in the 1960's* (New York: Simon and Schuster, 1979); and Annie Gottlieb, *Do You Believe in Magic?: The Second Coming of the Sixties Generation* (New York: Times Books, 1987).

12 See Pierre Biner, *The Living Theatre: A History without Myths,* trans. Robert Meister (New York: Avon, 1972), pp. 219–223.

13 In fact, it was Jonas Mekas who organized the first meeting of Newsreel, in New York City in December 1967. He saw the group as a fusion of underground and political filmmaking. See William Boddy and Jonathan Buchsbaum, "Cinema in Revolt: Newsreel," *Millennium Film Journal,* nos. 4–5 (Summer/Fall 1979): 43–52.

14 On visual art, see n. 2, Lawrence Alloway, *American Pop Art* (New York: Collier, 1974), and Lucy Lippard, *Pop Art* (New York: Oxford University Press, 1966). For an archival history of Judson Dance Theater, see my *Democracy's Body: Judson Dance Theater,*

1962–1964 (Ann Arbor, Mich.: UMI Research Press, 1983). Happenings and Fluxus are well-documented in Michael Kirby, *Happenings* (New York: E. P. Dutton, 1966); Hans Sohm, *Happening & Fluxus* (Cologne: Kölnischer Kunstverein, 1970); Jon Hendricks, ed., *Fluxus Etc.*, exhibition catalog, (Bloomfield Hills, Mich.: Cranbrook Academy of Art Museum, September 20–November 1, 1981; Jon Hendricks, ed., *Fluxus Codex* (Detroit: Gilbert and Lila Silverman Collection, in association with Harry N. Abrams, New York, 1989). The sources for a history of Off-Off-Broadway theater are more scattered; see the notes in chapter 1 for several of them. On film, see P. Adams Sitney, *Visionary Film: The American Avant-Garde* (New York: Oxford University Press, 1974; 2d ed., 1979). A later study, David James, *Allegories of Cinema: American Film in the Sixties* (Princeton, N.J.: Princeton University Press, 1989), discusses both formal and political aspects of underground and independent film. On music, see Michael Nyman, *Experimental Music: Cage and Beyond* (New York: Schirmer Books, 1974).

1 Another Space

1 Michel Foucault, "Of Other Spaces," trans. Jay Miskowiec, *Diacritics* 16 (Spring 1986): 24.

2 Fred McDarrah, *Greenwich Village* (New York: Corinth Books, 1963), pp. 30–32.

3 McDarrah was the staff photographer for the *Village Voice*.

4 David Boroff, "An Introduction to Greenwich Village," in McDarrah, *Greenwich Village*, p. 4. Boroff's introduction was a revised version of an 1961 article in the *New York Times*.

5 Boroff, "Introduction to Greenwich Village," p. 12.

6 McDarrah, *Greenwich Village*, p. 18.

7 Ibid., p. 20. For some additional historical background on Greenwich Village, see Edmund T. Delaney, *New York's Greenwich Village* (Barre, Mass.: Barre Publishers, 1967); Isaac Newton Phelps Stokes, *The Iconography of Manhattan Island* (New York: Robert H. Dodd, 1915–28); and John A. Kouwenhoven, *The Columbia Historical Portrait of New York* (New York: Doubleday, 1953; reprint ed., New York: Harper and Row, 1972).

8 McDarrah, *Greenwich Village*, p. 22.

9 Imamu Amiri Baraka (LeRoi Jones), "Greenwich Village and African-American Music," *The Music: Reflections on Jazz and Blues* (New York: William Morrow, 1987), p. 183.

10 McDarrah, *Greenwich Village*, p. 22.

11 Ibid., pp. 24, 32.

12 My sources for this map, besides McDarrah's *Greenwich Village*, include various articles, listings, and advertisements in the *Village Voice* and *New York Times* for 1963.

13 Interview with Dick Higgins, Barrytown, N.Y., May 12, 1988.

14 J. R. Goddard, "The MacDougal Scene: Summer Turns Up Heat Under Pressure Cooker," *Village Voice*, May 23, 1963, pp. 1, 6; J. R. Goddard, "MacDougal Cafes Open 'Operation Housecleaning,'" *Village Voice*, May 30, 1963, pp. 3, 16–17; Edith Evans Asbury, "Greenwich Village Argues New Way of Life: Coffeehouses Arouse Fresh Controversy Over Carnival Air," *New York Times*, August 6, 1963, pp. 1, 62.

15 Ronald Sukenick, *Down and In* (New York: William Morrow, Beech Tree Books, 1987).

16 Linda Solomon, "Notebook for Night Owls," *Village Voice*, May 23, 1963, p. 16.

17 McDarrah, *Greenwich Village*, p. 54.

18 See, for instance, "Artists Are Realtors' Best Friends, Edit Says," *Village Voice*, January 17, 1963, p. 25.

19 Leo Steinberg, "Contemporary Art and the Plight of Its Public," *Other Criteria* (New York: Oxford University Press, 1972), pp. 5–6. Originally published in *Harper's* (March 1962).

20 Henry Hewes, ed., *The Best Plays of 1963–1964* (New York: Dodd, Mead, 1964).

21 See Sitney, *Visionary Film,* chaps. 1 and 2, for a discussion of Deren's work, and pp. 347–352 for a discussion of Cornell and his influence.

22 Imamu Amiri Baraka, "Greenwich Village and African-American Music," and LeRoi Jones, "Loft and Coffee Shop Jazz," first published in *Down Beat* in 1963 and reprinted in *Black Music* (New York: William Morrow, 1967), pp. 92–98.

23 Olson's essay, originally published in 1950 in *Poetry New York,* became especially influential after it was reprinted in Donald M. Allen, ed., *The New American Poetry, 1945–1960* (New York: Grove Press, 1960), pp. 386–397.

24 Jackson Mac Low, introduction to *Representative Works, 1938–1985* (New York: Roof Books, 1986), pp. xv–xvi; my conversations with Mac Low, 1988.

25 See Diane DiPrima and LeRoi Jones, eds., *The Floating Bear: A Newsletter, Numbers 1–37, 1961–1969* (La Jolla, Calif.: Laurence McGilvery, 1973).

26 See Lippard, *Pop Art,* for a discussion of New York Pop and the influence of Robert Rauschenberg and Jasper Johns on the five artists named here, whom Lippard considers the "hard core" of New York Pop.

27 Quoted in Irving Sandler, "Is There a New Academy? Part II," *Art News* 58 (Summer 1959): 60.

28 Allan Kaprow, "The Legacy of Jackson Pollock," *Art News* 57 (October 1958): 56–57.

29 Martin Duberman, *Black Mountain: An Exploration in Community* (New York: E. P. Dutton, 1972), pp. 369–370.

30 Noël Carroll notes, "Performance," *Formations* 3 (Spring 1986): 63–79, that Art Performance and Performance Art, as he calls them, have separate sources in the fine arts and theater, respectively, although these two streams seem to meet in similar activities. On the side of Art Performance, Carroll points out that in calling Abstract Expressionism "action painting," Harold Rosenberg was already, if only metaphorically, nudging painting into the realm of performance (p. 66).

31 Al Hansen, *A Primer of Happenings & Time/Space Art* (New York: Something Else Press, 1965), p. 95.

32 Ibid., p. 97; Allan Kaprow interview in Richard Kostelanetz, *The Theatre of Mixed Means: An Introduction to Happenings, Kinetic Environments, and Other Mixed-Means Performances* (New York: Dial Press, 1968), p. 105.

33 Dick Higgins, "[On Cage's Classes]," in Richard Kostelanetz, ed., *John Cage* (New York: Praeger, 1970), pp. 122–123.

34 For information about this event, see Duberman, *Black Mountain,* pp. 370–379; Kirby, *Happenings,* pp. 31–32; and Mary Emma Harris, *The Arts at Black Mountain College* (Cambridge, Mass.: MIT Press, 1987), pp. 226, 228.

35 See chap. 1 of Banes, *Democracy's Body,* for an account of the Dunn course.

36 Jacoby, *The Last Intellectuals.*

37 Cowley, *Exile's Return* (New York: W. W. Norton, 1934; 2d ed., New York: Viking, 1951; reprint, New York: Penguin, 1976); Milton Klonsky, "Greenwich Village: De-

cline and Fall," *Commentary* 6 (November 1948), reprinted in Chandler Brossard, ed., *The Scene Before You: A New Approach to American Culture* (New York: Rinehart, 1955), pp. 20–28; Michael Harrington, *Fragments of the Century* (New York: E. P. Dutton, 1973); Aronowitz, "When the New Left Was New."

38 Aronowitz, "When the New Left Was New," pp. 15–17.

39 One important way that Greenwich Village defined itself in the early Sixties was by the political organizations that peppered it, both in and out of the Democratic party (many but not all of them left-leaning): the Greenwich Village Peace Center; New York School for Marxist Studies; Militant Labor Forum; American Humanist Association; Greenwich Village Chapter of Americans for Democratic Action; Village Independent Democrats; Students for Democratic Reform; Greenwich Village Democratic Club; Young Americans for Freedom; Greenwich Village Conservative Party Club; Village-Chelsea Women Strike for Peace; and Lower Manhattan Branch of the Socialist Party all listed their meetings in the *Village Voice* in 1963. So did the War Resisters League and its associated magazine, *Liberation;* although their offices were uptown on Beekman Street, WRL met regularly at the Textile Workers Union Hall on East Twelfth Street.

40 Paul and Percival Goodman, *Communitas: Means of Livelihood and Ways of Life* (Chicago: University of Chicago Press, 1947; 2d ed., New York: Vintage Books, 1960), p. 17.

41 Ibid., p. 227.

42 Paul Goodman, ed., *Seeds of Liberation* (New York: George Braziller, 1964), p. xi.

43 Ibid., pp. xi–xii.

44 Jane Jacobs, *The Death and Life of Great American Cities* (New York: Random House, 1961).

2 The Reinvention of Community

1 *Home Movies* was first presented by the Judson Poets' Theater at the Judson Memorial Church as part of a double bill with Arthur Sainer's *The Bitch of Waverly Place* on March 19, 1964. The cast included Gretel Cummings, Sudie Bond, Barbara Ann Teer, Freddie Herko, Sheindy Tokayer, Al Carmines, Otto Mjaanes, Jim Anderson, and George Bartenieff. It was directed by Lawrence Kornfeld, with music by Al Carmines. It was later produced Off-Broadway by Orson Bean at the Provincetown Playhouse, May 11, 1964, with the same cast and director. *Home Movies* was first published in Rosalyn Drexler, *The Line of Least Existence and Other Plays* (New York: Random House, 1967) and was reprinted in Albert Poland and Bruce Mailman, *The Off-Off Broadway Book* (Indianapolis and New York: Bobbs-Merrill, 1972), pp. 30–43. Susan Sontag describes its performance both vividly and concisely in "Going to theater, etc.," originally published in the *New York Review of Books* and reprinted in *Against Interpretation* (New York: Farrar, Straus and Giroux, 1966; reprint ed. New York: Dell, 1969), pp. 164–165.

2 *You May Go Home Again* was first presented by Joseph Cino at the Caffe Cino on February 17, 1963. A second production at the Cino, on June 15, 1965, included the following cast: Chuck McLain, Kay Carney, Shellie Feldman, Ronn Hansen, and Ron Faber. David Starkweather directed, assisted by Stanley Rosenberg and Paula Mason. The music was by Lucas Mason and the costumes by Ya Yoi. The play was published in Poland and Mailman, *Off-Off Broadway*, pp. 14–24.

3 *Home Free!* was written in 1963 and first presented by Joseph Cino at the Caffe Cino on
 August 23, 1964. The cast included Michael Warren Powell and Maya Kenin. William
 Archibald directed, assisted by Charles A. Golden. *Home Free!* was published in Lan-
 ford Wilson, *Balm in Gilead and Other Plays* (New York: Hill and Wang, 1965), pp.
 93–116.

4 *The Brig* was first performed May 15, 1963, at the Living Theater. It was directed by
 Judith Malina and designed by Julian Beck. The original cast included Jim Anderson,
 Henry Howard, Chic Ciccarelli, Warren Finnerty, James Tiroff, Tomm Lillard, Rufus
 Collins, Steve Thompson, Michael Elias, William Shari, Jim Gates, George Bartenieff,
 Steve Ben Israel, Leonard Kuras, Henry Proach, William Pratt, and David Siever. The
 production closed when the IRS seized the Living Theater building on October 9. It
 then reopened at the Midway Theater December 22, 1963, where it ran until Feb-
 ruary 16, 1964. The total number of performances at both theaters was 239. Daniel
 Blum, *Theatre World* (Philadelphia: Chilton Books), vol. 19 (1962–63), p. 181; vol. 20
 (1963–64), pp. 209, 235.

5 See Rochelle Gatlin, *American Women Since 1945* (Jackson: University Press of Missis-
 sippi, 1987), pp. 49–73.

6 See Gatlin; also William H. Chafe, *The American Woman: Her Changing Social, Eco-
 nomic, and Political Roles, 1920–1970* (New York: Oxford University Press, 1972), pp.
 186–187.

7 Betty Friedan, *The Feminine Mystique* (New York: W. W. Norton, 1963); introduction
 to "The American Female: A Special Supplement, *Harper's* 225 (October 1962): 117–
 119; Robert J. Levin, "Why Young Mothers Break Down," *Redbook* 115 (May 1960):
 30–31, 84–87; Jhan and June Robbins, "Why Young Mothers Feel Trapped," *Redbook*
 115 (September 1960): 27–29, 84–88.

8 Al Hansen, *A Primer of Happenings & Time/Space Art* (New York: Something Else
 Press, 1965), p. 30.

9 *We Shall Run* was first performed by Trisha Brown, Lucinda Childs, Philip Corner, June
 Ekman, Ruth Emerson, Malcolm Goldstein, Alex Hay, Deborah Hay, Tony Holder,
 Arlene Rothlein, Carol Scothorn, and John Worden as part of Judson Dance Theater's
 Concert #3 at the Judson Church, January 29, 1963. See Yvonne Rainer, *Work 1961–
 73* (Halifax, Nova Scotia: Press of the Nova Scotia College of Art and Design; New
 York: New York University Press, 1974), and Banes, *Democracy's Body,* pp. 85–88.

10 Josh Greenfeld, "Their Hearts Belong to La Mama," *New York Times Magazine* July 9,
 1967, pp. 10–20.

11 Thomas Bender, *Community and Social Change in America* (New Brunswick, N.J.: Rut-
 gers University Press, 1978; reprint ed., Baltimore: Johns Hopkins University Press,
 1982). It was, in fact, in 1963 that the English translation of *Community and Society*
 appeared, the book by the nineteenth-century German sociologist Ferdinand Tonnies
 that has provided for the last century the standard typology of *Gemeinschaft/Gesellschaft*
 (roughly translated as the two terms in the English title) to describe the bifurcation of
 life into domains that may be contrasted as private/public, country/city, folk/urban, tra-
 ditional/modern, network/atomism, cooperation/competition. According to Bender,
 Tonnies's dichotomy, by the 1960s, came to be understood and widely applied by
 American sociologists (like Maurice Stein and Roland Warren) as a sequential model—
 that is, that modernization is the story of community breaking down and inevitably
 evolving into the faceless society. This is the model with which Bender takes issue.

12 Maurice Stein, *The Eclipse of Community: An Interpretation of American Studies* (Princeton, N.J.: Princeton University Press, 1960; reprint ed., New York: Harper, 1964). See n. 11 for Bender's criticism of Stein's methodology. Roland Warren's *The Community in America* (Chicago: Rand McNally, 1963) is another sociological account of the ostensible disintegration of community. Both Stein and Warren date the beginning of this deterioration as the 1920s.

13 Caroline Ware, *Greenwich Village, 1920–1930* (New York: Houghton Mifflin, 1935).

14 Stein, *Eclipse of Community*, pp. 151–152.

15 Poland and Mailman, *Off-Off Broadway*, p. xiii. For a history of Off-Broadway, see Stuart W. Little, *Off-Broadway: The Prophetic Theater* (New York: Coward, McCann, and Geoghegan, 1972).

16 My account of the Living Theater is based on several sources, including Judith Malina, *The Diaries of Judith Malina, 1947–1957* (New York: Grove Press, 1984); Julian Beck, "Storming the Barricades," in Kenneth H. Brown, *The Brig* (New York: Hill and Wang, 1965), pp. 3–35; and Pierre Biner, *The Living Theatre* (New York: Avon, 1972).

17 Beck, "Storming the Barricades," pp. 21–22.

18 Shirley Clarke's film *The Connection* (1960), based on the Living Theater production, has a screenplay adapted by Gelber from his play and uses the musicians and actors from the Living Theater production, although neither she nor the Living Theater consider the film a document of the performance.

19 Beck, "Storming the Barricades," p. 30.

20 Ibid., pp. 21, 27, 34.

21 Joseph Chaikin, *The Presence of the Actor* (New York: Atheneum, 1972), pp. 49–51. On the Open Theater, see Robert Pasolli, *A Book on the Open Theater* (New York: Bobbs-Merrill, 1970; reprint ed., New York: Avon, 1972) and Eileen Blumenthal, *Joseph Chaikin* (Cambridge: Cambridge University Press, 1984).

22 Pasolli, *Open Theater*, p. 2, says that there were seventeen actors at the first meeting. Arthur Sainer in *The Radical Theater Notebook* (New York: Avon, 1975), p. 19, gives the names of nineteen actors who were members of the group in the spring of 1963: Catherine Mandas, Joe Chaikin, Mike Bradford, Peter Feldman, Murray Paskin, Gerry Ragni, Lee Worley, Isabelle Blau, Sydney Walter, Paul Boesing, Ira Zuckerman, Jim Barbosa, Barbara Vann, Ron Faber, Mimi Cozzens, Sharon Gans, Jordan Hott, Lynn Kevin, and Valerie Belden. Sainer joined the group after it had begun meeting, and he names three other playwrights who were involved at that time (Winter 1963): Earl Scott, Megan Terry, and Michael Smith. Smith, like Sainer, wrote drama criticism for the *Village Voice*. Jean-Claude van Itallie, Sainer states, joined later.

23 From Chaikin's notebooks, quoted in Pasolli, *Open Theater*, p. 31.

24 Geraldine Lust, introduction, in Arthur Sainer, *The Sleepwalker and the Assassin* (New York: Bridgehead Books, 1964). Quoted in Sainer, *Radical Theater Notebook*, p. 19.

25 Sainer, *Radical Theater Notebook*, p. 21.

26 See Blumenthal, *Joseph Chaikin*, esp. chaps. 4 and 5. The first public performances were at the Sheridan Square Playhouse in December 1963 and then at the Martinique Theater in April 1964.

27 Pasolli, *Open Theater*, pp. 5–6.

28 Blumenthal, *Joseph Chaikin*, pp. 105, 214; Pasolli, *Open Theater*, pp. 12–14. Pasolli calls the exercise "The Odets Kitchen," but he adds that the name of any other naturalistic playwright—Chayevsky, Miller, Inge—would do.

29　For a complete list of the two programs, see Blumenthal, *Joseph Chaikin*, p. 214. For descriptions of the works, see Pasolli, *Open Theater*, pp. 50–55.

30　Robert J. Cioffi, "Al Carmines and the Judson Poets' Theater Musicals" (unpublished Ph.D. dissertation, New York University, 1979), pp. 21–22; Poland and Mailman, *Off-Off Broadway*, p. xxv.

31　Interview with Lawrence Kornfeld, New York City, October 28, 1989; Jerry Tallmer, "Across the Footlights: The Corpse Sits Up," *New York Post*, March 23, 1964; Cioffi, "Al Carmines," pp. 24, 30.

32　The Obies, or Off-Broadway awards, sponsored by the *Village Voice*, were established in 1956 by Jerry Tallmer, the *Voice* theater critic at that time. They were expanded in the 1963–64 season to include Off-Off-Broadway.

33　See, for instance, George Oppenheimer, "Tastelessness Keynotes Latest Playlet Outbreak," *Newsday*, May 12, 1964; Whitney Bolton, "This One's Just Too 'Far Out,'" *Morning Telegraph*, May 13, 1964; and the other reviews of *Home Movies* in the clippings files of the Billy Rose Theater Collection, New York Public Library for the Performing Arts.

34　Michael Smith, "Theatre: Home Movies," *Village Voice*, May 14, 1964.

35　Poland and Mailman, *Off-Off Broadway*, p. xvii.

36　Joseph Cino, "Notes on the Caffe Cino," in Nick Orzel and Michael Smith, eds. *Eight Plays from Off-Off Broadway* (Indianapolis: Bobbs-Merrill, 1966), p. 53.

37　Poland and Mailman, *Off-Off Broadway*, p. xviii.

38　Robert Heide, "Cockroaches in the Baubles," *Other Stages*, February 22, 1979, p. 8.

39　Doric Wilson, in *Other Stages*, 1979, undated excerpt in *Caffe Cino and Its Legacy*, exhibition catalog (New York: New York Public Library at Lincoln Center, Vincent Astor Gallery, 1985), p. 7.

40　Patrick, "The Other Brick Road," *Other Stages*, February 8, 1979, pp. 3, 10. A fictional account of the Cino appears in act 2 of Patrick's play *Kennedy's Children*.

41　Larry Loonin, panel on Caffe Cino, NETC conference, New York City, August 19, 1986.

42　Heide, "Cockroaches," p. 8.

43　Patrick, panel on Caffe Cino.

44　William M. Hoffman, ed., introduction, *Gay Plays: The First Collection* (New York: Avon, 1979), p. xxiv.

45　Poland and Mailman, *Off-Off Broadway*, p. xxxi; Greenfeld, "La Mama," p. 16. Poland and Mailman, *Off-Off Broadway*, note that Stewart's "history is quixotic; the reality varies with the telling" (p. xxxi).

46　Greenfeld, "La Mama," p. 13.

47　Poland and Mailman, *Off-Off Broadway*, p. xxxii.

48　Ibid., p. xxxi, and Greenfeld, "La Mama," p. 16, both use the metaphor, but they tell the story of how Stewart discovered that metaphor differently.

49　Greenfeld, "La Mama," p. 14.

50　Michael Smith, introduction, in Orzel and Smith, *Eight Plays*, pp. 1–2.

51　Ibid.

52　Joseph Cino, "Caffe Cino," in Orzel and Smith, *Eight Plays*, p. 53.

53　Kirby, *Happenings*.

54　See ibid., pp. 16–17.

55　On Cage's 1952 performance, see Duberman, *Black Mountain*, pp. 370–379; Kirby, *Happenings*, pp. 31–32.

56 Kostelanetz, *The Theatre of Mixed Means,* pp. 100–101.

57 Haskell, *Blam!,* p. 19; p. 109, nn. 23 and 24; p. 113, n. 121. See *Ten from Rutgers University,* exhibition catalog (New York: Bianchini Gallery, 1965), and *Twelve from Rutgers,* exhibition catalog (New Brunswick, N.J.: University Art Gallery, 1977). On the Hansa Gallery, see Joellen Bard, *Tenth Street Days: The Co-ops of the 50's,* exhibition catalog (New York: Pleiades Gallery and the Association of Artist-Run Galleries, 1977), and Amy Goldin, "Requiem for a Gallery," *Arts Magazine* 40 (January 1966): 25–29.

58 Lawrence Alloway, "The Reuben Gallery: A Chronology," *Eleven from the Reuben Gallery,* exhibition catalog (New York: Solomon R. Guggenheim Museum, 1965). Reprinted in Lawrence Alloway, *Topics in American Art Since 1945* (New York: W. W. Norton, 1975), pp. 151–154.

59 "Claes Oldenburg," in Kostelanetz, *The Theatre of Mixed Means,* pp. 138–139.

60 Warhol and Hackett, *POPism: The Warhol '60s* (New York: Harcourt Brace Jovanovich, 1980), pp. 25–27, 31–34, 51–54.

61 Henry Geldzahler, who had grown up in Manhattan and graduated from Yale and Harvard, was at that time curator of twentieth-century American art at the Metropolitan Museum.

62 Warhol and Hackett, *POPism,* pp. 72–73.

63 Kirby, *Happenings,* p. 46.

64 Ibid., p. 52.

65 Ibid., p. 202.

66 Leonard Horowitz, "Art: A Day in the Country," *Village Voice,* May 23, 1963, p. 7.

67 Bud Wirtschafter, *What's Happening* (1963). The color film, 13-½ minutes long, available for rental from Film-Makers' Cooperative, shows bits of performances by Allan Kaprow, Chuck Ginnever, Wolf Vostell, Yvonne Rainer, La Monte Young, and Dick Higgins.

68 La Monte Young, ed., *An Anthology* (1963; 2d ed., New York: Heiner Friedrich, 1970).

69 Jon Hendricks, introduction, *Fluxus Etc.,* exhibition catalog for The Gilbert and Lila Silverman Collection (Bloomfield Hills, Mich.: Cranbrook Academy of Art, 1981), p. 4.

70 "Transcript of the Videotaped Interview with George Maciunas by Larry Miller, March 24, 1978," in Jon Hendricks, ed., *Fluxus Etc.: The Gilbert and Lila Silverman Collection, Addenda I* (New York: Ink &, 1983), pp. 10–28.

71 George Maciunas, "Manifesto," ca. 1963; Sohm, *Happening & Fluxus,* reprinted in Hendricks, *Fluxus Etc.,* p. 7.

72 Interview with Dick Higgins, May 12, 1988; "Interview by Larry Miller," p. 27.

73 Dick Higgins, "A Child's History of Fluxus," *Horizons: The Poetics and Theory of the Intermedia* (Carbondale: Southern Illinois University Press, 1984), pp. 87–88.

74 Ibid., pp. 88–89.

75 Ibid., p. 90.

76 Ken Friedman, "Explaining Fluxus," *WhiteWalls* 16 (Spring 1987): 16–17.

77 Ibid., p. 17.

78 Ibid., p. 18.

79 See the various Fluxnewsletters and other documents reprinted in Hendricks, *Fluxus Etc., Addenda I,* pp. 170–228.

80 Friedman, "Explaining Fluxus," p. 27.

81 "Interview by Larry Miller," p. 28.

82 Friedman, "Explaining Fluxus," p. 29.

83 For information about the Judson Dance Theater, see Banes, *Democracy's Body*.

84 Rainer, *Work 1961–73*, p. 8.

85 Sally Banes and Amanda Degener, videotape interview with Ruth Emerson, June 10, 1980, Bennington College Judson Project.

86 Interview with Elaine Summers, New York City, March 15, 1980.

87 Interview with Trisha Brown, Alex Hay, and Robert Rauschenberg, New York City, February 13, 1980, Bennington College Judson Project.

88 Judith Dunn, "My Work and Judson's," *Ballet Review* 1, no. 6 (1967): 26. In the fourth sentence I have substituted the word "decisions" for the original "discussions," which I think is a typographical error.

89 Jill Johnston, "Judson Concerts #3, #4," *Village Voice*, February 28, 1963, p. 9.

90 Interview with Jill Johnston, June 13, 1980.

91 Barbara Rose, *An Interview with Robert Rauschenberg* (New York: Random House, 1987; Vintage contemporary artists series, Elizabeth Avedon editions), p. 88.

92 Interview with Philip Corner, New York City, September 17, 1988.

93 See *Film Culture*, which began publication in 1955; P. Adams Sitney, ed. *Film Culture Reader* (New York: Praeger, 1970); Jonas Mekas's regular columns in the *Village Voice*, beginning in 1958; and his selected columns published in Jonas Mekas, *Movie Journal: The Rise of the New American Cinema, 1959–1971* (New York: Macmillan, 1972). Also see David E. James, *To Free the Cinema: Jonas Mekas and the New York Underground* (Princeton, N.J.: Princeton University Press, 1992).

94 Scott MacDonald, "Amos Vogel and Cinema 16," *Wide Angle* 9, no. 3 (1987): 41–42.

95 Ibid., see also Stephen J. Dobi, "Cinema 16: America's Largest Film Society" (Unpublished Ph.D. dissertation, New York University, 1984).

96 "The First Statement of the New American Cinema Group," in Sitney, ed., *Film Culture Reader*, pp. 81–82.

97 For a concise account of the founding of the Film-Makers' Cooperative and the Film-Makers' Showcase, see Sitney, *Visionary Film*. Also see Mekas's columns for a running account of the peripatetic Film-Makers' Showcase.

98 Melinda Ward, "Shirley Clarke: An Interview," in Melinda Ward and Bruce Jenkins, eds., *The American New Wave, 1958–1967* (Minneapolis, Minn.: Walker Art Center, 1982), p. 20.

99 Jonas Mekas, "The Year 1964," *Village Voice*, January 7, 1965; reprinted in Mekas, *Movie Journal*, pp. 173–174.

100 Ibid.

101 Jonas Mekas, "On the Misery of Community Standards," *Village Voice*, June 18, 1964; reprinted in Mekas, *Movie Journal*, p. 142.

102 See, for instance, Virginia Pope, "Changing, 'the Village' Keeps Its Charm," *New York Times*, November 20, 1927, sec. 5, p. 17; Diana Rice, "A New New York Invades 'the Village,'" *New York Times*, September 29, 1929, sec. 6, pp. 7, 16; Al Hirschfeld, "Counter-revolution in the Village: The Bourgeoisie Seems to Have Triumphed, but Some Centers of Resistance May Still Be Found There," *New York Times*, April 23, 1944, sec. 6, p. 16; Cowley, *Exile's Return*.

103 See Ware; also Jackson Lears, *No Place of Grace: Antimodernism and the Transformation of American Culture, 1880–1920* (New York: Pantheon Books, 1981).

104 Marshall McLuhan, *Understanding Media: The Extensions of Man* (New York: McGraw-Hill, 1964), p. 93.

105 Warhol and Hackett, *POPism*, p. 54.

3 *Which Culture?*

1 In thinking about American folk art, I have benefited from the various essays in Richard Dorson, ed., *Handbook of American Folklore* (Bloomington: Indiana University Press, 1982); Richard M. Dorson, ed., *Folklore and Folklife* (Chicago: University of Chicago Press, 1972); Dan Ben-Amos, ed., *Folklore Genres* (Austin: University of Texas Press, 1976); and also from the opportunity to respond to Carolyn Korsmeyer's paper, "The Amateur and the Academy: The Case of Folk Art," at the Eastern Division meetings of the American Society for Aesthetics, Rochester, N.Y., 1987, as well as from many years of discussions with Roger Abrahams, Barbara Kirshenblatt-Gimblett, and John Szwed.

2 Benedict Anderson's *Imagined Communities: Reflections on the Origin and Spread of Nationalism* (London: Verso, 1983) has been stimulating to my thoughts about the social formation and the implicit political aspirations of this group as a self-proclaimed community, even though Anderson's cases have the more overtly political project of nation-building, rather than artmaking, as their goal.

3 "What is American?" *Art in America*, no. 4 (1963): 20.

4 The caption for the cover identifies Susan Merrett as "an inventive amateur artist" and notes: "The picnickers are printed cutouts, and Miss Merrett's technique is surprisingly modern. This delightful primitive is in the Art Institute of Chicago" (p. 1).

5 Alice Winchester, "Antiques for the Avant-Garde," *Art in America*, no. 4 (1963): 53–59.

6 Poland and Mailman, *Off-Off Broadway*, pp. xii–xiii.

7 Kirby, *Happenings*, p. 48.

8 Ibid., p. 118.

9 Coosje van Bruggen, *Claes Oldenburg: Mouse Museum/Ray Gun Wing*, exhibition catalog (Cologne: Museum Ludwig, 1979), p. 13.

10 Barbara Rose, *Claes Oldenburg*, exhibition catalog (New York: Museum of Modern Art, 1970), p. 184.

11 Kirby, *Happenings*, pp. 204, 234–235.

12 Ibid., p. 13.

13 Hansen seems unaware that the Surrealists themselves often made their theater by borrowing forms from "compartmented" popular genres.

14 Hansen, *A Primer of Happenings*, p. 90.

15 "Movie Journal," *Village Voice*, April 18, 1963, p. 13; reprinted in Mekas, *Movie Journal*, p. 83.

16 Steve Paxton, interview, Washington, D.C., June 30, 1975.

17 Elaine Summers's *Suite* was first performed in Judson Dance Theater's Concert #2 in Woodstock, N.Y., August 31 or September 1, 1962, and was repeated in Concert #3 at Judson Memorial Church, January 29, 1963. The dancers at the Judson Church performance were Summers, Rudy Perez, John Worden, Trisha Brown, Philip Corner, Ruth Emerson, Malcolm Goldstein, John Herbert McDowell, Gretchen MacLane, Arlene Rothlein, Carolee Schneemann, Carol Summers, and Jennifer Tipton. The music was

by John Herbert McDowell. The choreographer and composer went to the Peppermint Lounge to "research" the Twist section (Michael Rowe and Amanda Degener, interview with John Herbert McDowell, February 19, 1980, Bennington College Judson Project).

18 Robert Rauschenberg's *Pelican* was first performed as part of Judson Dance Theater Concert #5 at America on Wheels, Washington, D.C., on May 9, 1963. The dancers were Rauschenberg and Per Olof Ultvedt (on skates) and Carolyn Brown (on pointe). The music was a tape collage, by Rauschenberg, that included march music by Handel and Haydn and found sounds from radio, television, and movies. Fred Herko's *The Palace of the Dragon Prince* was first performed at the Judson Memorial Church on May 1 and 2, 1964, to music by Berlioz and Saint-Saëns. It was danced by Herko, Carla Blank, Robert Holloway, Deborah Lee, Elsene Sorrentino, Sandra Neels, Phoebe Neville, Abigail Ewert, and Terry Foreman. David Gordon's *Random Breakfast* was first performed on Concert #5. The performers were Gordon and Valda Setterfield. The music was a collage by Gordon that included Vivaldi's *The Seasons* and Judy Garland singing "Somewhere Over the Rainbow."

19 Several of the Fluxus newspapers are reproduced in *Fluxus Etc.* For descriptions and photographs of Fluxus objects, see *Fluxus Etc.* and *Fluxus Codex.* The performance scores quoted here were published in *cc V TRE,* Fluxus Newspaper no. 1, January 1964.

20 Quoted in Jonas Mekas, "Movie Journal: The Underground and the Flaherty Seminar," *Village Voice,* September 12, 1963; reprinted in Mekas, *Movie Journal,* p. 95.

21 Janet Goleas, "Red Grooms," in Colin Naylor, ed., *Contemporary Artists,* 3d ed. (Chicago and London: St. James Press, 1989), p. 380.

22 Warhol and Hackett, *POPism,* p. 4.

23 Ibid., p. 7.

24 Max Kozloff, "Pop Culture, Metaphysical Disgust, and the New Vulgarians," *Art International* 6, no. 2 (1962): 36.

25 See Malina, *Diaries.*

26 Current folklore scholarship would argue that folklore is not anonymous. Rather, the personality of the maker is subsidiary to the continuance of the tradition. However, this was in no way a dominant view in the early Sixties, and certainly it was not part of the popular definition of folklore. Stuart Hall and Paddy Whannel, however, already in 1964 point out that to speak of spontaneity in folklore (and, they imply, anonymity) is "a shorthand method of accounting for what, in its own way, was a highly complex process for making art communally." (And, I might add, historically.) Stuart Hall and Paddy Whannel, *The Popular Arts: A Critical Guide to the Mass Media* (New York: Pantheon, 1964; reprint ed., Boston: Beacon Press, 1967), pp. 64–65.

27 Irving Howe later wrote that the urgent debate about mass culture came to an abrupt end in the late 1950s ("The New York Intellectuals," in *The Decline of the New* [New York: Harcourt, Brace and World, 1970], pp. 211–265). The intellectual journals may have stopped featuring the topic. But, ironically, through mass-market paperbacks the debate reached even wider audiences, spreading throughout the culture in the early Sixties via mass culture itself.

28 Bernard Rosenberg and David Manning White, eds., *Mass Culture: The Popular Arts in America* (New York: Free Press, 1957; paperback ed., 1964); Norman Jacobs, ed., *Culture for the Millions?: Mass Media in Modern Society* (Boston: Beacon Press, 1964; paper-

back ed. of 1961 Van Nostrand edition); Stuart Hall and Paddy Whannel, eds., *The Popular Arts: A Critical Guide to the Mass Media* (New York: Pantheon Books, 1964).

29 Leo Lowenthal, "Historical Perspectives of Popular Culture," *American Journal of Sociology* 55 (1950): 323–332; reprinted in Rosenberg and White, *Mass Culture*, pp. 46–58.

30 See Andrew Ross, "Containing Culture in the Cold War," in *No Respect: Intellectuals & Popular Culture* (New York and London: Routledge, 1989), for a discussion of mass culture in terms of the Fifties rhetoric of "germophobia," which permeated not only the discourse on mass culture, but all sorts of other cold war discourses as well ("Is fluoridation a Communist plot? Is your washroom breeding Bolsheviks?" [p. 45]). Germophobia also supplied the mass media themselves with their preferred theme— "the demonology of the 'alien,'" as in the science fiction film. In this respect, Ross proposes that the debate on mass culture expressed the need for American intellectuals to construct a *cordon sanitaire* that would quarantine national culture from foreign (that is, dangerous, pathogenic) elements. Also see Patrick Brantlinger, *Bread & Circuses: Theories of Mass Culture and Social Decay* (Ithaca, N.Y.: Cornell University Press, 1983), for a discussion of what he calls "negative classicism"—the view, repeated in various historical moments, that technological progress and the creation of mass culture lead to civilization's decline and fall, a view often posed in terms of social morbidity.

31 Hannah Arendt, "Society and Culture," in Jacobs, ed., *Culture for the Millions?*, p. 43. The book is a collection of papers presented at a seminar sponsored by Tamiment Institute and *Daedalus* in June 1959, most of which were published in *Daedalus*.

32 This pastiche, of course, is the very model of postmodernist art.

33 Oscar Handlin, "Comments on Mass and Popular Culture," in Jacobs, ed., *Culture for the Millions?*, pp. 63–70.

34 Symposium on Performance Art, moderated by Sally Banes, State University of New York—College at Purchase, April 8, 1983.

35 Sitney, *Visionary Film*, pp. 116–117.

36 Clement Greenberg, "Avant-Garde and Kitsch," in Rosenberg and White, eds., *Mass Culture*, pp. 98–107. Originally published in *Partisan Review* in 1939, it was also reprinted in *The Partisan Reader* (New York: Dial Press, 1946) and in Greenberg's collection of essays, *Art and Culture* (Boston: Beacon Press, 1961).

37 Exhibition catalog, *Post Painterly Abstraction* (Los Angeles: Los Angeles County Museum of Art, April 23–June 7, 1964).

38 Peter Selz, "Pop Goes the Artist," *Partisan Review* 30, no. 2 (Summer 1963): 313–316.

39 Edward Shils, "Mass Society and Its Culture," in Jacobs, ed., *Culture for the Millions?*, pp. 1–27.

40 See Brantlinger, *Bread & Circuses*.

41 Of course, even the avant-garde project was innocent of the indelible ethnic and class differences "rediscovered" in the later Sixties and early Seventies, and of the tenacious rootedness of cultural traditions those discoveries disclosed, which led in the Eighties and Nineties to talk of multiculturalism.

4 Equality

1 As it was, for instance, when a concert of work by selected members of the Judson Dance Theater was produced by the Once Group in Ann Arbor under the title "Cream

of the Crop," or when Andy Warhol and his Factory crowd, on their way to becoming more glamorous, began frequenting Caffe Cino.

2 First performed at Judson Memorial Church on April 28 and 29, 1963, *Terrain* was an evening-length work for six dancers. It was the first dance concert held in the sanctuary of the church since the workshop had begun the previous fall, and it also was the first event produced by the workshop that used the title Judson Dance Theater in its publicity. In a sense, it marked the crystallization of the Judson Dance Theater as an alternative institution.

3 *Dance for Lots of People* was first performed at Concert #7, June 24, 1963, Judson Memorial Church. The performers were Leroy Bowser, Pearl Bowser, Lucinda Childs, June Ekman, Ruth Emerson, Mark Gabor, Tony Holder, Harold Johnson, Deborah Lee, Rudy Perez, Katherine Pira, Arlene Rothlein, Carol Summers, Elaine Summers, and John Worden. The music was by John Herbert McDowell.

4 I should qualify this statement by pointing out that "equal opportunity for all" only took effect once people had already arrived in the group. The idea that all were treated equally did not take into account the initial issue of accessibility. By this, I mean to say that the Judson Dance Theater, celebrating its inclusiveness, did not acknowledge—as we would expect them to, in the Nineties—that one already practically had to be white to be in a position to join the group, and that to be fully inclusive they might have to exercise affirmative action and recruitment. Rudy Perez, of Puerto Rican heritage, was the only member of an ethnic minority I know of in the Judson group. I do not want to accuse the Judson Dance Theater of being racially or ethnically exclusive. As discussed in the next chapter, many African American dancers who probably could have joined the group simply did not find it relevant to their own concerns. But it is striking today that the rhetoric of inclusiveness and diversity was applied to a group that was ethnically quite homogeneous.

5 As the title of one of Warhol's *Mona Lisa* multiples—*Thirty Are Better Than One* (made in response to the much-touted visit of the famed Leonardo Da Vinci painting to the United States in 1963)—suggests, one American response to the aura surrounding the original *Mona Lisa* (a reigning "star" of the art world) was simply to reproduce it ad infinitum. This gesture was a conscious acknowledgment, perhaps even an irreverent celebration, of the way that museums had already democratized art—by selling inexpensive reproductions so that even working-class families could hang "masterpieces" on their walls. Yet in this work Warhol went a step further than the museum stores that peddled their own reproductions as admittedly cheap imitations—only second-best. Warhol brashly claimed, contra the museums', critics', and public's view of an original artwork as the inimitable, irreplaceable product of a genius' hand, that it was purely the quantity, and not the quality, of the copies—in this case, thirty per silk-screened (hence repeatable) package—that bested the original; that the value of an artwork was not based on quality, originality, uniqueness, or authenticity, but on quantity and reproducibility (which previously had disqualified a work as high art, moving it into the realm of kitsch). The hierarchy of original over copy in fine art had been momentarily overturned. See Patrick Smith, *Andy Warhol's Art and Films* (Ann Arbor, Mich.: UMI Research Press, 1986).

6 Andy Warhol, Kasper König, Pontus Hultén, and Olle Granath, eds., *Andy Warhol* (Stockholm: Moderna Museet, 1968), n.p.

7 Andy Warhol, *The Philosophy of Andy Warhol (From A to B and Back Again)* (New York: Harcourt, Brace & Jovanovich, 1975), p. 26.

8 The chart is taken from Sohm, *Happening & Fluxus,* n.p.

9 Taylor Mead, "Acting: 1958–1965," in Ward and Jenkins, eds., *American New Wave, 1958–1967,* p. 13.

10 Jonas Mekas, "From the Diaries: 30 September 1960," in Ward and Jenkins, eds., *American New Wave, 1958–1967,* p. 7.

11 Dick Higgins, *Selected Early Works, 1955–64* (West Berlin: privately printed, 1982), p. 17.

12 Robert Watts, *Duet for Tuba, 1963* and *F/H Trace, 1963,* in *Film Culture* 43 (Winter 1966, expanded arts issue): n.p.

13 In *The Making of the Counterculture,* Theodore Roszak writes about the opposition by the counterculture in the later Sixties to the "technocratic society" that had been built up in the Fifties and early Sixties. This was, he notes, a generation's resistance to an era of social/scientific engineering in which technological expertise became not only the means, but the goal for cold war America. "In the technocracy everything aspires to become purely technical, the subject of professional attention. The technocracy is therefore the regime of experts—or of those who can employ the experts. . . . Within such a society, the citizen, confronted by bewildering bigness and complexity, finds it necessary to defer on all matters to those who know better" (Roszak, *The Making of a Counter Culture: Reflections on the Technocratic Society and Its Youthful Opposition* [Garden City, N.Y.: Doubleday, 1969], p. 7). But already by the early Sixties there was resistance on a number of fronts, of which the avant-garde art world was one, to overspecialization and technological obsession.

14 On Paxton's use of walking, see Sally Banes, *Terpsichore in Sneakers: Post-Modern Dance* (Boston: Houghton Mifflin, 1980; 2d ed., Middletown, Conn.: Wesleyan University Press, 1987), pp. 59–61.

15 Antonin Artaud, "The Theater of Cruelty (First Manifesto)," *The Theater and Its Double,* trans. Mary Caroline Richards (New York: Grove Press, 1958), pp. 96–97.

16 Allan Kaprow, "A Statement," in Kirby, *Happenings,* p. 46.

17 *Shoes of Your Choice* had its premiere April 6, 1963, at the Old Gymnasium of Douglass College, Rutgers University, New Brunswick, N.J. Alison Knowles, *By Alison Knowles* (New York: Something Else Press, a Great Bear pamphlet, 1965), p. 5.

18 Yoko Ono, "Collecting Piece III," *Grapefruit* (Tokyo and Bellport, N.Y.: Wunternaum Press, 1964), n.p.; reprinted in Sohm, *Happening & Fluxus,* n.p.

19 Robert Watts, *Casual Event,* in *Events,* Fluxus ed., New York, 1963.

20 In 1963 *The Connection,* which had opened at the Living Theater on July 15, 1959, had returned to the repertory and was running in tandem with *The Brig.* Directed by Judith Malina and designed by Julian Beck, the production originally featured the Freddie Redd jazz group. Its original cast (actors and musicians) included Leonard Hicks, Ira Lewis, Warren Finnerty, Jerome Raphael, John McCurry, Garry Goodrow, Freddie Redd, Michael Mattos, Louis McKenzie, Jamil Zakkai, Jackie McLean, Larry Ritchie, Henry Proach, Barbara Winchester, and Carl Lee (Jack Gelber, *The Connection* [New York: Grove Press, 1960]).

21 Julian Beck, "Storming the Barricades," introduction to Kenneth Brown, *The Brig* (New York: Hill and Wang, 1965), pp. 22–23.

22 Ibid., pp. 26–27.

23 John Cage, "Lecture on Nothing," *Silence* (Middletown, Conn.: Wesleyan University Press, 1961; 2d ed., Cambridge, Mass.: MIT Press, 1966), pp. 115–117.

24 John Cage, "Erik Satie," originally published in the 1958 *Art News Annual* and reprinted in *Silence*, p. 82.

25 Calvin Tomkins, *The Bride and the Bachelors: Five Masters of the Avant Garde* (New York: Viking, 1965).

26 "Interview: Susan Sontag: On Art and Consciousness," *Performing Arts Journal* 2 (Fall 1977): 28.

27 Jonas Mekas, "Movie Journal: Joseph Cornell, the Poet of the Unpretentious," *Village Voice*, December 5, 1963; reprinted in Mekas, *Movie Journal*, p. 110.

28 *Pull My Daisy* was directed by photographer Robert Frank and painter Alfred Leslie, scripted and narrated by Jack Kerouac, and featured the poets Allen Ginsberg, Gregory Corso, and Peter Orlovsky as themselves, as well as the painters Larry Rivers and Alice Neel, the composer David Amram, the dancer Sally Gross, and the actress Delphine Seyrig all playing fictional roles.

29 As J. Hoberman has pointed out, Alfred Leslie later debunked this notion when he published an article on the film's production that showed how it was carefully designed, scripted, planned, rehearsed, and edited. (J. Hoberman, "*Pull My Daisy/The Queen of Sheba Meets the Atom Man*," in Ward and Jenkins, eds., *American New Wave: 1958–1967*, pp. 34–39.)

30 Jonas Mekas, "Movie Journal: *Pull My Daisy* and the Truth of Cinema," *Village Voice* November 18, 1959; reprinted in Mekas, *Movie Journal*, pp. 5–6.

31 In thinking about the different uses of the prosaic in the Sixties, the Russian Formalist concept of "defamiliarization" (*ostranenie*) is useful. As outlined by Victor Shklovsky in his essay "Art as Technique," defamiliarization (or "making things strange") is a strategy used by writers for reinvigorating perception, which becomes dulled by the habitual quality of daily life. I have applied an expanded notion of defamiliarization to the Sixties avant-garde in "Making Things Strange: The Use of the Ordinary in the Sixties Avant-Garde," *Choreography and Dance* (in press).

32 The dance was first performed on Concert #9, Gramercy Arts Theater, July 30, 1963. It is described in Jill Johnston, "The New American Modern Dance," in Richard Kostelanetz, ed., *The New American Arts* (New York: Collier Books, 1967), p. 184, and in Jill Johnston, "Motorcycle," *Village Voice*, December 19, 1963, p. 11. It also was described to me by Judith Dunn in my interview with her, Burlington, Vt., July 8, 1980, and by Beverly Schmidt Blossom in my interview with her, New York City, April 6, 1980.

33 Fredric Jameson uses this example in *The Prison-House of Language: A Critical Account of Structuralism and Russian Formalism* (Princeton, N.J.: Princeton University Press, 1972), pp. 55–56.

34 The Brillo boxes were first exhibited at the Stable Gallery, April 21–May 9, 1964.

35 Jonas Mekas, "Notes on Some New Movies and Happiness," *Film Culture*, no. 37 (Summer 1965); reprinted in Sitney, ed., *Film Culture Reader*, pp. 317–318.

36 Warhol and Hackett, *POPism*, pp. 39–40.

37 Cage, "26 Statements re Duchamp," *A Year from Monday* (Middletown, Conn.: Wesleyan University Press, 1969), pp. 70, 72.

38 *Nivea Cream Piece* had its premiere November 25, 1962, at the Fluxus Festival, Alle

Scenen Theater, Copenhagen, was performed at subsequent Fluxus concerts, and was published in Knowles, *By Alison Knowles,* p. 3.

39 *Gångsång* was written (February 27, 1963) and first performed (at Alle Scenen Theater, March 2, 1963) in Stockholm; it was published in Dick Higgins, *Jefferson's Birthday* (New York: Something Else Press, 1964), p. 263. Knowles's *Nivea Cream Piece* and Higgins's *Gångsång* were two of twenty-six events on a program of Happenings, Events, and Advanced Music presented by Al Hansen and the New York Audio-Visual Group for Research and Experimentation in the Fine Arts (many of whose members were in Fluxus) on April 6, 1963, at Douglass College, Rutgers University, New Brunswick, N.J.

40 See Hendricks, ed., *Fluxus Codex,* pp. 73, 210–215.

41 According to Stefan Brecht in *The Bread and Puppet Theater,* vol. 1 (New York: Methuen, 1988), pp. 107, 433–440, *The Christmas Story* was first performed in 1962 at the Putney School in Vermont and then at the Living Theater (December 20 and 21). In 1963 it was done at the Bread and Puppet Museum on Delancey Street and at the Spencer Memorial Church in Brooklyn Heights. *The Christmas Story* was repeated at various locations, including the Judson Memorial Church, Washington Square Methodist Church, the Pocket Theater, the Bridge Theater, the Astor Library, P.S. 122, and other locales, throughout the Sixties, until perhaps 1973. The description given here is taken from Robert Nichols, "Christmas Story, 1962," *Drama Review* 14, no. 3 (1970; T47): 91 (Brecht believes that this is probably a description of the 1963 performance at Spencer Church) and from a description by the Reverend William Glenesk, "Puppets Tell the Christmas Story," *Face to Face* (December 1969), quoted in Brecht, pp. 439–440.

42 Peter Schumann, "Bread and Puppets," *The Drama Review* 14, no. 3 (1970; T47): 35.

43 Interview with Philip Corner, New York City, September 17, 1988.

44 Higgins, *Postface,* pp. 4–5.

45 Interview with Jackson Mac Low, New York City, September 16, 1988.

46 Jerome Rothenberg, preface to Jackson Mac Low, *Representative Works, 1938–1985* (New York: Roof Books, 1986), pp. ix–x.

47 "DAILY LIFE" is published in *Representative Works,* pp. 170–173.

48 Interview with Mac Low. According to Mac Low, Maciunas worked at trying to arrange a Fluxus tour of the Soviet Union, but it never materialized.

49 Yvonne Rainer, "The Performer as a Persona: An Interview with Yvonne Rainer," *Avalanche* 5 (Summer 1972): 54.

50 See F. T. Marinetti, "The Variety Theater," *Selected Writings,* ed. and with an introduction by R. W. Flint, trans. Flint and Arthur A. Coppotelli (New York: Farrar, Straus and Giroux, 1972), pp. 116–122.

51 Kirby, *Happenings,* p. 13.

52 *Water* was performed on September 20 and 21, 1963, in Westwood, Calif. It is described in Kirby, *Happenings,* pp. 172–183.

53 *Gayety* was performed on February 8, 9, and 10, 1963, in Lexington Hall at the University of Chicago. It is described and Oldenburg's original script is published in Kirby, *Happenings,* pp. 234–261. Also, it has been documented on film by Vernon Zimmerman in *Scarface and Aphrodite,* available for rental from the Film-makers' Cooperative.

54 In Kirby, *Happenings,* p. 235.

55 Interview with Steve Paxton, Bennington, Vt., April 1, 1980.

56 Ulf Hannerz, *Exploring the City: Inquiries Toward an Urban Anthropology* (New York: Columbia University Press, 1980), p. 99.

57 Susan Sontag, "Happenings: An Art of Radical Juxtaposition," *The Second Coming;* reprinted in Sontag, *Against Interpretation,* p. 272.

58 Richard Kostelanetz, "Conversation with John Cage," in Kostelanetz, ed., *John Cage,* p. 11.

59 Hansen, *A Primer of Happenings,* p. 94.

5 Dreaming Freedoms

1 As the sociologist Zygmunt Bauman has pointed out, "the two cases of ambivalence, one associated with the experience of freedom and the other with the constraints linked to all group membership, continually generate the dream of community; a special kind of community, as it were, which bears no resemblance to any real communities known to historians or anthropologists (in Mary Douglas's curt verdict, 'small-scale societies do not exemplify the idealised vision of community')" Zygmunt Bauman, *Freedom* (Minneapolis: University of Minnesota Press, 1988), p. 53. The citation from Mary Douglas is from *How Institutions Think* (London: Routledge and Kegan Paul, 1987), p. 25.

Bauman's further comments on this aspect of the imagined community are useful in terms of the twin vision of liberation and fellowship in the heterotopia of Greenwich Village in 1963: "The fantasy, bred and fed by the disconcerting ambiguity of freedom, conjures up a community which puts paid to fear of loneliness *and* horror of oppression at the same time; a community which does not simply 'balance out' the two unpalatable extremes but effectively writes them off for good; a community in which freedom *and* togetherness can be enjoyed simultaneously—both coming, so to speak, free of charge. Dreamt-of communities of this kind serve as illusory solutions to a contradiction always encountered and never conclusively resolved in the reality of daily life" (p. 53).

2 Michael Harrington, *The Other America* (New York: Penguin, 1963).

3 John A. Kouwenhoven, "The Beer Can by the Highway; or, Whatever Became of Emerson?," in *The Beer Can by the Highway: Essays on What's American about America,* foreword by Ralph Ellison (Baltimore: Johns Hopkins University Press, 1988; originally published by Doubleday, 1961), pp. 215–242.

4 Sontag, "Happenings: An Art of Radical Juxtaposition," *Against Interpretation,* p. 263.

5 Philip Corner, "Brass orchestra Baby directors," in Benjamin Patterson, Philip Corner, Alison Knowles, Tomas Schmit, *Four Suits* (New York: Something Else Press, 1965), p. 169; *Blonde Cobra* is available from Film-Makers' Cooperative and on videotape from New Video. Sitney discusses the film in *Visionary Film,* pp. 330–334, as does James in *Allegories of Cinema,* pp. 125–127. Smith's spoken text for the film was published in Jack Smith and Ken Jacobs, "Soundtrack of 'Blonde Cobra,'" *Film Culture* 29 (Summer 1963): 2–3.

6 Viola Spolin, *Improvisation for the Theatre* (Evanston, Ill.: Northwestern University Press, 1963).

7 See Pasolli, *A Book on the Open Theater.*

8 See Ann Halprin, "It's All the Fault of Christopher Columbus," *Dance Magazine* 37,

(August 1963): 38–39, 61–62; Anna Halprin et al., *Collected Writings* (San Francisco: San Francisco Dancers' Workshop, 1973); and Anna Halprin et al., *Second Collected Writings* (San Francisco: San Francisco Dancers' Workshop, 1975).

9 See Simone Forti, *Handbook in Motion* (Halifax, Nova Scotia: Press of the Nova Scotia College of Art and Design; New York: New York University Press, 1974).

10 The "publication" of Fluxkits continued, with constantly changing contents. The 1977 *Fluxcabinet* was the apotheosis of the *Fluxkit*. See Hendricks, ed., *Fluxus Codex,* pp. 72–76. Hendricks notes that Ken Friedman informed him about a large *Fluxkit*—or small Fluxshop—that Maciunas made and which Friedman carried around the country like a traveling salesman's valise (p. 76). It is Hendricks's contention that Maciunas definitely borrowed this particular box format from Duchamp's *Boîte en valise.*

11 See Hendricks, ed., *Fluxus Codex,* pp. 103–110.

12 Walter de Maria, *Piece for Terry Riley,* written May 1960 and published in Young and Mac Low, eds., *An Anthology,* n.p. My information on *Pelican* comes from my interview with Trisha Brown, Alex Hay, and Robert Rauschenberg, New York City, February 17, 1980; floor plan and description of *Pelican* in Swedish, from unidentified source, given to me by David Vaughan, Spring 1980; Kostelanetz, *The Theatre of Mixed Means,* pp. 80–81; National Collection of Fine Arts, Smithsonian Institution, *Robert Rauschenberg,* exhibition catalog (Washington, D.C., October 30, 1976–January 2, 1977), pp. 182–184; Calvin Tomkins, *Off the Wall* (Garden City, N.Y.: Doubleday, 1980), p. 227. *Pelican* was first performed as part of Judson Dance Theater Concert #5 and the Pop Festival on May 9, 1963. It was repeated at the First New York Theater Rally in New York on May 24–26, 1965, with Alex Hay replacing Per Olof Ultvedt; at the Roller-drome in Culver City, Calif., on April 20, 1966; and again at America on Wheels in Washington, D.C., on April 26, 1966 (*Robert Rauschenberg,* p. 184).

13 See Jean-Paul Sartre, *Being and Nothingness,* trans. Hazel E. Barnes (New York: Philosophical Library, 1956), and Johan Huizinga, *Homo Ludens* (New York: Roy Publishing, 1950; Boston: Beacon Press, 1955).

14 Jill Johnston, "Dance Journal: Play," *Village Voice,* November 18, 1965, pp. 15, 22.

15 William E. Leuchtenberg, *A Troubled Feast: American Society Since 1945* (Boston: Little, Brown, 1973), p. 65.

16 Norman Mailer, "The White Negro (Superficial Reflections on the Hipster)," *Dissent* 4, no. 3 (Summer 1957): 276–293.

17 Boroff, "Introduction to Greenwich Village," in McDarrah, *Greenwich Village,* p. 10. Also, see Fred Powledge, "Negro-White Marriages on Rise Here," *New York Times,* October 18, 1963, pp. 1, 18.

18 Imamu Amiri Baraka, *The Autobiography of LeRoi Jones/Amiri Baraka* (New York: Freundlich Books, 1984).

19 See Geneviève Fabre, *Drums, Masks, and Metaphor: Contemporary Afro-American Theater,* trans. Melvin Dixon (Cambridge, Mass.: Harvard University Press, 1983), for a critical history of the black theater movement.

20 See Allen Woll, *Black Musical Theatre: From* Coontown *to* Dreamgirls (Baton Rouge: Louisiana State University Press, 1989), chapter 13, "Democracy in Action," for an account of the postwar integration of both casts and audiences and Actors' Equity's role in that struggle.

21 *Equity,* 1955–1966, cited in Woll, *Black Musical Theatre,* p. 225.

22 "Josephine Baker: A Lion Abroad, But More Like a Lamb at Home," *National Ob-*

server, April 6, 1964, p. 16, quoted in Phyllis Rose, *Jazz Cleopatra: Josephine Baker in Her Time* (New York: Doubleday, 1989), p. 242.

23 The performances of Josephine Baker and Her Company, as it was billed, opened at the Brooks Atkinson Theater on February 4, 1964, ran for sixteen performances (until February 16), then reopened at Henry Miller's Theater on March 31, where it ran for twenty-four performances (finally closing on April 19). See Daniel Blum, ed. *Theatre World: Season 1963–1964* (Philadelphia: Chilton Books, 1964), p. 78; Lewis Funke, "A Radiant Josephine Baker Returns," *New York Times,* February 5, 1964, p. 30. Baker's typically extravagant costumes were credited to Dior, Balmain, House of Lanvin, and Balenciaga; photographs show her elegant, bejeweled figure swathed in a close-fitting floor-length lace gown or a frilly, voluminous strapless confection. The music program was a mélange, from "Don't Touch My Tomatoes" to "Hello Young Lovers," and of course Baker's signature piece about expatriate ambivalence, "J'ai Deux Amours" (Blum, *Theatre World: Season 1963–1964,* p. 78).

24 *Porgy and Bess* opened on May 6, 1964, and closed after fifteen performances on May 17. It was directed by John Fearnley, with musical direction by Julius Rudel. *Cabin in the Sky* opened on January 21, 1964, and closed after forty-seven performances on March 1. It was directed by Brian Shaw, choreographed by Pepe DeChazza, and had musical direction by Eric W. Knight (Blum, *Theatre World: Season 1963–1964,* pp. 133, 216).

25 Woll, *Black Musical Theatre,* pp. 237–238.

26 *Tambourines to Glory* opened at the Little Theater on November 2, 1963, and closed, after twenty-four performances, on November 23. It was directed by Nikos Psacharopoulos; Clara Ward was choral director. (Blum, *Theatre World: Season 1963–1964,* p. 48.)

27 The production was codirected by Alvin Ailey and William Hairston and featured the Hugh Porter Gospel Singers. See, among other reviews, Whitney Bolton, "'Jerico-Jim Crow' Delightful Event," *Morning Telegraph,* January 14, 1964; Jay Carr, "Hughes' 'Jerico' Opens at Village Sanctuary," *New York Post,* January 13, 1964; John Molleson, "'Jerico-Jim Crow' Bound for Greatness," *New York Herald Tribune,* January 13, 1964; Norman Nadel, "'Jerico-Jim Crow' Worth Seeing," *New York World Telegraph and Sun,* January 13, 1964; Peter Share, "Theatre: 'Jerico-Jim Crow,'" *Village Voice,* January 23, 1964; Richard F. Shepard, "Theater: A Rousing 'Jerico-Jim Crow,'" *New York Times,* January 13, 1964. The production opened on January 12, 1964, and closed after thirty-two performances on April 26, 1964 (Blum, *Theatre World: Season 1963–1964,* p. 212).

Two other black musicals opened Off-Broadway in Greenwich Village in the 1963–64 season. One was *Trumpets of the Lord,* an adaptation by Vinnette Carroll of James Weldon Johnson's *God's Trombones: Seven Negro Sermons in Verse.* (See Woll, *Black Musical Theatre,* p. 242; Blum, *Theatre World: Season 1963–1964,* p. 209; and Lewis Funke, "Theater: 'Trumpets of the Lord' Opens," *New York Times,* December 23, 1963.) *Trumpets of the Lord* opened December 21, 1963, at Astor Place Playhouse, moved to One Sheridan Square on January 22, 1964, and closed after 160 performances on May 17, 1964. It was directed by Donald McKayle, and the musical director was Howard Roberts. The cast included Al Freeman, Jr., and Cicely Tyson as two of the preachers. The second was *Ballad for Bimshire,* by Irving Burgie and Loften Mitchell. The first production of The New Group, dedicated "to provide economic opportunities for the Negro" and "to display the richness of Negro culture," it was meant as an antidote

to the white-authored Caribbean musicals that gave Afro-Caribbean culture a purely exotic, tourist flavor. *Ballad for Bimshire*—whose composer, Burgie, had written many of the songs made popular by Harry Belafonte—looked at the colonial situation in Barbados from a black perspective. (Loften Mitchell, *Black Drama: The Story of the American Negro in the Theatre* [New York: Hawthorn Books, 1967], pp. 191–197; Woll, *Black Musical Theatre*, pp. 241–242; Arthur Sainer, "Theater: *Ballad for Bimshire*, *Village Voice*, October 24, 1963.) *Ballad for Bimshire* opened at the Mayfair Theater on October 15, 1963, and closed on December 15 after seventy-four performances. It was directed by Ed Cambridge, choreographed by Talley Beatty, and its cast included Ossiè Davis and Sylvia Moon. The musical director was Sammy Benskin. (Blum, *Theatre World: Season 1963–1964*, p. 199.)

28 *Blues for Mister Charlie* opened on April 23, 1964, at the ANTA Theater. An Actors Studio production, it was directed by Burgess Meredith; its cast included Al Freeman, Jr., Diana Sands, Rip Torn, and Pat Hingle. It closed after 148 performances on August 29, 1964. (Blum, *Theatre World: Season 1963–1964*, p. 110; John Willis, ed., *Theatre World: Season 1964–1965* (New York: Crown, 1965), p. 113.

29 *Walk in Darkness* was presented by the Greenwich Players at the Greenwich Mews Theater. Staged by Sidney Walters, with scenery and lighting by Ming Cho Lee, it opened on October 28, 1963, and closed on November 23 after twenty-four performances.

30 *Dutchman* was first given on January 7 and *Funnyhouse of a Negro* on January 14 at the East End Theater, Second Avenue and Fourth Street. The plays were produced by Theater 1964 (Richard Barr, Clinton Wilder, and Edward Albee). See n. 31, below, for the subsequent run of *Dutchman*.

31 *The Eighth Ditch* opened March 16, 1964, at the New Bowery Theater. Produced by the American Theater for Poets and directed by Alan Marlowe, with a set by Robert Morris, it was on a triple bill with Diane DiPrima's *Murder Cake* and Frank O'Hara's *Loves Labor*. (See Michael Smith, "Theater: The Eighth Ditch," *Village Voice*, March 19, 1964, p. 11.) This was the second production of the play, which had originally been published in the little magazine Jones coedited with DiPrima, *The Floating Bear* (#9, June 1961) and had been the occasion for the police to confiscate that issue of the publication and arrest DiPrima and Jones for sending obscenity through the mail. (J. R. Goddard, "Poet Jailed for Obscenity: Literary Magazine Hit. LeRoi Jones & Floating Bear," *Village Voice* October 26, 1961, p. 3.) The first production of *The Eighth Ditch* also had been by the same group (at other times referred to as the New York Poets' Theater), which had been cofounded by Jones, DiPrima, and Marlowe. It opened in October 1961 at the Off-Bowery Theater on a bill with DiPrima's *Discontent of the Russian Princess* and Michael McClure's *Pillow*.

 The Baptism opened on March 23, produced by Present Stages at the Writers' Stage Theater on a double bill with Frank O'Hara's *The General Returns from One Place to Another*. Jerry Benjamin directed, Taylor Mead played the homosexual (and the general in O'Hara's play), and Joe Brainard designed the set.

 Dutchman opened for an extended run on March 24 at the Cherry Lane Theater. Produced again by Theater 1964 and directed by Edward Parone, it was on a triple bill with Samuel Beckett's *Play* and Fernando Arrabal's *The Two Executioners*. After April 19 it was on a double bill with a revival of Albee's *The American Dream*. Robert Hooks played Clay and Jennifer West played Lula. It closed after 366 performances on Feb-

ruary 6, 1965. (Blum, *Theatre World: Season 1963–1964*, p. 226, Willis, *Theatre World: Season 1964–1965*, p. 179.)

32 LeRoi Jones, *The Baptism and The Toilet* (New York: Grove Press, 1967).

33 *The Eighth Ditch (Is Drama*, from *The System of Dante's Hell*, *The Floating Bear* 9 (1961): [1]–[7]; reprinted in DiPrima and Jones, eds., *The Floating Bear: A Newsletter* (La Jolla, Calif.: Laurence McGilvery, 1973), pp. 81–87.

34 Werner Sollors, *Amiri Baraka/LeRoi Jones: The Quest for a "Populist Modernism"* (New York: Columbia University Press, 1978), p. 280, n. 4.

35 LeRoi Jones, *Dutchman and The Slave* (New York: Morrow Quill Paperbacks, 1964).

36 Directed by Gene Frankel, *The Blacks* had opened in 1961 at St. Mark's Playhouse in the East Village, and in September 1963 it celebrated its thousandth performance. Its cast over the years included most of the important and emerging African American actors of the Sixties and after, among them Charles Gordone, James Earl Jones, Cicely Tyson, Godfrey Cambridge, Louis Gossett, Jr., Robert Hooks, Roscoe Lee Browne, Billy Dee Williams, Vinie Burrows, Esther Rolle, and Cynthia Belgrave. While the question of a white European author's and a white American director's representation of black revolution eventually became problematic for the all-black cast—James Baldwin and Ossie Davis attended some of the meetings held by the cast to discuss racial issues—the unmitigated Artaudian violence and the ritual style and structure of the play were influential on a number of new African American playwrights and young performers. Its long run and director Frankel's willingness to reinstate cast members who left temporarily for more lucrative roles provided steady jobs for many black actors throughout the early Sixties. By 1966 the Negro Ensemble Company would emerge from the group of actors involved in this production. (Sam Zolotow, "Tonight's Performance Marks 1000th Showing of 'The Blacks,'" *New York Times*, September 25, 1963, p. 37; Little, *Off-Broadway*, pp. 121–127.)

 The Blood Knot opened March 2, 1964, at the Cricket Theater. It was directed by John Berry at the Cricket Theater in the East Village and featured James Earl Jones and J. D. Cannon as the brothers. Jones was eventually replaced by Louis Gossett, Jr., and Cannon was replaced by Nicholas Coster and then by Fugard. The production closed after 239 performances on September 26, 1964. (See Howard Taubman, "Theater: Penetrating Play," *New York Times*, March 3, 1964, p. 30.)

37 *In White America* opened October 31, 1963, at the Sheridan Square Playhouse. It was directed by Harold Stone; Oscar Brand was the musical director. The cast included Gloria Foster, James Greene, Moses Gunn, Claudette Nevins, Michael O'Sullivan, and Fred Pinkard, and the musician was Billy Faier. It closed after 499 performances on January 3, 1965, and then reopened with an almost entirely different cast at the Players Theater on May 18, 1965. In between, the production toured New Jersey and New York suburbs. (Blum, *Theatre World: Season 1963–1964*, p. 201; Willis *Theatre World: Season 1964–1965*, pp. 175, 217.)

38 See Michael Smith, "Theatre: In White America," *Village Voice*, November 7, 1963; Al Cohn, "'White America' Portrays Tragedy of Being Black," *Newsday*, November 5, 1963; William Bender, "'In White America'—Beauty, Deep Emotion," *New York Herald Tribune*, November 1, 1963.

39 Letter from Denise Moses to Steven Rubin, October 22, 1964.

40 Stuart W. Little, "Fulfilling a Deep Need in the Deep South," *New York Herald Tribune*, August 16, 1964.

41 The Free Southern Theater toured the South at first under the auspices of the Coun-
cil of Federated Organizations, the Student Nonviolent Coordinating Committee's
(SNCC's) Freedom Schools, and black churches. In 1964 the group moved to New
Orleans, where it remained, becoming an all-black, community-based group as the
Sixties wore on, until its dissolution in 1980. See Thomas C. Dent, Gil Moses, and
Richard Schechner, eds., *The Free Southern Theater by the Free Southern Theater* (New
York: Bobbs-Merrill, 1969. Also see Stuart W. Little, "They'll Take Drama into the
South," *New York Herald Tribune,* April 2, 1964; "New Negro Theater Set for Jackson,"
New York Post; and "The Talk of the Town," *The New Yorker,* April 11, 1964, for the
first publicity in New York. Little's article solicited "contributions, scripts, and offers
of participation" and gave the address of the theater's New York agent.

42 Catalog of an exhibition of works by Bob Thompson, University Art Gallery at Amherst
College, Amherst, Mass., September 11–October 4, 1974.

43 In the early Sixties, Hollywood studios were pressured by the government and by the
NAACP into providing jobs for African Americans—both as actors and on the produc-
tion side. Sidney Poitier won an Academy Award for 1963's *Lilies of the Field.* Although
the world represented on television dramas, situation comedies, soap operas, quiz
shows, and commercials was predominantly white, in the early Sixties African Ameri-
can actors were beginning to appear on some series in roles more respectable than the
ubiquitous black housekeepers of the Fifties. *Car 54, Where Are You?* (1961–1963) and
East Side, West Side (1963–1964) both had African American actors as regular cast mem-
bers (Nipsey Russell and Frederick O'Neal in *Car 54,* and Cicely Tyson in *East Side,
West Side*), and such series as *The Defenders* (1961–1965), *The Nurses* (1962–1965), *The
Fugitive* (1963–1967), *The Naked City* (1958–1963), and *Slattery's People* (1964–1965)
often featured African American actors in guest roles. See Donald Bogle, *Blacks in
American Films and Television* (New York: Garland, 1988; reprint ed., Simon and Schus-
ter, 1989), pp. 235–245, for a discussion on the changing images of African Americans
on television in the Fifties and Sixties.

African American athletes often appeared on sports shows, and black comics such as
Bill Cosby and Richard Pryor appeared regularly on variety shows, as did numerous
singers and musicians—especially on the Ed Sullivan Show. Although the dancers on
"American Bandstand" were white Philadelphia teenagers, the show frequently show-
cased black rock and roll performers.

44 Brian O'Dougherty, "Art Views Crisis at Mississippi U.," *New York Times,* May 22,
1963, p. 38. One of the paintings included a Confederate flag with racist graffiti—
epithets that the artist, G. Ray Kerciu, had seen and heard on campus. Kerciu was
arrested and charged with desecration of the Confederate flag and obscenity after the
initial showing of the painting at the University of Mississippi. The charges were later
dropped.

45 Higgins, *Jefferson's Birthday,* pp. 60–65.

46 See Noël Carroll, "*Nothing But a Man; The Cool World,*" in Ward and Jenkins, eds., *The
American New Wave, 1958–1967,* pp. 40–47.

47 See Carroll, "*Nothing But a Man; The Cool World*"; also Thomas Cripps, "*Nothing But
a Man,*" in *Black Film as Genre* (Bloomington: Indiana University Press, 1978), pp.
115–127.

48 Jones, *Blues People,* pp. 226–227. The citation is from George Russell, "Ornette Cole-
man and Tonality," *Jazz Review* (June 1960), p. 9.

49 Beck, "Storming the Barricades," pp. 26–28.

50 Chaikin, *The Presence of the Actor*, p. 116.

51 Interview with Lawrence Kornfeld, New York City, October 28, 1989.

52 See, for instance, Anne Scott-James, "Found: A Place to Dance," *New York Herald Tribune*, April 14, 1963.

53 Walter Terry, "Dr. Hurok's Imported Elixirs," *New York Herald Tribune*, February 23, 1964.

54 U.S. Congress, Senate, Special Subcommittee on the Arts, Committee on Labor and Public Welfare, *Hearings on Government and the Arts*, 87th Congress, 2d sess., August 29–31, 1962 (Washington, D.C.: U.S. Government Printing Office, 1962). I am grateful to Sherry Keller for pointing me toward this reference.

55 Howard Taubman, "Obratsov Show Opens at the Broadway; 'Performers' Are Droll and Professional," *New York Times*, October 3, 1963, p. 28; Paul Gardner, "'Man in Moon' Offered at Biltmore Theater; Tour of Soviet Union Will Begin in June," *New York Times*, April 12, 1963, p. 34.

56 Taubman, "Obratsov Show Opens."

57 Allen Hughes, "American Exports: Many Choreographers Make Impact Abroad," *New York Times*, November 17, 1963; Walter Terry, "How Good Is the Bolshoi?," *New York Herald Tribune*, October 6, 1963.

58 Brooks Atkinson, "Critic at Large: Moscow Has a Look of Well Being But Its Citizens Hunger for the Arts," *New York Times*, February 26, 1963, p. 10.

59 *Encounter* (April 1963); quoted in Edward J. Brown, *Russian Literature Since the Revolution* (Cambridge, Mass.: Harvard University Press, 1982; revised and enlarged ed.), p. 226.

60 Henry Tanner, "Rifts Preceded Khrushchev Fall," *New York Times*, October 22, 1964, p. 1.

61 This view has been espoused more recently, with convincing evidence, by Eva Cockcroft, "Abstract Expressionism, Weapon of the Cold War," *Artforum* 12, no. 10 (June 1974): 39–41, and Serge Guilbaut, *How New York Stole the Idea of Modern Art: Abstract Expressionism, Freedom, and the Cold War*, trans. Arthur Goldhammer (Chicago: University of Chicago Press, 1983).

62 Jonas Mekas, "On the Baudelairean Cinema," *Village Voice*, May 2, 1963; reprinted in Mekas, *Movie Journal*, pp. 85–86.

63 Sitney, *Visionary Film*, p. 316.

64 Rice showed a rough cut of *The Queen of Sheba Meets the Atom Man* on January 28, 1963, at the Living Theater. His program notes announced that this was a seventy-minute version of a projected three-hour "epic" (Film-Maker's Cooperative Catalog no. 6, p. 208). After Rice's death in 1964, his assistant, Howard Everngam, oversaw the creation of the print distributed by Film-Maker's Cooperative. In 1979 a longer version edited by Taylor Mead, with an aural track collage of nostalgic popular songs, jazz, and symphonic music, replaced the Everngam version. This version may be rented from the Film-Maker's Cooperative and is the version that I have studied. (See Hoberman, *Pull My Daisy; The Queen of Sheba Meets the Atom Man*, in Ward and Jenkins, eds., *American New Wave, 1958–67*, pp. 38–39.)

65 On *Flaming Creatures*, see Sitney, *Visionary Film*, pp. 353–357; Susan Sontag, "Jack Smith's *Flaming Creatures*," in *Against Intepretation*, pp. 226–231; and Ken Kelman,

"Smith Myth," *Film Culture* 29 (Summer 1963): 4–6; the Kelman article is reprinted in Sitney, ed., *Film Culture Reader*, pp. 280–284.

66 [Jonas Mekas], "Fifth Independent Film Award," *Film Culture* 29 (Summer 1963): 1.

67 Sontag, "Jack Smith's *Flaming Creatures*," p. 226.

68 Contra Mekas's attribution, *Blonde Cobra* was edited by Jacobs from footage shot in 1959 by Bob Fleischner.

69 Jonas Mekas, "Movie Journal: More on Movie Renaissance," *Village Voice*, June 13, 1963; reprinted in Mekas, *Movie Journal*, p. 87.

70 Jonas Mekas, "Movie Journal: On Women in Cinema," *Village Voice*, July 25, 1963; reprinted in Mekas, *Movie Journal*, pp. 89–90.

71 Jonas Mekas, "Movie Journal: Changing Techniques of Cinema," *Village Voice*, August 8, 1963; reprinted in Mekas, *Movie Journal*, pp. 91–92.

72 Mekas, "Movie Journal: More on Movie Renaissance."

73 Jonas Mekas, "Movie Journal: On Censorship, the Mayor's Office, and the Underground," *Village Voice*, August 22, 1963; reprinted in Mekas, *Movie Journal*, pp. 93–94.

74 Jonas Mekas, "Movie Journal: *Flaming Creatures* at Knokke-Le Zoute," *Village Voice*, January 16, 1964; reprinted in Mekas, *Movie Journal*, pp. 111–112.

75 See Richard S. Randall, *Censorship of the Movies: The Social and Political Control of a Mass Medium* (Madison: University of Wisconsin Press, 1968).

76 See Melinda Ward, "Shirley Clarke: An Interview," in Ward and Jenkins, ed., *American New Wave, 1958–67*, p. 20, and *The Connection Co.* v. *Board of Regents*, 17 App. Div. 2d 671, 230 N.Y.S.2d (3d Dep't 1962).

77 *Times Film Corp.* v. *Chicago*, 365 U.S. 43 (1961).

78 Jonas Mekas, "Movie Journal: On Obscenity; Underground Manifesto on Censorship," *Village Voice*, March 12, 1964; reprinted in Mekas, *Movie Journal*, pp. 126–128.

79 Jonas Mekas, "Movie Journal: The Year 1964," *Village Voice*, January 7, 1965; reprinted in Mekas, *Movie Journal*, p. 173.

80 Mekas, "Movie Journal: On Obscenity; Underground Manifesto on Censorship"; reprinted in Mekas, *Movie Journal*, p. 128.

81 Mekas, "Movie Journal: The Year 1964"; reprinted in Mekas, *Movie Journal*, pp. 175–176.

82 Warhol and Hackett, *POPism*, pp. 36, 39–40.

83 Donald Kuspit, "Pop Art: A Reactionary Realism," *Art Journal* 36, no. 1 (1976): 31–38.

84 Malina, *Diaries*.

85 For example, "What's On" in the *Village Voice*, January 31, 1963, p. 31, lists the premieres of seven peace films on February 4 as a benefit for the New York Strike for Peace: George Zabriskie's *H-Bomb Over U.S.A.*; Richard Evans's *Toys on a Field of Blue*; Harvey Richards's *Women for Peace*; Ray Wisniewski's *Doomshow*; a collaborative film, *The Walk*, by Hamish Sinclair, Hillary Harris, Saul Gottlieb, and Ray Wisniewski; and two sneak previews. And "What's On" in the *Village Voice*, September 26, 1963, p. 20, lists Films Sponsored by the Greenwich Village Peace Center at the Living Theater for September 30.

86 " 'Jail Poets' Read at Living Theatre," *Village Voice*, September 5, 1963, p. 8.

87 Blum, *Theatre World: Season 1962–1963*, p. 181; Brown, *The Brig*; Jonas Mekas, *The Brig* (film, 1964).

88 Brown, *The Brig*, p. 49.

89 Ibid., p. 51.

90 Julian Beck, "Storming the Barricades," in ibid., p. 9.

91 Howard Taubman, "Theater: Marines in Jail," *New York Times*, May 16, 1963.

92 George Freedley, unidentified clipping, May 25, 1963, Billy Rose Theater Collection, the New York Public Library for the Performing Arts, Astor, Lenox, and Tilden Foundations.

93 Michael Smith, "Theatre: *The Brig*," *Village Voice*, May 23, 1963.

94 Judith Malina, "Directing *The Brig*," in Brown, *The Brig*, p. 92.

95 Ibid., p. 95.

96 It is interesting that all three of these theatrical visionaries had themselves been incarcerated. Vsevolod Meyerhold, the Russian director, experimented with Symbolist staging in the early years of the century, but after the October Revolution he became an ardent political dramaturge and the prime exemplar of Constructivism on the stage. His system of Biomechanics, based partly on Taylorism (an American approach to worker efficiency) and partly on commedia dell'arte, took the training of the actor's body to a geometrical and athletic extreme. His use of technology on stage—indeed, his revision of the stage space and the entire theater environment—was a radical innovation that came under fire with the advent of socialist realism. Imprisoned by the Stalinist regime in 1938, Meyerhold was executed two years later.

The ideas of Antonin Artaud, the French actor, director, theorist, and sometime Surrealist, were crucially influential on both the Living Theater and an entire generation of European and American avant-gardists in the Fifties and Sixties. In *The Theater and Its Double*, published in English in 1958, Artaud described a Theater of Cruelty made manifest through sensory bombardment and the invention of a new, scenic language of signs. Afflicted with nervous disorders from childhood, he was incarcerated in mental institutions in both adolescence and adulthood.

Erwin Piscator was a communist and pacifist who had created a politically committed, multimedia epic theater in Weimar Germany in the Twenties and collaborated with, among others, Bertolt Brecht and the Bauhaus architect Walter Gropius. Piscator was imprisoned briefly in 1931 following his production of a play advocating legal abortion. After emigrating to the United States in 1938, Piscator taught drama at the New School for Social Research in New York, where Judith Malina studied with him from 1945–1947. In 1951 he returned to Germany, eventually settling in West Berlin and working at the Volksbühne.

97 Malina, "Directing *The Brig*," pp. 84–87. In the section on Piscator, it was actually Auber's 1828 opera *La Muette di Portici*, which, when performed in Brussels in 1830, sparked the Belgian revolution.

98 See Sam Zolotow, "Tax Office Shuts Living Theater," *New York Times*, October 18, 1963; Jonas Mekas, "Movie Journal: Shooting *The Brig*," *Village Voice*, June 24, 1965; reprinted in Mekas, *Movie Journal*, pp. 190–194.

99 Michel Foucault, *Discipline and Punish*, trans. Alan Sheridan (New York: Random House, 1977; Vintage Books ed., 1979).

100 Brown, *The Brig*, p. 41.

101 Malina, "Directing *The Brig*," p. 97.

102 Brown, *The Brig*, p. 65.

103 Ibid., p. 65.

104 Ibid., pp. 54, 61.

105 Malina, "Directing *The Brig*," pp. 83–84.

106 Ibid., pp. 106–107.

107 Beck, "Storming the Barricades," pp. 18, 34–35.

108 "History Now," a transcript of a symposium at the Yale School of Drama, September 24, 1968, *Yale/Theater* 2, no. 1 (Spring 1969): 24.

6 The Body Is Power

1 Sainer, *Radical Theatre Notebook,* p. 4.

2 Claes Oldenburg, *Store Days* (New York: Something Else Press, 1967), pp. 39–40, 42.

3 Yvonne Rainer, program note, *The Mind is a Muscle,* Anderson Theater, April 11, 14, 15, 1968; reprinted in Rainer, *Work,* p. 71.

4 Paul Goodman, *Three Plays* (New York: Random House, 1965), p. 62.

5 Charles Olson, "Projective Verse," in *Human Universe* (New York: Grove Press, 1951); reprinted in Donald Allen and Warren Tallman, *Poetics of the New American Poetry* (New York: Grove Press, 1973), pp. 147–158.

6 *Proposition* was given its premiere October 21, 1962, at the Institute for Contemporary Art in London and was performed at various subsequent Fluxus performances. *Variation #1 on Proposition,* in which the artist makes soup rather than a salad, was given its premiere on November 9, 1964, at Cafe au Go Go in New York. See Knowles, *By Alison Knowles,* pp. 2–3.

7 The term grotesque is used here not in its everyday, pejorative sense, meaning monstrous, but in a sense derived from the fifteenth-century identification of postclassical, Romanesque art that mixes human, animal, and plant forms in ornamental imagery. Mikhail Bakhtin (see note 8) expands this definition to include body images, such as those in Rabelais's works, of pre-Renaissance folk or "low" art (especially in terms of performances like diableries, feasts, carnivals, and the commedia dell' arte).

8 According to Bakhtin, the grotesque body: "is not a closed, completed unit; it is unfinished, outgrows itself, transgresses its own limits. The stress is laid on those parts of the body that are open to the outside world, that is, the parts through which the world enters the body or emerges from it, or through which the body itself goes out to meet the world. . . . This is the ever unfinished, ever creating body, the link in the chain of genetic development, or more correctly speaking, two links shown at the point where they enter into each other. . . . It is an incarnation of this world at the absolute lower stratum, as the swallowing up and generating principle, as the bodily grave and bosom, as field which has been sown and in which new shoots are preparing to sprout" (*Rabelais and His World,* trans. Helene Iswolsky [Bloomington: Indiana University Press, 1984; reprint of 1968 MIT Press ed.], pp. 26–27). While Bakhtin's book on Rabelais was not available in English in the early Sixties and could not have directly influenced the American avant-garde, his analysis of the grotesque image of the body and its role in "uncrowning" official culture is illuminating in retrospect.

On Douglas's discussion of the effervescent body, see Mary Douglas, "The Two Bodies," *Natural Symbols* (New York: Pantheon, 1970; Vintage paperback 1973), pp. 93–102. In this essay Douglas notes that she is building on Marcel Mauss's seminal essay "The Techniques of the Body," first published in French in *Journal de la Psychologie* 32 (March–April 1936). Douglas argues that an urge toward formality and bodily control results from strong social control over the unruly body, while informality, self-

abandonment, and the loosening of bodily control corresponds to weak social control. She writes: "Social intercourse requires that unintended or irrelevant organic processes should be screened out. It equips itself therefore with criteria of relevance and these constitute the universal purity rule. The more complex the system of classification and the stronger the pressure to maintain it, the more social intercourse pretends to take place between disembodied spirits. Socialization teaches the child to bring organic processes under control. Of these, the most irrelevant and unwanted are the casting-off of waste products. Therefore all such physical events, defecation, urination, vomiting and their products, uniformly carry a pejorative sign for formal discourse. The sign is therefore available universally to interrupt such discourse if desired, as the editor of the revolutionary journal [who opened his editorial with a sprinkling of scatological obscenities] knew." Douglas's theory is attractive in thinking about the Sixties avant-garde, because it meshes several of what otherwise might be considered unrelated aspects of its practices, values, and potent images—its emphasis on intimacy, ordinari-ness, spontaneity, and bodily liberation, as well as its fascination with altered states of consciousness. These, for Douglas, are all part of the symbolic order of the effervescent or ecstatic culture, where control by the social group is weak, where interpersonal and public relations are indistinguishable, and where self and society also are undifferenti-ated; here, symbols are diffuse, there is a preference for spontaneous behavior, inside/outside distinctions are collapsed, and control of consciousness is not valued. Much of Douglas's essay is concerned with the expression by the physical body of social con-straints (that is, the smooth, regulated body). However, she points to, but does not develop, another highly suggestive perception—the ways in which the status quo is interrupted and subverted by the pressures of the effervescent, excessive body.

9 Compare Bakhtin: "The emphasis [in the grotesque body] is on the apertures or the convexities, or on various ramifications and offshoots: the open mouth, the genital organs, the breasts, the phallus, the potbelly, the nose. The body discloses its essence as principle of growth. . . . Mountains and abysses, such is the relief of the grotesque body; or speaking in architectural terms, towers and subterranean passages" (*Rabelais and His World*, pp. 26, 318).

10 Jill Johnston, "Ingenious Womb," *Village Voice*, April 6, 1961, p. 13. The script, a descrip-tion, and photographs of the Happening are given in Kirby, *Happenings*, pp. 94–104. *A Spring Happening* was performed March 22–27, 1961, at the Reuben Gallery.

11 Bakhtin writes: "Degradation here means coming down to earth, the contact with earth as an element that swallows up and gives birth at the same time. To degrade is to bury, to sow, and to kill simultaneously, in order to bring forth something more and better. To degrade also means to concern oneself with the lower stratum of the body, the life of the belly and the reproductive organs; it therefore relates to acts of defecation and copulation, conception, pregnancy, and birth" (*Rabelais and His World*, p. 21).

12 *Window Water Baby Moving* was made in 1959. It is described and analyzed in Sitney, *Visionary Film*, pp. 150–151.

13 In Rabelais's world, as analyzed by Bakhtin, the repository of the grotesque image of the body and its associated "ritual laughter" was medieval folk culture—carnival in particular, but also parodic literature, comic theater, and marketplace talk.

14 Bakhtin comments that in "grotesque realism": "The bodily element is deeply posi-tive. It is presented not in a private, egotistic form, severed from the other spheres of life, but as something universal, representing all the people. As such it is opposed to

severance from the material and bodily roots of the world; it makes no pretense to re-nunciation of the earthy, or independence of the earth and the body. . . . The material bodily principle is contained not in the biological individual, not in the bourgeois ego, but in the people, a people who are continually growing and renewed. This is why all that is bodily becomes grandiose, exaggerated, immeasurable" (*Rabelais and His World,* p. 19).

15 Ibid., p. 9.

16 Ibid., p. 19.

17 Ibid., pp. 324–325.

18 *Eat,* which took place the last two weekends of January 1964, was sponsored by the Smolin Gallery. It is documented, including Kaprow's map and Moore's photographs, in Michael Kirby, "Allan Kaprow's *Eat,*" *Tulane Drama Review* 10, no. 2 (T-30) (Winter 1965): 44–49.

19 Peter Schumann, "Bread and Puppets," *Drama Review* 14, no. 3 (T-47) (1970): 35.

20 Bakhtin, *Rabelais and His World,* p. 338; Kirby, *Happenings,* pp. 148–157.

21 *Vogue,* March 1, 1965, p. 185; cited in Lippard, *Pop Art,* p. 86.

22 Both performances are documented in Carolee Schneemann, *More Than Meat Joy: Complete Performance Works and Selected Writings,* ed. Bruce McPherson (New Paltz, N.Y.: Documentext, 1979). *Looseleaf* was first performed at the Judson Dance Theater workshop January 21, 1964, and later was performed publicly at the Bridge Theater, June 8–9, 1966. *Meat Joy* was first performed at the Festival de le Libre Expression in Paris, May 29, 1964, and was repeated at the Judson Memorial Church, November 16–18, 1964. The characterization of *Meat Joy* as "flesh jubliation" comes from Schneemann's letter to Jean-Jacques Lebel in February 1964 and is quoted in *More Than Meat Joy,* p. 62.

23 *Fluxus Preview Review,* 1963. See Hendricks, ed., *Fluxus Etc.,* p. 229. The description here is given as part of Patterson's *Methods & Processes.* Although the caption to Peter Moore's photograph in *Happening & Fluxus* identifies it as *Licking Piece,* according to Barbara Moore, it was originally untitled but came to be known as *Lick Piece.*

24 Drexler, *Home Movies,* in Poland and Mailman, *Off-Off Broadway,* pp. 32, 33, 41.

25 Ibid., p. 34.

26 Higgins, *Postface,* pp. 5, 76; Higgins, *Jefferson's Birthday,* p. 12.

27 *Bean Rolls* (New York: Fluxus, 1964); *Simultaneous Bean Reading* was first performed at Cafe au Go Go on November 16, 1964. The two excerpts from *Bean Rolls* were published in *cc V TRE,* Fluxus Newspaper No. 2 (February 1964). See Hendricks, ed., *Fluxus Codex,* pp. 299–300.

28 See, for instance, Alison Knowles, *A Bean Concordance* (Barrytown, N.Y.: Printed Editions, 1983).

29 See Hendricks, ed., *Fluxus Codex,* pp. 66–70.

30 Higgins, *Postface,* pp. 70, 78.

31 Nam June Paik, "Afterlude to the Exposition of Experimental Television," *fluxus cc fiVe ThReE,* Fluxus Newspaper No. 4 (June 1964).

32 Friedman, "Explaining Fluxus," *White Walls* 16 (Spring 1987): 23–24.

33 See Eldridge Cleaver, *Soul on Ice* (New York: Dell, 1968), p. 197.

34 See John Szwed's provocative essay, "Race and the Embodiment of Culture," on the discourse of race, bodies, and culture, and in particular his discussions of cultural borrowing "up" and "down" and of the ironies of antiracist rhetoric, in Jonathan Benthall

and Ted Polhemus, eds., *The Body as a Medium of Expression* (New York: E. P. Dutton, 1975), pp. 253–270.

35 Higgins, *Postface,* p. 60. Although Higgins does not set off *Methods and Processes* in italics, it is Patterson's work by that title to which he is referring.

36 Roberts Blossom, "The New Language," *Village Voice,* May 23, 1963, p. 14.

37 *Guns of the Trees* was released in 1961. It was shown on August 29, September 9 and 16, 1963, at the Film-Makers' Showcase, Gramercy Arts Theater.

38 James, *Allegories of Cinema,* p. 122.

39 Mailer, "The White Negro," pp. 278–279.

40 Jones, *Blues People,* p. 235.

41 Ibid., p. 225.

42 Brown, in Anne Livet, ed., *Contemporary Dance* (New York: Abbeville Press, 1978), pp. 44–45.

43 Sally Banes and Michael Rowe, interview with Philip Corner, New York City, February 25, 1980, Bennington College Judson Project; interview with Corner, September 17, 1988.

44 Koch, *Stargazer,* pp. 17–18. *Kiss* was filmed at sound speed (24 frames per second) but is projected at silent speed (16 fps). Its cast includes Naomi Levine, with Ed Sanders, Rufus Collins, and Gerard Malanga (these three kisses were filmed August 1963 and screened September 1963 at the Gramercy Arts Theater under the title *Andy Warhol Serial*); Baby Jane Holzer, with John Palmer and Gerard Malanga; John Palmer with Andrew Meyer; and Freddy Herko, Johnny Dodd, Charlotte Gilbertson, Phillip van Rensselaet, Pierre Restaney, and Marisol. These were filmed in November and December 1963. (Jonas Mekas, "The Filmography of Andy Warhol," in John Coplans, *Andy Warhol,* with contributions by Jonas Mekas and Calvin Tomkins [New York: New York Graphic Society, 1970], p. 146.)

45 Mekas, "Filmography," p. 147. *Blow Job* was filmed in the winter of 1963–1964 and was first screened by the Film-Makers' Cooperative at the Washington Square Galleries on March 16, 1964.

46 Jonas Mekas, "Movie Journal: Warhol Shoots *Empire,*" *Village Voice,* July 30, 1964; reprinted in Mekas, *Movie Journal,* p. 151.

47 Jonas Mekas, "Notes on Some New Movies and Happiness (August 1964)," *Film Culture* 37 (Summer 1965); reprinted in Sitney, ed., *Film Culture Reader,* p. 323.

48 Hoffman, introduction, *Gay Plays,* pp. xxiii–xxiv.

49 I am grateful to Deborah Jowitt for this insight.

50 Schneemann, *More Than Meat Joy,* p. 63.

51 Jill Johnston, "Meat Joy," *Village Voice,* November 26, 1964, p. 13.

52 Michael Smith, "Theatre: Love and Variations," *Village Voice,* September 26, 1963, p. 11.

53 Kenneth Anger, *Magick Lantern Cycle* (New York: Film-Makers Cinematheque, 1966), pp. 3–4, quoted in Sitney, *Visionary Film,* p. 116.

54 For some idea of the disparity between the social roles of men and women in the avant-garde itself, see, for instance, the autobiography of LeRoi Jones's wife, Hettie Jones, *How I Became Hettie Jones* (New York: E. P. Dutton, 1990), as well as Rainer, *Work 1961–73,* and Schneemann, *More Than Meat Joy.*

55 Nancy Armstrong and Leonard Tennenhouse, introduction, *The Ideology of Conduct* (New York: Methuen, 1987), p. 15.

56 Allan Kaprow, Score for *Household,* in *Assemblage, Environments, & Happenings,* pp. 323–324.

57 See, for instance, the influential book by John Berger, Sven Blomberg, Chris Fox, Michael Dibb, and Richard Hollis, *Ways of Seeing* (London: British Broadcasting Corporation; Harmondsworth: Penguin Books, 1972). Laura Mulvey's "Visual Pleasure and Narrative Cinema," *Screen* 16, no. 3 (Autumn 1975): 6–18, extends the ideas in Berger et al. from visual art into film. See also Rosemary Betterton, ed., *Looking On: Images of Femininity in the Visual Arts and Media* (London: Pandora Press, 1987).

58 For two different extended analyses of *Site,* see Maurice Berger, *Labyrinths: Robert Morris, Minimalism, and the 1960s* (New York: Harper and Row, 1989), pp. 81–101, and Henry M. Sayre, *The Object of Performance: The American Avant-Garde since 1970* (Chicago: University of Chicago Press, 1989), pp. 70–76.

59 Schneemann, *More Than Meat Joy,* p. 52.

60 Claude Lévi-Strauss, *The Raw and the Cooked: Introduction to a Science of Mythology: I,* trans. John and Doreen Weightman (New York: Harper and Row, 1969).

61 *Flower* was given twenty times on weekends during March 1963 at 9 Great Jones Street. My description of it comes from my viewing of Whitman's reconstruction in 1976; Whitman's stenographic film of parts of *Flower;* Whitman's script in Michael Benedikt, ed., *Theatre Experiment: An Anthology of American Plays* (Garden City, N.Y.: Doubleday, 1967; Anchor Books paperback edition, 1968), pp. 318–322, and Kirby's detailed record in *Happenings,* pp. 158–171. Also see Michael Benedikt, "Happening: Flower," *Village Voice,* April 4, 1963.

62 Brakhage's 1961 film is available from Film-Makers' Cooperative and Canyon Cinema. See Sitney's account of it in *Visionary Film,* pp. 150–153.

63 This 1964 drawing is reproduced in Larry Rivers with Carol Brightman, *Drawings and Digressions* (New York: Clarkson N. Potter, 1979), p. 134.

64 Kirby documents *The Courtyard* (performed in the courtyard of the Greenwich Hotel on Bleecker Street, November 23–25, 1962) in *Happenings,* pp. 105–117.

65 *The Madness of Lady Bright* opened at the Caffe Cino on May 19, 1964. It was directed by Denis Deegan, had sets by Joseph Davies, and lighting by John Torrey. Neil Flanagan played the role of Leslie Bright; Carolina Lobravico played the Girl, and Eddie Kenmore played the Boy. The production was later redirected by William Archibald and, with revised casts, ran for 168 performances. See Lanford Wilson, *The Rimers of Eldritch and Other Plays* (New York: Hill and Wang, 1967), pp. 73–91.

66 Susan Sontag, "Jack Smith's *Flaming Creatures,*" *Against Interpretation,* p. 230.

67 Stefan Brecht, *Queer Theatre* (Frankfurt am Main: Suhrkamp, 1978), pp. 25–26. Brecht does not mention, however, that the recording goes surprisingly and comically awry when Smith's voice asks, "Is there a lipstick that doesn't come off when you suck cock?" and the announcer answers, "Yes, indelible lipstick." (Quoted in Sitney, *Visionary Film,* p. 355). I am grateful to Authology Film Archives for showing me a print of *Flaming Creatures* when it was out of distribution.

7 *The Anxiety of the Absolute*

1 Norman O. Brown, *Life Against Death: The Psychoanalytic Meaning of History* (Middletown, Conn.: Wesleyan University Press, 1959; reprint ed., New York: Vintage Books, 1961), p. 310.

2 Sitney, *Visionary Film*, p. 174.

3 See, for instance, P. Adams Sitney, "Interview with Stan Brakhage," in Sitney, ed., *Film Culture Reader*, p. 223. Also see Stan Brakhage, "Metaphors on Vision," *Film Culture* 30 (Fall 1963).

4 Brakhage, "Metaphors on Vision," n.p.

5 For accounts of Young's background and career as a composer, see Kostelanetz, ed., *Theatre of Mixed Means*, pp. 183–218; Nyman, *Experimental Music*, pp. 68–72 and 119–123; and John Schaeffer, *New Sounds: A Listener's Guide to New Music* (New York: Harper and Row, 1987), pp. 71–76.

6 These and other 1960 compositions by La Monte Young are published in La Monte Young, ed., *An Anthology* (New York: La Monte Young and Jackson Mac Low, 1963; 2d ed., New York: Heiner Friedrich, 1970), n.p.

7 This piece was used by Simone Forti in her 1961 *Accompaniment for La Monte's "2 sounds" and La Monte's "2 sounds"* and in 1964 by Merce Cunningham as the sound for the dance *Winterbranch*. It has been described as "ashtrays pulled gently over mirrors" and "cans scraping slowly on windows" (Jill Johnston, "La Monte Young," *Village Voice*, November 19, 1964).

8 In Kostelanetz, ed., *Theatre of Mixed Means*, p. 193. Another such work, *Poem for Chairs, Tables, and Benches, Etc., or Other Sound Sources*, in which the furniture (or any object) is dragged and pushed along the floor, was the accompaniment that Yvonne Rainer used in part of her dance *Three Seascapes*.

9 Sohm, *Happening & Fluxus*, n.p.

10 Kostelanetz, ed., *The Theatre of Mixed Means*, pp. 208–211.

11 Ibid., p. 218.

12 Nyman, *Experimental Music*, pp. 123.

13 Jonas Mekas, "Movie Journal: On Cinema Verité, Ricky Leacock, and Warhol," *Village Voice*, August 13, 1964; reprinted in Mekas, *Movie Journal*, pp. 154–155.

14 Jonas Mekas, "Movie Journal: More on Warhol's *Sleep*," *Village Voice*, July 2, 1964; reprinted in Mekas, *Movie Journal*, pp. 146–147.

15 Jonas Mekas, "Movie Journal: On *Laterna Magica*, Superimpositions, and Movies Under Drugs," *Village Voice*, August 27, 1964; reprinted in Mekas, *Movie Journal*, p. 158.

16 Jonas Mekas, "Movie Journal: On the Psychedelic Explorations of Timothy Leary, On Chance, Strobe, and Cinema," *Village Voice*, July 22, 1965; reprinted in Mekas, *Movie Journal*, pp. 196–199; Mekas, "Movie Journal: On the Expanded Consciousness and the Expanded Eye," *Village Voice*, February 17, 1966; reprinted in ibid., p. 222.

17 *Film-Makers' Cooperative Catalogue* No. 6 (1975), p. 230.

18 See Sitney, *Visionary Film*, pp. 232–233, 249–261.

19 Chaikin, *The Presence of the Actor*, pp. 15–16.

20 Rainer, *Work 1961–73*, pp. 71, 287–288, 296–301. *Dance for 3 People and 6 Arms* was first performed at the Maidman Playhouse, March 24, 1962; *Dialogues* was first performed as part of Surplus Dance Theater, Stage 73, February 9, 1964; and *Some Thoughts on Improvisation* was first performed at the Once Festival, Ann Arbor, Mich., February 27, 1964.

21 Jack Smith, "Normal Love," *The Floating Bear*, no. 28 (December 1963): [4]; reprinted in DiPrima and Jones, eds., *The Floating Bear*, p. 334. The page-long story shares a title with the film that Smith began shooting in 1963, but it does not seem to be the

scenario for the film. (See Sitney, *Visionary Film,* pp. 357–358 for a description of the unfinished film.)

22 Brown, *Life Against Death,* p. 308.

23 See Jack Anderson, "The Paradoxes of James Waring," *Dance Magazine* 42, no. 11 (November 1968): 64–67, 90–91.

24 On Robert Dunn's class, which initially led to the Judson Dance Theater workshop, see chapter 1 of my *Democracy's Body.*

25 On Sontag, see Noël Carroll, "Trois propositions pour une critique de la danse contemporaine," in Michele Fèbvre, ed., *La Danse au défi* (Montreal: Parachute, 1987), pp. 177–188.

26 Jill Johnston, "Critics' Critics," *Village Voice,* September 16, 1965, p. 18.

27 First published in abridged form in *Mademoiselle* in 1965, the essay was reprinted in *Against Interpretation,* pp. 293–304.

28 Ron Rice, "Diaries and Notebooks," *Film Culture* no. 39 (Winter 1965): 95. The entry is dated July 9, 1963, Mexico City. The manifesto "Dazendada Works," undated, appears on pp. 118–119; in his introduction Jonas Mekas dates a letter signed Mr. Da Zen Dada, p. 119, winter of 1962–63.

29 Sitney, *Visionary Film,* p. 359.

30 See Noël Carroll, "Identity and Difference: From Ritual Symbolism to Condensation in *Inauguration of the Pleasure Dome,*" *Millennium Film Journal,* no. 6 (1980); 31–42. For my account of *Inauguration* I am deeply indebted to both Carroll's and Sitney's lucid readings of the film's rich, complex, and often confusing imagery.

31 Anger has made several different versions of *Inauguration of the Pleasure Dome.* The version I have seen, which is the only one in distribution in 1993, is the Sacred Mushroom Edition, first screened at Anger's Spring Equinox program at the Film-Makers Cinematheque in 1966. Earlier versions had appeared between 1954 and 1958. P. Adams Sitney gives a history of these versions and a thorough description and analysis of the various versions of the film in *Visionary Film,* pp. 104–115.

32 The swallowing of objects has a sacred significance. Anger, a follower of cult leader Aleister Crowley, begins his notes for the Sacred Mushroom version of the film by quoting Crowley's advice that some sort of Eucharist should be taken daily by every magician. This is the supreme ritual ceremony. "The magician becomes filled with God, fed upon God, intoxicated with God. . . . Day by day matter is replaced by Spirit, the human by the divine, ultimately the change will be complete; God manifest in the flesh will be his name." (Kenneth Anger, *Magick Lantern Cycle* [New York: Film-Makers Cinematheque, 1966], p. 3; quoted in Sitney, *Visionary Film,* p. 106.)

33 Carroll, in "Identity and Difference," underscores the ritual structure of the film and compares it with the kinds of ritual structures that Arnold Van Gennep identified and analyzed in his 1909 study, *The Rites of Passage* (Chicago: University of Chicago Press, 1960).

34 For instance, unless one has read Anger's note or Sitney's description and interpretation, it may be difficult actually to see certain events in the film, like Shiva poisoning Pan's drink or Pan's flagellation. In fact, Carroll and Sitney disagree as to whether the final scene involves *sparagmos*—the ritual Bacchic dismemberment of Pan.

35 Bruce Martin, Joe Medjuck, "Kenneth Anger," *Take One* 1, no. 6 (1967): 13, quoted in Sitney, *Visionary Film,* p. 114.

36 Interview with Corner, September 17, 1988.

37 Quoted in Kempton, "Beatitudes at Judson Memorial Church," p. 109.

38 Stanley Kauffmann, "Music by Al Carmines," *New York Times,* July 3, 1966, sec. 2, p. 1.

39 Al Carmines, "In the Congregation of Art," *Dance Scope* 4, no. 1 (Fall–Winter 1967–1968):30.

40 Kempton, "Beatitudes at Judson Memorial Church."

41 Interview with Rainer, July 20, 1980.

42 Judson Archives.

43 Kempton, "Beatitudes at Judson Memorial Church," p. 107. The Judith Dunn quote is also from ibid., p. 109.

44 Harvey Cox, *The Secular City: Secularization and Urbanization in Theological Perspective* (New York: Macmillan, 1966; rev. ed.), p. 116.

45 It was—like the churches described by Cox that in 1960 formed the Woodlawn Organization (a Chicago community coalition that successfully fought urban "renewal" efforts in the black south side neighborhood surrounding the University of Chicago)—entirely committed to serving the progressive sociopolitical agenda of not only its immediate community, but those whose interests it felt morally obligated to serve.

46 Kempton, "Beatitudes at Judson Memorial Church," p. 137.

47 Cox, *Secular City,* pp. 108–129.

48 William Barrett, *Irrational Man: A Study in Existential Philosophy* (New York: Doubleday, 1958; Anchor Book ed., 1962).

Index

Abstract Expressionism, 2, 28; reaction to, 53, 94

Abstraction: revolt against, 164; in Soviet art, 163–64

Abundance: of art events, 138; economic, 138–39, 160, 200

Acapulco (dance), 70, 123

African Americans, 145–58; art form fusion by, 117; assimilation into melting pot, 205, 207; bodies of, 204–12; culture of, white appropriation of, 204–6, 208–12; in dance, 154, 204–5, 209, 211; early history of, 18; equal opportunities for, 111; in film, 155–56, 207–8; improvisation by, 156–57; in music, 18, 153, 209–12; in musicals, 148–49; presence in Village, 145–46; separate culture of, 146, 154, 158; in theater, 146–53, 206–7; in visual arts, 153

Afternoon (dance), 37, 229

AG Gallery, 60, 62

Ailey, Alvin, 154

Albee, Edward, 24, 35, 40, 120, 149

Allen, Lewis, 74, 75

"Americana ballet," 91

"American Bandstand," 204

19, 22; nontheater events sponsored by, 42; political involvement of, 9, 41–43; purpose of, 186; realism in, 117–18

Lloyd, Barbara, 37, 71

Loew's Commodore theater, 21

Loft, The, 40–41

Loonin, Larry, 48

Looseleaf (performance art), 197

Love and Variations (play), 218–19

Loving (film), 217

Lowenthal, Leo, 100

Lust, Geraldine, 43

Lye, Len, 23

Maas, Willard, 55

McClure, Michael, 26

McDarrah, Fred, on history of Greenwich Village, 14–20

Macdonald, Dwight, 82, 100

MacDonald, Scott, on film society, 74

Macdougal Street, 21–22

McDowell, John Herbert, 71, 113

Maciunas, George: Knowles's bean multiples of, 202; in Fluxus, 60–65, 113, 164, 204; food events of, 203; ordinary featured by, 128; at Yam Festival, 59

McKayle, Donald, 154

Mac Low, Jackson: as anarchist, 41; in Cage composition class, 28, 29; in Fluxus, 60, 62; Happenings of, 52; as pacifist, 26; performance art by, 92; at poetry reading, 176; poetry-writing system of, 128; politics of, 127–28, 154; at Yam Festival, 59

McLuhan, Marshall, 8; on global village, 80, 247

Madness of Lady Bright, The (play), 49, 173, 231

Magic, search for, 248–49

Mailer, Norman, 146, 208–9

Mailman, Bruce, 47, 85–86

Malanga, Gerard, 36, 55–56, 124

Malcolm X, 145

Malina, Judith, 23, 40; *The Brig,* production of, 176–87; *The Connection,* production of, 157; directoral style of, 42; folk art used by, 98; prison experience of, 175–76; in *Queen of Sheba,* 166

Manchurian Candidate, The (film), 35

Man Is Man (play), 43

Many Loves (play), 41

Marionette Theater, 162

Markopoulos, Gregory, 56, 75, 168

Marlowe, Alan, 26

Marsicano, Merle, 71

Martha Jackson Gallery, 54, 153, 155

Maslow, Sophie, 91

Mason, Marshall, 2, 49

Mass (film), 76

Mass culture: anxiety about, 82; of consumerism, 138; influences of, 99–106

Mass Culture: The Popular Arts in America (book), 100

Mass media, influences of, 100, 101, 103

Maxfield, Richard, 53, 60

Mead, Margaret, 247

Mead, Taylor, 55, 124; on nonprofessionals, 114; at poetry reading, 176; in *Queen of Sheba,* 96, 107, 166

Meat Joy (dance/performance), 36, 173, 197, 216–17

Mekas, Jonas, 56; *The Brig* filmed by, 182; on cinematic revolution, 165–66, 168; on Cornell, 121; on *Eat,* 123–24; in film, 73–78, 166; films of, 207; on folk art in film, 89; on free speech, 171–73; on freedom, 169; on innovation, 114; on perception, 240–41; on support for arts, 170; on underground film entering Establishment, 173–74

Menken, Marie, 55

Merz assemblage, 134–35

Metaphors on Vision, 237

Method acting, 159

Metropolitan Opera, 5

Meyerhold, Vsevolod, 24, 181, 282 n.96

Microstructure, concern with, 120

Middle-class culture, influence of, 6

Milder, Jay, 53, 153

Miller, Larry, 62

Miller, Warren, 155

Millett, Kate, 2

Mind is a Muscle, The (dance), 242

Sally Banes is professor of dance and theater history and chair of the Dance Program at University of Wisconsin-Madison. The author of *Terpsichore in Sneakers: Post-Modern Dance* and *Democracy's Body: Judson Dance Theater 1962–1964*, she was formerly the performance art critic for the *Village Voice* and the editor of *Dance Research Journal*. She has written on dance, theater, film, and performance art for numerous publications, including the *Village Voice*, *Soho Weekly News, Hartford Courant, The Reader* (Chicago), *Connoisseur, Millennium Film Journal, Folklife Annual, The Drama Review, Performing Arts Journal, Ballet Review, Dance Chronicle,* and *Dance Magazine.* She has edited *Footnote to History,* by Si-lan Chen Leyda, and *Soviet Choreographers in the 1920s,* by Elizabeth Souritz. She also contributed the chapter on breakdancing to *Fresh: Hip Hop Don't Stop.* She was consultant/writer for the film *Retracing Steps: American Dance Since Postmodernism* and co-consultant for *Dancing with the Camera* and *Style Wars.*

Library of Congress Cataloging-in-Publication Data
Banes, Sally.
Greenwich Village 1963 : avant-garde performance and the effervescent body / Sally Banes.
Includes index.
ISBN 0-8223-1357-X (hard). — ISBN 0-8223-1391-X (soft)
1. Arts, American—New York (N.Y.) 2. Arts, Modern—20th century—New York (N.Y.) 3. New York (N.Y.)—Popular culture. 4. Greenwich Village (New York, N.Y.)—Popular culture. I. Title.
NX511.N4B26 1993
700'.9747'1—dc20 93-18393 CIP